CULTURALLY RELEVANT ARTS EDUCATION FOR SOCIAL JUSTICE

A groundswell of interest has led to significant advances in understanding and using Culturally Responsive Arts Education to advance social justice and education. This landmark volume provides a theoretical orientation to these endeavors. Emphasizing the arts as a way to make something possible, it explores and illustrates the elements of social justice arts education as "a way out of no way" imposed by dominance and ideology and offers a set of powerful demonstrations showing how this work looks in action.

Mary Stone Hanley is a professor at George Mason University, USA, and a poet, playwright, theater artist, and community activist who for over 40 years has used the arts to provoke and invite social justice.

George W. Noblit is the Joseph R. Neikirk Distinguished Professor of Sociology of Education at the University of North Carolina at Chapel Hill, USA. His work has focused on issues of race, school reform and, more recently, the arts. He is the bassist with The Blue Sky Travelers, an old-time string band.

Gilda L. Sheppard is Professor of Sociology, Cultural and Media Studies at The Evergreen State College in Washington State, USA, a community activist, and an award-winning filmmaker who has screened her documentaries in the USA and at Cannes Film Festivals and International Festival in Berlin.

Tom Barone is Professor Emeritus, Arizona State University, USA. He received the American Educational Research Association Division B Lifetime Achievement Award (2010), and the Tom Barone Award for Distinguished Contributions to Arts Based Research from the AERA Arts-Based Special Interest Group (2012).

CULTURALLY RELEVANT ARTS EDUCATION FOR SOCIAL JUSTICE

A Way Out of No Way

Edited by
Mary Stone Hanley
George W. Noblit
Gilda L. Sheppard
Tom Barone

Routledge
Taylor & Francis Group

NEW YORK AND LONDON

First published 2013
by Routledge
711 Third Avenue, New York, NY 10017

Simultaneously published in the UK
by Routledge
2 Park Square, Milton Park, Abingdon, Oxon OX14 4RN

Routledge is an imprint of the Taylor & Francis Group, an informa business

Library of Congress Cataloging-in-Publication Data
Culturally relevant arts education for social justice : a way out of no way /
edited by Mary Stone Hanley, George W. Noblit, Gilda L. Sheppard,
Tom Barone.
 p. cm.
 Includes bibliographical references and index.
 1. Education—Social aspects—United States. 2. Arts—Study and
teaching—United States. 3. Social justice—Study and teaching.
I. Hanley, Mary Stone, editor of compilation. II. Noblit, George W.,
editor of compilation. III. Sheppard, Gilda L. (Gilda Louise), editor of
compilation. IV. Barone, Tom, editor of compilation. V. Bell, Lee Anne,
1949– Storytelling for social justice.
LC191.4.C84 2013
306.43—dc23 2012038682

ISBN: 978-0-415-65660-3 (hbk)
ISBN: 978-0-415-65661-0 (pbk)
ISBN: 978-0-203-07757-3 (ebk)

Typeset in Bembo
by Apex CoVantage, LLC

A Way Out of No Way

Chorus:

Where there's struggle there's always hope
Sure as dying, ain't no fad
Struggle's one thing we've always had
Where there's struggle there's always hope

<div align="right">M. S. H.</div>

CONTENTS

PREFACE

This book arises from dual emotions: love and anger. Through this project, we work out of love of humanity in its many, complicated, and even distressing forms. We also work in anger at the formations of social life that deny people the use of their capabilities—that deny their beauty, their truths, and their arts. Love and anger drove us to this book, and through this book. These emotions have not gone away with the publication of this book. Their roots are too deep, too contested for resolution. If anything, though, the process of doing this book, we hope, shows others that strong emotions do not have to disable us. Rather they can drive us forward in the struggle for equity and social justice in the face of globalized injustice. Like all the authors here, we see this project as one step in a long struggle—a way out of no way.

Culturally Relevant Arts Education for Social Justice: A Way Out of No Way is the culmination of several years of effort by the editors and authors. The project began out of a concern that while we knew many people doing work at the nexus of arts, arts education, and social justice, this work remained all too hidden from others who wished to take advantage of these efforts. It is hard to build a movement without some sharing of strategies and struggles. Instead of simply bemoaning this unfortunate state of affairs, we decided to actually see if we could locate the work being done and create a volume from this work that could be the basis of a wider dialogue and action.

We created a call for proposals for the volume and spread it as widely as we knew how at the time. We used every Listserv, every conference, and almost every communication to spread the work and the call for proposals. Our initial concern was whether we would receive enough proposals to constitute a book. This was quickly put to rest. We received some 239 proposals. We were shocked at the volume of work being done, but even more dismayed by the fact that all this work was not getting out into the literature. Our concern shifted: Would the work be of

sufficient quality to warrant a book? As we read the proposals, we concluded that there was sufficient quality work for a book, but new concerns arose. The work we ended up soliciting ranged widely and drew on many different aesthetic, conceptual, and practical traditions. Social justice was defined differently, and different arts developed differences approaches. This was testimony to the richness of the work we uncovered but raised all types of questions about how to deal with the range and still have some coherency around which to build the book. We sorted the proposals into many different categorical schemes, which resulted in our invitations for some 40 proposals to be developed as chapters.

Thankfully, the authors produced well-crafted drafts, which we read and commented on. With these drafts in hand, we rejoined our search for a publisher. Routledge showed interest early, and we began to work with Naomi Silverman to craft this volume. We were asking to join Routledge's expanding list of books addressing social justice and the arts, and we had something quite different from the other books. The question became how to conceptualize and organize around this difference, and, more difficult for the editors, reduce the volume of works to make a book that could be published. Silverman worked tirelessly with us on this process. We found other outlets for some of the chapters, many in the *International Journal of Arts Education*; as time passed other authors found different outlets for their work as well. Nonetheless, in the end, we had to make very hard decisions about who would be included here. We expect that many of those we could not include will find their way into print as well. We encourage readers to seek out these works. They help fill out a complex but thrilling field of study and practice. There is much going on in the arts, art education, and social justice. We also encourage others working in the field to contribute to the dialogue as well. This book is but a starting point—it simply maps a field in which there is much going on.

In the process of focusing this book, we chose a particular audience to write toward—people who wish to do social justice through and with the arts. This includes arts educators in schools and community and higher education. Our audience also includes those who see themselves as artists who employ their talents in the service of social change and activism—they are educators as well. Finally, our audience includes those who are searching for a medium for their work in social justice. You will find authors speaking to you, offering a way out of no way.

In many ways, the title of this book came last. As above, the subtitle reflected our understanding of the significance of the book. In the face of closed doors, denied opportunities, and subjugation, the arts often represent to us, the editors, the only way to imagine differently, produce the new, and invigorate and strategize social change. We conceptualize the arts, art education, and social justice not as separate categories or distinct enterprises. We see them as one effort with many manifestations. Clearly, not everyone agrees with this way of thinking, and we view this as unfortunate and ultimately dangerous. The arts have such power that giving them moral purpose is necessary, and equity is the highest moral purpose we can imagine. After much deliberation, we came to the title *Culturally Relevant*

Arts Education for Social Justice, and we coupled this to *A Way Out of No Way*. Mary Stone Hanley, who we all acknowledge as the leader of this effort, had been using variations of this title for some of her own work. She had been reluctant to use it for the collective project, but in the end, it seems most appropriate. It acknowledges the power at play and centers culture and race.

To serve our audience as well as we can, we have organized the book around several distinctive features. First, we take on as many forms of arts, activism, and education that space has allowed. Visual art, theater, music, photography, dance, and film are all here. We include projects in juvenile justice, schools, museums, higher education, communities, and so on. Second, each chapter is explicit about its pedagogy—not only what was done and what this led to, but also the conceptual grounding and questions that guided the projects. Third, we organized two sections of the book, not to signal difference but rather to signal completeness. In some senses, all the chapters offer models and focus on reflections and theorizing. Yet different chapters lead with different emphases. The first section fronts 'models' of the art/social justice work. They are not the models offered in many educational innovations that require fidelity of implementation. Neither art nor social justice can survive such a lack of creativity. Thus, the models offered here are intended for the imagination and hopefully will generate new and different projects. The models require reflection and critique. The second section then fronts thought, conceptualization, imagination, and reflection. Here the chapters reveal how creative processes underlie culturally relevant arts education. In some sense, the model is only as good as what people do with it. With reflection and theorizing, art joins social justice educatively. Fourth, the introduction and conclusion are unlike bookends. That is, they hold the pieces together but do so differently. Mary Stone Hanley introduces the book by giving us a creative frame for art/social justice work that the chapters illuminate. Gilda L. Sheppard then coalesces the project with another creative frame, bringing us back to our purpose and commitments.

We invite you to join with us as we imagine culturally relevant arts education as a way out of no way. Imagination, creativity, and art production are at the root of the struggle for social justice.

—*Mary Stone Hanley, George W. Noblit,*
Gilda L. Sheppard, and Tom Barone

INTRODUCTION

Culturally Relevant Arts Education for Social Justice

Mary Stone Hanley

The title of this chapter and book is a mouthful of brain-rattling concepts that raise a lot of questions. What is social justice? What is culture? Why arts? My goal in this chapter is to give some real-world context for the title and provide theory and a model of pedagogy that is a framework for the chapters that follow. To be clear from the beginning, what I mean by pedagogy is not the bipolar perspective of curriculum as what you teach and pedagogy as how you teach it, but rather, pedagogy as the relationship of teaching, learning, and content. This model of culturally relevant arts education (CRAE) is based on intra- and interconnections—of learning, creating, disciplines, social power, controversies, theories, models, and experience. CRAE is a synthesis of my life as an artist, an educator, a researcher, an activist, and an African American woman and that of my students and fellow artists in a historical progression. I position interconnections here, at the beginning, to encourage you to think more about relationships than divergences in the development of CRAE.

CRAE is also based on a synthesis of the work of the artists and educators in this book who are doing social justice work with people of all ages in communities, schools, colleges, and universities. Their students are transformed as, regardless of social status, they struggle to understand and transform a medium, creating that which becomes resources for themselves and their communities. They are engaged in justice work that is internal and external, of self and the world, of recognizing the roots of internalized oppression, and of making demands on society for the recognition of the diversities.

The kernel of CRAE may have begun when I was 8 years old and I wrote my first poem to the blind lady who was my big brother's landlady. I read it to her; I don't remember the poem, but I remember her smile, her hug, and my mother's approval. I remember the sense of being somebody important that could give someone else such joy. I've known from the first—when my mother recited Dunbar, Langston, and Shakespeare to me; when I took

piano lessons from a teacher who taught me to play boogie-woogie riffs; when my friends and I played "talent show" on the back steps; when my brother taught me to dance to Little Anthony and the Imperials—how significant the arts were in helping me to make meaning of the world and to represent my vision in spite of the obstacles I faced as a Black girl growing up in the U.S. Rust Belt in the middle of the twentieth century.

"A way out of no way" is an oft-used phrase in the African American tradition of tenacity and hope that rings true for all people; even in the darkest of times, we humans struggle to find an alternative route to the integration that Freire (1974) describes:

> Integration results from the capacity to adapt oneself to reality plus the critical capacity to make choices and to transform that reality. . . . If [one] is incapable of changing reality, he adjusts himself instead. Adaptation is behavior characteristic of the animal sphere; . . . it is symptomatic of dehumanization. (p. 4)

To get to this place of our fullest humanity, consciously and unconsciously, we all engage in a never-ending push-me-pull-you dance along the continuum of social justice, looking for ways to assert our individual and collective desires and needs. This book focuses on the relationship of the arts and social justice as a way to travel toward integration.

Social justice has been described as an "equitable redistribution of resources" (Barry, 2005; Bell, 2007) and as recognition of culture and identity for those who are marginalized and subjugated in society (Fraser, 1997; North, 2006). Distribution and recognition are dialectically and dynamically interconnected; each continuously develops in relationship to the other. Without resources, people are easily disregarded. Through their opposition, they become visible to those who cannot or will not acknowledge them. The struggle for recognition consists of approaches used by the oppressed to turn the social gaze on their humanity, as well as a means to construct visions of self-determination.

In the 1960s, I went to a historically White college and struggled through a theater program in which the only roles I played were maids; a classmate openly related Blacks and apes because both were black and had flat noses. Having grown up in a working-class Black family in a segregated community, I seldom had to contend with racism. I had no name for my experience, which I later identified as institutional racism and White supremacy; I only knew it hurt and was confusing. In 1970, I moved to the West Coast at a time of major cultural changes; I found names for my former college experience in the civil rights and Black Power movements, and found a feminist voice among women who called ourselves Third World Women. It was a time of consciousness raising, reading, demonstrations, sit-ins, takeovers, and theorizing and experimentation—a time of self-inspiring creativity through which I began to transform my views of the world and my ability to change it.

Imagination and creativity are the source of social justice and the arts. A just society and an art form must first be imagined, then media, whether paint, words, or culture, must be transformed. Imagination is the capacity to think of possibilities

beyond what exists (Egan, 1992), and creativity is the mental and physical processes of decision making, risk taking, and change used in the development of novel ideas and products. The various levels of creativity include those outcomes that may change the world based on the approval of experts in the field (Csikszentmihalyi, 1996), like the work of Picasso, Duke Ellington, Steve Jobs, or Cesar Chavez. On a more limited interpersonal level is the creativity involved in a family meal or the work of youth who write poetry, take photographs to relate their view of the world, or create film and stories. At the other end of the spectrum is intrapersonal creativity, which involves sometimes miniscule mental shifts in perspective or interpretation of ideas and events (Beghetto & Kaufman, 2007) that may be novel only to oneself but are necessary in interpersonal creativity.

Imagination and creativity are embedded in Vygotsky's (1978) description of human survival in nature. He states that we "affect nature and create through . . . changes in nature new natural conditions for . . . existence" (p. 60). Thus, creativity is the human genius for transformation in a hostile natural world that includes drought, tornadoes, floods, and predators and in a social world that includes racism, sexism, homophobia, and fascism, to name only a few of the oppressive social constructions we have created. Indeed, creativity is our hardwired capacity to change the world into what we imagine, whether for good or for ill, and even to establish the moral compass that will determine our direction. Imagination and creativity are our ways out of the seemingly no way of human experience and meaning that is as chaotic, complex, and as multifarious as snowflakes in a blizzard; like eating and breathing, these capacities are essential to each individual and to the survival of the species. Thus, creativity is empowering; you take risks, test the world, shape media and meaning, and thereby change the world.

Agency

Agency is a cognitive process that drives creativity. Bruner (1996) describes agency as thinking for oneself in a problem-solving and decision-making context in order to arrive at responsible and successful choices. Bandura (2001) points to forethought, evaluation, self-regulation, reflection, and communication as attributes of agency that enable people to play a part in their self-development, adaptation, and self-renewal. In philosophical discourse, Martin, Sugarman, and Thompson (2003) state that agency is "the freedom of human beings to make choices in ways that make a difference in their lives" (p. 15). In the ultimate analysis, the generations' long march to create justice explains the dream of freedom—freedom to change the world into what is imagined to be healthy, strong, beautiful, enabling, and liberating. Agency is clearly in play as the artist or the activist makes decisions about dynamic layers of meaning, media, purpose, and audience to create and express, to transform.

The capacities of imagination, creativity, and agency are ways of knowing and doing that belie the powerlessness of the oppressed; subjugated people, whether because of race, national origin, class, gender, language, age, or sexual orientation,

have in their hands and minds the power to create like those with privilege because all humans create culture. However, when freedom of choice becomes muffled, creativity and agency may be redirected to resistance which is a place of freedom and hope. Resistance to the numbness and fear in the adaptation Freire (1974) describes is a creative process. The resistance of youth who drop out of school mentally or physically has multiple roots but may be an effort to be creative, assert agency, and find integration. Learning through the arts centers the creative process so that artistic agency (Hanley & Noblit, 2009), using media for interpretation, conceptualization, and expression can be used to question and transform thought and actions. Greene (2001) expresses the transformative meaning making of the arts when she states,

> We are concerned with possibilities, with opening windows on alternative re-alities, with moving through doorways into spaces some of us have never seen before.... We are interested ... in the kind of wide-awakeness that allows for wonder and unease and questioning and the pursuit of what is not yet. The kinds of insights and perspectives that often change people's lives. (p. 44)

Hence, access to arts education is a valuable resource for all children and adults; for those in marginalized groups, it is an act of distributive social justice.

I finished a BA in children's theater, and I began teaching in Headstart, then primary grades in public schools; in the summers, I taught theater skills to adolescents. During 7 years as a primary-grade classroom teacher, I noticed how the joy and ownership of learning shifted when I stopped talking and the children used visual arts to learn math or science, or drama and puppetry in language arts. The learning was deeper; they engaged, remembered more, and understood more readily.

When I worked with teenagers I observed that they struggled to make sense of the chaos of lives immersed in the challenges of race, gender, sexual orientation, and social class. As an echo of my own youthful experience, I have seen them transformed, emerging from a fog into clarity, when they learn they have voice and agency. They are surprised to find they are val-ued and valuable when they had felt themselves to be no more than cogs in the machinations of the world; indeed, they were producers of culture.

Similar to Vygotsky (1978), Dewey (1934) suggests that humans make forms like the arts to make sense of the chaos. We create representations of our world to better understand it, express our understanding, and engage in the human conversation of being. One of the forms we create is culture, which according to Geertz (1973) is "webs of significance" (p. 5), signs, symbols, and meaning spun to explain ourselves to each other and to create a common and remembered experience. Culture is what we share, value, teach, and pass along moment to moment, day to day, and genera-tion to generation. It can be as local as the culture of a family or classroom, or as global as Black or Latin culture or the culture of capitalism.

The paradox of viewing culture as a form, a rather static term, is that every individual in the culture is involved in the interpretation of narratives and events; thus, culture constantly rises and falls in part because individuals are developing as

individuals while they also create shared meaning. The arts are a way to focus the chaos of culture so that everyone, including artists, can grapple with the ever-shifting complexities of human meaning and experience.

In the early 1970s, I had little idea of how to merge my understanding of social justice and the arts until I cofounded a group called the Choreopoets with Gilda Sheppard, a coeditor of this book. We were a group of African American, 14- to 27-year-old activists who were also singers, dancers, actors, designers, and writers who put movement and music to African American poetry and prose. We performed folktales and danced to the poems of Claude McKay, Margaret Walker, and Langston Hughes, and the speeches of Fredrick Douglass and many others. It was a community-based social justice group; any interested African American could join. Our motto was an African adage, "If you can talk, you can sing; if you can walk, you can dance." "Each one, teach one" was another. The dancers taught the "pedestrians"; the actors taught performance skills; the singers taught us songs and harmony; and we all immersed ourselves in a wealth of Black literature that most of us had never known existed. I directed and choreographed much of the work, and we collaborated on others. We toured the West Coast and opened for the likes of Gil Scot Heron, Dick Gregory, and Angela Davis. Our goal was to affirm Black culture and to agitate for social justice through our art. It was an exhilarating and heady journey into the power and possibilities of the arts as a change agent. For 20 years, the Choreopoets involved many Black artists in the area who were transformed by the work, changed by our agency, activism, and artistry, and by the response of audiences of all ages and races.

In contrast, in the 1990s I began teaching in-service and preservice teachers in higher education. Even more suppressed than adolescents were the adults who had learned the "I can't" song so many years ago that it has become their mantra—I can't sing, can't draw, can't dance, can't write, can't think, can't be important, can't be listened to or heard, can't be of use, can't be an actor in the world. For them the arts became a monkey-off-my-back experience when they discovered what they thought they could not do was really a matter of perception and oppressive training.

One of the social justice aspects of this work lies in the empowerment that comes with the clarification of internal voice and the creative agency that then can be used to transform the world through works of expression. Through the arts, we can study the known and the ubiquitous unknown on conscious and unconscious, intellectual, intuitive, and emotional levels; we can inform, empathize, envision possibilities, and raise critical consciousness. No matter how deep the oppressive conditions, artists can reclaim humanity for themselves and their communities through their creative agency, and they model possibility for others who search for meaning and a way to empowerment.

Freedom and Self-Determination

Freedom is power and an essential part of the process and outcome of creativity; however, freedom is not boundless. It must be grounded and countered by the reality of the consequences and ethics of action on the world (Freire, 2001). The consequences of freedom are a subtext of art production because arts making

requires relentless choice making and compromise that have implications for the product. Each medium has its own characteristics that inform the artist's decisions and possibilities. Although imagination creates a wide field on which to play, the medium is one of the primary factors that determine the game. A poetic rose, a painted rose, and one that dances are three representations of the same thing but are different in how they are created and how they are perceived. The choices the artist makes will affect the quality of the work, while the medium, like a partner, pushes and pulls the meaning and form.

The percipient or audience is the third member in the game, bringing their interpretation to the work. Artists who work across the spectrum of social justice will work with the audience in mind or intuit the audience's life through connections with their own passions. My points here are that creating the arts teaches many things—line, color, rhythm, rhyme, words, structure, characterization, plot, focus, timing, and a myriad of other elements that artists use to make their forms. However, there are also other effects sometimes not recognized, such as the knowledge that you are a subject in the world; you can affect others across time and place; change comes from your imagination and disciplined work; and consequences are not necessarily in your control, but you can and will have to deal with them. Said another way, struggle can be empowering if you are focused and conscious of your purpose—a breathtakingly powerful understanding for subjugated people to embrace.

I worked for 7 years in the 1980s and 1990s with adolescents in drama program at a community arts center. I was the playwright and wrote plays with them or for them about their lives that they performed and toured to schools and community centers, raising issues that affected them, and thus everyone in the Black community. The program was developed for middle and high school youth who were at risk for failing in schools. I watched them read, write, and discuss deep artistic and life questions with intelligence; take on challenges and responsibilities; and chastise each other for not being prepared—and a question haunted me. How was it that these bright, articulate, funny, loving, creative youth glowed and achieved so much in a drama program and also failed in schools? What was it about the artistic experience that was lacking in their classrooms and schools? My search for an answer began in a PhD program at the University of Washington where I was mentored in multicultural education by faculty who helped me to understand the schools as institutions where the knowledge produced perpetuates and transforms an evolving society. I began to discern an answer: What was present in the drama program and often lacking in schools was creativity and active learning, attention to agency and students' desires, respect for the individuals that included a validation of their identities and cultures, and work that supported empowerment.

Haki Madjabuti observes that what "our children need is love and the arts. Love, so that they know their value; the arts so they can express that value" (personal communication, June 1997)

The following is a pedagogical model of CRAE (Hanley, 2011) that can be used to focus the arts on social justice (Figure 0.1). The model is an extension of the literature review by Hanley and Noblit (2009) and incorporates the goals of culturally responsive and culturally relevant pedagogies (Banks, 2010;

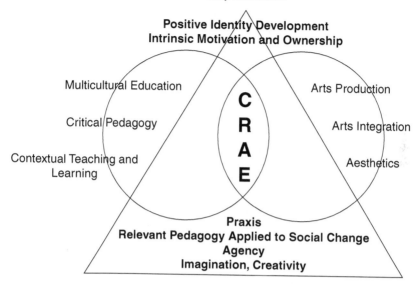

FIGURE 0.1 Culturally Relevant Arts Education.
Adapted from Hanley (2011).

Gay, 2010; Ladson-Billings, 2009; Sleeter, 1996),[1] which are about motivating artists[2] through pedagogy that uses their cultural knowledge and experience as an asset.

The foundation of the model is imagination and creativity that are instrumental in praxis (Freire, 1970). Praxis in CRAE is action and critical reflection about the arts and artists, the world, and art's work in the world. Critical reflection involves an analysis of the source and construction of power and knowledge. Kincheloe (2005) describes that process as

> an ability to step back from the world as we are accustomed to perceiving it and to see the ways our perception is constructed via linguistic codes, cultural signs, race, class, gender, and sexual ideologies, and other hidden modes of power. (p. 11)

In other words, critical reflection on power is crucial for CRAE because it is a use of the arts to teach and learn about injustice and its transformation.

There are six pedagogical models in the CRAE model: three in the arts and three in the nonarts. The three arts pedagogies are arts production, arts integration, and aesthetics. Through arts production, artists learn skills to express ideas and emotions through arts media. Arts integration involves the use of the arts to teach

and learn non-arts subjects; the best form of arts integration involves learning and using the elements of the arts, as well as the pedagogy of nonarts subjects. Unfortunately, arts integration is based on the siloed nature of education as it stands today, with a view of hierarchical disciplines with little connection to each other. In truth, color is science; music is mathematical, from composition to engineering; and you cannot write a poem or a song without the art of language. In fact, CRAE is an example of arts integration because the arts are used as pedagogy for social justice.

The third arts-based pedagogy is aesthetics, an immersion in the experiences and perspectives of the world of arts and artists. Who are the artists? What are their stories? How and what knowledge is constructed through the arts? What is the history and social contexts of the art form? This area of arts education provides a way to explore the artists' own culture through an examination of recognized artists and cultural forms from their cultural backgrounds, as well as those representing a diversity of global differences, including that of the dominant culture.

There are many ways to teach the arts, some of them entrenched in the sage-on-the-stage model, not far from the nineteenth-century image of the headmaster and his big ruler. I do not claim that CRAE is the only approach to arts education, only that it merges learning in the arts and social activism and is derived from what people, like the authors in this book, have already proved to be successful for transformation of self and society, both of which are undeniably challenging and profoundly important.

The nonarts pedagogies include the many dispositions, content, and instructional methods in the dimensions of multicultural education (Banks, 2010) including an interrogation of knowledge and approaches that affirm the learner's power to produce knowledge and the methods that challenge prejudices of any kind. The claim of culturally relevant/responsive theorists (Friedlander, & Darling-Hammond, 2007; Gay, 2010; Ladson-Billings, 2009) is that the use of artists' cultural knowledge as the core of instruction is more likely to engage artists in learning. Rather than being criticized for their culture, artists are empowered by their cultural knowledge, enabling ownership of learning, which stimulates intrinsic motivation, curiosity, and imagination. Gay (2010) describes culturally responsive education (CRE) as a form of pedagogy used to teach low-income students and students of color who have been perceived as deficient. Thus, she states that CRE would "teach *to and through* their personal and cultural strengths, their intellectual capabilities, and their prior accomplishments. . . . it [CRE] insists that educational institutions accept the legitimacy and viability of ethnic-group cultures in improving learning outcomes" (p. 26).

Critical pedagogy is the model that challenges dehumanization. In some contexts, it is deeply connected to multicultural education. Sleeter and McLaren (1995) describe the intersection of critical pedagogy and multicultural education as teaching that

> bring[s] into the arena of schooling insurgent, resistant, and insurrectional modes of interpretation and classroom practices which set out to imperil

cultural life, and to render problematic the common discursive frames and regimes upon which "proper" behavior, comportment, and social interaction are premised. (p. 7)

Leonardo (2004) describes the process of criticism, which is a focus of critical pedagogy, as a means to "cultivate students' ability to question, deconstruct, and then reconstruct knowledge in the interest of emancipation" (p. 12). Hence, artists involved in critical multicultural education pull, push, rupture, resist, analyze, challenge, reframe, and transform; that which was "natural" or dominant is open to interrogation and change.

To achieve the goals of CRAE is to have the disposition of artist centeredness, a focus on the generative imagination and creativity of the learner may be achieved in the final pedagogy, contextual teaching and learning (CT&L). CT&L is a cluster of instructional methods, such as problem-based, inquiry-based, or authentic instruction, or service learning that emphasizes the active engagement of the learner in research and creative problem solving applied to real-world situations—the more embedded the activities are in the lived experiences of the artist, the better. When these activities are about the transformation of injustice and are arts based—such as films or plays generated by artists that address a community problem, adolescent spoken word poets who work with younger children teaching them to speak to power through poetry, or muralists who record a community's struggles and triumphs or who remedy urban blight with color and form—the artists are engaged in CRAE.

Participation of CRAE is meant to provide a path through the chaos of subjugation and alienation experienced by many in schools and society so that they connect to intrinsic motivation and ownership of learning, a result of attention to agency and creativity. Hanley and Noblit (2009) found that positive identity development is a key to resiliency, which is necessary in the difficult work of social justice. The ultimate goal of CRAE is to promote empowerment so that all individuals—children to adults—may assert their inherent creativity to recreate a world that shares, recognizes, and includes their gifts.

Finally, the purpose of providing a model of CRAE is not to make a box for putting ducks in a row, ensuring that the pieces are all there. It is a synthesis of what many are already doing and a guide to further thought and discussion, a way to sharpen the structure.

Ubiquity

In closing, I want to point out to those who think the arts are unnecessary or frivolous add-ons to education that the importance of the arts to human culture is broadly underestimated. Day to day, minute to minute, formally and informally, we build relationships with family, community, the world; traverse time and space; record and reconstruct history; and structure the present and future through the imagination of artists of all levels of prominence and skill and by working

with the tools of the arts. We perceive and make sense through color, shape, form, texture, rhythm, timbre, melody, story, two- and three-dimensional images that move, and those that have stood for centuries. Everywhere we look, hear, or touch—walls, windows, books, screens, stages, museums, magazines, libraries, theaters, parks, malls, subways, sidewalks, grocery stores—a cacophony of voices offer perspectives and create possibilities. The work of transformation by artists is so pervasive that it often goes unconsciously experienced, which is undoubtedly a factor in the notion that the arts are superfluous, when in fact the labor of the arts is central to that which makes us human—the act of making meaning, the fulfillment of which is freedom, agency, and power—justice.

Meaning making is the core of education, if it is to be relevant and useful; without relevancy and usefulness, learning is vacuous and alienating, and resistance becomes a factor as learners try to reestablish their agency (Hanley, 2002). The arts as omnipresent; multiple perspectives are a means to a rich integrative education without boundaries; possibilities are as expansive as the artists' or the perceivers' imaginations and skill levels. The authors of the following chapters, who are artists, educators, advocates, and activists, present examples of how the arts change lives through education wherever learning takes place—in or after school or in community centers, museums, art studios, or rehearsal halls. They point to how the arts are at the very least a valued redistributed resource because through their use the marginalized are centered as change agents who learn to reinterpret their perspectives, social positions, and communities. They use the arts to push against external and internalized dominance by releasing the freedom to demand recognition of their own identity and dignity, to find a way out of no way.

Notes

1. Culturally relevant and culturally responsive pedagogies are theories and practices that are based on the centrality of culture in learning. The tenets are identical. We use the phrase *culturally relevant* here to distinguish it from prior models we developed (Hanley & Noblit, 2009) that were specifically about issues of race.
2. In search of a term that represents the reflection and action required in the CRAE model, I use the word *artist* to focus on the imagination and creativity involved in teaching and learning. Thus, the artistry that is central to CRAE is not overwhelmed by the necessary attention to critical multiculturalism and activism.

References

Bandura, A. (2001). Social cognitive theory: An agentic perspective. *Annual Review of Psychology, 52*, 1–26.

Banks, J.A. (2010). Multicultural education: Characteristics and goals. In J.A. Banks & C.A. M. Banks (Eds.), *Multicultural education: Issues and perspectives* (7th ed., pp. 3–30). Hoboken, NJ: John Wiley & Sons.

Barry, B. (2005). *Why social justice matters.* Cambridge, UK: Polity Press.

Beghetto, R.A., & Kaufman, J.C. (2007). Toward a broader conception of creativity: A case for "mini-c" creativity. *Psychology of Aesthetics, Creativity, and the Arts*, 1, 73–79.

Bell, L.A. (2007). Theoretical foundations for social justice education. In M. Adams, L. A. Bell, & P. Griffin (Eds.), *Teaching for diversity and social justice* (pp. 3–15). New York: Routledge.

Bruner, J. (1996). *The culture of education*. Cambridge, MA: Harvard University Press.

Csikszentmihalyi, M. (1996). *Creativity: Flow and the psychology of discovery and invention*. New York: HarperCollins.

Dewey, J. (1934). *Art as experience*. New York: Perigee.

Egan, K. (1992). *Imagination in teaching and learning: The middle school years*. Chicago: University of Chicago Press.

Fraser, N. (1997). *Justice interruptus: Critical reflections on the "postsocialist" condition*. New York: Routledge.

Freire, P. (1970). *Pedagogy of the oppressed*. New York: Seabury Press.

Freire, P. (1974). *Education for critical consciousness*. London: Continuum.

Freire, P. (2001). *Pedagogy of freedom: Ethics, democracy, and civic courage*. London: Rowan and Littlefield.

Friedlander, D., & Darling-Hammond, L. (with Andre, A., Lewis-Charp, H., McCloskey, L., Richardson, N., Araiza, O., Sandler, S., & Velez-Rocha, V.). (2007). *High schools for equity: Policy supports for student learning in communities of color*. Retrieved January 19, 2012 from http://www.srnleads.org/press/pdfs/hsfe_report.pdf

Gay, G. (2010). *Culturally responsive teaching*. New York: Teachers College Press.

Geertz, C. (1973) *The interpretation of cultures*. New York: Basic Books.

Greene, M. (2001). *Variations on a blue guitar: The Lincoln Center Institute lectures on aesthetic education*. New York: Teacher's College Press.

Hanley, M.S. (2002). Learning to fly: Critical multicultural education through drama. *Arts and Learning Research Journal*, 18(1), 75–98.

Hanley, M.S. (2011). You better recognize! The arts as social justice for African American students. *Equity and Excellence in Education*, 44(3), 420–444.

Hanley, M.S., & Noblit, G.W. (2009). *Cultural responsiveness, race, identity, and academic success: A review of literature*. Retrieved from http://www.heinz.org/programs_cms.aspx?SectionID=1&ParentID=233Ki

Kincheloe, J.L. (2005). *Critical constructivism*. New York: Peter Lang.

Ladson-Billings, G. (2009). *The dream keepers: Successful teachers of African American children*. San Francisco, CA: Jossey-Bass.

Leonardo, Z. (2004). Critical theory and transformative knowledge: The functions of criticism in quality education. *Educational Researcher*, 33(6), 11–18.

Martin, J., Sugarman, J., & Thompson, J. (2003). *Psychology and the question of agency*. Albany: State University of New York Press.

North, C.E. (2006). More than words? Delving into the substantive meaning(s) of "social justice" in education. *Review of Educational Research*, 76(4), 507–535.

Sleeter, C.E. (1996). *Multicultural education as social activism*. Albany: State University of New York Press.

Sleeter, C.E., & McLaren, P. (1995). Introduction: Exploring connections to build a critical multiculturalism. In C.E. Sleeter & P.L. McLaren (Eds.), *Multicultural education, critical pedagogy, and the politics of difference* (pp. 5–32). Albany: State University of New York Press.

Vygotsky, L.S. (1978). *Mind in society: The development of higher psychological processes*. Cambridge, MA: Harvard University Press.

SECTION I

Models of the Arts as Social Justice

Introduction

George W. Noblit

One of the challenges in creating a culturally relevant arts education (CRAE) is discerning what that means in practice. There are many people doing CRAE, but their work is not getting shared. The 10 'models' that follow in this section are offered not to limit us to the ideas they contain but to open us up to possibilities that we have not currently conceived for 'a way out of no way.'

Mary Stone Hanley opens with the theory and structure for CRAE. She presents the model as a synthesis of her lived experience as an artist, educator, and activist. However, as germane, her chapter is a synthesis of the work of the chapter authors, who worked and wrote unaware of the CRAE model. Nonetheless, each chapter connects with the multiple layers of CRAE, and Hanley's chapter presents CRAE as a theoretical framework.

Lee Anne Bell, Dipti Desai, and Kayhan Irani have written an ideal chapter to open this section. The Storytelling Project model has a participatory process and supporting critical lens for young people to analyze inequities and develop strategies. It is based on counterstorytelling, moving through stock stories, concealed stories, and resistance stories to stories of transformation.

Yael Harlap and Hector Aristizábal offer us a model of theater as *praxis*—a dialogic cycle of action and reflection focused on liberation. Their model builds on the work of Boal, and in the workshops they discuss here, they demonstrate that the arts can be a model process for engaging social change.

Cheryl T. Desmond and Marta Benavides focus on Movimiento Siglo XXIII that began in El Salvador to live intentionally and consciously. The model they offer is the AHA Museum of Folk Arts and Cultures for Planetary and Global

Citizenship in El Salvador. This civil society initiative engages citizen-artists in folk arts and cultures to promote an active and living culture of peace.

A second approach using theater for social justice is offered by Leyla Modirzadeh. Documentary theater is offered as a model to uncover secret stories and to create empathy. This chapter discusses her work with Ping Chong and Lincoln Center, and how the model works both with schools and communities.

Kawachi A. Clemons and Kristal Moore Clemens offer us a model from music. They take the musical genre of Hip Hop and develop it as a critical pedagogy. They demonstrate that a CRAE takes the music that youth embrace and turn it into a model of politics of possibility and change.

Patty Bode, Derek Fenner, and Basil El Halwagy provide a model of working with the visual arts in juvenile justice settings. Rejecting a suggested focus on a White street artist, they instead took on public murals and street art from the 1920s Harlem renaissance on. Working both with the teachers and with the youth proved doubly effective.

Providing a model of CRAE, Ann Rowson Love and Deborah Randolph describe a museum residency at the Ogden Museum of Southern Art in New Orleans. The Artists and Sense of Place residency became a process of community change, allowing a place-based education take on a fuller social justice mission.

Kristien Zenkov, James Harmon, Athene Bell, and Marriam Ewaida offer a model of how to use photography in city schools. They provide us with a way to use photography to both picture equity and practice it. They used photoelicitation techniques to have students picture both what was going on in their school and how the student's successes could be depicted.

Critical documentary filmmaking is the model Stephanie M. Anderson offers CRAE. Here the focus is on creating experiences of recognition of urban youth in the production spaces they create. In this model, the public presentation of documentaries in an official public media becomes a significant moment of recognition and achievement for youth.

Stacey S. Levin investigates the potential of film for challenging media arts students to critically examine homophobia and heterosexual privilege. Finally, Nana Osei-Kofi takes us into graduate programs, explaining her model of arts-based inquiry and its challenge to more conventional research methods. Osei-Kofi documents this model as a new and promising form of social justice engagement— which can affect both the community and researchers alike.

These models clearly are generative and can be adapted to many arts and arts education projects. They are offered here as starting points for CRAE.

1

STORYTELLING FOR SOCIAL JUSTICE

Creating Arts-Based Counterstories to Resist Racism

Lee Anne Bell, Dipti Desai, and Kayhan Irani

1. How can storytelling through the arts help young people create counterstories for resisting racism in their schools and communities?
2. How do such counterstories provide opportunities for the creation of new, transformative stories?

The Storytelling Project model described in this chapter offers both content and process ideas for addressing racism through narrative and the arts to realize social justice goals of equity and justice (Bell, 2010). We illustrate how the model can support young people—particularly those most marginalized by race and class—to identify, talk back to, and imagine alternatives to stock stories about them and their communities that rationalize their subjugated position in society. The arts provide a lens and vehicle for expressing counterstories that challenge racism and other forms of injustice and for generating new stories to embolden action and change.

We draw from the definition of social justice outlined by Bell (2007) as both a goal and a process. The goal of social justice is ensuring full and equal participation of all groups in a society that shares resources equitably and provides physical and psychological safety and security. "In such a society, individuals are both self-determining (able to develop their full capacities) and interdependent (capable of interacting democratically with others)," and we believe the process of social justice "should also be democratic and participatory, inclusive and affirming of human agency and human capacities for working collaboratively to create change" (Bell, 2007, pp. 1–2). Central to the Storytelling Project model is a participatory process and community of support that enables young people to develop a critical lens for analyzing inequities and collaborative action strategies to challenge injustice in their schools and communities, using the arts as a vital tool.

The Storytelling Project Model

The Storytelling Project model (Bell, 2010) uses four story types to analyze racism and other issues of social injustice. These story types are stock stories, concealed stories, resistance stories, and emerging/transforming stories (see Figure 1.1). Stock stories are the normalizing or hegemonic stories that support things as they are. They are promoted in mainstream ideas, institutions, and media that rationalize and reinforce the racial status quo. Such stories provide only a narrow and usually self-interested rendering of reality through the lens of the dominating majority and provide a skewed and partial picture of how race operates in the United States. These stories can be challenged, however, through counterstories that bring in contradicting information and experiences and expand our understanding of how race operates. We differentiate counterstories into three types: concealed, resistance, and transforming/emerging as a continuum of ways to critically analyze racism and generate challenges and alternatives to it.

We analyze stock stories through holding them up to scrutiny from the perspective of the second story type, concealed stories. Concealed stories unearth narratives about race and racism, many by communities of color whose lived experiences are eclipsed by stock stories but that speak to a much broader understanding of the role race plays in our society. They also include stories by White people who expose White supremacy from the inside, revealing the codes through

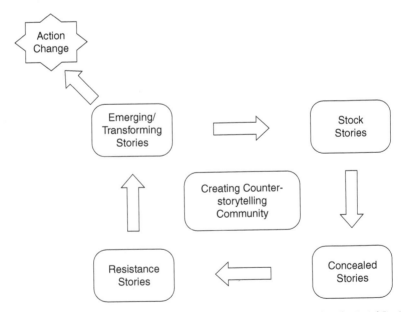

Figure 1.1 Storytelling Project Model. In Bell, L.A. (2010). *Storytelling for Social Justice: Connecting Narrative and the Arts in Antiracist Teaching.* Routledge. Used by permission.

which privilege and advantage operate. Such stories are not often told in mainstream history books, newspapers, and other media but can be unearthed by investigating alternative sources in history, art, literature, music, and popular culture. Such stories provide a lens for critical analysis of stock stories.

The third story type in our model, resistance stories, acknowledges that there have always been people in our society, from all racialized groups, who have resisted and fought back against racism. Their examples provide guidance for antiracist work today and offer important lessons to draw from. Such stories call into question the ahistorical and individualized representations of reality that are so popular in our talk-show, personality-saturated media. They connect us to the broader patterns in our history that persist into and shape the present, reminding us that things can be otherwise.

The final story type is emerging/transforming stories. These stories build on the critique developed from examining stock stories through the lens of concealed and resistance stories to become the base for designing new actions to be taken in the present. Emerging/transforming stories invite people to take a stance and join the line of resisters against racism by imagining and enacting more inclusive and just alternatives tailored to their present circumstances.

The model as a holistic sequence provides a framework for developing a strong critique of racism, grounded in an understanding of historical and institutional patterns and practices, and focused toward inventing new possibilities for taking action against racism in the present. The model also recognizes that this is an ongoing process, that there is always the danger of recruitment back into the status quo, and that emerging/transforming stories can lead to change but can also become new stock stories if we are not vigilant about and continue to expand our own partial knowledge in the ongoing process of discerning how racism, and other forms of oppression, operate.

The model acknowledges the central role of dialogue, collaboration, and community in this process. Antiracism is not an individual project. At the heart of the Storytelling Project model is the development of a critical counterstorytelling community (Bell, 2010). Such a community develops capacities of collaborative critique and provides a supportive environment in which to imagine and generate ideas for change. Central to the creation of such a community are habits of dialogue across different social positions of race, class, gender, sexuality, age, and other categories that mediate access to resources and power (see Adams, Bell, & Griffin, 2007). Through attending to racial positionality, such a community counters the tendency to conceal stories that make us uncomfortable and encourages us (develops the courage in us) to reveal patterns and practices that sustain inequality in our own interactions. Through this focus on creating counterstorytelling community and dialogues across difference, we hope to thus produce and enable civic agency (McGregor, 2007).

We have found in our work with young people using the Storytelling Project model that the arts play a powerful role in developing capacities of agency,

imagination, and hope (see Bell, 2010; Roberts, Bell, & Murphy, 2008, for extended descriptions of this work). The arts have the capacity to unsettle taken-for-granted notions, open up experience to new ways of understanding, and generate possibilities for human interaction not previously considered (Greene, 1995, 2004). Highlighting the multiple forms of liberatory practice allows students to locate themselves on a spectrum of antiracist work. Placing their own situations within a larger context of hope and liberation counteracts feelings of despair that may arise from confronting the pervasiveness of institutionalized racism. Addressing stock stories through the arts helps to break through the crust of received ideas and assumptions so that we can encounter alternative information (counterstories) about how race operates in peoples' lives and our social institutions. A map showing the way out of oppression is pieced together through the examples of resisters and resistance stories that offer a context for emerging/transformative stories that enable students to place themselves in a broader context and vision for taking action.

In the rest of this chapter, we develop two focused examples to illustrate the story types of resistance and emerging/transforming stories in the Storytelling Project model. First, we discuss a photography project that artist-educator Jennie Aleshire, an alumna of the Art Education program at NYU, facilitated with teenage youth of color. Then we analyze how high school youth used the *Storytelling Project Curriculum* to counter internalized oppression and move toward a place of hope grounded in action and connected to history.

Contesting Stock Stories of "Disadvantaged" Youth

One of the stock stories that frames society's representation of poor youth of color living in major cities is that they are "disadvantaged." Emerging in the 1960s and 1970s, this discourse of "disadvantaged youth" fueled by research and the media has greatly impacted educational and social policies and school practices (Anyon, 1997, 2005; Fine & Weis, 1998; Fulbright-Anderson, Lawrence, Sutton, Susi, & Kubisch, 2005; Giroux, 2003; Kitwana, 2002; Noguera, Ginwright, & Cammarota, 2006).

In this counterstorytelling project, teenagers from Bridgeport, Connecticut; Manhattan; South Bronx; and Queens began a conversation about the label "disadvantaged community" after reading an advertisement for their beloved organization, Morry's Camp, in an issue of Oprah Winfrey's O magazine. The advertisement, "Help kids from disadvantaged communities," struck a deep cord as many of the teenagers had attended Morry's Camp since they were small children.

As a way of critiquing the notion of disadvantage, artist-educator Jennie Aleshire turned this stock story on its head by asking the teenagers to think of the ways they are "advantaged." This reframing lead to a thoughtful and illuminating discussion that focused on what it means to be advantaged, generating counternarratives that challenge normative notions of economic success and financial wealth as the signifiers of "advantage." The teenagers spoke about how their families, homes, churches, places they visit, knowledge, opportunities, choices they made,

and friends had a positive impact on their lives that made them "advantaged." As one of the teenagers, Humberto Ona III, proclaimed,

> Being disadvantaged is thinking that material things make you advantaged. I have my family to hold me up. You are advantaged by what you instill in yourself, by your character, your identity, and what influences you. Advantage is something you have inside of yourself.

Based on their discussion, students developed photographic representations of their "advantages." They carefully chose locations and using props "framed" themselves in the photographs to represent how they are advantaged (Figure 1.2). Based on their subjective knowledge of themselves and their culture, this creative storytelling strategically inserted the voices of youth of color into the stock stories of race/racism, producing in its wake concealed stories, or what Gloria Anzaldua (2002) in a different context calls "subversive knowledge." These counterstories suggest alternative definitions of social capital that underscore community cultural wealth (aspirational, navigational, and motivational) that are ignored in mainstream accounts of social capital (T. Yosso, 2006; T.J. Yosso, 2006).

For example, one student, Melissa Pognon, chose to frame herself in Union Square, a place she loves to go after school and work. She says, "I chose this spot because I get to see a lot of different people from different backgrounds, different

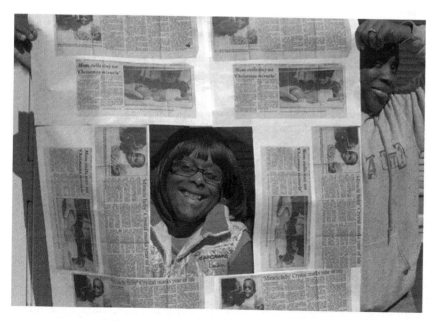

Figure 1.2 Jennie A. Moctezuma, "Framing Advantage."
Used by permission.

ethnicities, and they all have different stories to tell. It is so exciting just learning about people. That makes me advantaged." Another student, Crystal Moore, used several copies of two newspaper articles, stories about her survival as a premature baby, to frame her face. She carries the newspaper stories with her to remind her that life is a miracle. Her attitude toward life reflects this: "I'm a survivor. I take everything with a grain of salt whether it is good or bad, and I turn it into my own experience. The littlest thing out of my day, I take it to make it the best thing."

This exhibition "Framing Advantage" was displayed at the Morry's Camp Fundraiser and other public venues in Manhattan. The placement of these photographs with the teenagers' written narratives in an exhibition engage the viewer in considering normalizing constrictions in how we see and how we might expand our vision by considering counterstories. As counternarratives, these photographs created by youth of color communicate their experiences and identities and in so doing open new spaces for dialogue. "If it is by speaking their word that people, by naming the world, transform it," as Paulo Freire (1999) reminds us, then "dialogue imposes itself as the way by which they achieve significance as human beings " (p. 69). Here, the youth use images to name their world and transform it, stimulating a conversation between the teenage photographers, fundraisers, and others viewers. This dialogue led to the creation of new emerging/transforming stories as the youth exhibit led Morry's Camp to rethink their advertisements and develop alternative ways of fundraising that responded to the concerns and critique the students raised.

"The photograph is a call to look" (Miller, 2006, p. 128), and these photographs challenge the ways we have been taught to "see" as a result of rational structures of Western thought. Similar to other forms of art, the photographs in "Framing Advantage" expand, shift, and transform our understanding of youth of color by producing other ways of knowing—or what we call emerging/transforming stories of race/racism. It is in this creation of new visualities (Bustamante, 2006), or new ways of knowing, that we can transform our racialized normative understanding of youth of color as disadvantaged, rather than advantaged. By unframing the discourse of "disadvantaged youth" and reframing it, the photographs open different possibilities for dialogue about racial discourse in our communities and nation and also challenge our capitalist notions of advantage in solely economic terms.

Combining Critique with Hope and Possibility

While the Storytelling Project uses art to examine and interrogate the slippery cloak of race and racism in America, this isn't a simple intellectual poking around racism's many folds. It is a deep-sea dive into one's own life, one's historical memory, and a potential reordering of one's vision. Feelings of hopelessness and defeat, manifestations of internalized oppression, can easily come up in such deep analyses of racism—especially when exposing persistent racist beliefs and practices (Boal, 2000). One of the challenges in this reflexive process is to maintain and hold out hope for participants.

The *Storytelling Project Curriculum* uses art strategically to help students forge ahead, despite the painful reality of institutionalized racism that is coming into focus. Through positioning the work of artists of color as invaluable in revealing concealed stories, and through the use of participatory art-making exercises, students are able to act, create, resist, and propose alternatives, generating their own transforming/emerging stories. The curriculum offers an antiracist framework that students can interact with and build on, so that they see themselves as a part of a larger community dedicated to ending racism. The use of art in this curriculum grounds the student in imagining—creating doors of opportunity and change out of a world of discrimination and into a place of their dreams.

Kester articulates the concept of the aesthetic as a social change tool. He writes that the aesthetic "is located at the intersection between the experience of subjective autonomy and the subject position provided by a dominant culture" (Kester, 1997, p. 20). This dipping from life, to art, to history, to personal story is what makes the *Storytelling Project Curriculum* unique and difficult, as well as rewarding. The arts deepen a sense of self and expand the sense of community. Students' analytical and aesthetic faculties are enhanced and encouraged to work together so that they can rehearse and remember the complex weave needed to make a new social fabric. Augusto Boal's Theater of the Oppressed (1995) provides a powerful pedagogical foundation for us to see how the arts, within this model, bring students from antiracist discourse to practice.

Boal has said that art is a mirror that reflects reality, but it is a magic mirror. One we can reach into to transform the image into what we want it to be. This idea underlies all of the Theater of the Oppressed work: that the artist works from the real, transforming it. And, anyone can be an artist—it just takes a vision of the possible, of what can be. This concept of his is grounded by Boal's work with Paulo Freire and his inclusion of Freire's pedagogy—to see, analyze, and act. This is most clear in Boal's exercise "Complete the Image" (Boal, 2002). Here the exercise moves students through an analytic process where they must contend with the image they see, the "real" image, and with change. They must change themselves—change their position—act—in order to make new meaning out of the image.

We place this exercise at the beginning of the resistance chapter in our *Storytelling Project Curriculum* because, at this point, the curriculum is priming the students to take over (free PDF available at http://www.barnard.edu/education; click on "Grants and Projects," then "Get the Storytelling Project Curriculum"). In resistance stories, we offer artistic and real-life examples of people and communities resisting oppression, to help the students make the most of the next and final chapter—emerging/transformative stories—where they are asked to create their own action plans.

Using "Complete the Image" prepares the way for students to take on the practice of democratic social change, engage in the battles for liberation, and take a stand against hopelessness and inaction. It is a safe space for practice and integration. In the exercise, there is no right or wrong, there is the process of analyzing

and creating, and re-creating by moving from one frozen body image into another, without speaking. The images that students try out are what we see in life: images of solidarity, violence, mutual support, or nonviolent actions. But while we are asking students to "complete the image," they are never making a "complete image"—an image that will never change. They are always struggling with change, with perception. They practice being inside the image, being analyzed by others, and being outside the image, analyzing it. They are embodying the intersection Kester describes as "the experience of subjective autonomy and the subject position provided by a dominant culture" (1997, p. 20). In order to gain a sense of comfort with this complex relationship between oneself and society, one needs practice. Instead of throwing the students into emerging/transformative stories, into creating action plans, we first have them explore their relationship to the larger community of resisters by literally experiencing the exercise of democracy (Freire, 2002, p. 36).

In a focus group with high school students who had gone through the curriculum, the students spoke about this phenomenon—facing the present hurts that racism brings while staying connected to the work of their communities of allies and committing themselves to continue to fight for their dreams. One young woman reflected back on the process and the lessons in class. She said, "I'll remember the topics that we talked about, and I'll remember how I feel and how, say like if I'm having a really sad day or I went for an interview and couldn't get it, I'll remember like, I gotta keep trying because this is what my people have been through."

This young student speaks about a renewed commitment to ending racism. Referencing her "people" she takes strength from their battles, even the painful ones, and that feeds further action while simultaneously easing the pain of being targeted by racist practice. She is hopeful for her future and optimistic about her stance in life. This is the power of the curriculum, and it is how students can see themselves as resisters in charge of the shape of their future. She exemplifies what Freire speaks about when he says, "Thus, nascent hope coincides with an increasingly critical perception of the concrete conditions of reality. Society now reveals itself as something unfinished, not as something inexorably given; it has become a challenge rather than a hopeless limitation" (Freire, 2002, p. 12). The curriculum has prepared her to carry on the work outside the classroom, with all the complications that may come.

New understanding about racism is processed and synthesized through the arts and in turn reinforces and rehearses the students' power to effectively interrupt racist practices and work toward ending racism. Within each activity in the model, art and story are deployed to combat hopelessness. Thus, the Storytelling Project offers an integrated approach to teaching and learning about race and racism through storytelling and the arts—one that offers hope, agency, and a way out of the constrained spaces of oppression so that dialogue can occur, new possibilities can be imagined, and actions can be initiated toward change. Using the arts to understand

and explore resistance is a more powerful force for transformation because of the regenerative properties, the subjunctive action, the imagination, and the visioning process for creating the future. The coupling of the analytical and transformative aspects of art and art making is an important way to move through the pain while holding out hope and light. Through the Storytelling Project model and curriculum, we see clearly the struggle of the present moment but are not bogged down. Rather, we create links for continuing to move out of that struggle—a struggle that is filled with imagination, creativity, creation, regeneration, and love.

References

Adams, M., Bell, L.A., & Griffin, P. (2007). *Teaching for diversity and social justice* (2nd ed.). New York: Routledge.

Anyon, J. (1997). *Ghetto schooling: A political economy of urban educational reform.* New York: Teachers College Press; Teachers College, Columbia University.

Anyon, J. (2005). *Radical possibilities: Public policy, urban education, and a new social movement.* New York: Routledge.

Anzaldua, G., & Keatings, A. (2002). *The bridge we call home: Radical visions for transformation.* New York: Routledge.

Bell, L.A. (2007). Theoretical foundations for social justice education. In M. Adams, L.A. Bell, & P. Griffin (Eds.), *Teaching for diversity and social justice* (pp. 3–15). New York: Routledge.

Bell, L.A. (2010). *Storytelling for social justice: Connecting narrative and the arts in antiracist teaching.* New York: Routledge.

Boal, A. (1995). *Theatre of the oppressed.* New York: Theatre Communications Group.

Boal, A. (2000). *The rainbow of desire: The Boal method of theatre and therapy.* New York: Routledge.

Boal, A. (2002). *Games for actors and non-actors* (2nd ed.). New York: Routledge.

Bustamante, M. (2006). New transdisciplinary visualities as an alternative to redistribute the power of thought. *Social Justice, 33*(2), 165–170.

Fine, M., & Weis, L. (1998). *The unknown city: Lives of poor and working-class young adults.* Boston: Beacon Press.

Freire, P. (1999). *Pedagogy of the oppressed.* New York: Continuum.

Freire, P. (2002). *Education for critical consciousness.* New York: Continuum.

Fulbright-Anderson, K., Lawrence, K., Sutton, S., Susi, G., & Kubisch, A. (2005). *Structural racism and youth development: Issues, challenges, and implications.* Washington, DC: Aspen Institute.

Giroux, H.A. (2003). *The abandoned generation: Democracy beyond the culture of fear* (1st ed.). New York: Palgrave Macmillan.

Greene, M. (1995). *Releasing the imagination: Essays on education, the arts, and social change.* San Francisco, CA: Jossey-Bass.

Greene, M. (2004). *Imagination, oppression and culture: Creating authentic openings.* Paper presented at the Interrupting Oppression and Sustaining Justice Conference, New York.

Kester, G. (1997). Editor's note. *Art Journal, 56*(1), 38–45.

Kitwana, B. (2002). *The hip hop generation: Young blacks and the crisis in African-American culture.* New York: Basic Books.

McGregor, C. (2007). Mapping agency through aesthetic production: Producing and enabling youth as civic subjects. *Inter-American Journal of Education for Democracy, 1*(1), 1–34.

Miller, C. (2006). Images from the streets: Art for social change from the homeless photography project. *Social Justice, 33*(2), 122–134.

Noguera, P., Ginwright, S.A., & Cammarota, J. (2006). *Beyond resistance! Youth activism and community change: New democratic possibilities for practice and policy for America's youth.* New York: Routledge.

Roberts, R.A., Bell, L.A., & Murphy, B. (2008). Flipping the script: Analyzing youth talk about race and racism. *Anthropology and Education Quarterly, 39*(3), 334–354.

Yosso, T. (2006). *Critical race counterstories along the Chicana/o pipeline.* New York: Routledge.

Yosso, T.J. (2006). Whose culture has capital? A critical race theory discussion of community cultural wealth. In A.R. Dixson & C.K. Rousseau (Eds.), *Critical race theory in education* (pp. 167–189). New York: Routledge.

2

USING THEATER TO PROMOTE SOCIAL JUSTICE IN COMMUNITIES

Pedagogical Approaches to Community and Individual Learning

Yael Harlap and Hector Aristizábal

1. How do *communities* learn to use theater as praxis for social justice?
2. How do *individuals* learn to share these tools and approaches with communities?

On a sunny January day, in the Playhouse Theater in Derry, Northern Ireland, a small group of workshop participants is creating a scene based on an incident one of them had witnessed in the supermarket. Pablo, playing a new immigrant to Northern Ireland, asks Emma, a young woman, to let him cut in front of her in the check-out line. The woman bursts out in anger: "Why do you people think you can come here and do whatever you please? If you can't wait in line like the rest of us, go home!"

The group stops improvising and starts talking. What should everyone else do in response to that outburst? What would bystanders do in real life? As they brainstorm, Hector, the invited artist-in-residence leading the workshop, swings by: "OK, how's the scene going? Almost ready? Good! In the scene, I want to see choreography. Also, at some point in the scene everyone will sing. And somewhere in the scene there will be a swarm of flies." Everyone stares at him. "How much time do we have?" "Five minutes!"

Just a few short minutes later, it is time for all the groups to share their short plays. The supermarket scene begins with shoppers crisscrossing the stage pushing imaginary grocery carts. Someone sings, "Where are the eggs? Honey, go find the eggs!" Someone else intones, "Can't forget the toilet paper!" Pablo dashes between the shoppers, looking for water. The real-life incident has inspired theater, ripe with possibilities for intervention and transformation toward a more socially just world.

Schooling, despite its many benefits, teaches us to be agreeable, to our detriment. Many scholars have explored how schools teach children and youth to be compliant and to reproduce existing social inequities (e.g., Apple, 1979; Freire, 1970; Willis, 1977). To challenge injustice and create a just society and world, children, youth, adults, and whole communities need another kind of education. We need to learn how to enter into—and stay committed to—genuine dialogue, to engage dissent in a meaningful way, to exercise our creativity toward imagining ourselves differently, and to connect to the roots of our identity. Theater offers possibilities for pedagogical engagement toward social justice.

This chapter documents reflections that emerged from 5 weeks of intense, collaborative social justice and popular theater praxis with teens, members of a women's mutual support group, university students, educators and artists, and residents in a social housing community in Derry, Northern Ireland. By praxis we refer quite literally to a dialogic cycle of action and reflection, with a commitment to human well-being and liberation (Freire, 1970). Over 5 weeks, the two authors, along with three others, led workshops almost daily in different community settings and, later that evening or the next morning, sat for several hours at the kitchen table in the house we shared and discussed the different games and exercises we had led, how they worked, how we felt, what we observed in others' reactions, and more. In this chapter, we will begin by introducing ourselves and the circumstances that gave us the opportunity to collaborate. Then we will describe our work in Derry and explore the two questions we pose above, in terms of what we learned from our work in community workshops and at the kitchen table: How do communities learn to use theater as praxis for social justice? How do individuals learn to share these tools and approaches with communities?

Introducing Ourselves and Theater of the Oppressed

Hector Aristizábal is a theater practitioner and psychotherapist who has worked with traditional storytelling, ritual creation, giant puppet making, and Theater of the Oppressed (T.O.) for more than 20 years. T.O., developed by Brazilian Augusto Boal (1985, 1995), is a philosophy and methodology about liberation and about learning to become a human being. Out of this philosophy emerges a set of theatrical and aesthetic techniques to use with and in communities to work collectively toward liberation from oppression. Boal (1995, p. 14) described T.O. as "a system of physical exercises, aesthetic games, image techniques and special improvisations whose goal is to safeguard, develop and reshape this human vocation, by turning the practice of theater into an effective tool for the comprehension of social and personal problems and the search for their solutions."

Aristizábal has used T.O. in his native Colombia and his adopted home of Los Angeles, as well as in more than 25 other countries. He was invited by Derry's Playhouse Theater's International Culture Arts Network to spend 5 weeks in

Derry offering a series of workshops for local communities and to train community activists, mental health providers, artists, and educators using theater to deal with postconflict trauma and the use of art for social justice and healing (Aristizábal & Lefer, 2010). Yael Harlap is now an associate professor in education at the University of Bergen and at the time was in transition between moving from Canada, where she had used T.O. in workshops for university professors and teaching assistants, to Norway. Harlap joined Aristizábal in Derry, along with three others who had been T.O. practitioners for only a few years, in order to develop her own practice as a T.O. 'joker,' or facilitator.

T.O. comprises a variety of tools and approaches; here we will share just a few to give you, the reader, a visceral sense of what we do, and we will illustrate them with vignettes from Derry. In our workshops, we would start each session, as Augusto Boal did, with exercises and games. These activities build community and provoke participants to become more aware of themselves as physical, embodied beings, less automatic and more humanized in their actions and choices. One of the hallmarks of Aristizábal's approach to using T.O. with communities is that he works quickly, with little verbal processing between activities. This keeps participants from entering into reflection in this early stage of the workshop, preventing them from becoming self-conscious and judgmental. Another is that he invites movement, song, and unexpected elements into games as well as the plays that the group will ultimately create together, in order to conjure spontaneity, awaken creativity, invite people to use their talents, and encourage a movement toward the symbolic and away from literal realism. For example, a group constructing a scene together might be asked to include such 'unexpected elements' as a traditional folk song, a burst of clapping, and the word *clown* repeated 10 times. These unexpected elements disrupt the tendency for groups to become overly serious when they start creating plays together and also prevent the plays from being heavily linear and rigidly naturalistic.

> Participants walk quickly around the room, being mindful to not slip into the unthinking pattern of following someone else's path. "Freeze!" Hector calls. "Find a partner! One of you is a world-renowned expert in *grassinfallopia*—explain it to your partner!" After one minute: "Partners! You are so inspired by that definition of *grassinfallopia* that you are moved to create choreography about it!"

One of the foundations of T.O. is the use of *Image Theater*, in which participants create frozen and silent tableaus—like a photograph or a single frame of a film—in response to specific issues and based on their own feelings and experiences. David Diamond (2007, p. 93) describes an image created by one participant as "a living photograph of *a moment of struggle* in the participant's life"—or a collective image of struggle created together by a group of participants.

Now the participants are in two lines facing each other. Each person in line A makes an image, individually, of what it means to be Irish. Each person in line B imitates the image across from them, and adds a sound. Then, in pairs, participants create an image of conflict. "Transform it into an image of friendship!" Hector calls out, "Back to the image of conflict! Friendship! Conflict! Friendship! How do we get from here to there?" Participants created a series of transitional images between conflict and friendship—an exercise created on the spot that we called the Derry Bridge.

Another T.O. tool—and the first that Boal developed with his acting troupe—is *Forum Theater*. In Forum Theater, the actors/participants perform a short play about a protagonist who is struggling with oppression. The play is structured to contain a crisis, or a series of escalating crises, and to end in catastrophe from the point of view of the protagonist. Audience members are invited to become 'spect-actors'—rather than spectators—and to intervene in the scenes by replacing the protagonist and trying out alternatives, different ways in which the protagonist could respond to the circumstances in order to change the tragic outcome. In our work, we often use Forum Theater in conjunction with Image Theater—inviting participants in a workshop to replace a protagonist in a frozen image and to create a new image, attempting to resist the oppression depicted.

The arts space in the D-Block at the housing estate is cold in January, but after an hour of theater games, coats are flung onto the chairs. Six participants are huddled in a small group to tackle the topic of sectarian division. Hector asks them to create six group images, each using the other group members to sculpt an image of how they feel about sectarianism, adding themselves to the image as the protagonist, the struggling character. One image shows two people talking on the phone, each with a 'ghost' representing inner feelings, fists raised towards each other. A woman places herself, as the protagonist, in a crouch between the phone-talkers and the ghosts, hands out as if to stop and separate the two sides. Hector jumps in, places his hand on her shoulder. "Does anyone have an idea about what this character could do?" Other participants, who had been working on small groups on different themes, take turns taking over the protagonist role and transforming it into a new frozen image. One participant grabs the wrists of the ghosts' raised fists, creating a bridge between them. Another screams in silence. Person after person experiments, creating alternative images.

The joker—the person who is facilitating the entire process—engages the community in a dialogue using theater as the medium. Typically, the joker also invites the community to analyze interventions verbally, by posing questions to the group of 'spect-actors': "Is this real? Or is it magic? Why/why not? What would happen if she did that in real life?" The words serve to crack open the artificial

veneer of polite consensus that often keeps us from truly naming and addressing injustice and oppression.

How Do Communities Learn to Use Theater as Praxis for Social Justice?

Awakening the Imagination

This volume and recent others (Barndt, 2006; Cleveland, 2008; Cohen, Varea, & Walker, 2011; Goldbard, 2006; Helguera, 2011; Kester, 2004; Naidus, 2009; Thompson, 2012) are testament to the recent burgeoning interest in the relationship between the arts and social change, usually in community settings, but also in schools and in higher education, where bachelor, master, and certificate courses and programs in community arts are increasingly on offer. A study by the International Centre for Art and Social Change looked at 46 artists, arts organizations, and university programs working not just in theater, but across all arts disciplines and found that their work engaged social change by building relationships, creating dialogue, raising consciousness and awareness, fostering participation, and working toward equity and justice (Harlap, 2006)—all practices that are a part of social change work in any domain, whether grassroots activism or social work or education. However, two themes stood out as particular to *the arts* as a process for engaging social change: *giving voice and telling stories* and *creating new visions and opening new imaginations for what the world could be*. These last two roles that are particular to the arts in social justice work were integral parts of our community workshops in Derry. Aristizábal will often emphasize to workshop participants that imagination is the most basic human right because it creates access to all the other human rights. Without imagination, we do not have the capacity to imagine ourselves to have rights. Creating the conditions that invite people to reconnect with their imagination is a prerequisite for them to be able to dream of, and act toward, a better world.

Most participants in T.O. workshops and activities have never been involved in theater before and do not necessarily think of themselves as 'creative.' In particular, most institutional settings, such as schools, do not encourage us to use our bodies. Most education uses language as a filter, and beyond childhood, people are rarely engaged in physical activity in a learning environment. One way to awaken the imagination is to reconnect with the body and engage with the energy of a group. The joker creates a container in which participants play together, as they did in childhood when they learned to crawl, walk, talk, and socialize. An initial series of games and exercises invites participants to sing, dance, tell stories, and create images, without judgment or evaluation. As we described above, we move quickly in this early stage; there is no time for people to stop and think, "Wow, I look foolish," and become self-conscious. We, and many other T.O. practitioners, have seen these techniques work with all kinds of people all over the world, from

Afghanistan to India to Colombia, with people of all ages, all social and economic backgrounds, with or without formal education.

Welcoming 'Mistakes,' Inviting Experimentation

From the first hour that we are together with a group or community, we actively create a space in which mistakes are invited. In fact, we build a culture of celebrating mistakes as opportunities for learning. Mistakes are also an opportunity for us to send a message that goes against much of what we learn in school and many other institutions: that there are many possible answers to a question, there is not just one answer, and there is not just one way to live. We do this quite literally: When a person makes a mistake in one of our games, they are invited to die a symbolic death in the center of the group. Once participants feel free to make mistakes—they can die and come back to life, and nothing terrible happens—it creates the freedom to imagine, experiment, and play. This is foundational in our work; it is only possible for people to take personal risks and imagine alternatives to the world as it is because we have created an environment in which openness and exploration are contagious.

This approach works against a culture of standardization that is endemic in our schools and other institutions (McNeil, 2000; Sacks, 1999; Schmidt, 2001; Sizer, 1984). Standardized education is a collapse of imagination; it demands the pretense that all children, all people, are the same. Is there such a thing as a 'standard child'? We have been socialized by family, school, and religious institutions to feel shame when we step outside a norm. When we first start using Image Theater with a group or community, we ask participants to create frozen images of their feelings and experiences. Then we ask the group to name what they see in the images. There is a tendency for the image makers to hold their breath: Will the others guess right? Will they know what the image 'really means'? Sometimes group members are hesitant to respond to the invitation to share what they see, worried that they are seeing the 'wrong' thing.

"What do you see?" is a simple yet powerful question. It opens the door to the idea that an image can have many meanings. An image of two people shaking hands can be interpreted as two friends or two enemies, a drug deal or a peace agreement; they can hold opposites simultaneously. Images are polysemic, that is to say, they have many meanings, which is key to why art is so powerful in the struggle for social justice. In this process in which communities are learning and relearning to imagine themselves, the polysemic nature of images opens participants to the embodied understanding that there are many alternatives, many ways of being and seeing, as well as many possibilities for acting toward liberation from oppression.

Modeling Transformative Community

At the beginning of each workshop session in Derry, we created a circle in which every participant would introduce her or his name with a dramatic physical movement.

Everyone else in the circle then echoed back the name and motion, ritualizing each person's entry into the community, what we called the 'village.' When late-comers joined the group, all activity paused for them to introduce themselves and see their name and motion reflected in the echo from the group—a ritual in which each participant is seen, heard, respected, and recognized. From the opening activity to the ritualized circle of three breaths taken together that we used to close every workshop session, participants are members of a sudden, temporary 'village,' a symbolic representation of the larger community in which they live.

What we are doing in the 'sudden village' is akin to what critical pedagogues and feminist pedagogues work toward in classroom practice—a way of being together that is authentic, liberatory, nonhierarchical, critical, and democratic (Bunch, 1983; Freire, 1994/1970; hooks, 1994; Maher, 1985; Rich, 1985; Shor, 1996; Shrewsbury, 1987). The sudden village creates new possibilities for performance. First, the village celebrates values such as creativity, spontaneity, and nonhierarchy, and through the games and exercises, participants are invited to explore new ways to be and new ways to be in relationship to others—new ways to perform in the world (Butler, 1997; Goffman, 1959). Second, participants take part in improvisations—for example, in Forum Theater—such that they literally rehearse new ways of performing in oppressive situations, possibilities for transforming daily life. The liberatory space created in the cauldron of the workshop, and the experience of performing in a new way, becomes a model for the socially just society. The hope and dream of T.O. is that enough of the participants are motivated to take the transformative experience within the workshop beyond the workshop and into their communities and daily lives.

How Do Individuals Learn to Share These Tools and Approaches with Communities?

For the seeds planted in our workshops in Derry to continue to grow, it was critical that local organizers or informal leaders in each setting participated and developed or enhanced their skills to carry the beginnings of this new process forward. Some of the community members were able to participate in multiple workshop sessions designed for different audiences, cross-pollinating communities and strengthening their T.O. skills. For example, several of the people who participated in the work-shops in the social housing community that took place twice weekly for a month, and culminated in a public Forum Theater performance, also participated in a 3-day workshop for artists, activists, and educators at the Derry Playhouse The-ater. Augusto Boal (2006) described the spreading of T.O. as tools for liberation and social transformation as 'multiplication': the solidarity created when different groups of oppressed people are interlinked and are able to share their learning about oppression and liberation. The variety of different and overlapping 'sudden villages' generated over the 5 weeks we spent in Derry are an example of that process.

However, many individuals who are exposed to T.O. in this way—and many others, who experience a workshop or performance far away from their home community—wish to deepen their engagement and skills with T.O. tools. If they have the means, they may travel long distances to attend week-long workshops with experienced jokers. Otherwise, they hone their skills through trial and error in their own communities, often in isolation from other T.O. practitioners, though increasingly international networks are developing through online communication tools. Over the past years, Aristizábal has become increasingly curious about additional pedagogical approaches for developing theoretical and practical T.O. skills in individuals who would like to be more deeply engaged as practitioners. In Derry, we experimented with the traditions of mentoring and apprenticeship as models for individuals to continue their evolution as jokers. Harlap and the other three T.O. practitioners who came to Derry to work with and learn from Aristizábal had an immersive experience; we all lived together in a house for 5 weeks, cooked together, ate together, went into the different community workshops together, and each day spent several hours discussing the previous workshop in detail and planning the upcoming session.

In the workshops, the apprentices started the 5 weeks by participating and observing Aristizábal, each other, the community, and themselves and their own reactions. They gradually took on more responsibility for jokering as the weeks passed, and by the end, each of the apprentices took on a directorial role in shaping the Forum Theater plays developed in the social housing community. At the kitchen-table conversations, we documented the different games, activities, and T.O. sequences that we had used in the previous session. We talked about our perceptions of what had transpired in the session: the dynamics of the particular group and what the joker—usually Aristizábal, but over time also the apprentices—had done that had worked particularly well or less well. Each of us also shared our personal reactions to the session and received feedback from each other. We asked each other questions—to describe particular games or sequences, to explain our intentions in taking a particular move, or how to handle a specific sticky situation. We compared the current experience to other jokering situations we had each encountered.

In our last kitchen-table session, we went around the table, and each of us, in turn, received feedback from all the others. We also spoke about the mentoring process and what had been particularly valuable about the experience. One of the elements that was emphasized by both the apprentices and Aristizábal was the praxis itself—the iterative cycle of action and reflection that we engaged with daily. At times it felt tedious to list all the games, exercises, and sequences and discuss each in detail. When the sun was shining, we were tempted to have a quick, perfunctory conversation and run outside—but we stayed at the kitchen table. We learned simply to slow down, not to rush from one project to another, but to stay engaged in deep reflection and offer each other observations. In this process, we became forced to articulate why we do what we do, and this helped us to gain clarity both about what our T.O. practice is and why we continue to do it.

In addition, we translated the concept of celebrating mistakes from the workshops into our work together. In workshop situations, the apprentices had space to experiment, and no one rushed in to rescue us when we faced challenges. In our kitchen-table conversations, Aristizábal avoided making judgments—negative *or* positive—about the apprentices' work. Psychologists know that when people work for extrinsic rewards, like praise or money, their evaluation of the work as intrinsically rewarding diminishes (Deci, Koestner, & Ryan, 1999, 2001). Instead of offering praise or critique, Aristizábal asked questions to provoke self-reflection without communicating approval or disapproval. This required the apprentices to start asking different kinds of questions of themselves—why did we make certain choices, what else might we have done, what might the outcome have been, and how do we *know?*—and ultimately, it helped them become more self-reliant in the evaluation of the work they themselves were doing in the community.

Third, we want to emphasize that the mentor learns as much from the apprentice as the apprentice learns from the mentor. From our perspective, this is because in an endeavor that is genuinely educational, learning is a sacred act, and love is the main way to teach—not only love between the student and teacher, but love for something bigger than us—in our case, for T.O., artistic practice, and social justice. The mentor has more experience or more access to resources, but both mentor and mentee are continuing to learn and develop themselves.

Although the educational situation that we were in together was one of great privilege—not everyone can arrange to take 5 weeks away from daily life in order to work closely with a mentor—there are elements that can be applied to other sorts of educational situations, in particular when the arts are being engaged toward imagining and generating a more socially just world. As described previously, elements that made our time in Derry a tremendous learning experience for both mentor and apprentices included the following:

1. A balance between authentic action in the field—whatever that field is—and a set-aside space for reflection, ideally with thoughtful others;
2. Replacing judgment and evaluation with curiosity and inquiry; and
3. Love within the mentor-apprentice relationship and for the shared endeavor.

If we had to use one word to encapsulate the learning process, it would be *humane*. Many forces, including standardization in education, press us to dehumanize ourselves and each other. Our process of learning with and from each other models an education that serves a humanizing impulse, just as T.O., when it is done well, also serves that impulse.

Coda

A few months after we left Derry, we received an e-mail from Orla, one of the local T.O. practitioners, describing how the projects are continuing:

[T]he energy you infected us with makes it all a pleasure. [One participant]. . . says that having taken part with you he's really keen now to learn how to carry through this way of workshopping and creating plays, while [two others] are going to take on a new group of young people and start them from scratch with more traditional style community theater at first and then lead them into doing something using T.O. . . . Other lovely news is that we're hoping to set up regular meetings for the people who participated in the master classes.

All of the apprentices have begun offering T.O. workshops in their own communities and plan to continue democratizing theater and working toward social justice as their life's work.

Aristizábal returned to Belfast, Northern Ireland, in Autumn 2011 for an additional 5 weeks and was able to create the opportunity for three apprentices to join him. In 2012, he mentored apprentices during a residency in Beijing and Lanzhou, China, and in Hong Kong.

References

Apple, M. W. (1979). *Ideology and curriculum*. London: Routledge and Kegan Paul.

Aristizábal, H., & Lefer, D. (2010). *The blessing next to the wound: A story of art, activism and transformation*. Brooklyn, NY: Lantern Books.

Barndt, D. (Ed.). (2006). *Wild fire: Art as activism*. Toronto: Sumach Press.

Boal, A. (1985). *Theater of the oppressed*. New York: Theater Communications Group.

Boal, A. (1995). *Rainbow of desire: The Boal method of theater and therapy*. London: Routledge.

Boal, A. (2006). *Aesthetics of the oppressed*. Oxon, UK: Routledge.

Bunch, C. (1983). Not by degrees: Feminist theory and education. In C. Bunch & S. Pollack (Eds.), *Learning our way: Essays in feminist education* (pp. 248–260). Trumansburg, NY: Crossing Press.

Butler, J. (1997). *Excitable speech: A politics of the performative*. London: Routledge.

Cleveland, W. (2008). *Art and upheaval: Artists on the world's frontlines*. Oakland, CA: New Village Press.

Cohen, C. E., Varea, R. G., & Walker, P. O. (Eds.). (2011). *Acting together: Performance and the creative transformation of conflict: Vol. 1. Resistance and reconciliation in regions of violence. Vol. 2. Building just and inclusive communities*. Oakland, CA: New Village Press.

Deci, E. L., Koestner, R., & Ryan, R. M. (1999). A meta-analytic review of experiments examining the effects of extrinsic rewards on intrinsic motivation. *Psychological Bulletin, 125*(6), 627–668.

Deci, E. L., Koestner, R., & Ryan, R. M. (2001). Extrinsic rewards and intrinsic motivation in education: Reconsidered once again. *Review of Educational Research, 71*(1), 1–27.

Diamond, D. (2007). *Theatre for living: The art and science of community-based dialogue*. Victoria, BC: Trafford.

Freire, P. (1994/1970). *Pedagogy of the oppressed* (Rev. ed.). New York: Continuum.

Goffman, E. (1959). *The presentation of self in everyday life*. Garden City, NY: Anchor.

Goldbard, A. (2006). *New creative community: The art of cultural development*. Oakland, CA: New Village Press.

Harlap, Y. (1996). *Toward training: The meanings and practices of social change work in the arts.* Report commissioned by International Centre of Art and Social Change, Vancouver, BC. Retrieved from http://www.icasc.ca/research

Helguera, P. (2011). *Education for socially engaged art: A materials and techniques handbook.* New York: Jorge Pinto Books.

hooks, b. (1994). *Teaching to transgress: Education as the practice of freedom.* New York: Routledge.

Kester, G. H. (2004). *Conversation pieces: Community and communication in modern art.* Berkeley: University of California Press.

Maher, F. (1985). Classroom pedagogy and the new scholarship on women. In M. Culley & C. Poruges (Eds.), *Gendered subjects: The dynamics of feminist teaching* (pp. 29–48). Boston: Routledge and Kegan Paul.

McNeil, Linda M. (2000). *Contradictions of school reform: Educational costs of standardized testing.* New York: Routledge

Naidus, B. (2009). *Arts for change: Teaching outside the frame.* Oakland, CA: New Village Press.

Rich, A. (1985). Taking women students seriously. In M. Culley & C. Poruges (Eds.), *Gendered subjects: The dynamics of feminist teaching* (pp. 21–28). Boston: Routledge and Kegan Paul.

Sacks, P. (1999). *Standardized minds: The high price of America's testing culture and what we can do to change it.* Cambridge, MA: Perseus.

Schmidt, J. (2001). *Disciplined minds: A critical look at salaried professionals and the soul-battering system that shapes their lives.* Lanham, MD: Rowman & Littlefield.

Shor, I. (1996). *When students have power: Negotiating authority in a critical pedagogy.* Chicago: University of Chicago Press.

Shrewsbury, C. (1987). What is feminist pedagogy? *Women's Studies Quarterly, 15,* 6–13.

Sizer, T. R. (1984). *Horace's compromise: The dilemma of the American high school.* Boston: Houghton Mifflin.

Thompson, N. (Ed.). (2012). *Living as form: Socially engaged art from 1991–2011.* Boston: MIT Press.

Willis, P. (1977). *Learning to labour: How working class kids get working class jobs.* New York: Columbia University Press.

3

KINDLING THE IMAGINATION

The Twenty-Third-Century Movement
(Movimiento Siglo XXIII) and the
AHA Museum of Folk Arts and Cultures
for Planetary and Global Citizenship
(Museo AJA de Culturas y Artes Populares
para la Ciudadania Global y Planetaria)

Cheryl T. Desmond and Marta Benavides

1. In what ways do the arts work as a cultural and social transformation for people who have experienced more than 500 years of cultural conquest and oppression?
2. How can a free Museo AJA liberate people and support them in manifesting the Bien Vivir: the way to enjoyment of life by all, while taking care of the planet?

Siglo XXIII

The Twenty-Third-Century Movement (Movimiento Siglo XXIII) began in El Salvador after the signing of the 1992 peace accords, ending 12 years of the Salvadorian Civil War. This is a movement of committed people issuing a challenge: to live intentionally each moment, in the consciousness that each action affects present and future life. This movement dreams and works for the creation of the best possible world for the present and future generations. It is a movement for social transformation through an active and living culture of peace. It affirms the belief of the goodwill inherent in every human being, the creative potential of humankind, and, therefore, the ability to create a just society that is based on

We would like to acknowledge the research support of Kristen Kane-Osorto and Hierald Osorto in the preparation of this chapter.

gender equity, inclusive of all ages and without discrimination based on ethnic, social, religious, political, and sexual differences. Its purpose is to identify the dreamers and together create the conditions to unite and act for the peoples of the world and mother earth. The Siglo XXIII movement embraces the arts as a means of social and cultural transformation.

Museo AJA

In this chapter, we tell the story of one of the projects of Siglo XXIII, the AHA Museum of Folk Arts and Cultures for Planetary and Global Citizenship (Museo AJA de Culturas y Artes Populares para la Ciudadania Global y Planetaria) in Santa Ana, El Salvador. We describe its activities and the daily lives of the people who visit and work in the museum, including Salvadorians and international visitors, and portray the effects of the arts as experience and transformation for people who had their culture uprooted from them for more than 500 years of conquest, colonialism, and neocolonialism.

In fall 2004, Marta Benavides, the founder of the Siglo XXIII movement, approached the mayor's office in Santa Ana about opening a people's museum in an empty room in the municipal plaza. Santa Ana is the second largest city of the country and the area where the coffee barons had resided and consolidated their wealth and power beginning in the nineteenth century. The mayor allowed the use of one of the conference rooms for the folk arts and cultures museum. Although the Museo AJA was a small place, it was accessible to all because admission was free of charge and the location was ideal since so many people of all ages and walks of life had to come to municipal offices for all kinds of official transactions. Two blocks away resided the Western Regional Arts Museum, exhibiting international and Salvadorian artworks; however, visitors are required to pay an admission fee, and in effect, this fee excludes a very high percentage of El Salvador's people.

A few months later, however, the mayor reclaimed the space for a health clinic for the women of the public market. He explained that the cultural director in the mayor's office said that the Museo AJA did not have "real" art as did the Western Regional Arts Museum. Though the municipal authorities did not see the importance of the Museo AJA, people had come to know and appreciate the museum. After the museum closed, people kept asking for it to be opened again. Thus, after many efforts to locate, acquire, and adapt a place for this purpose, the present Museo AJA opened a few blocks from the center of the city in celebration of the International Day of Peace, September 21, 2005. The Museo was made possible through the work and support of the Benavides-Marroquin family.

Nearly 5 years later, the Museo has become an important cultural center for the people of Santa Ana and international visitors. In the following paragraphs, we describe the activities and people of the Museo AJA.

Silverio, a Mayan man, light chocolate skinned, broad shouldered, short, muscular, dark eyed, with wide cheek bones, sits at the long wooden table in the museo's

conference/arts and crafts room. He is intently cutting an empty soda can into several pieces that he lays out carefully on the table. In the corner, Catalino, an indigenous Lenca, thin and wearing a ball cap, silently weaves a hammock strung from two hooks in the wall. Nearby, in the small atrium garden, the tingling of broken, colored glass pieces, drilled and strung, sounds sharp and melodic. Voices are heard in the entry hall as the main door opens. Señora Angelica gets up quietly from the sewing machine in another corner and walks to the entry to greet the visitors to guide them on their tour through the entry and the two large exhibit rooms: "We are at the AHA Folk Arts and Cultures Museum in Santa Ana. This is a free of charge civil society initiative, set in a colonial style house that was acquired and adapted for this purpose, by the Benavides Marroquin sisters, to honor their mother and father's memory." The Benavides-Marroquin parents dreamed of a democratic, just, and peaceful society, in a healthy planet. They educated their daughters to manifest this way of life: the *Bien Vivir, or the way to the enjoyment of life by all, while taking care of the planet.*

The entry of the museum has a floral memorial to the ancestors and the Benavides' family with a prayer bowl for visitors. A guest book sits on a colorfully painted table with a mirror hanging above which poses the question, "*Who is the solution to the problems?*" Visitors write their impressions, messages of congratulations, recommendations, and agreements of the value and beauty of this work. The written comments include the following:

> "This experience has stirred my heart and has given me the spark to go on."
> "The museum is very important because it helps to conserve our culture and educate us physically and spiritually."
> "Thank you for teaching us the origins of our people."
> "It is very important what you have done with the museum; there are no places like this in Santa Ana or in the rest of El Salvador."
> "This is an example of a museum that raises consciousness and helps us learn about the diversity of cultures."
> "Congratulations on this grand initiative that raises our consciousness to change our activities and practices to that we can have a better quality of life and peace in society."
> "The museum is marvelous, I like it a lot and it is a big contribution to the Salvadorian Society."
> "It is wonderful to have the opportunity to come and see this inspiring and fulfilling place. May the peoples (sic) minds and hearts be open."

In the entry room, the Day of the Dead (Dia de los Muertos) altar has been set up, with flowers, vegetables, paper cutouts, a skull, and plastic skeletons of all types. The altar also includes pictures of some key deceased people from the community, the country, and the world. A Katrina doll stands, watching and smiling slyly over the installation, a symbol of how we should look at life and death. The altar affirms life, nature, sustainability, fun, and peace.

The Planetary Citizenship Room is filled with found and recycled articles such as plastic soda bottles, dried palm fronds, colored and shimmery paper, sugarcane, stones, clay pots, shawls, painted gourds, and beautiful pictures painted by museo student workers on recycled cardboard, found in the streets. All these objects are creatively arranged and displayed to educate visitors on the care of the planet and of the universe. They challenge visitors to be about sustainability, to follow ecological practices, to celebrate Salvadoran indigenous history and arts, and to learn of the international days and events of the month and season that are commemorated by the United Nations and the Siglo XXIII movement. The museum walls are hung with posters commemorating the International Day of Water, the United Nations Millennium Development Goals, climate change, and food sovereignty and security. An empty box with a hole cut into the center lures visitors to reach in and guess at the objects, followed by a pictorial representation and meaning of each object, all of which help to clean water in a country where nearly 90% of the groundwater is polluted. Next is a step-by-step path where each visitor walks by drawings of native plants of El Salvador and then onto an illustration of a trench with photos of one that was dug at the Siglo XXIII movement's permaculture farm north of San Salvador, El Salvador's capital. The farm is a lung for the city, a place where rainwater is caught for purification and filtration as a means to improve the water table and sustain biodiversity, and as a place for recreation and solace. A photo shows how the trench drains water during a downpour and thereby protects the tomatoes growing nearby and stops soil erosion.

In the Global Citizenship Gallery, installations are exhibited using donated and acquired items, paintings, and arts and crafts from around the world. A map of the planet displays the various countries represented by the artworks in the exhibit. The installations are changed often to share various collections of glass, musical instruments, masks, ceramics, textiles, clay, toys, and so forth. Each exhibits presents objects of beauty and crafts to the visitors with a message to educate about the peoples and cultures of the world to develop appreciation and caring for the oneness of humanity.

The visitors and the university student volunteer guide the walk through the museum, chatting in Spanish, interspersed with sounds of laughter and astonishment. Julio brings them down the open walkway by the atrium to the meeting room where Silverio turns with a full smile and holds up the metal butterfly he has made from the soda can. He joins the group walking by Catalino, past the kitchen opening, and into the larger garden at the back of the house. In the garden, a student project on composting is demonstrated and illustrated by the various bins. The student will be able to sell some of the plants he has grown in the garden and the composted soil when it is ready. Flowering and edible plants grow vigorously in the rich, turned soil. Each is labeled with an accompanying drawing that illustrates its role in a permaculture garden. A small fountain made of broken roof tiles is found in the corner. Painted gourd birdhouses hang on the walls.

Beauty created out of love and care for the common good and mother earth is found in the museum. The Museo AJA is a project that engages everyday people in folk arts and cultures to promote an active and living culture of peace. It feeds and revives the cultural and artistic roots deep within the souls of the Salvadorian people and helps to awaken them from the nightmares of their past, which are often repeated in their daily lives as they live in a country where 40% of the inhabitants live in dire poverty. The museo affirms their right to dream of their heritage, its beauty, and its arts and to imagine and create beauty in their own lives.

Other Siglo XXIII Projects

In addition to the Museo AJA, the Siglo XXIII movement has founded and maintains several other projects, including the Ecological House in the indigenous town of Nahuizalco, Sonsonate, which has low-intensity gardens and a biological corridor for species in danger of extinction. On Sundays after Catholic mass, indigenous grandmothers, who are often the last to be fed in an impoverished family, are honored and celebrated at the house with a nutritious meal and a cultural program of singing or a drama. Other projects include the permaculture farm in San Salvador; the Culture of Peace annual fair; and the International Free University for Peace in Santa Ana, where trainings and conferences are held on building a culture of peace and on key emerging issues. The National University in San Salvador is the site where Siglo XXIII has held the celebration of the World Social Forums, which are held in El Salvador with the cooperation of media outlets, cultural centers, ecological groups, universities, international entities, and various municipalities. The Siglo XXIII movement has expanded its reach to international expressions, projects, and processes such as conferences and trainings in central Pennsylvania; butterfly and hummingbird gardens created in the Highlander Center in Tennessee; programs regarding a culture of peace, nonviolence, and ecology in California; participation on a variety of international ecumenical and secular networks and various processes at the United Nations; collaboration with the Artists for the 23rd Century, who are artists from various cities in the United States and other countries; and with the various exchange groups that visit Siglo XXIII movement projects to experience *convivencias*. The "spirit of 'convivencia' is—from *con* (together) and *vivencia* (aliveness) . . . 'living together,' the interrelation of humankind and nature" (Benavides, 1994, p. 222). The Siglo XXIII Convivencias are intentional intensive shared living experiences in which people celebrate, reflect, and work together to create better understandings about humanity and the planet with Siglo XXIII members and networks, and visiting groups.

Social Transformation through a Culture of Peace

Siglo XXIII understands culture as "the sum total of ways of living built up by a group of human beings and transmitted from one generation to another"

(Alexander, R.J. et al., 1989, p. 353). Thus its museum with the intentional use of symbolic language without reading requirements kindles the imagination, stirring the emotions of inspiration, passion, and hope within the roots and souls of the people of El Salvador, a nation that had its indigenous art and culture destroyed by more than 500 years of conquest, colonialization, coup d'état wars, massacres, and repression resulting in extreme impoverishment and violence. In their destruction and enslavement of the native peoples of Cuscatlán, the colonizers not only decimated the indigenous population but also almost eradicated their culture and language and repressed their spirituality and cosmological vision, a vision that is closely linked to the care and respect of mother earth. In the times before the arrival of the Spanish, the arts were integrated in the daily lives of the Pipil, Mayan, and Nahuatl peoples who inhabited this tiny thumb of Central America along the Pacific Ocean. With the obliteration of the arts and cultures of their past, future generations with only genetic fractions of their full-blooded ancestors had lost the sense of the whole of their identities and the fullness of the rich civilizations their ancestors had created centuries before. As the philosopher and educator Dewey (1934) stated,

> The sense of an extensive and underlying whole is the context of every experience and it is the essence of sanity. . . . Without an indeterminate and undetermined setting, the material of any experience is incoherent. Torn from their common context and denied access to their cultural heritage, any people without material evidence of their art and culture in their daily lives carries a well of madness in their hearts and souls. (pp. 194–195).

Dewey continued,

> A work of art elicits and accentuates this quality of being a whole and of belonging to the larger, all-inclusive whole which is the universe in which we live. . . . It also explains the religious feeling that accompanies intense esthetic perception. We are, as it were, introduced into a world beyond this world which is nevertheless the deeper reality of the world in which we live in our ordinary experiences. We are carried beyond ourselves to find ourselves. (p. 195)

This meaning of the arts and the culture in life is vividly expressed by the Salvadorian poet and revolutionary Roque Dalton, in the following excerpt from his poem:

Like You (Como tú)

> I believe the world is beautiful,
> that poetry is, like bread, for everyone.

(1994, p. 121)

To understand how Salvadorians had been denied their cultural heritage and torn from their common context, a brief history is helpful.

Brief History of El Salvador

Pedro de Alvarado, of Bada Joz, Spain, first journeyed to Hispaniola in 1510, what is now the island of Dominican Republic and Haiti, and in 1519 accompanied Hernan Cortes in his expedition to conquer Mexico. Later in 1524, General de Alvarado marched a contingent of men into Guatemala and into the land that would become El Salvador. Known for his cruelty to native populations as documented in various sources, including the Lienzo de Quauhquechollan, de Alvarado enslaved native peoples and murdered them by means such as hanging, burning, and throwng them to dogs. Anderson (1992) asserted that "when the Spaniard came, he substituted an alien hierarchy, totally out of contact with the masses, which tried to reproduce medieval Spain in modern America. The Indian was Christianized, forced to submit to Spanish law and customs ... and fitted to the Spanish economy" (p. 15).

Through the next three centuries, until Mexico declared its independence from Spain in 1821, El Salvador (which translated means the "Savior of the World") and its peoples were in the grip of Spanish domination. Through the next 40 years of the nineteenth century, the area of Central America including Guatemala, El Salvador, and Honduras was filled with political and ideological struggles among various dictators and leaders. Beginning in the 1860s and into the twentieth century, more enlightened leaders served as presidents of El Salvador and established a number of constitutions. A profound economic change also occurred during this period: Historically, El Salvador was a land with a diversified economy whereby its people were able to feed themselves; then it entered the industrial age and the modern world market through the development of a one-crop, cash economy of coffee, an agricultural monoculture that limited and eliminated its ability to feed its own people.

Coffee profits enabled the rise of an already land-rich plutocracy of the "Fourteen Families" in El Salvador, foreigners who married locals and were educated abroad and became the "cosmopolitan upper class" (Anderson, 1992, p. 24). This pattern has continued through the current times; estimates are that only a few hundred families in 1990 own 80% of the land. Through the twentieth century, the overwhelming majority of El Salvador's 1.5 million inhabitants were *colonos* (sharecroppers) who lived on the estates as farm laborers. Only a small local middle class of small business owners and craftsmen lived in the villages. From their insignificant salaries, the laborers paid in cash rent for the hovel where they lived and received the rest of their salaries in tokens to buy food, clothing, medicine, and small goods from the landowner's store. Descendants of the indigenous peoples of El Salvador and the darker campesinos were considered culturally inferior by all other social classes. Through the decades, a smoldering resentment grew among the rural impoverished people against Spanish rule and the Ladinos who owned their labor and most of their lives.

The 1929 stock market crash and the subsequent Great Depression caused the market for coffee worldwide to spiral downward to such low prices that some landowners let their coffee fruit rot in the fields, and sold their farms. The rural farmworkers suffered worse with loss of work and a sharply devalued colon (the national coin of El Salvador, even though since 2001, El Salvador has an economy that uses the U.S. dollar). During those hard times, stories of the 1833 Indian revolt against white rule were told around campesino gatherings and bonfires.

In 1930, a young Salvadorian leftist, Agustin Farabundo Marti, who had left El Salvador due to government persecution and had joined struggles and movements for democracy and human rights in Mexico and Nicaragua, slipped quietly back into the country. He was arrested several times as he joined the protests by rural farmworkers against the oppressive government and landowners in demand of food and wages. Leaving El Salvador again to escape imprisonment, Marti returned in early 1931 and joined with the campesinos in rallies and marches on the capital.

In reaction, the government instituted martial law in March 1931, using the military to stop the strikes and demonstrations throughout the western departments (provinces) of Sonsonate and Santa Ana. In May 1931, a massacre of workers and peasants occurred in the town of Izalco, Sonsonate, followed by a similar killing in Zaragoza, La Libertad. In the following months of 1931, the military crackdown slowed the incidence of the demonstrations and protests but fueled a hidden fire of hatred and resentment among the campesinos. However, the tremendous unrest led to a military coup d'état in December 1931 and the seating of a new president, Hernandez Martinez. In the next month, large groups of laborers and revolutionaries united in their mission to declare a revolt and planned for an attack on the barracks of the chief towns in each department as a way to take action against the police and National Guard. On January 20, 1932, the unrest occurred in several areas, and a state of siege was declared in effect by the government in six departments including Sonsonate and Santa Ana. Two nights later, a full revolt broke out with the rebels seizing the coffee towns of Juayua and Salcoatitan. The rebels moved toward the town of Nahuizalco and were successful in overthrowing the military presence in several small towns in the western region. However, to control the western departments, the rebels needed to control the main city, Sonsonate, the capital of the department of Sonsonate. After hours of fighting with numerous deaths, the rebels were unable to take Sonsonate and fell back to a nearby town. Messages were sent to the capital city of San Salvador for the government and military to send troops to quell the rebellions. News of the rebellion headed north, and within 3 days from the onset of the rebellion, United States and Canadian vessels were cruising near the coast of El Salvador. Spurning their assistance, the Salvadorian military general in charge announced that the rebellions had been crushed and that nearly 5,000 communist rebels had been liquidated. In spite of the military's strong use of its power to crush the rebellion, the upper classes in the weeks that followed the end of the rebellion denounced the government for its leniency toward the "criminal elements" that abetted the rebels and demanded repressive action.

In response to this criticism, the government, starting in the town of Izalco, rounded up all men who were carrying machetes, of Indian features, and in poor campesino dress. Accompanied by their women and children, the men were herded into the towns' centers, and the *matanza,* or massacre, began. After digging a mass grave, the men and those women and children who refused to leave them were pushed against the wall of the church and shot by the firing squads and then thrown into the graves. Similar incidents took place all over the western part of the country in towns and in the isolated countryside. Although no records were kept, estimates state that the rebels killed 100 of the military, and that anywhere from 10,000 to 50,000 rebels and campesinos were killed in the fighting of the rebellion and in the massacres that followed and continued through 1932.

As Dalton wrote,

> Todos nacimos mitad muertos en 1932
> Sobrevivimos pero medio vivos (1988, p. 124).

> (We were all born half dead in 1932
> We survived but half alive.)

In the wake of these events, Martinez was able to hold on as sitting president. After his instatement of military officers into the government, his presidency was recognized by the United States.

During the next several decades until 1961, several military coups d'état and violent electoral frauds occurred as reform leaders challenged the army officers and wealthy oligarchy, resulting in a stronger and stronger police state. These oppressive measures were regularly contested by the people, so the regimes responded with more repressive actions, an increment of the human rights violations, while poverty and hunger also daily increased. Popular movements for justice grew stronger every day and spread, challenging the rule of law and calling for social, economic, and cultural rights. By this time, the Catholic Church had been through a process of enlightenment, and many religious and secular followers of the theology of liberation—deemed communist by the government—joined the calls and the movements for justice and peace. Thus, in the name of national security and to combat communism similar to what had been done in the 1954 coup d'état in Guatemala, and the 1964 coups d'état in Brazil and Uruguay, the security forces received more training and arms materiel and moved to crush the peaceful demonstrations and judicial demands. They moved rapidly to disappear, kill, and imprison anyone in the leadership in any sector of the popular movement: teachers, students, peasants, artists, women, scientists, journalists, trade unionists, small merchants, priests, and catechists. A young female high school student leader would suffer the repression just the same, and more, for she could not only be tortured but also raped.

In this context of repression and in the disappearance and killing of citizens, the Monsignor Oscar Arnulfo Romero, a moderate, who was even considered conservative by some, bishop, was named Archbishop of the Archdiocese of San Salvador. The Catholic Church hoped in this way to contain religious involvement in the growing protests against the Salvadorian government. Yet, Romero was a very disciplined, studious, and committed man, and in acting out his commitment to minister to the impoverished, suffering people of the country, he was evangelized and transformed. His work, in defense of the repressed and silenced majority, led to his assassination on March 24, 1980. His murder as well as the continuing and increasing number of murders, rapes, disappearances, imprisonments, and the tens of thousands of internal and external displacements were what detonated the beginning of the 12-year armed conflict, a civil war that split the nation, killing thousands of civilians, although it was called a low-intensity war by the United States. The armed conflict ended when both sides agreed to the United Nations–sponsored peace accords, signed on January 16, 1992.

The Arts and Justice

These experiences have stained the walls of El Salvador's history right through the civil war. This history depicts the essence of the reason that the Siglo XXIII movement projects in the western departments are so significant for the rise of justice and resonate so strongly with the people. The Siglo XXIII movement's Museo AJA, with its collection of everyday-life arts and crafts, uses the arts to educate the common people about how art is alive and how the energy of the arts can be used to transform their lives in the soil they work, the water they drink, the air they breathe, the nurturing of their identity, and the fostering of respect for themselves and others. The dynamic nature of the arts at the Museo AJA in this small corner of Santa Ana nourishes the seeds of hope that flower into the rights of peace and justice for all peoples.

These experiences and practices celebrate life and enhance the colors and rhythms of daily living, and they affirm the understanding that humans have been born to be happy and enjoy the riches represented by the whole universe. The Museo AJA embodies philosophical and practical lessons that can be useful to anyone committed to social transformation through culture, and in particular a culture of peace. The installations and reflections are tools for delight and for the effective work of the expansion of consciousness, the deepening of understanding, and the possibility of transcendence through creating meaning. The insights can be useful to both the Western Regional Arts Museum down the street and for the peoples of the global South whose histories echo those of El Salvador. And, as many foreign visitors have said, the Museo AJA holds especially important lessons for the peoples of the global North, the industrialized nations, because of the disconnections from culture and the arts in the lives of the people of the global

North as a result of globalization, consumerism, and individualism. The experience of the arts calls to those of the global North to tend to their own cultural gardens and to let others around the world do the same. To manifest peace, we all must intentionally work for it. The Museo AJA Web site can be found at http://www.museoaja.org.

References

Alexander, R.J., et al. (1989). In *Webster's encyclopedic unabridged dictionary of the English language* (p. 353). New York: Gramercy Books.

Anderson, T.P. (1992). *Matanza* (2nd ed.). Willimantic, CT: Curbstone Press.

Benavides, M. (1994). Spirituality for the twenty-first century. In N.B. Lewis, L. Hernandez, H. Locklear, & R.M. Winbush (Eds.), *Sisters struggling in the spirit: A women of color anthology* (pp. 219–235). Louisville, KY: Woman's Ministries Program Area.

Dalton, Roque. (1988). *Las historias prohibidas del Pulgarcito*. San Salvador, El Salvador: University of Central America.

Dalton, Roque. (1994). Como Tu. (J. Hirschman, Trans.). *Poetry like bread: Poets of political imagination*. Willimantic, CT: Curbstone Press.

Dewey, J. (1934). *Art as experience*. New York: Perigee Books.

4

DOCUMENTARY THEATER IN EDUCATION

Empathy Building as a Tool for Social Change

Leyla Modirzadeh

1. How can documentary theater create empathy and educate its audiences around issues of racism and xenophobia while still remaining entertaining and compelling to watch?
2. Can documentary theater be a tool for social change without becoming preachy and obviously didactic—especially when performed for young audiences?

Introduction

Given the current political climate of xenophobia and paranoia as evidenced by anti-immigration sentiment and rhetoric, education with an emphasis on social justice cannot be overemphasized. Also given the current dwindling resources allocated toward the arts in education, now is the time to initiate and take charge of arts activities within our own educational spheres and create what educator Jonathan Kozol calls "islands of decency" everywhere we can (Kozol, 1991). Creating empathy ranks as one of the most powerful tools in bridging cross-cultural differences and addressing racism. Documentary theater plays a vital role in educating groups using empathy as a conduit for social change. In contrast to more didactic approaches where the learner receives information from the instructor through readings and lectures, theater builds an empathetic bond between the story and the spectator. The *Undesirable Elements* series uses the singular act of highlighting an individual as special and unique, and this has the power to create discernment and regard in the spectator. The creation of beauty through attention to details of the personal rather than the general also stands as a reminder that those details that make one human are also universal, which in turn creates

empathy in the viewer. The purpose of this chapter is to advocate an expansion of this model of empathy-building-based learning.

I became fascinated by the possibilities of theater as a way of teaching students through my experiences working with Lincoln Center Institute and with Ping Chong. As cowriter and codirector at the Lincoln Center Institute, I created two seasons of documentary theater called *Secret Histories: Journeys Abroad, Journeys Within* with Ping Chong. These plays, based on oral histories of refugees in New York, place the personal narrative in historical and global context. Clark Theater, the educational wing of Lincoln Center, invited educators to design their curriculums around this project. After extensive interviews, we chose three participants (one from Iran, one from Bosnia, one from Liberia) to tell their stories onstage using a script written from their interviews. Students saw the productions after having studied the histories, politics, and cultures of the performers' respective homelands.

The first part of this chapter describes the work of Ping Chong and the *Undesirable Elements* series (http://www.undesirableelements.org). The second part examines the pedagogical applications of this particular model of multicultural documentary theater, as examined through the Lincoln Center Institute productions and their accompanying curriculums (http://www.lcinstitute.org). The last part provides an example of the ways in which this project can educate and heal a community in the wider world.

Ping Chong and the *Undesirable Elements* Project

In 1994, I was working as a professional stage actress in Seattle, Washington. One day, I received a call inviting me to audition for a show called *Undesirable Elements* created by the acclaimed New York theater artist Ping Chong. His work mostly focused on different cultures and examinations of history, which interested me very much. I asked if I could interview with him in New York. We met at Café Gitane in Nolita. I knew this was not a typical play and that I would not be asked to read from a script or perform a monologue. After he got his coffee, he sat across from me with pad and pen and started asking me a series of pointed personal questions in his matter-of-fact New York accent. "What's your background?" I knew that part of the reason I had been called to participate in this show had to do with the fact that I am half Iranian. "Do you speak Farsi? Have you experienced any racism? What exactly happened?" I attempted to tell my life story as succinctly as possible, without wasting his time with too many details. "More details," he said, and I handed him a stack of forms that I had already filled out. The forms were for potential participants to fill out beforehand. I had filled in spaces for favorite poems and songs from my cultural heritage. As an actress, I was accustomed to creating characters in the context of fictional circumstances, so this process felt a little invasive and a lot uncomfortable. I wasn't sure what he wanted, and I certainly was having trouble relaxing and sharing my full self with him. Doubt followed me as

I got up to shake his hand and walked back out onto the street. Definitely a failed interview, I thought. As I descended into the subway that autumn day, I had no idea that Chong and I would still be working together 17 years later.

I come from a varied background. My mother is a New Yorker from Irish Catholic and Russian Jewish heritage; my father emigrated from Tehran, Iran, in the 1950s, from a Shiite Muslim family. I went to Catholic schools. I grew up living in France, Iran, and California. My half sister is half Mexican. Being of mixed heritage made me focus even more on issues of inclusion and tolerance. The word *multicultural*, far from being just an overused buzzword to me, always felt personal and present in my life. I understand the word to mean the peaceful coexistence of multiple cultures. By *cultures* I mean ethnic cultures, religious cultures, and any sets of behaviors and customs that place one group apart from another.

Ping Chong grew up in New York City's Chinatown with Chinese immigrant parents. Much of his theater work was already exploring the subject of cultural heritage and identity even before he started *Undesirable Elements*. In July of 1992, Chong was in Holland teaching a group of international students. Everyone spoke English, but one night, when they all retired to the bar for a drink, the students reverted to their native languages. Sitting on his barstool, Chong listened to the sounds of various languages spoken all around him. The idea of making a piece with people speaking multiple languages came to him that night. He already had a commission from Artists Space in New York to create an environmental work that he titled *A Facility for the Channeling and Containment of Undesirable Elements*. Carlos Solanis of Artists Space wanted to have more than just a gallery for visual art and had asked Chong to make a performance piece using the art piece as the set. He decided to stage a simple piece using people who were not native English speakers. These nonperformers presented their stories, intermixed with their native languages, in a poetic chorale of voices.

If I had been there in 1992 at the first incarnation of *Undesirable Elements*, I would have been on one of many catwalks around the gallery looking down on yellow and black pools of liquid surrounded by white rock salt. The cast was composed of nonactors from various backgrounds: Lebanese, Filipino, Nicaraguan, Choctaw, Ukrainian, and Japanese. Seated on the rock salt, participants shared their customs, religion, race, language, and personal stories. "These were witnesses to living history," Chong said, "and they might never even have met under other circumstances" (Pratt, 2004, p. 14).

In the past 18 years, more than 40 U.S. productions have followed, as well as versions abroad. I performed in the fourth *Undesirable Elements*. I've been told that our Seattle version, with nine participants, was one of the most elaborate productions of the piece. A small viewing gallery of the participants' personal artifacts skirted the perimeter of the stage where viewers could peer through glass, as if in a museum, and see precious objects from the participants' native homelands. Since then, the form has been distilled to a very simple template, both in the writing and the visual style of the pieces. Rock salt remains an element from the original concept

but usually in the form of a half circle, straight edge to the audience, surrounded by a semicircle of equidistantly placed chairs. Each chair has a music stand to hold the script and a microphone. Each chair also has its own pool of light from above. Sometimes, when possible, projections appear behind them in the shape of countries. A circle of light also beams down in the center at alternating points.

The Model

A brief explanation of the elements of the text Ping Chong developed for the play will serve to underscore the importance of the collaboration between performer/participant and director/writer in telling these stories. The text itself, with its own formal template, developed over time. First, the potential participants fill out preliminary forms subdivided into these four categories: (a) "Background," (b) "Chronology," (c) "Names," and (d) "Poems." The category of "Background" includes the following sample questions: "*How is your cultural identity reflected in your daily life (foods, traditions, activities)? Have you struggled with issues of cultural identity? How do you currently identify yourself? Do you have memories of feeling like an outsider/ other in your culture of origin and/or current community? Have you experienced direct or indirect racism or discrimination? Have you witnessed racism or discrimination within your community towards others? What are some assumptions that people make about people from your culture? What are some of the major issues that you see as currently pressing within your community?*" (Chong, 1999a, n.p.).

Since this is an ongoing theater project, the process usually follows this standardized format. From these forms, Chong chooses people for initial interviews. Finally, a group of participants (usually around six) comprise the final performing group. After extensive interviews with the final group, Chong edits the stories into succinct entries. These entries follow a chronology punctuated by historic national or worldwide events, making the personal and the public both equally important. A group hand clap separates the entries, clearing the air much in the same way the sound of Chinese New Year firecrackers clear the air for the new year to come. The participants do not choose how their entries will be written. Chong integrates their stories and writes the show through his own unifying voice. The participants then read from the scripts that sit on the music stands. An entry in the script looks something like this:

(ALL CLAP)
TIFFANY: 1937
TIFFANY/DALIA: 1937
ALL: 1937
TIFFANY: Baltimore, Maryland
SAGNO: In the American South a Black person . . .
TIFFANY: . . . cannot try clothes on in a store . . .

DALIA: . . . cannot drink from the same water fountains as Whites . . .

TIFFANY: . . . cannot sit in the front of the bus because it is reserved for Whites . . .

DALIA: . . . cannot get a good job, even if he or she is educated, because Blacks are not allowed to rise in the South.

TIFFANY: Abrahim Moses, after much suffering in the segregated South, follows many Black Americans before him. He leaves everything he has known and moves to Liberia. He will become a very rich man, owning coffee and cocoa plantations.

SAGNO: He will become my grandfather.

(ALL CLAP) (Chong & Modirzadeh, 2004, p. 8)

In addition to the name game, personal and historic entries, and the "What do you think of?" section, the show also incorporates a section where everyone sings a song in their native tongue and a section where everyone speaks a poem. The show begins with the participants saying their birth date and birthplace in their language and an anecdote about the day they were born. The show ends with each participant saying the same entry as the beginning but this time in English. There are also some lines that have endured through every production and now are regular inclusions in almost every script. This line, encapsulating one of my favorite sentiments, appears in every show: "You can choose anything in the world you want, my child, but you can never choose your heritage."

The Lincoln Center Institute Productions

Ping Chong's *Undesirable Elements/Secret History* project eventually became an ongoing series of works exploring the effects of history and identity on the lives of people in a particular community. The simple act of naming oneself in public proved to be so powerful that communities around the world and all over the United States wanted to have their own version of the project. As Chong puts it, the "people onstage are having a communion with the audience. And a communion with a group of people is a very powerful act" (Moyers, 2003). This communion also caught the attention of educators. If documentary theater could entertain, inspire, and ultimately bring diverse groups of people together in communion, then the educational possibilities of this project could be limitless.

In the winter of 2004, I got a call from Chong's office asking if I wanted to collaborate on creating an *Undesirable Elements* for a group of educators at Lincoln Center Institute (the educational wing of Lincoln Center). The show needed to be 45 minutes long, and they had requested that we focus on young refugees living in New York City. We also had to keep in mind that they were orienting their show to students from kindergarten to high school and maybe

some college groups. The show would premier in July for a group of young teachers who were attending Lincoln Center Institute's summer session. These artists planned to create curriculums around our show to bring to their schools. Students would then come in to the Clark Theater (a 130-seat theater at Lincoln Center Institute) to see the show and further discuss it in their classrooms afterward. Lincoln Center Institute also had scheduled a week of touring within the school system.

I accepted the challenge, even though I had only performed in the productions before and had never written one myself. Sara Zatz, with whom I collaborated closely, had worked on many of these shows as a production manager and knew the process well. Length, subject matter, and audience age range comprised the main differences between the usual piece and this production. We usually have the participants tell their own story, but since we only had 45 rather than the usual 90 minutes, we agreed that no more than three stories could be told. Three people look a little lonely onstage, though, so we decided that we would have two narrators to help tell the three main stories. The bigger question for us was how to make our show appropriate for school groups. Finding younger participants made sense since they would be closer in age to the audience members. We eventually realized that this was actually difficult because young people are either in school during the day or in college during rehearsal times and not readily available. We ended up with a group of three who were in their midtwenties. We thought the younger audiences would be able to relate more to the younger participants' stories. Within the context of the scripting, we had to consider how to present certain issues to younger audiences and how much history we would have to explain. Usually the scripts have a lot of historical information, but we were very limited with our time constraint. Did young students know about the Iran-Iraq war and what happened in Bosnia? We had to figure out how to present that material in a distilled way to school audiences. These were some of the challenges of presenting the show for young people. The benefits outweigh the challenges though since the topics introduced in the show make for more interesting discussions back in the classroom. In this way, too, the production lends itself to educating students about world events and the importance of social justice through an eyewitness account from a person closer to them in age. The creation of empathy would best be accomplished through young performers telling their own stories juxtaposed against dramatic yet accessible historical narratives.

Recruitment now became the big challenge. In the past, the host organization would find the participants for Chong to interview. This time, we had to recruit locally without a partner organization. We launched a broad recruiting effort to find young refugees in New York by contacting organizations such as the International Rescue Committee and even Bellevue Hospital, which has

the Center for Victims of Torture. We interviewed a good number of people until finally we decided on Sanaz Mozfarian from Iran, Bekim Chela from Bosnia, and Sagno Alseny from Liberia. Besides looking for a compelling personal story, we wanted people who would engage the interest of young people and with whom they could empathize. Empathy, as in all of these shows, stands as the main ingredient to breaking down stereotypes and creating real cross-cultural understanding. In the end, the young audiences related most to Sagno, a former prisoner of war who drove a cab in New York. Sara Zatz had this to say about the impact of Sagno's story and the importance of presenting in a theater setting.

> **Sara Zatz:** That first year of 2004 was very significant. Since then, we've done school-sized presentations with Sagno. They invited Sagno to come into one of the schools and talk to the class. I really saw the impact that his story had on the students. [Sagno told of] his own experiences as a refugee from Liberia going through the civil war and seeing his father killed in front of him. And, at that time in 2004, the real discussion about the "conflict diamonds" was coming out in [the movie] *Blood Diamonds*. He talked about working in the diamond mines. I actually saw the kids really relate to that. In a lot of ways they related to Sagno, not so much because they had had similar experiences in the war, but a lot of them were missing their fathers in some way. I think they really responded to his loss of his father; I think that really hit home for them.
>
> **Leyla Modirzadeh:** Do you think there is a difference when students come to the theater as opposed to seeing it in their own school?
>
> **Sara Zatz:** We always try to do a formal professional theatre production of whatever the show is that we are doing. We hope that we'll tour in the communities too. There is a formality to being in the theater space that gives authority and prominence to the show that the audience is seeing. That's really important, particularly when you see [stories that have been marginalized in the past] on stage in this professional setting. It has an authority that people recognize as being important. The second part is to provide a theatrical experience for communities that maybe don't go to the theater, don't feel welcome at the theater, or can't afford the theater. Bringing it into the communities then gives people access to it where otherwise they wouldn't get to see it.

Aesthetic Education

Lincoln Center Institute uses "aesthetic education" as its model, and our show fit well with their philosophy of "engaging the learner's imagination to look at things as if they could be otherwise" (Samson, 2005, p. 70). By using works of art as points of entry into learning about traditional subjects such as history or

social sciences, educators using aesthetic education principles hope that students will discover their own thinking in a more creative and integrated way. As Maxine Green says, "A work of [art], when fully perceived and carefully attended to, makes a demand upon beholders—a demand that they change, look with new eyes, hear with new ears, become something they have not been before" (2001, p. 44). After the initial show for the educators in July 2004, they created classroom curriculums based on the production. Andrea Masters, of Lincoln Center Institute, put together a wonderful text called *Windows on the Work* that includes relevant articles about immigration, displacement and loss, and the process of making *Journeys Abroad, Journeys Within*, which was the title of the *Undesirable Elements* at Lincoln Center Institute. This text also served to document student responses to the piece. It stands as supplemental background material for student study and also as enrichment to educators wishing to build classes around the histories of particular cultures relevant to the play and themes of inclusion and diversity.

In *Windows on the Work*, the teachers respond to seeing the show before beginning to teach their classes. Some teachers mentioned that their immigrant students and students who feel like outsiders might feel a sense of relief and understanding after seeing the piece. Another educator had this to say:

NILDA: In [my classes], there are primarily white students from affluent backgrounds. When I teach them about struggle and injustice, I see a barrier. They don't want to believe me, because if they do . . . they have to admit, "I've had privileges. I've had an easy life and I haven't experienced the struggle that other people have." So I know that if I took them to see *Undesirable Elements*, they would immediately say "How can this be true? I thought that if you worked hard you could have the same things as others. How come the man from Liberia, Black himself, is afraid to talk to Black people in America? And what about the Muslim woman—why isn't she wearing a veil?" The students would come to the show with so many different assumptions, and all these different stereotypes would be challenged. For my students, these stories would put a face on injustice, make it real. (Dickstein, 2005, p. 38)

Here is a sampling of responses from public school students in fall 2008 after their participation with the *Undesirable Elements* Education Program:

> *I learned to express my feelings, have voice for words and show emotions.*
> *I am now better at sharing what I feel with people that I don't really know.*
> *What I learned . . . is that everyone has [his or her] own perspective. Another thing I learned was that when other people tell you what happened to them, it sometimes reminds you of a moment that happen[ed] to you.* (Ping Chong and Company, 2008, p. 1)

Impact on Community

The *Undesirable Elements* model can also educate within a community. My own experience creating a piece for a small town in Mississippi can attest to this. I took the model outside the classroom and into the wider community, initially as an experiment in social activism. The community was Oxford, Mississippi: birthplace of William Faulkner, home of the first Southern university to be desegregated, historically entrenched in racial inequality and divisiveness. I thought if I could find people marginalized by the dominant White Southern culture, then maybe I could tell their stories respectfully and give voice to those voices that have historically been silenced. The William Winter Institute for Racial Reconciliation cosponsored my project. After many calls for participants and not many responses, I finally found four people willing to get onstage and tell their stories about what it has been like for them to live in that community having their particular identity. My participants were a gay man who identified as half Mexican; an albino African American girl from the Delta; a young woman who was a Japanese immigrant; and an African American woman who was the functionally illiterate daughter of sharecroppers, 1 of 14 children raised in the segregated poverty of rural Mississippi. The performances were groundbreaking. Over 200 people came and laughed and wept together in an incredible catharsis of shared history and healing. In the darkness of the theater, an open dialogue could begin about topics commonly avoided. Two older White women came out of the theater crying and rushed up to clutch my hands. They thanked me and said that they had lived through segregation and witnessed terrible things in their community over the years. This was, they said, the single most healing event they could remember in their town. As they left, one of them told me, "I will cry all the way home." A number of people wrote me from the show, and here is one of the many responses:

> I had the privilege of seeing "Secret Histories: Oxford" last Sunday. While feeling intimately connected as part of the human family, I thought: if this could be performed in every high school and middle school in this country, surely the bullying problem within our society should reduce somewhat. Maybe the "Secret Histories" should be a mandatory play for all incoming college students too. Even the most thoughtful of us [who] try "to imagine a walk in the shoes of another," are, by our very nature, abandoned to a level of basic instincts of fear . . . fear of the unknown. So we must be constantly schooled and educated. Thank you to so many of you who make poetic attempts at trying to help us all understand and respect one another.

Conclusion

Beauty matters and beauty depends on the specific and the particular. Generalities beget misunderstandings, and composite banalities lead to gross stereotypes.

The *Undesirable Elements* series uses the singular act of highlighting an individual as special and unique, and this has the power to create discernment and regard in the spectator. The creation of beauty through attention to details of the personal rather than the general also stands as a reminder that those details that make one human are also universal, which in turn creates empathy in the viewer. As Elaine Scarry (1999) asserts:

> Beauty . . . actually assists us in the work of addressing injustice, not only by requiring of us constant perceptual acuity . . . but by more direct forms of instruction . . . What happens when we move from the sphere of aesthetics to the sphere of justice? Here symmetry remains key, particularly in accounts of distributive justice and fairness "as a symmetry of everyone's relation to one another." (p. 13)

It is this symmetry of relation that destroys the hierarchical dominant structure and creates an empathic lateral relation to others, even others with perceived differences. The possibility for social change from the *Undesirable Elements* project lies in its power to create empathy across type. The show's deceptively simple format of oral history storytelling, as if gathered around a primal campfire, also supports the idea of "distributive justice and fairness as a symmetry of everyone's relation to one another." Symmetry suggests spatial relation, and the show begins and ends with the time, date, and place of each participant's birth. Particularity of origin and geography, here, becomes less a justification to separate from each other, and more an invitation to realize our common original source. Theater here celebrates the differences between people without polarizing the people themselves. Social change happens when ideas change, and ideas change when education prepares the ground for new ideas to take root. Documentary theater of this kind proves that art can educate toward that end.

References

Chong, P. (1999a). *Background information form.* New York: Ping Chong and Company.

Chong, P. (1999b). *Poems form.* New York: Ping Chong and Company.

Chong, P., & Modirzadeh, L. (2004). *Secret history: Journeys abroad, journeys within.* New York: Ping Chong and Company.

Dickstein, R. (2005). Responding to secret history: Journeys abroad, journeys within. In *Windows on the work* (p. 38). New York: Lincoln Center for the Performing Arts, Heckscher Foundation Resource Center.

Greene, M. (2001). Variations on a blue: *The Lincoln Center Institute lectures on aesthetic education.* New York: Teachers College Press.

Kozol, J. (1991). *Savage inequalities: Children in America's schools.* New York: Crown.

Moyers, B. (Writer/Executive Producer). (2003). Survivors [Television series episode]. *NOW with Bill Moyers.* New York: PBS.

Ping Chong and Company. (2008, Fall). *Community impact and response.* Brooklyn, NY: Undesirable Elements/Education Program.

Pratt, D. (2004). *Portraits of others* (p. 14). New York: Lincoln Center Playbill.

Samson, F. (2005). Drama in aesthetic education: An invitation to imagine the world as if it could be otherwise. *Journal of Aesthetic Education, 39*(4), 70–81.

Scarry, E. (1999). *On beauty and being just.* Princeton, NJ: Princeton University Press.

5

WHAT THE MUSIC SAID

Hip Hop as a Transformative Educational Tool

Kawachi A. Clemons and Kristal Moore Clemons

1. How does student art inform educators on what to teach and how to engage youth in a critical pedagogy?
2. In what ways can a critical Hip Hop pedagogy foster in students a desire to reinvent and reimagine the possibilities of a truly inclusive America?

> It doesn't matter to me if you write song lyrics, poetry, or prose—if you are concerned about what's happening in your world, and especially if you take issue with it, songs, poetry, and short stories are very important ways to express what you are feeling. And don't forget visual arts and dance. The most important thing I learned as a young person is that the song forms I knew, the songs I liked, were the best ones for me to use to express myself.
>
> Bernice Johnson Reagon

"Music in the Movement" ~ Our Story

It was a warm summer's evening in Clinton, Tennessee. Gathered together were more than 1,000 college-aged men and women to attend the Children's Defense Fund (CDF) Freedom Schools' annual summer servant leader intern training at Alex Haley's Farm. This evening was especially exciting because we would all have the opportunity to hear from Hollis Watkins, a veteran civil rights activist. Watkins's speech on his experiences during the movement was a heart-wrenching, poignant account of the 1960s struggle for civil rights. However, it was his presentation after the speech that left the greatest impact. Watkins moved the crowd with his candid renditions of a few civil rights songs. Before exiting the stage, Watkins asks, "Is it alright if I do one more?" The crowd roared as Watkins sang, "Free . . . give us freedom . . . freedom come and it won't be long. Free (holding a long tone)." As he repeated the chorus, the entire audience began

singing. He proceeded to engage the audience with call and response, improvising verses as the crowd recited the refrain to the melody of Harry Belafonte's "Banana Boat" song.[1]

What Hollis Watkins's music said to us was permanently imprinted in our minds. We meditated on the power of the music. We began to think about how we could create a desire in young people to possess the passion to "do" the work of social justice that Hollis Watkins eloquently expressed. That was our challenge and call to action!

Introduction

Music has served as a vital component in the way various cultures have preserved their way of life. In particular, the Negro spiritual and blues musical traditions narrative form provide insight to the plight and hope of a people seeking equality. A defining condition of being human is that we have to understand the meaning of our experience (Mezirow, 1997). It is our position that the creation and observation of artistic forms of representation serve to shape our experiences and mediate a "way of knowing" of self and the world around us. Our work sought to understand how to utilize a Hip Hop pedagogical model through the following lines of inquiry: How does student art inform educators on what to teach and how to engage youth in a critical pedagogy? In what ways can a critical Hip Hop pedagogy foster in students a desire to reinvent and reimagine the possibilities of a truly inclusive America?

This chapter describes Hip Hop as a unique medium to engage educators and students to work toward creating positive change in their respective communities. Our desire was to infuse the tenets of Hip Hop as a transformative educational tool that built on what Hill calls Hip Hop pedagogy: "Hip hop pedagogy reflects an alternate, more expansive vision of pedagogy that reconsiders the relationships among students, teachers, texts, schools, and the broader social world" (Hill, 2009, p. 120). The work that follows documents the experiences of two activist-educators who engaged a community of mostly African American students enrolled in a Hip Hop–inspired CDF Freedom Schools[2] program located at a historically Black university in the South. In addition to the description of the program and curriculum, we also included the voices of the students who participated in the summer program. We believe their work function as forms of "educational protest, . . . scholarship intended to provide new insight and opportunity for educational praxis" (Stovall, 2005, p. 197).

Adams et al. (1997) reminds us that social justice is both a process and a goal. Thus, our program's social justice mission was to create an environment where "students developed a sense of their own agency as well as a sense of social responsibility toward and with others and the society as a whole" (Bell, 1997, p. 3). We set out to support students in understanding concepts such as oppression and liberation and to analyze interlocking systems of discriminatory practices through Hip Hop.

I Am Hip Hop; I Can Make a Difference

The summer of 2007 marked a critical year for the CDF Freedom Schools national training. The CDF trained more than 1,000 servant leader interns[3] to serve more than 8,500 children. The training theme for that year was "Music in the Movement." The workshops highlighted the social organizing and educating power of music from both a historical standpoint and in terms of the political organizing power.

Various points throughout the training seemed like series of concerts rather than a series of spaces for critical dialogue on the importance of arts integration. The historical information provided about music and the movement for civil rights was engaging. However, we were not convinced that national training participants left with a concrete understanding of the direct link to how and why our brothers and sisters used music and the arts to fight for social justice then and now.

In American society and abroad, we are inundated with the impact of Hip Hop culture. Issues of commercialization, misogyny, capitalism, and citizenship can all be discussed through Hip Hop. Dyson (2004) posits that Hip Hop expresses the desire of young Black people to reclaim their history, reactivate forms of Black radicalism, and contest the powers of despair and economic depression that presently besiege the Black community. With that in mind, we knew we wanted to pick up where the national training left off. We were committed to finding the necessary tools to encourage all students and teachers to generate a dialogue about Hip Hop on their college campuses, in their churches, and most importantly, at their CDF Freedom Schools.

David Levine (2008) defines transformative education as the notion that students, particularly those less privileged, be encouraged toward expansive affective and cognitive growth, and the notion that schools can act as vehicles for change within society and redefine and deepen democracy and equality. We used this definition as a foundation to bridge our individual interests in CDF Freedom Schools and Hip Hop into one comprehensive 5-week summer program.

The CDF Freedom Schools program focuses on the theme "I Can and Must Make a Difference" in my self, family, community, country, and world. The students who participate in the program are intentionally called "scholars" to empower them to become their own educational advocates. Scholars are separated into four levels/grades: Level I (K–2), Level II (3–5), Level III (6–8), and Level IV (9–12). The servant leader interns use a curriculum designed by the CDF that is equipped with lesson plans, discussion questions, and an outside resource list.

A typical day at CDF Freedom Schools begins with Harambee!—a 30-minute activity to celebrate and affirm the value of each participant and prepare for work and learning ahead. After Harambee! the integrated reading curriculum (IRC) begins and lasts for 2 hours and 45 minutes. In that time, scholars engage in cooperative group activities, conflict resolution discussions, Drop Everything and Read (D.E.A.R.) time, critical thinking, social action, and group reading. Scholars' multiple intelligences are tapped into because they report back what they have

read through poetry, song, diagramming, and role-playing (Seiler, 2008). Every site transitions to an afternoon curriculum based on the staff's talents and expertise.

Hip Hop Arts Infusion

Our Hip Hop Inspired Freedom School (HHIFS) fell under the university's Hip Hop Initiative's precollegiate program. Our 5-week summer program served third through ninth graders. During the summers of 2007 and 2008, 63 and 57 scholars were enrolled, respectively. In addition to implementing the IRC and the afternoon curriculum based on Hip Hop, we organized a host of field experiences and a finale to showcase student artwork and performances to which the community was invited. The integration of Hip Hop served as a way to provide young scholars with a culturally relative curriculum around that which Giroux (1996) describes as communal knowledge that provides students opportunities to be critical and negotiate their sense of history, identity, and place.

To effectively engage the scholars with our arts approach, we used the HHIFS to provide servant leader interns additional exposure to arts-integrated planning and instruction through an on-site workshop. The goal was not to teach the interns as preservice educators. Rather, it served as a means of providing young activists the tools to infuse their respective art forms with the five CDF themes, in a manner in which they were able to teach about, in, and through the arts. Cornett (2007) posits that "each of us has natural inclinations and competencies in arts areas. Teachers should begin with a strength—an area they feel they know something about and feel comfortable doing" (p. 13). The HHIFS servant leader interns were given the opportunity to select their afternoon activities based on the Hip Hop element they were most at ease with performing and instructing. As Hanley, Brown, Jay, and Clemons (2005) note, "Hip Hop, an art form that involves music, literary skills, and performance skills, presents a means of cognitive, affective, and psychomotor learning, imagination, qualitative problem-solving, sensory awareness, concentration and focus, literacy, and cultural knowledge—qualities intrinsic to the arts" (p. 4).

Cultural Context of Research

This study investigates the use of the Hip Hop musical aesthetic in a CDF Freedom Schools setting. The participants were Level III and Level IV scholars. The scholars came with a range of educational levels and varying musical abilities. Some students self-identified as poets or rappers, while others shared a sincere appreciation for music and Hip Hop culture. During the summer of 2007 and 2008, we were able to collected data on various aspects of the program. We conducted pre- and posttests on students' reading comprehension level. We organized focus groups with the parents to understand the program's impact from their perspective. The HHIFS hosted two cohorts of preservice educators in a multicultural service-learning experience,

which created a space for teacher educators to explore the cultural tensions and dynamics within the field of service learning (Clemons, Coffey, & Ewell, 2011).

This participant-orientated, qualitative research was designed to work with elementary and middle school students interested in creating art while participating in a summer enrichment program with a strong emphasis on social justice. Instead of focusing on interviews of students about their stance on civil rights, Hip Hop, and living in an urban community in the South, we sought to uncover what their music was saying by analyzing their songs, poetry, and prose. Through this type of document analysis, we were able to provide insight into the ways in which music and a curriculum focused on social justice can impact student engagement.

Freestyle: Four Elements and the Curriculum

Hip Hop studies scholars have recognized the disc jockey (DJ) as a primal force and foundation of the culture of Hip Hop. Throughout its development, many DJs have gone on to become music producers. We view the modern Hip Hop producer as a derivative of the DJ. For this element, we chose to incorporate music technology. Scholars interacted with local artists and Grammy Award–winning producer 9th Wonder to learn the history and concepts of Hip Hop music production.

Taken from the term master of ceremonies, the MC was the voice of the party or event.[4] DJ Kool Herc, one of Hip Hop's founding fathers, notes that individuals would recite "little phrases and words from the neighborhood that we used on the corner . . . Like we talkin' to a friend of ours out there in the crowd" (George, 2004, p. 52). The HHIFS MC component incorporated rapping/poetry and other representations that used the manipulation of language, including the writing and editing of the HHIFS scholar–produced newsletter.

The HHIFS graffiti component included representations of visual art as well as digital forms of artistic expression using computer graphic design software. Graffiti, a highly stylized form of visual art, has played a key role in the production and dissemination of Hip Hop culture. Break dancing is a form of creative movement that has spawned a generation of dancing acrobats who use mental abilities to coordinate bodily movements. Under the direction of one of our servant leader interns and a local dance instructor, scholars created choreographed routines and creative movement in dramatic presentations at the finale performance.

The Hip Hop arts component placed the student in the center of the pedagogical process as learner and dispenser of acquired knowledge. Servant leader interns coached scholars as they took on the responsibilities of organizing their peers (planning and rehearsals) and performances.

We built on Hanley's Hip Hop Arts and Leadership Project concept[5] as a guide to design the afternoon activities. We offered courses in documentary arts, spoken word/music production, visual arts, graffiti fashion design, dance, and zines/editorial writing. The scholars acquired and developed a variety of skills and produced

a soundtrack and documentary based on their experiences. For example, in the HHIFS documentary scholars hosted a talk show that discussed race relations in America. They discussed topics like equal access to jobs, gentrification, and their thoughts on the documentary *Mighty Times: The Children's March*.[6] We showed this film during the first week of the program to illustrate the pivotal role children played in the movement for civil rights.

For Eisner (1998), dispositional outcomes in the arts reflect "a willingness to imagine the possibilities that are not now, but which might become . . . and the ability to accept multiple perspectives and resolutions" (p. 99). HHIFS's summative and formative evaluation of arts outcomes was evidenced throughout the creative process as well as in the various forms of representation presented at the HHIFS finale (art gallery and stage production).[7] For example, in the summer of 2007, HHIFS scholars chose to address the topic of underage drinking. After reading statistics and case studies of the issue, scholars' discussions yielded the desire to write, direct, and produce a video docudrama on the social, mental, and physical implications of underage drinking. The idea and desired outcome for all arts-integrated activities was to support scholars in pursuing social justice activism through the artistic process in and on their own terms. As Shor (1992) notes, "education is more than facts and skills. It is a socializing experience that helps make the people who make society" (p. 15). Critical dissection of the social, political, and economic issues impacting the scholars' generation yielded projects and performances that took on a praxial[8] nature—creating performance ethnography as "a way of acting on the world in order to change it" (Denzin, 2007, p. 135).

What the Music Said: Rap, Politics, and Resistance

In this section, we will describe HHIFS scholars' artistic contributions through the use of spoken word, poetry, and rap lyrics. The students from both summers recorded a CD to document their experiences. The presence and performance of various artistic sensibilities has served a foundational role in Black and African American folklore. Rap lyrics express the ongoing preoccupation with literacy and orality that has characterized African American communities since the inception of legally coerced illiteracy during slavery (Dyson, 2004). In contemporary Black popular culture, rap music has become one of the spaces where Black vernacular speech is used in a manner that invites dominant mainstream culture to listen—hear—and, to some extent, be transformed (hooks, 1994, p. 171). Two male, level III scholars discussed their feelings of sadness and strength as it related to death and loss in their immediate families in their song "It's Okay" (Lemons & Tedder, 2007, track 5). The scholars describe, through artistic action, how Hip Hop can be used as a transformative educational tool. They begin their song with a thick description of how they empathize with others who have had to deal with the loss of loved ones. They make it very clear that they have lost close relatives due to untimely deaths related to drugs, violence,

and illness. They paint a portrait of the violence in their neighborhoods and the everyday struggles they see their loved ones endure as they work to provide food and shelter for their families. They share how they miss the people and how often part of missing loved ones means living with sad memories. Their descriptive narratives became the soundtrack toward a collective liberation. The chorus reminds the listener that "it's okay" to cry when these feelings arise. The scholars encourage the listener to become vulnerable to their circumstances as they strive for peace. This particular song was referenced in a focus group conducted with HHIFS parents. In this communal discussion, a Level II scholar's mother described the impact of "It's Okay." In her testimony, she mentioned how her daughter, in dealing with a recent death, used the rap song as a means of consolation. She indicated that her daughter proclaimed, "Mom, I feel like he's talking to me. It's okay that she's (her grandmother) gone." That moment brought tears of joy and sadness, which was evidenced, in other group responses to the "It's Okay" confession.

A female, Level IV scholar from the 2007 program wrote and performed, "Let the Children Be Heard" (Hart, 2007, track 2), a poem that describes her vision of the trials and tribulations of the youth in America.

> Give me a moment of silence
> Five minutes of peace
> Close your mouth and let me think
> Let me think about the world
> And what's been going on
> How these children manage to stay strong
> You give all the props to the soldiers in Iraq
> What about the youth
> Who have the courage to fight back?
>
> Rachel is bipolar and schizophrenic
> Her mind ain't right
> Cause abusers and rapists been all up in it
> Uncle, cousins, her daddy and her boyfriend.
> Her body is a cage in itself
> Never again will she trust another man
>
> God has been with Emanuel
> In every foster home he's seen
> Stood through every crack pipe
> From the time he got dirty to the time he became clean
> When his parents finally came
> They delivered to him more hell
> Manny decided to find his home . . . in jail

Zinae had the voice of an angel
But you could hear the snake wrapped around her throat
She wouldn't let a piece of food go through her system
If she did . . . she'd choke
While staring through public school mirrors
She saw nothing but trash
She hated she has to prostitute for much needed cash

Tyrie was tied up at the wrong place at the wrong time.
Nine years old and blamed for a crime
Although his family abandoned him
He kept hope alive
Never once did he stop praising Christ

Destiny lay with six dudes to get affiliated
Lived as a sex addict until her body could no longer take it.
AIDS destroyed her temple
And the hundred plus men she slept with
She can't take it back no matter how much she regrets it
She finally grew tired and wanted out
But her gang wouldn't let her take a new route
When she gave her life to Christ
They sent her to heaven
Killed her and her child
She was six weeks pregnant

I took this moment of silence to honor their story
Fighting these battles and ending with giving God the Glory
Exiting the Earth leaving a streak of pain
In loving memory
I will never forget their names
I do remember the heroes of yesterday
But I emphasize the modern
Children go through the greatest struggles
And it seems like they're forgotten.

The young scholars participating in HHIFS reclaim what Burnim and Maultsby (2006) call a sense of musical agency. Musical agency, as Burnim and Maultsby posit, seeks "to broaden our understanding of modes of resistance African Americans have utilized from the antebellum period to the present" (p. 5). The importance of allowing the young scholars to write, present, and reflect on their own terms brings on a characteristic where "regardless of where or when it is performed (the) music speaks to and for each generation—especially the generation that creates

it" (Taylor, 1986, p. 22). This Level IV scholar's poem is also an example of what Denzin (2007) calls a feminist communitarian moral ethic.

This ethic presumes a dialogical view of the self and its performances. It seeks narratives that ennoble human experience, performances that facilitate civic transformation in the public and private spheres. This ethic ratifies the dignities of the self and honors personal struggle. It understands cultural criticism to be a form of empowerment, arguing that empowerment begins in that ethical moment when individuals are lead into the troubling spaces occupied by others. In the moment of coperformance, lives are joined and struggle begins anew (p. 134).

The scholar walks us through short narratives of struggle and resistance to challenge the reader to think about those who do not have the means to advocate for their well-being.

Finally, during the summer of 2008, we challenged the scholars with the question "What is Hip Hop?" Throughout that summer, they discussed the differences between conscious rap music and commercial or mainstream rap music. The scholars argued over the importance of the message in rap music and determined that because they were products of the Hip Hop generation, they were "Hip Hop." The piece that follows is a result of collaboration between two Level III scholars—one male, one female—and their servant leader intern. They wrote this song in response to the question, "What is Hip Hop?" The group performed their piece, "I Am Hip Hop" (Garcia, Russell, & Dunn, 2008, track 8), live at the end of the summer celebration.

Verse 1—Servant Leader Intern

Freedom School what
Everybody what

Can I kick it?
Yes you can
Well a'ight Hip Hop lets take a stand
I can and must make a difference in my
Self
Family and
Community
Country and
World

That's right y'all together we stand and
divided we fall
I am hip hop, I am on "the
yes, yes, y'all and don't stop"

Don't stop we do it,
Hip Hop is ours so we got to make improvements

It's a whole lot going on now,
It's a whole lot of biting styles,
And that ai'nt cool, cuz we don't style bite in
the Freedom School
Naw, we too original
Make a different we can make a change this instant
It's all on us now, we gotta hold this down
We go'in "touch it, read it, learn it, teach it,"
then tell your friends all about it
So they can come next year with you so we
can grow as a crew and stay true

Stay you
Cuz I'm a stay me
H-I-P H-O-P
_____ spit rhymes so dopely

Chorus:
I am Hip Hop I can make a difference (repeat 4xs)

Verse 2—Level III Scholar, Male

I am Hip Hop you should know
Wearing fresh out shoes and baggy clothes
Making a change with a positive rap
putting hip hop all over the map
Cuz all these rappers talk about girls
but this rapper is changing the world
Hip Hop we ain't doing it right all we talk
about is getting drunk all night
Everybody come to Freedom School with me
_____ on the check sound saying rhymes dopely

Verse 3—Level III Scholar, Female

Freedom School is the place to be
Come on y'all come party with me
Hip Hop, I will always be
Making a change in my community
It's recognition time

You will see
Spreading my wings come fly with me
I'm Hip Hop and so are you
I made a difference, you made one too

You made one too
You made one too

Chorus:
I am Hip Hop I can make a difference (repeat four times)

The HHIFS scholars and servant leader interns remind us that Hip Hop, more specifically the live performance of rap music, has from its early contexts been a practice of communal production. Rap encourages close narrative forms and flexible wordplay and promotes individualized listening over community dance (Dimitriadis, 1996).

We were inspired by the scholars' work primarily because we remembered the struggles we experienced at the beginning of the program. At first, scholars would say, "We read too much." Yet, by the end of the 5 weeks, scholars wanted to take every book home with them. Parents lamented about their scholars coming home with historical facts about the architects of Hip Hop and saying things like, "Mom, that's not the Freedom School way" or "Why don't we solve this with some conflict resolution?" Our experiences during both summers expanded Hill's (2009) notion of Hip Hop pedagogy. The work at the HHIFS took on a voice of commitment. For Black art to be committing, "it must move beyond protest and teach possibilities . . . commit us to what we can become and are becoming and inspire us to dare the positive in a world defined by the negative" (Karenga, 2002, p. 397).

We witnessed firsthand how students engaged in the process of writing lyrics, producing beats, and organizing live performances can create meaningful work. The scholars used Hip Hop as their lens to remix the "I Can and Must Make a Difference" theme. Their translation of this concept into rap songs and poetry expanded the overall mission of the CDF. We also learned from the servant leader interns that, for them, Hip Hop pedagogy was a pedagogy of passion where each of them could dive into their artistic repertoire. The servant leader interns considered themselves to be artists first and teachers second. Yet, by the end of both summers, they felt comfortable with the title Hip Hop Arts Educator.

Notes

1. Performing artists found ways to support movement activities. Harry Belafonte's "Banana Boat" song in Parchman Penitentiary became a song about Freedom Rides, "Calypso Freedom."

2. One of the most visible efforts of the Mississippi Freedom Summer of 1964 was the establishment of more than 50 freedom schools involving hundreds of students and volunteer teachers. The CDF Freedom Schools grew out of the Black Scholar Leadership Network (BSLN), a national organization that operated from 1991 to 1996.

3. The term MC, as noted by Christopher "Play" Martin, is also often defined as "microphone checker" or "move the crowd," which implies an ability to get the crowd moving (dancing) during a DJ's set (party).

4. The CDF Freedom Schools refer to their teachers as "servant leader interns."

5. The HHIFS Hip Hop arts component is derived from the Hip Hop Arts and Leadership Project developed by Mary Stone Hanley, PhD. Our adaption included Hanley's approach where discussions about Hip Hop culture would be a regular aspect of group sessions but would emerge as dialogue among themselves (scholars) and professional (servant leader intern) and other Hip Hop artists based on their need to discover how they might proceed in their writing and performances. The goal is not to tell them what to think but to encourage them to think about their artistic and social choices.

6. This film chronicles the children of Birmingham, Alabama, who challenged segregation in 1963.

7. Cornett (2007) suggests that assessment is primarily used as a motivational tool. Multiple assessments are used with focus on students "showing they know" through long-term projects, arts-based performances, and exhibits (p. 12).

8. In this sense, praxis, or the praxial nature as we discuss, denotes a certain kind of practice. As Habermas (1974) further posits, "The end . . . of the practical disciplines or praxis is not theoretical knowledge . . . (it) is to change our forms of activity and bring them into closer approximation to the full ideal of free human activity" (p. 17).

References

Adams, M., Bell, L. A., & Griffin P. (1997). *Teaching for diversity and social justice: A sourcebook.* New York: Routledge.

Bell, L. A. (1997). Theoretical foundations for social justice education. In M. Adams, L. A. Bell, & P. Griffin (Eds.), *Teaching for diversity and social justice: A sourcebook.* New York: Routledge.

Burnim, M. V., & Maultsby, P. K. (2006). *African American music: An introduction.* New York: Routledge.

Clemons, K. M., Coffey, H., & Ewell, S. (2011). "Service is the rent we pay": A tale of how service learning bridged the gap between theory and practice. In N. Webster & T. Stewart (Eds.), *Exploring cultural dynamics and tensions within service-learning.* Charlotte, NC: Information Age Publishing.

Cornett, C. E. (2007). *Creating meaning through literature and the arts: An integration resource for classroom teachers.* Upper Saddle River, NJ: Pearson.

Denzin, N. K. (2007). The politics and ethic of performance pedagogy. In P. McLaren & J. L. Kincheloe (Eds.), *Critical pedagogy: Where are we now?* New York: Peter Lang.

Dimitriadis, G. (1996). Hip hop: From live performance to mediated narrative. *Popular Music, 15*(2), 179–194.

Dyson, M. (2004). The culture of hip-hop. In M. Forman & M. A. Neal (Eds.), *That's the joint! A hip-hop studies reader* (pp. 68–76). New York: Routledge.

Eisner, E. (1998). *The kinds of schools we need.* Portsmouth, NH: Heinemann.

Garcia, V., Russell, S., & Dunn, A. (2008). I am hip hop [Recorded by V. Garcia, S. Russell, & A. Dunn]. On *Durham Freedom School final report* [CD]. Durham: Durham Freedom School North Carolina Central University.

George, N. (2004). Hip-hop's founding fathers speak the truth. In M. Forman & M. A. Neal (Eds.), *That's the joint! A hip-hop studies reader* (pp. 45–56). New York: Routledge.

Giroux, H. A. (1996). *Fugitive cultures: Race, violence, and filth.* New York: Routledge.

Habermas, J. (1974). *Theory and practice* (J. Viertel, Trans). London: Heinemann.

Hanley, M. S., Brown, S., Jay, M., & Clemons, K. (2005, April). *Transformative and culturally responsive pedagogy: Teaching multiculturally through Hip Hop.* Paper presented at the 2005 American Educational Research Association Annual Meeting, Montreal, Canada.

Hart, J. (2007). Let the children be heard [Recorded by J. Hart]. On *Durham Freedom School final report* [CD]. Durham: Durham Freedom School North Carolina Central University.

Hill, M. (2009). *Beats, rhymes, and classroom life: Hip hop pedagogy, and the politics of identity.* New York: Teachers College Press.

hooks, b. (1994). *Teaching to transgress: Education as a practice of freedom.* New York: Routledge.

Karenga, M. (2002). *Introduction to Black studies.* Los Angeles: University of Sankore Press.

Lemons, W.M., & Tedder, R. (2007). It's okay [Recorded by W. M. Lemons & R. Tedder]. On *Durham Freedom School final report* [CD]. Durham: Durham Freedom School North Carolina Central University.

Levine, D. (2008). The birth of the citizenship schools: Entwining the struggles for literacy and freedom. In C. Payne & C. Sills Strickland (Eds.), *Teach freedom: Education for liberation in the African American tradition.* New York: Teachers College Press.

Mezirow, J. (1997). Transformative learning: Theory to practice. *New Directions for Adult and Continuing Education, (74),* 5–12.

Seiler, G. (2008). The P-O-W-E-R of Children's Defense Fund Freedom Schools. In C. Payne & C. Sills Strickland (Eds.), *Teach freedom: Education for liberation in the African American tradition.* New York: Teachers College Press.

Shor, I. (1992). *Empowering education.* Chicago: University of Chicago Press.

Stovall, D. (2005). Critical race theory as educational protest. In W. Watkins (Ed.), *Black protest thought and education.* New York: Peter Lang.

Taylor, W. (1986). Jazz: America's classical music. *The Black Perspective in Music, 14*(1), 21–25.

6

THE ARTS AND JUVENILE JUSTICE EDUCATION

Unlocking the Light through Youth Arts and Teacher Development

Patty Bode, Derek Fenner, and Basil El Halwagy

1. How can teachers of youth in the juvenile justice system gain meaningful professional development to expand arts integration practices?
2. How can the intellectual and creative prowess of court-involved youth be revealed and unleashed?

This chapter stems from a conversation between Derek Fenner and Patty Bode when Fenner was an arts administrator and invited Bode to take on the role of artist-educator in a Massachusetts Department of Youth Services (DYS) facility for youth in Boston. He asked, "How about going into one of our DYS sites, and developing an integrated arts curriculum on the work of Shepard Fairey?"[1]

Bode replied, "Yes and no."

She explains: The "yes" response was an indicator of my eagerness to work in the juvenile justice system in a 1-month residency with young men between the ages of 12 and 19 and their academic teachers. I knew I would learn a great deal from the students and teachers, and I was humbly hopeful that I could bring some meaningful engagement in visual art to the youth in this DYS facility. I also felt optimistic that my work as a teacher educator could bring some value to the academic teachers by way of modeling arts-integrated curriculum.

However, I also said "no" because I knew that the setting in which I would be teaching would be filled with approximately 99% youth of color and that "no" came from a commitment to "desegregate curriculum," as Geneva Gay (2010) describes the work of culturally responsive teaching. My reluctance was specifically about race and its implications for culturally responsive pedagogy and decolonizing curriculum. I was uncomfortable with promoting the image of the artist Shepard Fairey, as a White guy who had grown up comfortably middle class, earned a college degree at a prestigious art school, and been arrested several times for his street-art

escapades, but had spent very little time locked up. While that arguably may be an unfair, oversimplified way to depict Fairey's biography, my suspicion was that it would be the salient encapsulation interpreted by the young men in the classrooms of this residency. For me, a middle-class White woman entering a DYS site populated by youth of color from some of Boston's most vulnerable neighborhoods to offer education in any form would require some critical reflection on my part. With a dedication to social justice education (Nieto & Bode, 2012), and efforts to be critically conscious of my own whiteness, I am vividly aware that my current middle-class privilege brings a great deal to bear when working in economically strapped, urban communities.

Approaching this integrated arts curriculum in a DYS school through the lens of Shepard Fairey's artwork presented me with a serious dilemma. Certainly, there was a great deal to be gained by studying Fairey's work as a street artist—his imagery, techniques for artistic production, and success as an entrepreneurial business person. But I was determined to bring works of art by people who were racially and culturally congruent with the experiences of the students in the DYS juvenile justice facility. Fairey's whiteness was not a detriment in and of itself, but his work in isolation would present an incomplete curriculum.

This incomplete curriculum increased my concern about being one more of many White women teachers in the educational lives of these DYS students, especially in an environment where it is critical that social justice education not only affirm students in who they are, but also help them imagine who they can become. While I had been successful in building caring bonds of solidarity with youth of color in my career, I knew it was also important for young men of color to be taught by young men of color. So, to create a more diverse teaching team, I asked Fenner if I could coteach with one of my former graduate students, Basil El Halwagy, the third coauthor of this chapter, who brought his multiple talents including experience teaching in urban public schools in the neighborhood where many of these youth grew up. Fenner whole-heartedly agreed and committed to support El Halwagy's work as a coteacher on the project. Then, El Halwagy and I proposed alternative content to the curriculum that Fenner had originally suggested. Our curriculum titled *Street Artists and Community Voice* included Fairey's work, as one of *several* street artists and muralists throughout art history.

We proposed a study of public murals and street art from U.S. art history spanning from the 1920s Harlem renaissance through contemporary works in 2009. We would initiate the unit with Aaron Douglas's Harlem renaissance era murals, especially the four panels of *Aspects of Negro Life* and then chronologically follow mural painting and street art in our lesson plans. With this approach, we desegregated the curriculum by both addressing *who was teaching* the content as well as interrogating who was *represented* in the content. Fenner's initial skepticism gave way to full support and a commitment to continue to use a social justice education lens in the development of future programming. The approach supported

students in making authentic cultural connections to artists' biographies and conceptual knowledge. This intersected with their academic achievement and was eventually expressed in vibrant paintings, collages, spoken word, and a student-produced documentary film, *A Freedom of Life Is on Us*.[2]

To paint a complete picture of the artist-educator residency in which the three of us implemented this curriculum, we provide some background information on the DYS settings in Massachusetts and the grant-funded Unlocking the Light (UTL) program administered through the statewide nonprofit called the Collaborative for Educational Services (CES).[3] In what follows, we attempt to bring you inside the walls of juvenile justice education to set the stage on which the artist residency occurred.

On the Inside

On a typical day, approximately 1,500 young people reside within the 56 DYS facilities throughout Massachusetts. All of the youth who pass through DYS residential programs (4,500 per year) have the right to an education. There are, however, significant and inherent challenges to providing an academically meaningful education in DYS settings. The student body in DYS facilities is highly transient; residential detentions last anywhere from a few hours to 24 months, creating a unique challenge for teachers who are required to teach to state-regulated curriculum standards while trying to build rapport with a student body that is constantly shifting.

Students in one classroom may range in age from 11 to 20 years and vary widely in their academic grade level, learning needs, and styles. Approximately 45% of the DYS student population has been identified as having special education needs. With a class roster that is constantly changing, teachers are trying to reach students of various ages and learning levels who are experiencing the trauma of separation from families. Many of the students have experienced chaotic school lives and civic neglect that have led to difficulty and frustrations in academic subjects throughout their education. Yet, these youth hold tremendous promise and deserve to fulfill that potential through rigorous academic challenge and robust artistic expression. As survivors of complex trauma, many of these youth have developed both the resiliency and creativity to deal with enormous challenges.

Clearly, juvenile justice schools need to be of the highest quality, with an extremely skilled faculty who can engage and guide students to develop into productive citizens in this democracy. The need for effective professional development is starkly evident in these settings, yet the system itself poses some unique challenges to high-quality teacher training. Within these multifaceted constraints, yet hopeful perspectives, Derek Fenner, guided by firsthand experience as a teacher in the DYS education system, designed an arts-integration model that he titled *Unlocking the Light: Integrating the Arts in Juvenile Justice Education*.[4]

Understanding the Model of UTL

In 2006, CES and DYS initiated UTL, which offered practical strategies for juvenile justice teachers to engage and teach their court-involved students. Through classroom-based residencies, artist-educators and teachers collaborated in developing, teaching, and refining curriculum units that deliver arts instruction and standards-based academic content to students. In this model, teachers observe new pedagogical methods while the artist-educator is leading the class. Then, gradually, the classroom teachers resume more responsibility for the teaching and implement those arts-integration techniques in their pedagogy. In this way, DYS teachers become "art students" in their own classrooms alongside their students who are simultaneously learning from the artist-educators. During multiple-day residencies, typically distributed over several weeks, artist-educators demonstrate creative new approaches to curriculum, instruction, and assessment.

Evaluations of the UTL model have revealed that integrating the arts into DYS classrooms gives students a chance to find successes that build on each new skill and concept, developing confidence, self-expression, and a willingness to accept and meet higher expectations. As students develop their awareness and confidence, teachers grow as well, gaining new skills, new perspectives on student strengths, and new strategies to encourage students to reach their potential.

Obvious Outrages: Excavating the School-to-Prison Pipeline

UTL provides a model of hope and tangible results for teacher accomplishment and student achievement in a system that has not traditionally served our youth well. But what has been left unsaid here is the obvious outrage we feel about the civic neglect, educational breaches, and shredded social fabric that channel so many of our youth into lockup. For too many youth, once their lives become entangled in the court system, a lifetime of legal branding follows, resulting in high levels of recidivism as minors, which in turn leads to imprisoned adulthood. While this chapter is too brief to provide a full review of the research on the school-to-prison pipeline, we mention some of the most salient and alarming aspects of these studies on what Marian Wright Edelman expanded to call the "cradle-to-prison pipeline" (2007). This scholarship underscores the dire need for action.

The Children's Defense Fund has graphically announced the statistics that young Black men in the United States are incarcerated in juvenile justice systems at four times the rate of White youth (Children's Defense Fund, 2008). Several studies have pointed out that school disciplinary policies such as Zero Tolerance have contributed to the astonishing rate at which young people are funneled from classrooms into incarceration (Noguera, 2003; Wald & Thurau, 2010). The Harvard Advancement Project and Civil Rights Project[5] in consultation with attorneys, psychiatrists, academicians, educators, and children's advocates, published a multidisciplined review that reported that Zero Tolerance is unfair and contrary

to the developmental needs of children and often results in the criminalization of children (Advancement Project, 2010).

In addition to studies that examine the discipline policies of K–12 schools (Brown, 2007), Sabina Vaught (2011) articulates the constellation of forces in schools and courts that place blame on the youth, their families, and their communities. John Raible and Jason Irizarry (2010) reach beyond critiquing the K–12 school structure by urging higher education to take deliberate steps through teacher education. They emphasize that preservice teachers need to be educated about the crisis and to examine the role of teacher surveillance of youth through classroom management strategies as one of the factors that pushes students out of school and into the penal system (Raible & Irizarry, 2010). Furthermore, in a review of a collection of scholarship, Johanna Wald and Daniel J. Losen (2003) cited three specific themes that emerge in the research about the connections between school life and prison life for youth: (a) "*Failure to provide appropriate behavioral interventions* [in schools] *may be contributing to delinquency among students with disabilities*"; (b) "*following removal from school, many students experience enormous difficulty in reentering*"; and (c) "*effective interventions and programs that reduce risk and enhance protective factors for youths at risk for delinquency exist*" (pp. 12–14). The conclusions of Wald and Losen (2003) point to the urgency and the political will required to expand and replicate models of preventive measures for youth.

The daily lives of the youth in our artist-educator residency are vividly illustrated in the bleak reports of this research. Clearly, we need to care for our youth while they are in school to prevent their entanglement in the courts, and we need to keep them in a college/university pipeline as opposed to a prison pipeline. This literature underscores the need for meaningful, transformative staff development for teachers. This chapter aims to present a picture of possibility and hope for students and teachers, who are working inside the system to stay engaged in educational opportunity. UTL matches what Wald and Losen (2003) describe as a model that enhances protective factors for youth at risk, by focusing on teacher practices inside DYS schools. This chapter provides a glimpse of one model that met with success.

Street Artists and Community Voice: Our Artist-Educator Residency

We enter one specific DYS school in this case study to highlight some moments of our artist residency in which the three of us, Bode, Fenner, and El Halwagy, participated as collaborative artist-educators. Bode and El Halwagy worked with the teachers in social studies, math, and science classrooms studying examples of art by Aaron Douglas, Diego Rivera, Faith Ringgold, Brett Cook, and Kara Walker.

Meanwhile, in the English language arts classroom, Fenner collaborated with the students and the English teacher to create a video documentary of the artist residency experience. So, while students were in English class, they filmed and

edited video of the teaching and learning that was happening in the other three classrooms with El Halwagy and Bode. The students became film producers who could interrogate and critique visual culture while viewing their world through the lens of a video camera and editing screen. One of the students, Jamal, spoke to the metacognitive influence of arts-integrated content on his learning: "It's like we're learning two different things—but on the same topic, at the same time, you know, it's like the teachers that we have here and the artists that came in, it's like tag-teaming, getting together and teaching us better and better things."

Building Solidarity and Challenging Deficit Views

On the first day, El Halwagy worked in math classes, and Bode worked in social studies. We set goals with the students and posted them on the whiteboard: "To understand the sociopolitical context of artists from historical eras and current art worlds" and "To activate critical consciousness and engagement in contemporary visual culture." While some teachers consistently held high expectations of their students, there were other teachers who advised us to water down the vocabulary; they warned us that "these kids" would not understand what we were talking about. We bristled at the deficit views toward students, but we knew it was essential for us to establish trusting relationships with both teachers and students; we did not want to disrespect teacher expertise. The ultimate goal of this residency was to transform teaching practices. Whenever we met teacher comments based in deficit-minded assumptions, we offered the notion that an arts-based approach might be something that has not yet been tried and then we demonstrated inquiry-based methods that uncovered student knowledge in the traditions of liberatory education (Freire, 1970) and drew the teachers into participating in such pedagogy.

For example, in social studies class, we studied the 1934 mural painted by Aaron Douglas in the New York Public Library mural series, titled *Aspects of Negro Life: From Slavery through Reconstruction* (Figure 6.1). With the painting projected on the screen, we asked the students, "What do you notice? What do you wonder?" We emphasized that there were no right or wrong answers, and after a few minutes, the students quickly adapted to the notion of student-generated discourse. They called out their comments and collaboratively constructed a sophisticated analysis of the imagery. When one student had a question, other students answered. When one student displayed insight, other students discussed the notion. The chorus of voices sounded something like this: "That dude in the center. He's got something. He's pointing to those buildings. Those buildings are some kind of important architecture. I see shadows of people. What are they doing? I think some are playing music, and some are dancing. But not everybody's playing music—some look scared."

Bode added, "OK, what makes you say that? That some are scared? You said you see people, shadows, figures—what's that called when we only see the shadow, or the outline?"

Figure 6.1 *Aspects of Negro Life: from Slavery through Reconstruction, 1934* by Aaron Douglas, (1898–1979). Oil on canvas. 5′ × 11′ 7″. (152.4 × 353.1 cm). Art & Artifacts Division, Schomburg Center for Research in Black Culture, The New York Public Library, Astor, Lenox and Tilden Foundations.

"Silhouette!"

Bode starts printing a vocabulary list on the board, she prints *silhouette*. "Yes, silhouette, so we see silhouettes, some are playing music and some are scared. What makes you say that? And why would an artist use silhouettes?"

"Look at the instrument, that's a horn. Like a trumpet."

"And what makes you say some are scared?"

"The way they are bending and looking away. Cowering. Yeah, cowering."

"But they're not all cowering. Look, some are marching in an army, way in the back. The background, not in front, what's that called?"

"Foreground, dog, that's called foreground. You got background, and you got foreground. Put those on the list, yo."

Bode adds *background* and *foreground* to the vocabulary list.

"Oh there something in the upper corner—horses. Somebody's riding them with pointed things. Hats. Woah! It's the Klan. The KKK. Is that the Klan? Oh, if that's the Klan, then that white stuff is cotton, they're picking cotton, that's what they're doing!"

Bode says, "What makes you say that? What makes it cotton?"

"Well it's that white stuff on the plants, the way they're positioned. Their gesture."

Bode adds *gesture* to vocabulary list.

"Now I'm wondering if that dude in the middle is a preacher? Is he helping to emancipate the slaves, like we were talking about the other day?"

Bode writes *emancipate* on the board, and *enslaved people*. (One student has his head on the desk, and she whispers in his ear, "You're too smart to have your head down in school." He joins the conversation.)

"And you see the other dude he's got something, too. Both of them have something important in their hands. The circles are pointing to it. The circles are like a bull's-eye."

"What's that called? Those kinds of repeated circles, one inside the other?"

"It's called a bull's-eye."

"Yes, it is and there's another word . . ."

"Symmetry?"

"Centered?"

"Concentric!"

Bode says, "Yes, those are all descriptive words, *concentric* is the word I was thinking of," and she writes *concentric* on the board. "Let's look at this word and look at what the artist is doing with these circles . . ."

"I got it! It's from the word *concentrate* like he's concentrating our attention on those dudes and their hands. The circles are concentrating on certain parts of the painting." The dialogue in social studies class continued the entire class period. Eventually, the class made a list on the whiteboard and in their sketchbooks of images in the paintings that told the viewer about the sociopolitical context, such as: the Ku Klux Klan, Civil War soldiers, the workers picking cotton, the musicians, the preacher, the shape of the trees (to place the setting in the South). They also made a list of artistic visual strategies that Douglas used, such as silhouettes, gesture, concentric circles, and monochromatic colors. Meanwhile, in math class, the students worked with El Halwagy and the math teacher in a geometric study of concentric circles as well as angles. One of the students, Derren, pointed out, "The art connects really good with math and geometry. They're connecting math education with art. It's real, real good."

The discussions and study of visual art continued in math and social studies classes, while in science class, Bode and El Halwagy launched an exploration of physics and color. By the end of the first week, every student had several pages of their sketchbooks filled. They covered pages with concentric circles and geometric knowledge. They investigated Aaron Douglas's monochromatic palette in color theory minipaintings, while completing several experiments in color and collage. Every sketchbook also contained a student-developed historical timeline replete with thumbnail images from art historical pieces to illustrate specific eras from the 1860s through 2009.

In the following weeks, students also studied the work of Diego Rivera, Faith Ringgold, Brett Cook, Mark Bradford, and Kara Walker. After many days of researching imagery through painting and collage, they ended the study by comparing the work of Shepard Fairey to the work of Bernard Williams.[6] They analyzed the use of silhouettes in solid black and the complexity of symbolism. They spontaneously spoke in terms of the artists' "sociopolitical context" or the artists' "intended discourse" when pointing out the references to U.S. history and the layering of meaning. They were intrigued by the use of text and image and held scholarly debates about their interpretation. While their intellectual engagement

continued, their art production expanded. The classroom teachers were coteaching content with Bode and El Halwagy while making their own artwork as well. Ultimately, each student developed a symbol to represent a social issue about which he hoped to make a visual statement. Their final mixed-media pieces were layered with wallpaper, newspaper, magazine scraps, photocopies, drawn imagery, stenciled text, and paint.

Field Trips and Counternarratives

A field trip is a rare event in DYS settings, but Fenner was able to negotiate a visit to the Institute of Contemporary Art, Boston (ICA),[7] to engage in the retrospective exhibit of Shepard Fairey's work. Determined to enact a counternarrative to the state institution's reluctance regarding DYS field trips and their cautions about students' lack of engagement, we brought a van-full of students to the ICA. It was almost 3 weeks into our residency by the time we embarked on the field trip, and the students were now fluent in the historical influences on a range of artists' work from 1920 through 2009. They had experimented with mixed-media collage techniques similar to Fairey's studio practices and had studied his body of work while deconstructing the text of his manifesto. In the ICA galleries, while they were busily writing notes on clipboards and circling into discussion groups, they invoked the demeanor of a graduate school seminar. A museum visitor approached some of the students and said, "Excuse me—since you work here—I have a question about this artwork. . ." At that moment, Anthony, a youth in our group, stepped forward and said, "Well we don't work here, but we can help you. We have studied this work extensively and we can answer anything you need." It was a moment of turning dominant group status on its head. Anthony continued to guide that museum visitor through several galleries, explaining Fairey's techniques, intent, and subject matter.

Displaying Youth Knowledge

After the field trip, students completed the final canvases and continued their academic engagement. On the final day of the residency, we worked together to transform the social studies classroom into an art gallery and hung every piece of work in a culminating installation. Each student had developed an artist statement, which they described to our small audience and to the video camera. The images described below can be seen online along with the students' descriptions by linking to the video documentary described subsequently.

Anthony's painting depicted wildlife in a landscape setting. One edge of the canvas, he had collaged photographs of three leopards in a violent struggle. He surrounded them with red paint. On the remainder of the canvas, he painted a naturalistic, idyllic landscape with a huge brown bear looking off in the opposite direction of the leopards.

Anthony spoke eloquently about this choice of imagery, "On one side here, these animals represent the violent struggle of the past. On this side, the bear is facing this way because that's all behind, and the bear's just kind of . . .walking the other way . . . the bear can be free and it symbolizes being able to do what you want to do. Being able to focus on what you're doing without a whole bunch of other things around to distract you. But you can never forget the past. The bear is strong, determined, healthy and looking away from that past. Leaving it behind for a brighter future. I am the bear."

When all the students had completed their oral presentations, in a spontaneous request, the students urged the school director to keep the "art gallery" installation in place for family visits that evening—and she agreed. The students were elated at the prospect of sharing their academic knowledge and their artistic production with their loved ones. As Steven said, "This shows that my art would be part of my life, basically about struggle, because a lot of people could relate to that."

Teacher Transformation

We were all transformed by the experience. Bode and El Halwagy learned about the constant adaptations and flexible teaching strategies required of DYS teachers. Fenner saw culturally responsive pedagogy in a new light. The students achieved academic knowledge and artistic production that far exceeded their own expectations and reached beyond classroom teachers' imaginations. Some of the DYS teachers who had demonstrated initial resistance to the value of art in their classroom asked us to leave art supplies, inviting us to return to coteach with them again. The teachers who were already engaged in meaningful curriculum felt supported and rejuvenated in their work. All teachers were shedding deficit thinking about their students and planning the next "big unit" that would uncover more student knowledge and provide them with innovative means to engage all learners.

Documentary: Go through the Process with Us

The youth created a documentary film throughout the process of this residency that they titled *A Freedom of Life Is on Us*. It is a powerful assertion of youth voice that depicts the intellectual prowess and multiple intelligences that are uncovered when arts-integrated content is infused in these restrictive settings. The full-length documentary can be viewed online (http://vimeo.com/29963896). It is the students' intent to show the documentary to as many viewers as they can reach. As Anthony asserted, "We made this documentary to allow people outside the setting to go through the process with us."

Transitioning Out

UTL has been a critical part of a broader strategy to effectively transform student experiences by radically changing professional development within

the DYS system. The program reenergizes participating teachers, encourages them to collaborate with artists and other academic teachers, and challenges them to raise their expectations of their students' potential. UTL provides possibilities for a national model for both inside and outside of the criminal justice setting.

It goes without saying that *all* teachers and *all* students in *all* schools should have access to such meaningful arts-integrated curriculum and professional development, but for our most vulnerable youth for whom the line between participation in democracy and a future in the prison industrial complex is very fragile and thin, we owe them and our society nothing less than radical change in teaching strategies. One of the students, Derren, aptly articulated the experience:

> When I found out about this whole month-long project, I was excited. My creative side, I feel like it comes out more when I'm making movies, documentaries. Unlocking the Light has pushed us to dream— dream big. Although we are incarcerated we do feel we need to be somebody in life, however we struggle with things like anger, depression and hunger and it leads us to an environment such as this. We all have a purpose in life, some find it before others, and some don't find it all. Don't be an example of wasted talent. Just hold your head and dream high.

Notes

1. For more information of the work of street artist Shepard Fairey, see his official Web site (http://obeygiant.com/), which blends commerce with political message, and his gallery Web site (http://www.subliminalprojects.com/main/). The magazine he co-founded in 2004 is *Swindle* (http://swindlemagazine.com/index.php).
2. This 22-minute film can be seen in its entirety online (http://vimeo.com/29963896).
3. The Collaborative for Educational Services is a nonprofit organization dedicated to fostering educational excellence, opportunity, and growth for all learners (for more information, go to http://www.collaborative.org).
4. Unlocking the Light was developed with support from a grant from the U.S. Department of Education. For more information about UTL, see the official Web site (http://www.unlockingthelight.org/).
5. See full report online (http://www.civilrightsproject.ucla.edu/research/discipline/opport_suspended.php). Note that since that time the Civil Rights Project has moved from Harvard to UCLA and can be found online (http://www.civilrightsproject.ucla.edu/index.html).
6. Learn more about Bernard Williams's work online (http://www.re-title.com/artists/Bernard-Williams.asp).
7. For more information regarding the Institute of Contemporary Art, Boston, visit the Web site (http://www.icaboston.org/) with a specific link to the archives (http://www.icaboston.org/exhibitions/exhibit/fairey/). Also see the catalog from the ICA exhibit of Shepard Fairey's work.

References

Advancement Project. (2010). *Test, punish, and push out: How "zero tolerance" and high-stakes testing funnel youth into the school-to-prison pipeline.* Washington, DC: Author.

Brown, T. M. (2007). Lost and turned out: Academic, social and emotional experiences of students excluded from school. *Urban Education, 42*(5), 432–455.

Children's Defense Fund. (2008). *America's cradle to prison pipeline* (Report, 2nd ed.). Washington, DC: Author.

Edelman, M.W. (2007). The cradle to prison pipeline: An American health crisis. *Preventing Chronic Disease, 4*(3), A43.

Freire, P. (1970). *Pedagogy of the oppressed.* New York: Seabury.

Gay, G. (2010). *Culturally responsive teaching: Theory, research and practice* (2nd ed.). New York: Teachers College Press.

Nieto, S., & Bode, P. (2012). *Affirming diversity: The sociopolitical context of multicultural education* (6th ed.). Boston: Pearson.

Noguera, P.A. (2003). Schools, prisons, and social implications of punishment: Rethinking disciplinary practices. *Theory into Practice, 42*(4), 341–350.

Raible, J., & Irizarry, J.G. (2010). Redirecting the teacher's gaze: Teacher education, youth surveillance and the school-to-prison pipeline. *Teaching and Teacher, 26*(5), 1196–1203. doi:10.1016/j.tate.2010.02.006

Vaught, S. (2011). Juvenile prison schooling, and re-entry: Disciplining young men of Color. In F. Sherman & F. Jacobs (Eds.), *Juvenile justice: Advancing research, policy and practice* (pp. 310–330). Hoboken, NJ: John Wiley & Sons.

Wald, J., & Losen, D. (2003). Defining and redirecting the school-to-prison pipeline. In J. Wald & D. Losen (Eds.), Deconstructing the school-to-prison pipeline [Special issue]. *New Directions for Youth Development. Theory, Practice, Research, 2003*(99), 9–15.

Wald, J., & Thurau, L. (2010). Taking school safety too far? The ill-defined role police play in schools. *Education Week, 29* (22), 24–26.

7

PUSHING AGAINST THE WATER

Artists and Sense of Place Museum Residency Program in New Orleans

Ann Rowson Love and Deborah Randolph

1. Who are the social change agents in museum-school residencies?
2. How can a museum residency program contribute to the social relevance of the art museum?

Jeffrey Cook was a welcome presence from the minute he walked through the door at Mahalia Jackson Elementary School, his alma mater. As a found-object artist, he immediately was drawn to a stack of windows removed from one of the school buildings slated for demolition. The windows became inspiration for the Artists and Sense of Place museum residency in which students transformed black-and-white photocopies of a broken window photograph taken in their neighborhood into colorful works of art. The students' and Cook's neighborhood was plagued by blight before the 2005 levee breaks flooded 80% of New Orleans. The message Cook brought to the students concerned community change from blight to beauty.

The Ogden Museum's artist residency program Artists and Sense of Place did not set out to explore social justice issues in New Orleans. The program concentrated on placing artists in their own neighborhood schools to explore place and art making, and to provide opportunities to garner community ownership of a new art museum. What emerged from a decade-long series of residencies led these authors to reexamine the program using the lens of social justice, arts, and place-based education. Although the collaboration focused on the learning and art making of elementary students, we also became very interested in artists and school principals as change agents, two roles that have been virtually unexplored in the literature related to art museum residencies.

New Orleans is famous for the distinctive cultural identities of its neighborhoods. Often insular, these identities are challenging to uncover unless long-term relationships develop. Building relationships with the distinct communities of New

Orleans was one of the central goals of the museum's education department. This study, along with the two case studies included here, is a starting point for telling social justice, place-based, and arts-integrated stories about the culture of New Orleans neighborhoods. We do not look at New Orleans as a victim of Katrina or the BP oil spill. Rather, we want to explore celebration, voice, and museum ownership through the lens of leadership. The metaphor we developed through our analysis of residency documentation and interviews alludes to the sensitive place New Orleans holds in relation to water and nature. "Pushing against the water" became an organizing frame for discussing the themes we found.

Prior to the opening of the Ogden Museum of Southern Art–University of New Orleans, Artists and Sense of Place residencies were designed to serve as a way to introduce the museum to the neighborhoods. We knew the importance of neighborhood identity and wanted to build community audiences for our new museum, but we also wanted the community to take ownership of the museum. In order to do this, we asked the question, "What would happen if we placed artists who are represented in our museum collection in their own neighborhood elementary schools?" What emerged was a model of museum and community engagement that relied on museum-based and school-based leadership working in partnership with contemporary artists. Although we did not realize it at the time, the residencies would become a catalyst for change in each individual neighborhood as students and artists explored issues of place that were as distinctive as the neighborhoods themselves.

The program was carefully documented during implementation through photography, curriculum materials, journals, surveys, and exit interviews. However, the larger program's impact on school leadership and artists over time had not been studied. This chapter will present the Artists and Sense of Place museum residency model. Ten years of collected data and interviews with participating school principals and artists contribute to this qualitative research project including two case studies. We propose through our analysis that art museums interested in community activism and social change should reconsider the museum-school residency as one that includes social relevance through sense of place. The following questions framed our inquiry:

- How does the Artists and Sense of Place museum residency program contribute to the social relevance of the art museum?
- How does Artists and Sense of Place impact the participating artists and principals?

Artists and Sense of Place Museum Residency Program

Over the past two decades, there has been a shift in museums from being about something to being for someone (Weil, 2002). Since 1992, the American Association of Museums called for increased community participation in all levels of

museum planning and programming (Hirzy, 1992). Artists and Sense of Place facilitated the community participation of museum staff, community artists, school principals, teachers, and students. The museum educator acted as liaison between artist and school during the 4-week residency. With the artist, the museum educator conducted preresidency planning with the school principal and team teachers, cowrote curriculum, and conducted staff development at the school site. The museum educator documented the process through journaling and digital photographs. Each residency included collaborative artworks or installations created by the artists and students for the school and museum exhibition. After the exhibition, an artwork was installed at the school site, and one entered the museum's collection. Museum educators, artists, and principals collaborated on each phase of the planning and implementation of the museum residency program.

Place-Based Education

Although we had not conducted a thorough literature review when the program was first articulated, the program is aligned with current understandings about place-based education, including place-conscious education (Gruenewald, 2003) and critical place-based art education (Graham, 2009). According to Gruenewald, place-conscious education addresses five dimensions—the perceptual, the sociological, the ideological, the political, and the ecological dimensions of place. Humans interact with, manipulate, and develop cultural identity through place. In a time when school curricula include textbooks that lack connection to local communities and high-stakes testing leads the accountability movement, Gruenewald stressed the importance of schools providing opportunities for students to make sense of their own places.

Artists and Sense of Place explored the five dimensions articulated by Gruenewald (2003) from research and art making about historical figures in the French Quarter to the built environment and architecture of the Lower Garden District to the ecology of Bayou Barataria. The residencies often provided the first opportunity students had to engage in the study of their own neighborhoods. We found that fact surprising in a city filled with distinct neighborhood communities. The act of exploring their neighborhoods through research and art making allowed students to critically reflect on their place in the neighborhood and society. While discovering the history and geography of their neighborhood, students began to look closer at the details revealing vibrancy as well as decline. Social justice issues such as blight, environmental devastation, and marginalization, distinct to each neighborhood, emerged from the students' understanding of place. This research examines the social justice issues presented during the residencies.

Methodology

We employed three methods to explore how the museum residencies contributed to the social relevance of the museum and in what ways the residencies made

a social impact on school culture, neighborhood, community, and participating artists. We investigated these questions through the analysis of Artists and Sense of Place artifacts, semistructured interviews with artists and principals, and collaborative analysis and writing between the researchers.

The first method employed to investigate these questions was the analysis of Artists and Sense of Place artifacts including scrapbooks, photographs, reports, and artworks. These artifacts were reviewed to determine the residencies' social impact on the schools, artists, and communities. We also considered how artworks represented the underlying social justice messages of the residencies through visual art. The artists' artworks from before and after the residencies were examined to determine the residencies' contribution to the evolution of the artists' work and their approach to these issues. The students' and the collaborative artworks were examined to determine how these pieces reflected an understanding of neighborhood and community.

We interviewed artists and principals, who had participated in Artists and Sense of Place, as a second research methodology. We began by locating and inviting artists and principals from the project to participate. Unfortunately, we were unable to locate all principals and artists because of relocations due to school closings and general diaspora after Hurricane Katrina. The disruption of lives, the difficulty for thousands in returning to New Orleans after the storm, took its toll on the school systems and museums in the city. However, it is the resiliency of the residents and the passion to return that is echoed in the interviews we were able to secure. We continue to identify and interview artists, principals, and other individuals who were involved in Artists and Sense of Place.

Because of the trusting relationship built over time between the researchers and study participants, the interviews became conversations about the residencies. Both researchers were present for the interviews. We were interested in why the artists and principals initially decided to participate in the project and how they remembered the process. Participants were encouraged to explore their own questions about the residencies.

Our method for analysis was constant comparison among Artists and Sense of Place artifacts, interview recordings, and dialogue between researchers. We examined the artifacts and recordings collaboratively, noting emerging themes, discussing their context and relevance, and negotiating the unifying framework for the study.

Metaphorical Framework

While interviewing individuals for this study, the researchers returned to the museum for the weekly music event *Ogden After Hours*. Jazz pianist David Torkanowsky, who performed that night, was asked what he liked about performing in New Orleans. He replied, "I like how New Orleans is pushing against the water." We decided that the metaphor of "pushing against the water" had layers of meaning that would help to tell the Artists and Sense of Place story.

Three clear public messages emerged during the residencies. The messages suggested the Janus nature of place—looking in one direction, the neighborhoods reveal beauty and grace, while the other direction points to destruction and injustice. Artists and Sense of Place provided awareness of the physical beauty and blight of the neighborhoods. It highlighted the racial diversity of the city, including the often-repressed history of bondage and freedom. It examined the primeval landscape representing rich natural resources and recognizing as the wetlands vanish that the city is literally pushing against the water.

Evolving Role of the Artist as Community Educator and Activist

Art museum residencies gained popularity over the past two decades as a means to provide social relevance and community engagement through interaction with contemporary artists working in schools, libraries, and other community centers (Henry, 2004; Pujol, 2001). Pujol, a nationally recognized contemporary artist, raised a number of challenges artists face when partnering with museums and local communities. Pujol stated, "Artists of color are often recruited with the messianic hope that they will quickly bridge the gap between formerly elitist institutions and the community of color nearby" (p. 5). Further, he addressed departmental conflicts within the museum. Often, residency programs are initiated by museum education departments rather than curatorial departments. Artists value the mission of education departments seeking meaningful community engagement, but they also desire recognition by and support from curatorial departments. Additionally, Pujol raised questions about the ownership and overall quality of the resulting artworks.

From the perspective of a museum educator, Henry (2004) acknowledged the challenge related to ownership when museums and communities collaborate with artists. Referring to the quality of the resulting artworks, Henry advised that artists should achieve successful final products while also valuing the educational opportunity for local communities to engage in art making with a contemporary artist. Despite the challenges, Henry stated, "Of all the collaborative forms between artists and art museums, artist residencies undertaken with specific audience/educational goals stand alone in their ability to transform museums and connect with audiences" (p. 44).

Addressing the Challenges in a Museum Residency

The Artists and Sense of Place museum residency program incorporated a number of components that alleviate concerns raised by Pujol (2001) and Henry (2004). The Ogden Museum education department worked collaboratively with the curatorial department to identify artists in the collection and their corresponding neighborhoods. Additionally, the museum and the school share ownership of the resulting works of art. After the museum exhibition, one work of art, or part of an installation, enters the museum collection, while one is installed at the school.

Pushing against the Water as a Metaphorical Framework for Participating Artists

After reviewing documents from the residencies, analyzing artworks produced by artists before and after their participation, and interviewing three of the four artists discussed in this chapter—Gina Phillips, Alexander Stolin, and Jose Torres-Tama—a number of common elements emerged.[1] Using the guiding metaphorical frame, pushing against the water, we present artist reflections regarding the program's impact related to the artistic process, the collaboration with the museum, the quality of works of art from residencies, the impact on the artists' own work and learning, and the role of the artist as activist.

When artists push against the water, there is a striking resemblance to another common metaphor, "pushing the envelope." For the museum residency program, artists agreed they were challenged to use new and different materials and techniques, moving beyond their comfortable, artistic process routines. They saw the program as an opportunity to expand on their processes, to experiment. Although all three of the artists interviewed discussed how they built on their use of materials, they adapted their techniques for elementary school–age children. Gina Phillips used her own process and methods, using fabric and mixed media, but "fleshed out her ideas" for ease of use in the classroom. Jose Torres-Tama returned to a visual art medium that he had not used for 17 years, pastel. By collaborating with sixth-grade students on historical portraits, he dealt with the challenges of pastel, a temperamental medium. The dynamic color and movement the medium lent the portraits outweighed the challenge. Likewise, Alexander Stolin, who is known for his draftsman-like realism, broke from his artistic process to add abstraction and mixed media to his collaborative works with students.

Artists push against the water and seem to float on top when they describe their partnership with the museum. All three artists mentioned the seamless logistics of their residency implementation at the schools—they didn't notice the undercurrent of activity, scheduling, and logistics. Additionally, the artists appreciated the support from the museum's education department—having the outreach coordinator assisting in every classroom.

Regarding the quality of the resulting artworks, all three artists pushed against the water—pushing finished pieces they would be proud to exhibit, to enter the museum's permanent collection, and to install at the school. The artists conducted extensive research and experimented with materials during the planning process to ensure the feasibility of their project with children. As a result, they pushed against the water in their own learning and subsequent art making. For one of her residencies, Gina Phillips learned about the architectural styles of the Lower Garden District, while for another she read geographic material about the Mississippi River. Jose Torres-Tama began historical research for the project related to free people of color in the French Quarter, including Rose Nicaud, the first coffee vendor in New Orleans; Edmund Dede, a composer; and Marie Laveau, a famous

entrepreneur, landowner, and voodoo priestess. This research continued for several years and lead to a series of artwork, a museum exhibition, and a book. Torres-Tama stated that he never would have created the portraits, nor would he have reintroduced color into his artwork had it not been for the museum residency program. Stolin, who still paints in a realistic manner, incorporates handmade paper and mixed media that he developed during his residency into his work.

Regarding social issues, there seems no better metaphor than pushing against the water in a community that saw the ravages of water produced by the flooding after Hurricane Katrina. Torres-Tama was the only artist with an articulated position regarding his work in social justice prior to the residency program. He conducted performance-based residencies throughout the country working with urban youth. Although his performance residencies relate to cultural identity and marginalization, the residency program was his first prolonged program, his first experience working with elementary students, and his first experience based on visual art. He reflected on the lack of teaching about local community due to homogenized social studies curriculum texts. "I think we make history really boring, we need to make it come alive," the artist reflected. To Torres-Tama, the residency provided the empowerment to learn, to help students "realize their own history" through nurturing and guiding rather than regurgitation of textbook facts. Gina Phillips stated that she hadn't been a community activist during her residencies prior to Hurricane Katrina; however, that changed after the hurricane. She became inspired to take part in the community and is currently working with another Artists and Sense of Place artist to open an arts center at Louis Armstrong School, which did not reopen after the storm. The artists anticipate that the school-turned-arts-center will offer classes and provide exhibit space and studios for artists. The art center is in their Lower Ninth Ward neighborhood.

Evolving Role of School Principal from Transformational to Community Leader

Community artist residencies must have a champion from within the school. This person is often the principal, a transformational leader, defined by Sagor (1992) as one who collaboratively defines and focuses the school community. In the same way as an artist chooses materials, techniques, and processes, the principal determines what programs will enhance their vision for the school and create powerful and empowering places for students. The principal makes the decisions to push the school against the water by going beyond the mandated curriculum to the place where learning resonates for children.

Principals often bring arts into the school as a catalyst for transformation. Artists and Sense of Place was a rallying point for the principals. We suggest that the residencies helped the principal evolve from a transformational leader creating a vibrant culture within the school to a community leader, placing the school at the forefront of social issues impacting students. The social justice messages that the

residencies illuminated through visual art took students, teachers, and especially the principal into the larger community.

Goldring and Greenfield suggested that the current role of school leaders places these individuals in a "larger context of social action and community." They continued,

> School leaders are located more prominently in the center of discourse, educating the broader public about the importance of, and the need to support, the critical connections between schooling and the "good society." Social justice may be the overarching reference point for leadership in this case. (2002, p. 16)

The residencies situated school principals in the middle of social justice discourses, which they had not expected. While students and artists explored their sense of place as defined by the neighborhood, school leaders contemplated the school's place in the community through the residency.

Pushing against the Water as a Metaphorical Framework for Participating Principals

Because New Orleans is metaphorically and literally pushing against the water, there is a greater sense of urgency to "make it right" to use a phrase from the recovery. Principals understand the urgency and want to help students understand their place in the community.[2] As Jackie Danillidis, Estelle Elementary's principal whose residency took place shortly after the flood, stated, "It was bringing a sense of community back to a community that had been fractured . . . Many of our families were scattered, splintered."

The principals who participated in Artists and Sense of Place were all women, and most had been working as principals for more than 10 years. They were also native to Greater New Orleans, and the residencies provided a renewed interest in community for them. Principal Perretta Mitchell stated that working with the architecture of the neighborhood in the Gina Phillips residency, Neighborhood Fabrication, in which students created representations of Lower Garden District architecture with cardboard and fabric strips, reminded her of childhood places.

> Those children lived there, in that neighborhood, and passed those buildings everyday and probably never looked up to see how they were designed . . . I think it gave the children a better sense of the community. And even myself because I lived in that area as a child through age fourteen. My father was a policeman, one of the first Black ones. He walked that beat on Dryades street.

Another residency took place in the neighborhood where Mitchell spent her childhood. Jeffrey Cook's residencies not only helped students become aware of

their neighborhood, but also gave them a desire to improve it by changing blight to beauty. These students were pushing against the water every day as they navigated a neighborhood flooded by neglect. Student surveys among the artifacts analyzed indicate that 6 months after the residency the students still remembered Cook's message of change.

As principals Mary Jane Clark and Jean Krieger noted, we may never know the impact of the residencies on the students. When explaining the meaning of "pushing against the water" to New Orleans, Torkanowsky noted that horns sound better because of the resonance created by being surrounded by water. The resonance of the residencies for students may come in the form of resilience to the devastation from poverty and floods, awareness of fragile natural resources, or a greater understanding of freedom. The principals chose to bring Artists and Sense of Place into their schools and, by doing so, brought the school and its students into the larger community.

Case Studies

Despite changes after Hurricane Katrina, the program continues. There's a stronger urgency among school principals to take ownership of cultural history and identity—to have a stronger connection to community. Likewise, artists engage in art-making experiences that explore community identity, embracing both collective memory and social change. Here are two memories assembled by artifacts and interviews presented as case studies. Both point to the social justice implications for place-based art-making experiences in pre-and post-Katrina New Orleans.

Free People of Color: Jose Torres-Tama at McDonough No. 15, Mary Jane Clark, Principal, French Quarter

During week 2 of the 2002 residency, students reflected on their experiences during the recent Mardi Gras. Torres-Tama asked them to write about what the tradition means to them in terms of place, family, and storytelling. Torres-Tama read the student journals and made selections to have the students perform through dramatic reading, singing, or movement. As a warm-up, Torres-Tama stands in the center of a circle of students—a black mask trimmed with gold glitter on his face. He moves around the circle, gestures to underscore his tale. He tells of another time, but in the same place where Mardi Gras was just celebrated, the French Quarter. His story is about oppression, perseverance, and triumph. An early American composer gains an audience, yet he leaves for a life in France because he is a person of color; a successful coffee vendor defies laws of her time despite the fact that she is a person of color; a business woman and voodoo priestess buys land and becomes one of the most legendary New Orleans figures—she is a person of color. These are glimpses of the lives of free people of color—Edmond Dede, Rose Nicaud, and Marie Laveau.

Torres-Tama asks the children to step in—continue the story through their own. He turns to Louis, "Tell us what you wrote about in your journal." Louis reads aloud.[3] His story is about being a Mardi Gras Indian spy boy. He describes how he sets out in front of his Indian gang to search for others, warning his gang with drumbeats. When the gangs meet, they dance and shake hands. Torres-Tama encourages him to come into the circle to share a song, movements. As Louis moves from his desk into the circle, Torres-Tama notes the significance of having a Mardi Gras Indian in the class—another longtime African American tradition in New Orleans. The kids look at Torres-Tama and roll their eyes, but Torres-Tama continues still whirling around the circle and asks Louis to sing. Louis turns his head to the ceiling, as if seeing right through it and sings, "Shallow water oh mama . . . Nobody kneeling and nobody bowing . . . shallow water oh mama" loud and clear with no reservations about performing before 32 peers.

These residency moments illustrate Torres-Tama's process leading each student to tell his or her own story. He weaves the stories and performances together into one group performance piece replete with their own art gallery of vibrantly colored portraits of free people of color. The story intertwines history and students' lives—a continuum of time and place.

Surreal Bayou: Roberto Ortiz at Estelle Elementary, Jackie Danillidis, Principal, near Bayou Barataria National Preserve

Roberto Ortiz, a tall, Puerto Rican American artist with a long, jet-black ponytail, walks into an elementary classroom, the spring after Hurricane Katrina. Approached by a small girl, he is asked in Spanish, "Do you speak Spanish?" He answers her back in Spanish, "Yes, I do . . ." A happy exchange and a giggle, followed by an embrace provides the starting point for Ortiz's classroom introduction to his residency conducted near his own childhood neighborhood. Later, Ortiz learned that the student was newly enrolled at the school.

Although Estelle was one of the first Greater New Orleans schools in Jefferson Parish to reopen after Katrina, the demographics of the school changed. Many students enrolled prior to Katrina had yet to return; new students, including recovery and construction workers' families, enrolled. A growing demographic included many Mexican families joining the school; school services including English as a second language expanded. Likewise, many teachers returned to work; however, child care for young children was unavailable for many teachers. The principal immediately set up child care services on-site. Since the school lacked trained early childhood educators, all teachers shared in taking care of each other and each other's families. Everyone—teachers, administrators, students, Ogden museum educators, and the artist—was reeling from damaged homes and a fractured community. The strength of this residency centered on offering the students positive messages using humor and creativity rather than focusing on negative aspects of loss—homes, friends, and community. The residency helped them make

sense of the fragility of Louisiana wetlands, while at the same time exploring creative expression.

As a surrealist landscape artist, Ortiz found inspiration from his youth, where he explored the swamps near his home on the Westbank in New Orleans. Ortiz's choice to focus on surreal wildlife reinforced student learning about Louisiana ecosystems. After reviewing the wildlife of the wetlands, Ortiz asked students to construct new animals—the upper half body as one mammal, amphibian, or fish and the lower half based on another.

Ortiz constructed two large paintings produced on 4 × 10' sheets of galvanized steel, one showing a Cypress bayou, the other a river wetland. All of the student-created artworks found their place on one of the paintings as magnets. The paintings and the animal magnets operated as a metaphor, a voice for reasserting students' place in their fragile environment. On one hand, because the students' works were magnets, the compositions became real-life puzzles offering opportunities for continuous change and reordering, kind of like life after hurricanes.

After the exhibition at the museum, students voted on which painting to hang in their school and which would enter the museum's collection. They chose their favorite one to stay at the museum so that "more people could see it." Visitors could experience how one school community dealt with a changing neighborhood, a new demographic within the community, and a fragile ecology through creativity and humor.

Conclusion

Even though museums may not push against the water in the same way that New Orleans has, we all push against the water as we stretch what can be done to make our museums socially relevant and active to enliven communities. We recommend that other museums consider residencies as a way to push beyond traditional programs and safe approaches to help the museum discover its voice in the social justice discourses, which can transform the community. We hope that this chapter has provided the information and inspiration for other museums to find their own ways to push against the water.

We understand that these discourses may be uncomfortable and sometimes difficult to move toward action. Pushing against the water also implies change in direction and the swift movement of water into different channels. As in the disruption and change brought about by the 2005 New Orleans levee failures, museum programs face change brought about by their own "hurricanes." Although it was the first museum residency program brought back to the city after Hurricane Katrina, Artists and Sense of Place had to push against the water—changes in funding and staffing led to shorter residencies, fewer participating classrooms per school, a virtual elimination of teacher training, and less time spent digitally documenting the process. Artists are no longer required to live in the neighborhood,

but then the neighborhoods of New Orleans are forever altered; artists are welcomed into each school as neighbors.

Notes

1. The artists consented to use their names.
2. Principals consented to use their names.
3. The student's name is a pseudonym.

References

Goldring, E., & Greenfield, W. (2002). Understanding the evolving concept of leadership in education: Roles, expectations, and dilemmas. In J. Murphy (Ed.), *The leadership challenge: Redefining leadership for the 21st century* (pp. 1–19). Chicago: University of Chicago Press.

Graham, M. (2009). Critical place-based art education: Community, ecology, and artmaking. *Translations, 18*(2).

Gruenewald, D. A. (2003). Foundations of place: A multidisciplinary framework for place-conscious education. *American Educational Research Journal, 40*(3), 619–654.

Henry, D. (2004). Artists as museum educators: The less told story. *Museum News, 83*(6), 44–47.

Hirzy, E. C. (1992). *Excellence and equity: Education and the public dimension of museums.* Washington, DC: American Association of Museums.

Pujol, E. (2001). The artist as educator: Challenges in museum-based residencies. *Art Journal, 60*(3), 4–6.

Sagor, R. (1992). Three principals who make a difference. *Educational Leadership, 49*(5), 13–18.

Weil, S. (2002). *Making museums matter.* Washington, DC: Smithsonian Institution.

8

PICTURING EQUITY IN CITY SCHOOLS

Using Photography to See What Justice Means to Urban High School Students

Kristien Zenkov, James Harmon, Athene Bell, and Marriam Ewaida

1. What do urban, often diverse, youth believe are the purposes of, supports for, and impediments to their school engagement and success?
2. How might asking young people to illustrate their ideas about school with photographs provide youth, teachers, and the broader public with *better* ideas about adolescents' perspectives—especially about their understandings of justice?

"Eyes on the Future"

> My three-year-old sister, Kya, helps me succeed in school. I want to set a good example for her by staying in school and eventually going to college. My sister watches me and emulates everything I do. Because of this, I have to make the right decisions on a daily basis so she will know how to make right decisions when she gets older. . . . I do not want my sister hanging out with the wrong group of people, so I make sure my friends and I have the same constructive goals and optimistic attitudes about our future. I have to be the one to lead her down the right path.
>
> —Carmisha

Carmisha's reflection was accompanied by a hazy close-up of a bubbly African American toddler. Carmisha made the image and described it as a part of a photography-driven literacy project (Through Students' Eyes, or TSE) through which urban high school and middle school youth were asked to document their perspectives on school. Carmisha was often responsible for providing long days of child care for her little sisters; she loved taking care of her siblings, but doing so frequently cut into time for her own schoolwork. For Carmisha and many of her

diverse city peers, school would be a more equitable and just place—and a more *relevant* institution—if it supported her learning how to help her younger family members focus on their own education and discover how to make more constructive decisions in the years ahead.

Introduction

As city teachers and "boundary-spanning" professionals who work daily in urban schools, we encounter innumerable challenges that require us to question the justice by which our students are served. These include the limits of bureaucratic school traditions, the test of responding to poverty-bound communities, violence that often seems to envelop our classrooms, and the pressures of high-stakes tests (Duncan-Andrade, 2005). Via TSE, we have attempted to respond not only to these factors, but also to student dropout (or "pushout") rates that have hovered at close to 50% for more than four decades (Balfantz, Bridgeland, Bruce, & Fox, 2012; Children's Defense Fund, 2008).

We believe our project is allowing youth to *picture* equity and show us how to *practice* it. Perhaps most importantly, the question of how to make schools socially just places might best be answered by young people themselves, using the aesthetic forms and media with which they are already proficient but which are most often not incorporated into school curricula. While we did not *ask* Carmisha and the other young adults in our project about social justice and schools, we found numerous insights in their images and writings about what they consider to be equity-oriented content and pedagogies. Equity and social justice might best be understood both *by* and *through* arts-based processes of reflection in which we engage our students.

Contexts and Literature

In a time of increasing disparity in the educational attainment of diverse racial, ethnic, gender, and class demographics, understanding urban youths' relationships to school is an imperative for the future of this nation's democratic values (Noguera, 2003). Without such an understanding, it is conceivable that urban education systems in the United States will continue to groom an undereducated underclass resembling a domestic Third World populace (Van Galen & Noblit, 2007). We are troubled by city schooling systems that marginalize students of color and lower socioeconomic status and fail to address the achievement gaps between these youth and their most often wealthier and Whiter counterparts (Ladson-Billings, 2007).

In addition, as educators with more than eight decades of collective experience in urban classrooms, we have heard many students' laments about the irrelevance of our curricula and schools. We know now that these grievances represent cause for much concern, as these youths' expressions represent aftershocks of an

earthquake of injustice and school disengagement (Balfantz & Legters, 2004). Adolescents' persistent, if subdued, complaints are actually indicators of their peers' and communities' multigenerational indifference to school (Ferguson, 2008).

But concentrating on these dropout numbers, achievement statistics, and laments does little to inform us of the causes behind these trends or to provide us with socially just solutions to these community relationships to school (Erickson et al., 2007). Rather, we have begun to pay attention to the foundational question of the role of school in our urban students' lives (Doda & Knowles, 2008). We know that the everyday curriculum of school denunciation that these young people encounter results in adolescents' growing perception of the insignificance of school.

Missing in most current discussions of what makes an effective—and socially just—teacher or school for urban settings are the voices of city youth (Marquez-Zenkov, 2007). In response, we have appealed to a growing body of literature on young adults' points of view on school (Cook-Sather, 2009). This research suggests that visual tools provide insights about adolescents' perspectives that language-centered methods cannot (Ewald, 2001) and are useful for engaging students in the deconstruction of repressive school realities (Schratz & Loffler-Anzbock, 2004). Urban youth can be especially articulate informants for how school structures might be more just (Ayala & Galletta, 2009).

Methods of the TSE Project

Informed by these studies, we appealed to broader notions of literacy and our own experiences as arts advocates and photographers for methods that would allow youth to illustrate their perceptions of school and their ideas about socially just curricula and pedagogies. "New" concepts of literacy suggest that schools should rely more on "texts" with which diverse students are proficient, including visual and digital media (Alvermann, 2004). These visually based tools have proved to be highly engaging for seemingly aliterate youth (Morrell, 2007) and capable of providing often-inaccessible information about young adults' perspectives (Zenkov, 2009). These insights into urban adolescents' literacies evoked the tools with which we conducted this project and study.

We utilized *photo elicitation* techniques (Harper, 2005) with approximately 200 diverse, urban middle and high school students to explore their perspectives on curricula, teachers' pedagogies, and school in general. These young people were an economically homogenous group, but they came from our major midwestern city's most racially and ethnically diverse neighborhoods. Supported by local grants, we provided project participants with digital or 35 mm point-and-shoot cameras and instructed them in the basics of camera operation. Youth worked with us, their high school English teachers, and university teacher educators—during in-class and after-school sessions—biweekly for between 4 months and a year, using the photo elicitation process to address three questions with images and reflections:

1. What is the purpose of school?
2. What helps you to be successful in school?
3. What gets in the way of your school success?

Pictures about which students wrote were chosen based on these youths' and our perceptions of the relevance of these photos to the project questions. From more than 10,000 images, TSE participants eventually selected approximately 400 photos as illustrations of these responses and discussed these in 1:1 conferences. Youth then described these in paragraph-length writings (Zenkov & Harmon, 2009). For the findings of this chapter, we—this chapter's authors—content analyzed these pairs of photographs and reflections, documenting prevalent visual and descriptive themes (Prosser & Schwartz, 1998). We then reconsidered these topics, looking for suggestions about the teacher knowledge and practices and the school structures and curricula that students believed promoted equity in their schools.

Findings

Our examination of youths' pictorial and written responses suggest findings that might influence city teachers' and teacher educators' efforts as well as policy makers' and curriculum specialists' thinking—both in terms of the insights adolescents offer and the arts-based processes utilized. In our analyses of their photographs and reflections, it became clear that they saw as synonymous the challenges of and solutions to injustice and the challenges of and solutions to general school success. These young women and men revealed qualities of teachers committed to serving diverse adolescents, alternative methods for *seeing* students' ideas about teachers' roles and practices, and school structures that might guide urban educators toward educational equity. We have organized these findings under three themes—mentors and mentoring, youths' and families' experiences, and opportunities to reflect. We describe and illustrate these themes with participants' images and writings.

Mentors and Mentoring

The youth in our project identified two primary equity-oriented concerns associated with notions and examples of mentoring in their school experiences. First, they described how their teachers, school leaders, and even the very institutions of school assume the worst about the people in their lives and the individuals and networks who influence them, rather than being appreciated for the constructive roles they play in each other's lives. Secondly, in these mentoring-focused images and writings, youth depicted how they recognized that not only had *they* been poorly served by schools, but their adult family and community members had as well—a gross systemic injustice. They illustrated how mentoring programs could address both of these challenges.

The role models to whom our diverse urban adolescents look are different from what most teachers and school administrators might consider "traditional" examples. Many classroom teachers and school leaders might make negative assumptions about the roles these individuals play in young adults' lives, but the young women and men in our project count on even the peers and adults in their lives who have failed to find school and worldly success as ideals who can motivate them—and whom they can inspire—to pursue academic and personal achievement. One of the solutions to the daily injustice of these damaging assumptions might be allowing youth to share how even negative examples of school and life attainment can prompt young adults to be conscious of their own academic and worldly success. Derek's image of himself and his cousin—who was flashing a gang sign—revealed the positive mentoring role that even a young man engaged in the often-destructive network of a gang might play (Figure 8.1).

"Motivation"

The first picture I chose is a picture of me and my cousin. The reason I chose this is because he is my family and that could be a big factor in me doing

FIGURE 8.1 Derek Alexander, "Motivation."
Used by permission.

well in school. When I think about the things I could do for my family it
motivates me. . . . My family helps me by staying on me, by asking me a lot
about school and trying to help me all the time, and making sure I'm doing
what I'm supposed to do.

—Derek

The young women and men in our project frequently highlighted the con-
structive examples of these peers, family members, and community adults, in
part to remind us that their teachers and schools often fail to recognize these
positive exemplars. Our students advocated—visually and textually—for the
consideration of these less-than-obvious ideals as role models for their school
achievement.

In response to the injustice of negative assumptions about these exemplars,
TSE participants suggested that their teachers and school administrators might
bring family and community members who were serving as models into their
school lives. We could even make their identification as constructive examples
a part of the school curricula. Using an image of his brother, Marcus spoke to
the ways in which even a high school dropout could motivate him to achieve in
school.

"Leader"

This is a picture of my brother and he taught me everything I need to know
about school and life. . . . [W]hen it comes down to school and my books,
he constantly stays on me and teaches me to do the same for my younger
brother. . . . [H]e's the only person that's really been there for me. . . . I think
kids need role models because they need someone to set the standard on
what they could be doing. My brother sets the standard by providing for his
girlfriend, my mom, my little brother and me. He shows me that it's possible
to put your mind to anything and accomplish it.

—Marcus

Too often, we as teachers are looking for models that represent success in con-
ventional ways, rather than understanding that these young adults can appreciate
constructive lessons in the complexity of mentors' lives. The easiest path to justice
might involve allowing youth to create these equitable options: Urban adolescents
might formally serve as mentors for their peers, and schools might offer credit-
bearing classes through which young adults create multimedia mentoring materi-
als to support their classmates with their life challenges.

The second equity-oriented challenge related to mentoring these youth iden-
tified was the reality that the adults in their lives had experienced school as an
irrelevant institution; they had also been served by teachers who *demanded* that

they appreciate school rather than *listening* to their concerns. These young women and men recognized that schools often were not organized to serve their needs, nor had they been for their older family and community members. TSE youth were focused on solutions to this injustice, to ending this cycle of disengagement by serving as mentors for their family members and advocating for training that these adults had never received. These young women and men longed for these adults to be able to serve as positive role models for their younger siblings and family members. They wanted mentoring programs that provided their families with new tools for becoming more productive citizens and better parents.

Youths' and Families' Experiences of Inequity

The intersections between youths' experiences of inequity and their family and community members' experiences with injustice appeared not just when the TSE participants depicted their perspectives on mentoring. These connections emerged in relation to economic worries and school schedules that failed to take into account adolescents' and their adult family members' life demands. They appeared when youth documented concerns about the general irrelevance of school that teachers and administrators allowed to persist and surrounding the services that these young women and men and their families needed to succeed.

Many of the injustices that the TSE youth portrayed related to the economic challenges their families faced and for which these young women and men often were responsible. They were conscious of the fact that they spent considerably more time responding to these economic difficulties than did young adults in other communities. They knew that these worries were both wrong—in an ethical sense—and a distraction when they were attempting to focus on school. Lindsey's image (Figure 8.2) and writing in the next section ("Uphill All the Time") illustrate how *family* financial uncertainties had become *her* concern.

"Uphill All the Time"

> This is a photograph of the hill I walk up and down every day to get to and from work. I started working full time at the zoo to help out my family. . . . [W]hat I make helps pay for my dad's prescription medications and allows me to take care of my own expenses . . . Every day when I come home from work I walk uphill, and I feel like I'm walking uphill all the time.
> —Lindsey

Lindsey would graduate from high school the following year, but she worried daily about her father's health and care, and she worked part time during the school year and full time in the summers to pay for his prescriptions. Schools, teachers, and administrators who promote justice would appreciate the details of Lindsey's and

FIGURE 8.2 Lindsay Barber, "Uphill All the Time."
Used by permission.

her peers' lives, adjust school schedules to help her support her family emotionally and financially, and provide access to information about health care options.

Our students also repeatedly described how the multigenerational perception of school's irrelevance was a primary concern, and they were frustrated by teachers' inabilities or refusals to respond to the views of irrelevance that they and their families knew. The solution to this compounded perception might be teachers and school leaders who make school a place that involves explicitly relevant interactions and structures that address the immediate and long-term needs of adolescents *and* their families. Teachers might dare to develop relationships with youth and their families and see these out-of-school relationships as an inherent element of their work.

Teachers committed to equity and justice might take on explicit guiding roles with these young adults' family members, particularly to support their literacy and general education needs. Echoing the evidence shared by many of her TSE peers, Kayla revealed how she had found a purpose for school in her own life—she was near the top of her senior class—but she recognized a personal and systemic injustice in the fact that her father had not finished high school, lacked employment skills, and was unaware of how to support her academically struggling younger

siblings with school. Accompanying a photo of her dad, Kayla's description extended this call for teachers and school administrators to serve both youth and the adults in their lives.

"What, Kay, What Do You Want?"

> My father is always telling us about how he wishes he would have graduated from high school. My dad quit school because of his experience in [our] school district. . . . When he made friends, busing took them away. Both of his parents were taken by the time he was 12, so when his friends were taken too he had no one to turn to for advice or dependency. That's why he dropped out. . . . My dad has had to work multiple jobs for long hours to make ends meet. My dad is a strong person, but he is also tired and withered. I don't want the same thing to happen to me.
>
> —Kayla

A school committed to equity might provide Kayla's dad with some of the same core classes that she was completing, so they both could graduate and pursue other options. And once the education needs of these adult family members were satisfied, they would better appreciate school's value and share this value with these adolescents and the younger members of their families.

Opportunities to Reflect

Finally, the most interesting aspect of their school experiences that TSE youth regarded as an impediment to their school success and evidence of the injustices they encountered was the fact that teachers too infrequently allowed them to reflect on the very importance of school and identify potentially more constructive school relationships. They knew that their own and their family members' relationships to school were less than positive, and they longed for opportunities to shift these associations. These young adults were capable of this metacognitive work and knew that if teachers allowed them to articulate the challenges they faced, they might also identify solutions to these difficulties.

TSE youth related numerous instances where teachers assumed that adolescents were *choosing* to be disengaged from school because they didn't care about their education or their futures. Their images and writings suggest that teachers and school administrators must learn to "ask first" rather than take for granted what they know about *why* students are or are not engaging in school. Chiquitta's image (Figure 8.3) and reflection in the next section ("Stage Fright") addressed the actual reasons why she and many of her peers were choosing not to be involved with their school activities.

FIGURE 8.3 Chiquitta Williams, "Stage Fright."
Used by permission.

"Stage Fright"

> When I look at this photo of a stage, I am reminded of when I was in fifth
> grade and we had to come up with a rap about the first amendment. I had to
> go first, went to the stage, freaked out, paused for a moment and then man-
> aged to perform. This stage also represents good things, like overcoming my
> fears of speaking in front of others and building self-esteem. . . . This photo
> represents both the challenges and the benefits of education.
>
> —Chiquitta

Chiquitta and many of her classmates were merely *reluctant* to participate in school,
rather than *resistant* to doing so. But teachers too often assume that these young
people are willfully defying their instructions.

In addition to teachers who do not presuppose why students are disregarding
their school obligations, an equitable and effective school would incorporate in-
structional processes that are rooted in students' ongoing deliberations about their
school activities, materials, and relationships. Both youth and teachers would ben-
efit from the processes and outcomes of these reflections. Neena's writing—which

accompanied an image of her TSE project journal—reveals how our project might serve as an example of how to include such processes in our curricula and the constructive effects of such deliberations.

"Realizations of . . . "

> I took this photograph of this writing and film because this project has made me realize the importance of school. . . . Ever since I started this project I feel as if I put more effort into schoolwork and now I look forward to coming to school every day. I enjoy it because now I realize that my education is the key to my future. I'm not going to get anywhere or be anybody in life if I don't go to school. My current G.P.A. is a 4.17, which is the highest I have ever had. . . . Because of my grades my family is really proud of me and that's great to know that you can make your family proud.
> —Neena

Teachers committed to equity would recognize that young adults need these explicit considerations to be given elements of practically every lesson. For us as English language arts educators, integrating this practice is easy to do, as it involves authentic reading, writing, speaking, and listening activities and even allows us to incorporate aesthetic and visual texts with which today's youth are familiar.

Conclusion

In our work with city adolescents, we now begin with asking students to use photographic and technology-based visual tools to answer the *question* of the importance of school rather than assuming that school has value for them. The results of this study reveal how these arts-based tools and processes provide youth, teachers, and broader audiences with insights into the challenges of and solutions to inequity in our schools. Teachers committed to confronting injustice in city schools need to resist the tendency to lower expectations for *any* students and return to young adults day after day with an explicit commitment to making schools sites of equity.

In their photographs and reflections, the TSE youth called on us to bring unexpected role models into their schools and to incorporate the identification of these role models and mentoring activities into the school curriculum. Their images and writings have divulged very reasonable apprehensions about school that have grown from years of frustration with irrelevant activities, teachers' and schools' insensitivity to young adults' perspectives, and family perceptions that school is an institution where diverse urban adolescents should *not* expect to be respected or to find justice or success. These adult family members are seeking opportunities

to make right their own painfully irrelevant high school experiences so that they might serve as better mentors for the children and youth in their lives.

The evidence of our project points to the inquiries in which we are engaging young adults not as *leading* to the best examples of equity in our schools, but as perhaps *the* best example of such equity. By considering the voices and images of these disengaged adolescents, our project is moving debates about "equity" and social justice–oriented teachers and schools into the arena of youth. Such qualities and methods are urgently needed if our city schools are to serve as sites of equitable learning *and* learning about equity. Ultimately, these student-centered, arts-based processes might help to ensure that no school subject matter exists without explicit connections to the highest ideals of justice.

References

Alvermann, D. E. (2004). *Adolescents and literacies in a digital world*. New York: Peter Lang.

Ayala, J., & Galletta, A. (2009). Student narratives on relationship, learning, and change in comprehensives turned "small." *Theory into Practice, 48*(3), 198–212.

Balfantz, R., Bridgeland, J. M., Bruce, M., & Fox, J. (2012). *Building a grad nation: Progress and challenge in ending the high school dropout epidemic*. Retrieved from http://www.americaspromise.org/our-work/grad-nation/building-a-grad-nation.aspx

Balfantz, R., & Legters, N. (2004). *Locating the dropout crisis: Which high schools produce the nation's dropouts? Where are they located? Who attends them?* Baltimore, MD: Center for Social Organization of Schools, Johns Hopkins University.

Children's Defense Fund. (2008). *The state of America's children 2008*. Retrieved from www.childrensdefense.org/child-research-data-publications/data/state-of-americas-children-2008-report.html

Cook-Sather, A. (2009). *Learning from the student's perspective: A methods sourcebook for effective teaching*. Boulder, CO: Paradigm.

Doda, N., & Knowles, T. (2008). Listening to the voices of young adolescents. *Middle School Journal, 39*(3), 26–33.

Duncan-Andrade, J. M. R. (2005). Developing social justice educators. *Educational Leadership, 62*(6), 70–73.

Erickson, F., Bagrodia, R., Cook-Sather, A., Espinoza, M., Jurow, S., Shultz, J. J., & Spencer, J. (2007). Students' experiences of school curriculum: The everyday circumstances of granting withholding assent to learn. In F. M. Connelly, M. F. He, & J. Phillion (Eds.), *Handbook of curriculum and instruction*. Thousand Oaks, CA: Sage.

Ewald, W. (2001). *I wanna take me a picture: Teaching photography and writing to children*. Boston: Beacon Press.

Ferguson, R. F. (2008). *Toward excellence with equity: An emerging vision for closing the achievement gap*. Cambridge, MA: Harvard Education Press.

Harper, D. (2005). What's new visually? In N. K. Denzin & Y. S. Lincoln (Eds.), *The Sage handbook of qualitative research* (3rd ed.). Thousand Oaks, CA: Sage.

Ladson-Billings, G. (2007). From the achievement gap to the education debt: Understanding achievement in U.S. schools. *Education Researcher, 35*(7), 3–12.

Marquez-Zenkov, K. (2007). Through city students' eyes: Urban students' beliefs about school's purposes, supports and impediments. *Visual Studies, 22*(2), 138–154.

Morrell, E. (2007). *Critical literacy and urban youth: Pedagogies of access, dissent, and liberation.* New York: Routledge.

Noguera, P. (2003). *City schools and the American dream: Reclaiming the promise of public education.* New York: Teachers College Press.

Prosser, J., & Schwartz, D. (1998). Photographs within the sociological research process. In J. Prosser (Ed.), *Image-based research: A sourcebook for qualitative researchers.* Bristol: Falmer Press.

Schratz, M., & Loffler-Anzbock, U. (2004). The darker side of democracy: A visual approach to democratizing teaching and learning. In J. MacBeath & L. Moos (Eds.), *Democratic learning* (pp. 132–150). London: RoutledgeFalmer.

Van Galen, J., & Noblit, G. (2007). *Late to class: Schooling and social class in the new economy.* Albany: State University of New York Press.

Zenkov, K. (2009, Summer). The teachers and schools they deserve: *Seeing* the pedagogies, practices, and programs urban students want. *Theory into Practice, 48*(3), 168–175.

Zenkov, K., & Harmon, J. (2009). Picturing a writing process: Photovoice and teaching writing to urban youth. *Journal of Adolescents & Adult Literacy, 52*(7), 575–584.

9

EDITING LIVES

The Justice of Recognition through Documentary Film Production

Stephanie M. Anderson

1. In what ways do arts-based programs, like that of the Educational Video Center (EVC), complement and expand on traditional forms of education?
2. Why are these programs particularly important for urban youth?

Changes in the national educational system over the last decade have led to the continued underfunding of urban schools and have placed an emphasis on high-stakes testing as a predictor of educational success. While the consequences of these changes have fallen negatively and disproportionately on low-income youth and youth of color (Fine et al., 2004), including increased dropout/pushout rates in Black and Latino communities, a decline in college enrollment among youth of color, and deteriorating health and criminal justice outcomes for youth of color without educational credentials (Fine & Ruglis, 2009), the performance demands created by high-stakes testing have also led to shifts in curricular foci. Dismissed as recreational or as forms of entertainment, the arts in general and film in particular are moved to the background, while traditional forms of written literacy and math are emphasized (Rattansi & Pheonix, 1997). With the augmented demand on the arts to demonstrate "evidenced-based" outcomes for youth development, funding for programs that offer creative and artistic outlets for youth continues to be scarce. Similar to how educational shifts have fallen most negatively and disproportionately among urban youth, the scarcity of funding coupled with the availability of such arts-based programs already being more available in privileged communities only further disadvantages poor youth and youth of color (Hart & Atkins, 2002).

Amidst the context of diminishing funds and the cornering of the arts into outcomes-based paradigms, it is also crucial to examine the ways in which involvement in the arts can enable positive psychological, social, and civic outcomes for youth. Iris Marion Young (1990) iterates the importance of having one's culture

and social contributions publicly and institutionally reaffirmed among marginalized and disadvantaged populations. Described as the justice of recognition—the ability to present, represent, and do—it denotes the right to speak and be heard, to have the opportunity for effective acknowledgement and representation. Due to the capacity of the arts to create spaces of critical inquiry, individual and collective expression, and opportunities for public participation, they carry the ability to offer an exercise in social justice for those who have been denied social opportunities.

Working within Young's (1990) theoretical framework, in this chapter I explore experiences of recognition created for and by urban youth in the production spaces of critical documentary filmmaking. Developed from research that comes from a larger program evaluation done in collaboration with a nonprofit youth media organization, EVC, I discuss the possibilities produced through having the opportunity to (re)present one's own knowledge and lived experiences. As youth in general and marginalized and disadvantaged youth in particular are both objectified and surveilled within mainstream media, the publication of their stories and experiences through documentary film provides them a venue to position themselves as subjects in, not objects of, their experiences. As such, (re)presentation not only happens through producing creative expressions like documentary film, but also surfaces through participation with public audiences on social issues. Privileging youth creativity, knowledge, and production, educational spaces like that of EVC point to the potentiality of the arts to enable the development of social critique and facilitate a sense of social responsibility to engage in the larger civic politic.

EVC

Located in New York City, EVC is a nonprofit youth media organization that teaches documentary film production to low-income youth and youth of color. As specified in their mission statement, EVC is "dedicated to teaching documentary video as a means to develop the artistic, critical literacy, and career skills of young people, while nurturing their idealism and commitment to social change" (http://www.evc.org). With more than 25 years in operation, EVC offers multiple programs that teach youth how to research, shoot, edit, and produce documentaries on social issues of their choosing. Produced documentaries have addressed issues of teen pregnancy, homophobia within high schools, sexual assault in youth relationships, depression among youth of color, and environmental justice and discrimination to name a few. While EVC personnel oversee workshops and programs, participating youth organize and direct much of the documentary production. Students spend many hours in collaboration discussing and researching their selected topic, working together as a crew during shoots and interviews, and polishing their final piece during postproduction in the editing room.

In seeking to understand the ways in which youths' experiences at EVC informed their sense of self and their feelings of social responsibility, I recruited

a purposive sample of EVC students and alumni for participation in individual interviews. I initially contacted all students and alumni for participation in the study in order to best represent the experiences of all levels of students at EVC. Of those who expressed interest, I selected participants in relation to their time spent at EVC in order to obtain a typical case sampling based on level of EVC participation (Teddlie & Tashakkori, 2009). The final sample included participants who were diverse in their level of EVC participation, ages 18–24, and balanced by gender (i.e., four males and five females). Of the nine participants, five were born in the United States, and seven out of the nine participants identified as individuals of color.

Individual interviews were conducted in a semistructured narrative format and lasted between 45 and 90 minutes. I devised interview protocol questions in collaboration with EVC personnel and asked about students' and alumni's motivations for joining the organization, the documentary skills gained throughout their participation, how they feel their lives have changed through participating in EVC, and their reflections about researching issues of social justice. Coinciding with the idea that people depict their lives through a series of narratives (Chase, 2002), I encouraged students and alumni to tell stories about their experiences at EVC. From participant responses, I asked follow-up questions directed toward the students' and alumni's stories rather than in strict adherence to the interview protocol. Finally, for a year prior to and throughout data collection, I had monthly meetings with EVC personnel and frequently attended public screenings and workshops. Through doing so, I was able to engage informally with EVC students and discuss my observations with personnel. In addition, prior to interviewing, I also watched all the documentaries that interviewees produced in order to better understand their experiences and the social issues they addressed.

Movement from Societal Critique to Action on Injustices

Within the social justice literature, many theories have been proposed to characterize how individuals and groups who live within oppressive circumstances come to have a societal critique and in turn take action on the injustices in their lives. Theorists such as Freire (1970) and Martín-Baró (1994) argue that everyday embodied experiences provide the basis of knowledge and foundation for critique. In being positioned in and seeing from the margins, as DuBois (1903), hooks (2000), and Hill-Collins (2000) describe, those who have been denied social opportunities have a distinct positionality and language for analyzing the dominant culture. As both an object of public evaluation and scrutiny and a subject who looks back (hooks, 2003), possibilities arise for unique ways to understand the present and reinvent the future. Viviana, for example, expresses how collaborating on a documentary about sexual assault in youth relationships caused her to rethink her understanding of healthy romantic partnerships.

> What I love about EVC and working with documentaries in general is that it just kind of brings things to light . . . that you . . . are so used to that it's the norm, but then you sit down and your blinders are removed and you see it a lot better and you're like, wait a minute this isn't normal and if it is considered normal it shouldn't be considered normal.

Educational philosophers John Dewey (1916, 1934) and Maxine Greene (1995) also emphasize the importance of knowledge gained through reflection on and interrogation of everyday lived experiences. With the intention of disrupting the normalized as Viviana experienced, Dewey and Greene advocate for the arts as an entryway into encountering and articulating alternative experiences and thus conceiving of alternative realities. In describing how art nurtures the imagination, Greene (1995) writes, "At the very least, participatory involvement with the many forms of art can enable us to *see* more in our experience, to *hear* more on normally unheard frequencies, to *become conscious* of what daily routines have obscured, what habit and convention have suppressed" (p. 123, italics original). Greene and Dewey argue that the arts are a crucial component to education: they create openings for the development of critical subjectivities and provide a medium for public participation.

In interviews with EVC students and alumni, many explained that the process of creating and producing a documentary film (i.e., the constant juggling of ideas, images, sounds, and sequences) challenged them to see from multiple perspectives, while also offering a venue to express their point of view. In depicting how documentary film is inherently crafted, Diana, for example, describes having to take a position on her topic:

> Like how are you going to represent someone. Like you have this whole interview, but you can choose what to include and what not to include. Like we made a documentary on young people in prison. We could have very well made the young people look like they're robbing people, they're bad, but instead we looked at what their family life was like, why do they need this money. So it's really a manipulated process. But, so empowering for filmmakers, but also for the audience to understand where you're coming from. It's like a way to communicate without ever talking.

With many of EVC students coming from underserved and marginalized communities, the social issues they address in their documentaries often have personal relevance. As a response to the media portrayals of youth in general and youth of color in particular, EVC programs offer students an opportunity to voice their perspectives. In her utilization of video in ethnography, Sarah Pink (2001) writes that through experiences in front of and behind a camera people fashion their identities for public consumption. Through their documentaries, students at EVC have the ability to tell stories about the experiences of youth and social

institutions from their vantage point. They negotiate not only the presentation of their identities as filmmakers but also—and importantly—the realities of the people in their films. Literally placed in a position of "looking back" through documentary film production (hooks, 2003), EVC students have a platform to look beyond what is presented at the surface and critique dominant social representations in society.

The Power of (Re)Presentation: The Development of Agency and Social Responsibility

Students and alumni at EVC described the opportunity to critically weigh and dissect issues affecting their lives as invaluable; however, as Young (1990) reminds us, also having access to resources in order to work toward social change is a crucial factor for social justice. In a very literal sense, their experiences must carry social significance outside the classroom walls. As a capstone for the end of the program, student documentaries produced at EVC are screened at public media venues around New York City and include locations such as Time Warner and HBO. Throughout the interviews, when asked to describe their best moment at EVC, most interviewees expressed that the presentation their documentaries at the public screenings was their favorite. Craig explains his experience presenting his documentary on religion:

> To have the opportunity at Time Warner, like, kids don't do that every day. Even a kid who is coming up, you know, as an adolescent and they want to pursue film, I'm pretty sure a lot of them haven't had the opportunity to make a documentary and present it in front of people at Time Warner in like a [coughs] in, in a screening room, like in a nice screening room, and people ask you questions about it, like how you feel, uh, just ask you . . . how could that like—just over all it's a great program [laughs]. I'm getting like caught up in my words. . . . me, I wouldn't want any other program.

Reflected in Craig's affect through his multiple attempts to put his experience into words, speaking publicly in a formal setting such as Time Warner made him feel distinct. He states that "like, kids don't do that everyday [sic]" and "a lot of them haven't had the opportunity," pointing to the uniqueness of the experience. While presenting onstage at prestigious venues like that of Time Warner may be an uncanny experience for many youth, it might carry particular importance for students at EVC, as they come from communities where educational resources and opportunities are less available.

Diana elaborates on the connection between opportunity, privilege, and having an individual's experiences and opinions validated. In response to critics who argue that programs like EVC simply let "kids play with cameras," she replies:

Um . . . I would think obviously they, they never had an experience like this. They've never been [sighs] sort of so underprivileged and then finally given the opportunity to express themselves that they just can't understand what it's like. Like if you're given everything you need your whole life and people—when you come home from school people ask you how your day at school was, if you never had anyone ask how your day at school was and then go into an organization and people ask you what it is like in your community, you're going to respond in a positive way. But if you had that growing up, even though you might think it's something small, you're never going to understand what the experience is like for someone who has never had that.

While Diana describes being able to express herself in relation to her overall EVC experience, having her voice heard and listened to is emblematic of the legitimization students receive at the public screening of their documentaries: Through standing up onstage and presenting their documentaries, their beliefs and opinions are publicly reaffirmed. As such, in the process of documentary film production, EVC students not only engage in a contact zone of their diverse perspectives (Torre, 2005), but also enter into wider public discourse and speak to dominant dialogues about youth experiences.

Nira characterizes screening her first documentary as not only her favorite moment at EVC, but also an important marker of achievement in her life.

NIRA: When I screened my documentary, *Faces of Food*, it was the biggest achievement the first achievement I would have ever made . . . and, because I didn't go to my, um, I didn't go to my prom, I didn't go to my graduation . . . I don't know why but that was the only thing I had ever achieved, and it mattered a lot.
STEPHANIE M. ANDERSON: What was it like to be up onstage?
NIRA: Overwhelming. I felt like I was productive in some part of my life, you know. So even though it was hard for me to come here everyday [sic] after school, and . . . you know, you would want to do good in cla—in school, it was time and I was applying for college, and everything. It was overwhelming. It was hard to be with such a group, um, but I made it. So it was a very, a very good feeling for me that, you know, that I achieved something.

Although Nira described both the process of creating the documentary and the public screening as "overwhelming," she characterizes the premier as the highlight of her EVC experience. Like Craig, presenting her documentary in an official public media venue was an important moment of recognition and achievement. Yet, Nira describes the event as her "first achievement," a distinguishing mark of her moving forward in her life. Interestingly, she places this achievement in contrast to other celebratory events in high school that she did not attend: prom and

graduation. Her distinction may be related to the content and nature of the documentaries produced at EVC (i.e., films that address social issues affecting the lives of youth). For example, when asked what about documentary film was compelling to her, Nira explains:

> It's real stuff, I guess . . . real stuff means like, you know, you can present real problems that are going on. You can present your feelings. You can . . . you can represent somebody else who is going through all that. You can do real stuff out in the world, you know.

In working on and producing a tangible product on issues that are important to her, Nira describes feeling empowered.

As youth in general and marginalized and disadvantaged youth in particular are both objectified and policed within mainstream media, the publication of their stories and experiences through film provides them a venue to look and speak back. As critical subjects, they offer alternatives and counterdiscourses to the dominant frame of consumption and crime that characterizes urban youth. As such, the documentary production process as a whole provides them with a sense of their capacity to work toward social change. As described by Juan:

> I think doing documentary filmmaking has changed my perspective in the sense that like you can make a change. Little or small or tiny, but you can make a change. . . . I think maybe I have I have like got this idea of making documentaries just not to inform people but also to do something else. . . . I think that after being in documentaries I have learned like to be a little more hopeful that if you work hard that in the end then something's gonna be done.

Through the public screenings of their documentaries, EVC students receive public legitimization of their thoughts, opinions, and critiques expressed in their films. As noted by Cammarota and Fine (2008), social justice–oriented programs teach youth that conditions of injustice are "challengeable and thus changeable" (p. 2). Seeing the constructed yet not determined nature of society can create a sense of agency and an awareness of the opportunities available to take action. Importantly, having the means to constructively engage with social issues may provide the difference between feelings of despair and a sense of social responsibility to take action on them. In tackling the various social issues through documentary film and then seeing the reactions of other young people and adults to their productions, EVC students experience the justice of recognition and see potential ways in which they can engage and address social issues affecting their lives.

The sense of individual and collective agency that EVC youth describe through participating in the program and presenting their documentaries onstage may also lead students to future civic engagement. When asked if he saw himself

continuing to be involved in a specific social issue as he moved forward with his education, Rick responded:

> I mean, I really felt like I did so much on this one topic [youth and religion] alone, I could so much with other social issues, um, corrupting our world, well not corrupting well happening in our world. I mean, like I have a better sense of what is going on in the world. I mean, I know—I knew like certain issues were occurring, but then I didn't really give, gave such—a lot of thought about it because I have my life, I have my own life to worry about why am I worrying about these issues when there is other people trying to solve it? But then I feel like I should become a part of it, I mean it's my world too, why—I mean, if I don't then, I'm just living a lie then.

Throughout his interview, Rick described how he now "has a better sense" of social structures and processes and the diversity of human experience. In characterizing the movement between the formation of critique and taking action for social change, Hamilton and Flanagan (2007) describe three necessary components for this movement among youth: (a) the belief that the status quo is amiss, (b) an alternative view of the way society could be, and (c) a sense of what actions youth can take to bring about change (p. 453). Embodying these three factors, Rick explains that with coming to see the world differently through documentary film, he now has an obligation to act; inaction, in his mind, would be "living a lie." With the critical interrogation of social issues that affect their lives, students at EVC challenge conventional standards and portrayals of the youth in the media. The entirety of the documentary process (i.e., researching, shooting, editing, and producing) expands the understanding of what constitutes social and civic engagement.

Cammarota and Fine (2008) write that through involvement in participatory action research collectives youth "learn to act upon and address oppressive social conditions lead[ing] to the acknowledgement of [their] ability to reshape the context of [their lives] and thus determine a proactive and empowered sense of self" (p. 10). As a type of social justice–oriented youth program, EVC provides an opportunity for youth to actively engage with and thus act on social issues that affect their lives, enabling feelings of collective and individual agency and also a sense of social obligation to the larger public (Watts & Flanagan, 2007).

Documentary Film as an Exercise in Social Justice

In returning again to the writings of hooks (2003) and Freire (1970), it seems that not only the development of a societal critique but also active participation in work on social issues facilitates feelings of social responsibility. As evidenced in the words of EVC students and alumni, participation in the documentary production process and subsequent presentation of their films to public audiences provided insights and openings for future involvement. Freire (1970) writes, "society now

reveals itself as something unfinished, not as something inexorably given; it has become a challenge rather than a hopeless limitation" (p. 10). As Freire describes, EVC youth expressed hope for the future. Documentary film production importantly gave them respect for their creativity, opinions, and experiences.

The opportunity to more fully participate in issues affecting their lives exemplifies the justice of recognition (Young, 1990). Producing a documentary film on issues important to them, EVC youth received the institutional means for "fostering politicized cultural discussion" (p. 152). The program structure at EVC emphasizes the development of individual competencies and sees youth as community assets rather than as liabilities within the documentary process. In doing so, it provides public recognition and honors youth knowledge and production. Through placing the documentary power of inquiry within the hands of youth, EVC offers a venue for the display of positive difference and expression. With the justice of recognition, these youth grew a sense of entitlement to speak and be heard, to dialogue in public discourse, and to participate as democratically engaged subjects.

As Young (1990) also reminds us, disadvantaged or marginalized groups and individuals must have effective recognition and representation for their distinct voices and experiences. Not as an erasure of difference but as an honoring of complexity, the justice of recognition describes a key enabling condition for youth to identify, revise, and voice their perspectives. For students at EVC, documentary film served as their vehicle to move between and toward social critique and civic engagement. Having developed an entitlement to name and critique their experiences and knowledge, they rewrite dominant scripts and take up a responsibility to act collectively.

The Arts and Documentary Film within Larger Educational Contexts

With the increased frequency of media and digital technologies in our everyday lives, the incorporation of media and digital technologies within education holds particular promise to draw on youth expertise and create possibilities for the coexistence of multiple ways of knowing. As identified by Dimitriadis (2004), "young people today are using contemporary media to define themselves ... these texts ... are circulating and being picked up in many different and often unpredictable ways" (p. 35). Working within a language they already speak, digital technologies such as film can provide a more relatable approach to and understanding for youth. In speaking of films and documentaries, Greene (1995) describes that in watching films, "viewers are left with disrupted categories, with numerous particularities in their eyes and minds, with unresolved tensions, with relentless ambiguities. If they are informed at all about what it signifies to engage with film, to perceive it as something other than photographed reality, they are left with huge and provocative questions" (p. 102). For EVC youth, documentary film complicated and expanded their process of seeing and producing (MacDougall, 2006).

In not only viewing but also researching, shooting, editing, and producing, film requires particular attention to detail and a kind of reflection and revision that are goals of secondary and postsecondary education. Like writing, the arts are also an expression of thoughts and experiences. Being different, however, their potential visual nature enables the ability to "show" and not only "tell," often communicating at the exclusion of narration. As such, the arts demand a unique form of engagement and consideration of issues not present in traditional forms of education. If the goal of education is for the development of the continued capacity of growth that builds on the everyday life experiences of young people (Dewey, 1916), the arts may provide an essential complement to traditional forms of education and research.

In regard to cultivating feelings of social responsibility and civic engagement, using technologies to publicize their findings and messages may help youth realize the variety of ways in which they can speak back to and within public discourses. Evidenced in the experiences of EVC students, engagement in documentary film not only helped them navigate digital media but, importantly, also provided them a "medium of social awakening" through which to express themselves and imagine possibilities for presenting social issues from a different angle (Buckingham & Willett, 2006, p. 8). In this sense, the programs at EVC helped youth establish bridges between academic and civic participation: Documentary film served as a tool through which to interrogate social issues and explore alternative solutions (Kirshner, 2007).

The existence and continuation of youth programs that cultivate social justice inquiry on social issues through the arts and digital technologies carry particular importance for equipping marginalized and disadvantaged youth with an enabling way of seeing and acting on the world. At a time when opportunities for urban youth are diminishing, we need to advocate for programs and organizations that offer them a place to develop individual and collective agency, confidence about their ability to effect change, and the mechanisms through which to do so. Experiential and social justice–oriented youth programs, like that of EVC, provide youth the justice of recognition and create openings to imagine a different future.

References

Buckingham, D., & Willett, R. (Eds.). (2006). *Digital generations: Children, young people, and new media.* Mahwah, NJ: Lawrence Erlbaum.

Cammarota, J., & Fine, M. (Eds.). (2008). *Revolutionizing education: Youth participatory action research in motion.* London: Routledge.

Chase, S. (2002). Learning to listen: Narrative principles in a qualitative research methods course. In R. Josselson, A. Lieblich, & D. McAdams (Eds.), *Up close and personal: The teaching and learning of narrative research* (pp. 79–99). Washington, DC: American Psychological Association.

Dewey, J. (1916). *Democracy and education: An introduction to the philosophy of education.* Littleton, CO: Feather Trail Press.

Dewey, J. (1934). *Art as experience*. New York: Berkley Publishing Group.

Dimitriadis, G. (2004). *Performing identity/performing culture: Hip hop as text, pedagogy, and lived practice*. New York: Peter Lang.

DuBois, W. E. B. (1903). *The souls of black folk*. New York: Dodd, Mead & Company.

Fine, M., Roberts, R., Torre, M., Bloom, J., Burns, A., Chajet, L., . . . Payne, Y. (2004). *Echoes of Brown: Youth documenting and performing the legacy of Brown v. Board of Education*. New York: Teachers College Press.

Fine, M., & Ruglis, J. (2009). Circuits and consequences of dispossession: The racialized realignment of the public sphere for U.S. youth. *Transforming Anthropology, 17*(1), 20–33.

Freire, P. (1970). *Pedagogy of the oppressed*. New York: Continuum.

Greene, M. (1995). *Releasing the imagination: Essays on education, the arts, and social change*. San Francisco, CA: Jossey-Bass.

Hamilton, C., & Flanagan, C. (2007). Reframing social responsibility within a technology-based youth activist program. *American Behavioral Scientist, 51*, 444–464.

Hart, D., & Atkins, R. (2002). Civic competence in urban youth. *Applied Developmental Science, 6*(4), 227–236.

Hill-Collins, P. (2000). *Black feminist thought*. New York: Routledge.

hooks, b. (2000). *Feminist theory: From margin to center* (2nd ed.). Cambridge, MA: Sound End Press.

hooks, b. (2003). The oppositional gaze: Black female spectators. In A. Jones (Ed.), *The feminism and visual cultural reader* (pp. 94–104). New York: Routledge.

Krishner, B. (2007). Introduction: Youth activism as a context for learning and development. *American Behavioral Scientist, 51*, 367–379.

MacDougall, D. (2006). *The corporeal image*. Princeton, NJ: Princeton University Press.

Martín-Baró, I. (1994). *Writings for a liberation psychology*. Cambridge, MA: Harvard University Press.

Pink, S. (2001). *Visual ethnography*. Thousand Oaks, CA: Sage.

Rattansi, A., & Pheonix, A. (1997). Rethinking youth identities: Modernist and postmodernist frameworks. *Identity: An International Journal of Theory and Research, 5*, 97–123.

Teddlie, C., & Tashakkori, A. (2009). *Foundations of mixed methods research: Integrating quantitative and qualitative approaches in the social and behavioral sciences*. Thousand Oaks, CA: Sage.

Torre, M. E. (2005). The alchemy of integrated spaces: Youth participation in research collectives of difference. In L. Weis & M. Fine (Eds.), *Beyond silenced voices* (pp. 251–266). Albany: State University of New York Press.

Watts, R. J., & Flanagan, C. (2007). Pushing the envelope on youth civic engagement: A developmental and liberation psychology perspective. *Journal of Community Psychology, 35*, 779–792.

Young, I. M. (1990). *Justice and the politics of difference*. Princeton, NJ: Princeton University Press.

10

TACKLING HOMOPHOBIA AND HETEROSEXUAL PRIVILEGE IN THE MEDIA ARTS CLASSROOM

A Teacher's Account

Stacey S. Levin

1. How can media arts students be challenged to critically examine homophobia and heterosexual privilege?
2. How can film criticism serve as collective social action?

To be honest, it is difficult work to ruffle feathers as a high school film/video production teacher in a suburban middle-class neighborhood, especially when there exists the option to keep things simple, or maintain the status quo. Moreover, the marginalization of art education in schools would render any teacher of the arts thankful to just have a teaching position. So why rock the boat? Why not keep the curriculum light—focus on the technical aspects of filmmaking and leave it that? All it takes is hearing your students, students you see every day, students you are fond of, use the derogatory term *faggot* as a joke or an insult or exclaim "that's so gay" to describe something unfavorable, and it calls you to take action.

In my research, I have learned that an essential aspect of any social justice project is to take *action*. Simply directing students to avoid using hateful speech is an option but fails to unveil the root of the heterosexism underlying students' remarks. It only places a Band-Aid on what can otherwise serve as a teachable moment. Stating that homophobic speech is hurtful also just touches the surface. Students may still leave the classroom with their beliefs intact and unchallenged. I want my students to understand the language they use, question their own assumptions about homosexuality, and trace the origins of their heterosexist beliefs. The curriculum was what I turned to, to integrate an effective way to address students' homophobic attitudes and heterosexual privilege.

Film Criticism as Social Action

Careful inspection of the film/video curriculum I inherited upon hire pointed to a need for revision. It was missing a comprehensive film criticism component. As the foundation for uncovering the power of the film/video craft, film criticism is a method for analyzing and evaluating the techniques of how a film is constructed, why the filmmakers constructed it that way, and what the imagery communicates. It unpacks the audiovisual capability of a film to tell a story, evoke emotion, and generate diverse viewer responses, all crucial elements to understanding the complexities of not only film but also our visual culture at large. In these ways, film criticism invites discussion. It can be an avenue to incorporate current events and sociopolitical issues.

Film criticism became the key to developing a viable plan of social action. I restructured the curriculum to incorporate film material that addressed matters of social justice for students to confront and critically analyze. With this new curriculum, film criticism would bring conversations about race, class, gender, and sexual orientation into the classroom. It would awaken students' critical consciousness, encourage peaceful engagement in difficult dialogue, and present paths toward social transformation (Darts, 2004; Freire, 1970; Giroux, 1983, 1997; Greene, 1995; hooks, 1994).

Rewriting the curriculum posed one challenge, but actually implementing it created another. I wrestled with the question, How do we move students from individual stories and histories, a Western notion, toward a social, *collective* process? (Boler, 1999). As teachers, we recognize that students are products of their surroundings. Familial, cultural, and religious values shape their understanding of the world (Griffin & Harro, 1997). Many students are steadfast in their beliefs and tend to shut down when there are challenges to these beliefs. So how do we as teachers facilitate a social justice effort that not only moves us to action but also calls us to *collective action* in the face of these constraints? (Apple, 2004; Aronowitz & Giroux, 1985; Boler, 1999; Freire, 1970; Giroux, 1997; Weiler, 1988).

Megan Boler (1999) advocated for a *pedagogy of discomfort*. She stated, "A pedagogy of discomfort invites students to leave the familiar shores of learned beliefs and habits, and swim further out into the 'foreign' and risky depths of the sea of ethical and moral differences" (p. 181). To demonstrate a pedagogy of discomfort, I present my unit lessons on the film *The Laramie Project* in this chapter. An analysis of the film and its messages serve as a springboard to introduce the concepts of homophobia and heterosexism.

In my teaching experience, homophobia is the social justice issue that is most challenging for students to confront. As Fone (2000) asserted, "In modern Western society, where racism is disapproved, anti-Semitism is condemned, and misogyny has lost its legitimacy, homophobia remains, perhaps the last acceptable prejudice" (p. 3). Some students have difficulty releasing or even loosening the grip on their homophobic beliefs. Many students are not cognizant of their heterosexual privilege and that they are among lesbian, gay, bisexual, transgender, queer, and

questioning (LGBTQ) classmates. Moreover, students exhibit discomfort when recognizing their active or passive roles in LGBTQ oppression (Griffin, 1997). These are reasons why I reserve the homophobia unit for midyear, when students have formed solid relationships with one another and with me and have gained experience in thoughtful class discussions about other forms of oppression.

The following is a step-by-step account of how I carry out the unit on homophobia and heterosexism. It is important to note that I pace myself over a number of class sessions in order to allot the necessary time for all of the unit segments.

Toward an Inclusive Curriculum

I begin the unit by giving a bit of background about the film *The Laramie Project*. The film, created in 2002 by Moisés Kaufman, is based on Kaufman's play by the same name. The plot surrounds the 1998 murder of Matthew Shepard, a 21-year-old gay male college student attending the University of Wyoming. His homophobic attackers brutally beat him, tied him to a fence in a remote area, and left him to die. Shepard's murder gained national and international media attention to hate crimes. The film captures the diverse public reactions to Shepard's death.

I explain that the film is a docudrama—it has elements from both the documentary and drama genres. Actors play the roles, but some of their lines derive from actual transcripts of interviews with Laramie, Wyoming, townspeople. The film also incorporates authentic media footage. I screen the film over 3 days (as 42-minute class periods do not allow for one full viewing). However, showing the film to students in sections is beneficial. It provides time for questions and answers that offer a guided view of the film.

After viewing the film in its entirety, students analyze the filmmaking techniques used to create the film, including cinematography, editing, sound, and music. I emphasize that the film repeatedly spotlights the lone fence where Shepard's attackers bound him. Students conclude that the fence symbolizes the alienation Shepard suffered for being gay and depicts the cruelty of his attackers. We also discuss directorial choices such as the curious omission of any visual representation of Shepard, even by way of an actor or a photograph. Some students surmise that choosing not to have an actor portray Shepard, and omitting actual images of Shepard, illustrates the loss of him. Other students condemn the omission of Shepard's imagery, fearing that it renders him invisible. Given these perspectives, I ask students to evaluate whether the cinematic decision to omit a reenactment of Shepard's beating effectively emphasizes or inadvertently softens the horrific events of his murder (D. Dabney, personal communication, May 3, 2010).

This filmmaking discussion leads to an analysis of the messages that *The Laramie Project* conveys. Students concur that the film captures various perspectives on homosexuality. To understand these perspectives, I ask students to analyze the characters' philosophical, religious, and moral standpoints on homosexuality.

Students interpret the themes that emerge in the film including hate, "live and let live," active heterosexism, passive heterosexism, tolerance, and acceptance.

Showing a film *before* diving into controversial conversation is an effective warm-up exercise. Interpreting the film's messages allows students to take as much distance as they need from their personal stances (Griffin & Harro, 1997; Roy, 1997; Wolz, 2010). Students can reference instances from the film rather than speak from experience. When I feel students are prepared to confront their beliefs and engage in difficult dialogue, I shift to a discussion on their personal reactions to the film.

It is at this point that I remind students of our classroom rules and that these rules have allowed us to establish a healthy rapport and a safe classroom environment. The rules include being respectful to one another; keeping an open mind, especially when thoughts and opinions are different from one's own perspective; sharing airtime during discussions; and avoiding the use of hurtful, dismissive, and derogatory language. Such rules are crucial to encouraging an open dialogue and, more importantly, protecting the well-being of LGBTQ students. I advise that teachers be careful not to single out LGBTQ students or expect them to speak on behalf of all LGBTQ persons (Griffin & Harro 1997; Owens, 1998; Roy, 1997). Teachers must also make it a priority to respond to any needs and concerns of LGBTQ students (Sears, 1987).

After reestablishing classroom rules, I invite the class to share their initial responses to the film and its messages. Admittedly, it is not an easy task to be a mediator between students' different positions on homosexuality and morality. Yet, if you silence students, it shuts conversation down (Li Li, 2004; Roy, 1997). I insist that students step back from their positions and remind them that it is no longer about their individual stories. I ask students to challenge their own viewpoints because simply allowing them to occupy camps is not going to lead the class to a deeper level of analysis (Griffin & Harro, 1997). I ask questions like, "When you take this position, what do you gain? What do you lose?" (Kantor, 1998). As a mediator, I listen and read back the themes I am hearing. I charge students with the task of grounding their opinions in facts and challenge them to defend why another perspective may be appropriate.

It is practical to think that such a dialogue gets heated. To preserve a peaceful atmosphere, I encourage students to think of the classroom as a forum for discussion rather than debate. I assure everyone that although we may hold different perspectives, we all have good intentions.

This leads to a conversation about justice. I ask students to define a just society. Most answer with a comparison of justice to ethics and reference a right-or-wrong system. I remind them that the term *just* is a descriptor open for redefinition as opposed to the more closed system of right or wrong (D. Blumenfeld-Jones, personal communication, October 21, 2008). In other words, the term *just* is not static. What constitutes a just world is ever-changing.

Next, I hand out a questionnaire to each student. The questionnaire is not something I collect but rather an opportunity for students to reflect on how they

are thinking about homosexuality. Some questions are true/false statements regarding homosexuality and stereotypes. An example of a true statement is that LGBTQ persons are at risk of experiencing harassment, isolation, and violence brought on by friends, family members, coworkers, community members, and/ or strangers (Blumenfeld, 1992; Fone, 2000; Griffin & Harro, 1997; Kantor, 1998; Owens, 1998; Rivers & D'Augelli, 2001; Sears, 1987). An example of a false statement is that homosexuality is a sickness (Fone, 2000; Griffin & Harro, 1997; Kantor, 1998; Pharr, 1988; Sears, 1987). Other questions ask students to process their own notions of the LGBTQ community. After students complete the questionnaire, I provide the true/false answers, which prompt discussion. I clarify confusing concepts by encouraging questions and address misconceptions by presenting accurate research (Sears, 1987).

I distribute a sheet of vocabulary words and working definitions to each student. Vocabulary terms include *lesbian, gay, bisexual, transgender, queer, sexism, heterosexism, heterosexual privilege, homophobia, biphobia, gender identity, gender roles,* and *sexual orientation*. In *Teaching for Diversity and Social Justice*, Griffin and Harro (1997) supply definitions of these terms and a helpful chapter on how to facilitate a curriculum on heterosexism. Student volunteers read the vocabulary aloud. I instruct students to refer to the terms during the unit so that they can engage in informed dialogue by applying the appropriate language.

I draw two columns on the chalkboard and write "female" in one column and "male" in the other. I invite the class to generate a list of roles for each gender. I ask students to think about where these norms originated and if they vary in other cultures. Students evaluate whether any of the gender roles have changed over time and whether males and females fit neatly in the constraints of the categories on the list. Students are able to identify exceptions to the fixed female and male categories. It becomes apparent that gender roles are problematic—that the norms, behaviors, and actions used to define masculinity and femininity are oversimplified. Students come to realize that gender is more fluid than mainstream society acknowledges (Butler, 1993).

I borrow the next exercise from Pharr's (1988) workshop on homophobia and sexism. I ask students to envision what the world would be like without homophobia (Pharr, 1988, p. 7). Students break into groups to brainstorm ideas. We reconvene as a class and process each group's answer. I record the responses on the chalkboard and highlight the class' collective solution to eliminating homophobia. The common themes that emerge are tolerance for difference, equity for all, and freedom from gender stereotypes. These themes segue into a crucial discussion about how strict gender norms undergird sexism and homophobia (Blumenfeld, 1992; Fone, 2000; Griffin & Harro, 1997; Pellegrini, 1992; Pharr, 1988).

To demonstrate how sexism and homophobia intersect, I start with a dialogue about sexism. I ask students to consider the power relationship between men and women. Most students point to male dominance, yet some cite examples of females' advantages over males. I make clear that although in given situations

women may *individually* experience an advantage over men, women, unlike men in the United States, do not hold the *institutional* and *social* power to systematize these advantages (Griffin 1997; Pellegrini, 1992; Pharr, 1988).

I return to the discussion of gender roles. I emphasize that strict gender expectations operate to ensure that males hold social power over women (Griffin & Harro, 1997; Pellegrini, 1992; Pharr, 1988). When women act to resist their gender roles, they encounter political, economic, and cultural roadblocks set in place to keep women subordinate to men (Pharr, 1988). I explain that LGBTQ persons suffer for diverging from assigned gender expectations as well. Their gender roles are fluid and problematize the rigid male and female heteroidentities working to reinforce male supremacy (Blumenfeld, 1992; Fone, 2000; Pellegrini, 1992; Pharr, 1988). Students begin to understand that the stigmatization of both women and homosexuality are part of the sexist arrangement to sustain heteromale dominance (Griffin & Harro, 1997).

This guides the class into a conversation about homophobia. We analyze Owen's (1998) definition of homophobia as "an irrational and distorted view of homosexuality . . . [the] anxiety, disgust, anger, and hatred toward homosexuals" (p. 7). We study Pellegrini's (1992) idea of conceptualizing homophobia as plural. She theorized that there are four types of homophobias that can be "mapped along gender lines: (1) the homophobia of men toward other men; (2) the homophobia of men toward women; (3) the homophobia of women toward other women, and (4) the homophobia of women toward men" (Pellegrini, 1992, p. 48). I explain that lesbian, gay, bisexual, transgender, and queer persons are not "a monolithic, homogenous" group (Owens, 1998, p. 3) and reiterate that LGBTQ persons can experience homophobia differently from one another (Pellegrini, 1992). I affirm that though there is diversity among how LGBTQ persons are faced with homophobia, there are movements that encourage LGBTQ persons to join forces to promote initiatives (Sedgwick, 1990) such as the National Day of Silence, the Safe Schools Improvement Act, the Student Nondiscrimination Act, and the "It Gets Better" video campaign. I provide a list of organizations including the Gay, Lesbian and Straight Education Network (GLSEN); Parents, Families and Friends of Lesbians and Gays (PFLAG); and the Trevor Project that offer education and methods of action in promoting acceptance, ensuring safe school environments, and supporting LGBTQ youth.

Next, students explore the social construct of heterosexism and what heterosexual privilege means. We analyze Griffin and Harro's (1997) definition of heterosexism as "the societal/cultural, institutional, and individual beliefs and practices that assume that heterosexuality is the only natural, normal, acceptable sexual orientation" (p. 162). I emphasize that heterosexuals, whether knowingly or unknowingly, receive benefits for being heterosexual. The class forms a list of what these advantages are such as not suffering abuse for one's same-sex orientation, not having to hide one's identity, and possessing the freedom to marry one's partner in any state within the United States.

In the final unit segment, I ask the class to describe the actions taken by the characters in *The Laramie Project* to interrupt homophobia and heterosexism. We discuss what it means to be a heterosexual ally, and I invite students to recall any instances in which they have experienced, witnessed, or heard about someone acting as an ally. I ask students to devise a list of the possible costs and benefits of taking action against homophobia. From what I have observed over time, the students list more benefits than risks. Then I ask the class to identify school scenarios that target or ignore LGBTQ students. Students brainstorm how they can act as allies in these situations (Wijeyesinghe, Griffin, & Love, 1997). For the final activity, students write a reflective essay on *The Laramie Project* and the class discussions. I find that written reflection offers another opportunity for students to confront the subject matter, especially if they have been too shy or intimidated to verbalize their thoughts in class. Reflections have an added benefit as they point to areas where the curriculum can improve and evolve.

Overcoming Obstacles and Moving Toward Change

I am aware of detractors' claims that broaching the subject of homosexuality in the classroom is too hot an issue with possible job risks. Teachers decide to avoid what they perceive to be a troublesome topic in fear of phone calls from parents and administrators (Boler, 1999; Owens, 1998; Rivers & D'Augelli, 2001; Roy, 1997; Sears, 1987). Moreover, I understand firsthand the reality of negotiating the plethora of responsibilities placed on teachers. However, I do not view social justice as yet another chore. I view it as my duty as a responsible educator.

I urge that teachers stay open to the idea of incorporating critical discourse on homophobia and heterosexism in curricula. It is not permissible for teachers and students to continue to ignore and marginalize LGBTQ students in order to avoid discomfort and controversy.

As teachers, we need to commit to wanting such a social transformation for ourselves as well as our students. I think of Ceara Sturgis, who in 2009, as a 17-year-old honors student and lesbian in a Jackson, Mississippi, high school took a stance by posing in a tuxedo for her yearbook portrait. Administrators denied her request to wear a tuxedo and insisted that she wear the traditional drape for girls (Byrd, 2009). Sturgis's senior photograph was excluded from the yearbook portraits, and she bravely challenged her school's gender discrimination policy in federal court (*Sturgis v. Copiah County School District*, 2011).

I think of Constance McMillen, who in 2010, battled her Itawamba County School District in Fulton, Mississippi, for its refusal to allow her to bring her girlfriend to the high school senior prom and wear a tuxedo to the event. Rather than review and reconsider its policies, the district opted to cancel the prom entirely. With the assistance of the American Civil Liberties Union, McMillen successfully sued the district, yet the ruling did not require the district to reinstate the prom. Consequently, McMillen endured a backlash from classmates, parents, and

school officials and became a victim of a prom hoax where she, her date, and five classmates were directed to a fake prom while the rest of the senior class attended a private prom at an undisclosed location (Broverman, 2010). Unwavering, McMillen became an activist, took to the media to discuss her plight, and was victorious when a federal court ordered the school "to adopt a comprehensive nondiscrimination and nonharassment policy that covers sexual orientation and gender identity and expression" (Esseks, 2010, para. 3).

I think of Maverick Couch, who in 2012, as a 16-year-old openly gay Waynesville High School student in Ohio, has been fighting for his right to wear a T-shirt to school that states, "Jesus Is Not a Homophobe." His motivation for the shirt was to rally his peers, faculty, and school officials to support LGBTQ acceptance and awareness on the National Day of Silence. Instead, Couch was threatened with suspension, prompting him to enlist the help of Lambda Legal, an organization that fights for the rights of LGBTQ individuals. The school district deemed the shirt's message "sexual in nature and therefore indecent and inappropriate in a school setting" (*Couch v. Wayne Local School District*, 2012, para. 2), ultimately exposing its narrow definition of, and judgment of, homosexuality. As of late, a federal judge ruled that Couch be permitted to wear the shirt to school on the National Day of Silence. Proceedings are ongoing as Lambda Legal presses on to ensure that Couch can wear the shirt to school on any day.

I also reflect on those students who were bullied and publicly humiliated by classmates for their sexual orientation or perceived sexual orientation that led to tragic suicides. Tyler Clementi, Seth Walsh, Asher Brown, and Billy Lucas must never be forgotten.

Each of these stories, and the stories of countless LGBTQ teenagers who are denied their human and civil rights, motivate me to continue to do social justice work.

I do recognize my power position as a teacher (Freire, 1970; Li Li, 2004; Roy, 1997). From a student's perspective, I am the authority and expected to impart golden truths. Given this power relationship, I must be mindful not to impose my politics on students (Boler, 1999; Li Li 2004; Roy, 1997). Rather than indoctrinate, I must educate—to present social justice issues and equip students with a critical lens to interrogate social constructs.

I acknowledge that there will be students who outright refuse to accept any perspective I present that jeopardizes their belief systems. There also lies the possibility that students who appear to be onboard with social justice, may just be acquiescing to get through my class (Roy, 1997). Such situations are disheartening to any teacher trying to engage her students in complex analysis. However, this sort of resistance should be viewed as an indicator of where those students are in their personal and educational growth. It is up to students to decide whether they want to adopt new perspectives or retain their current beliefs, but this decision should come only after they have been exposed to a variety of discourses surrounding the topic of study.

In the face of challenges, there is the option to avoid conversations about homosexuality in the classroom altogether. For me, keeping silent is *not* an option. Keeping silent would reinforce heterosexual privilege. Silence would perpetuate a hostile

school atmosphere that violently alienates, ignores, and ostracizes LGBTQ students (Kantor, 1998; Owens, 1998; Rivers & D'Augelli, 2001; Sears, 1987). Silence would maintain the epidemic of incessant bullying of LGBTQ youth inside and outside of school and feed the crisis of a rising and alarming number of LGBTQ suicides.

A socially responsible alternative is to welcome difficult dialogue in the classroom and address possible concerns beforehand. Communicating with colleagues, administrators, and parents in advance can ease potential backlash and perhaps garner support of a more inclusive curriculum (Sears, 1987). Consulting LGBTQ community leaders as well as gathering educational resources from LGBTQ organizations can alleviate teacher unpreparedness. Inviting LGBTQ guest lecturers can dispel misinformation and aid teachers in raising awareness.

While obstacles remain in tackling homophobia and heterosexual privilege in the media arts classroom, an excerpt written by a former student of mine demonstrates the positives of encouraging open dialogue. I was delighted to receive an unexpected e-mail from the college sophomore at the time, in which he recollected his memories of my high school media arts class. He specifically referenced lessons on *The Laramie Project* and stated that "ever since . . . I have been accepting to people who have different sexual preferences than I do."

In my experience as a media arts teacher, film can be a way to start dialogue about social injustices and ignite students' social consciousness. Analyzing controversial film content affords students the opportunity to scrutinize accepted "truths" and the dominant systems set in place to maintain these "truths." Through an examination of the filmmaking process itself, students can discover how film can work to either disrupt or keep the status quo. Although some students may grapple with overcoming their biases and demonstrate resistance to subject matter that conflicts with their worldview, a colleague once assured me, "It is not our job as teachers to fix everything today. How students understand and what they understand informs where they are at that particular moment." The action I *can* take as a media arts teacher and social justice advocate is to put films like *The Laramie Project* out there and be confident that the lessons are in the imagery. Exposing students to films that tackle controversial concepts and uncover social injustices can activate dialogue, challenge students to think critically as a collective, and perhaps move students to transform "arbitrary social hierarchies" (Boler, 1999, p. 180).

References

Apple, M.W. (2004). *Ideology and curriculum* (3rd ed.). New York: RoutledgeFalmer.

Aronowitz, S., & Giroux, H.A. (1985). *Education under siege: The conservative, liberal, and radical debate over schooling*. South Hadley, MA: Bergin & Garvey.

Blumenfeld, W.J. (1992). Squeezed into gender envelopes. In W.J. Blumenfeld (Ed.), *Homophobia: How we all pay the price* (pp. 23–38). Boston: Beacon Press.

Boler, M. (1999). *Feeling power: Emotions and education*. New York: Routledge.

Broverman, N. (2010, April 5). McMillen: I was sent to fake prom. *The Advocate*. Retrieved from http://www.advocate.com

Butler, J. (1993). *Bodies that matter: On the discursive limits of "sex."* New York: Routledge.

Byrd, S. (2009, October 15). Ceara Sturgis, lesbian high school student, told she can't wear tuxedo in yearbook. *The Huffington Post*. Retrieved from http://www.huffingtonpost.com

Couch v. Wayne Local School District. (2012, April 4). *Lambda Legal*. Retrieved from http://www.lambdalegal.org/in-court/cases/couch-v-wayne-local-school-district

Darts, D. (2004). Visual culture jam: Art, pedagogy, and creative resistance. *Studies in Art Education, 45*(4), 313–327.

Esseks, J. (2010, July 20). Victory for Constance McMillen! [Web log post]. Retrieved from http://www.aclu.org/blog/lgbt-rights/victory-constance-mcmillen.

Fone, B. (2000). *Homophobia: A history*. New York: Metropolitan Books.

Freire, P. (1970). *Pedagogy of the oppressed* (M.B. Ramos, Trans.) (New rev. ed.). New York: Continuum.

Giroux, H.A. (1983). *Theory and resistance in education: A pedagogy for the opposition*. New York: Bergin & Garvey.

Giroux, H.A. (1997). *Pedagogy and the politics of hope: Theory, culture and schooling*. Boulder, CO: Westview Press.

Greene, M. (1995). *Releasing the imagination: Essays on education, the arts, and social change*. San Francisco, CA: Jossey-Bass.

Griffin, P. (1997). Introductory module for the single issue courses. In M. Adams, L.A. Bell, & P. Griffin (Eds.), *Teaching for diversity and social justice* (pp. 62–81). New York: Routledge.

Griffin, P., & Harro, B. (1997). Heterosexism curriculum design. In M. Adams, L.A. Bell, & P. Griffin (Eds.), *Teaching for diversity and social justice* (pp. 141–169). New York: Routledge.

hooks, b. (1994). *Teaching to transgress: Education as the practice of freedom*. New York: Routledge.

Kantor, M. (1998). *Homophobia: Description, development, and dynamics of gay bashing*. Westport, CT: Praeger.

Li Li, H. (2004). Rethinking silencing silences. In M. Boler (Ed.), *Democratic dialogue in education: Troubling speech, disturbing silence* (pp. 69–86). New York: Peter Lang.

Owens, R.E., Jr. (1998). *Queer kids: The challenges and promise for lesbian, gay, and bisexual youth*. Binghamton, NY: Haworth Press.

Pellegrini, A. (1992). S(h)ifting the terms of hetero/sexism: Gender, power, homophobias. In W.J. Blumenfeld (Ed.), *Homophobia: How we all pay the price* (pp. 39–56). Boston: Beacon Press.

Pharr, S. (1988). *Homophobia: A weapon of sexism*. Inverness, CA: Chardon Press.

Rivers, I., & D'Augelli, A.R. (2001). The victimization of lesbian, gay, and bisexual youths. In A.R. D'Augelli & C.J. Patterson (Eds.), *Lesbian, gay, and bisexual identities and youth: Psychological perspectives* (pp. 199–223). New York: Oxford University Press.

Roy, P.A. (1997). Language in the classroom: Opening conversations about lesbian and gay issues in senior high English. In J.T. Sears & W.L. Williams (Eds.), *Overcoming heterosexism and homophobia: Strategies that work* (pp. 209–217). New York: Columbia University Press.

Sears, J.T. (1987). Peering into the well of loneliness: The responsibility of educators to gay and lesbian youth. In A. Molnar (Ed.), *Social issues and education: Challenge and responsibility* (pp. 79–100). Alexandria, VA: Association for Supervision and Curriculum Development.

Sedgwick, E.K. (1990). *Epistemology of the closet*. Berkeley: University of California Press.

Sturgis v. Copiah County School District. (2011, December 8). *American Civil Liberties Union*. Retrieved from http://www.aclu.org/lgbt-rights/sturgis-v-copiah-county-school-district

Weiler, K. (1988). *Women teaching for change: Gender, class, & power.* New York: Bergin & Garvey.

Wijeyesinghe, C.L., Griffin, P., & Love, B. (1997). Racism curriculum design. In M. Adams, L.A. Bell, & P. Griffin (Eds.), *Teaching for diversity and social justice* (pp. 82–109). New York: Routledge.

Wolz, B. (2010). Cinema as alchemy for healing and transformation: Using the power of films in psychotherapy and coaching. In M.B. Gregerson (Ed.), *The cinematic mirror for psychology and life coaching* (pp. 201–225). New York: Springer.

11

EXPLORING ARTS-BASED INQUIRY FOR SOCIAL JUSTICE IN GRADUATE EDUCATION

Nana Osei-Kofi

1. What are ways to creatively introduce graduate students to the possibilities of arts-based inquiry in social justice research and practice?
2. How can arts-based inquiry be used to inspire social justice–focused graduate students to deeply examine and engage with different ways of knowing?

Years ago, I attended a roundtable on arts-based research methods at the annual conference of the American Educational Research Association. This was my first introduction to arts-based inquiry. Finding arts-based inquiry, a neglected piece of me, pushed aside in the name of "scholarship," was reawakened. Growing up, I lived for dance, theatre, and painting. As an academic, however, there was no place in my life for these things, other than as a hobby or as an observer, or so I thought. When I was in graduate school, I officially named academic writing as my new and chosen form of artistic expression. Yet despite my love for writing, after being introduced to arts-based inquiry, I knew writing alone would never be enough. Arts-based inquiry reawakened a creativity within that has allowed me to bring my whole self as a social justice advocate, scholar, teacher, and artist to my work in academia. So what is arts-based or arts-informed research and inquiry? Cole and Knowles (2008) describe it as

> a mode and form of qualitative research in the social sciences that is influenced by, but not based in, the arts broadly conceived. The central purpose . . . [is] to enhance [our] understanding of the human condition through alternative (to conventional) processes and representational forms of inquiry, and to reach multiple audiences by making scholarship more accessible. (p. 59)

Through this process, I believe strongly as Finley (2008) argues that "arts-based inquiry is uniquely positioned as a methodology for radical, ethical, and revolutionary

research that is futuristic, socially responsible, and useful in addressing social inequities" (p. 71).

Arts-Based Inquiry and Social Justice

Presently, I direct a graduate certificate program that focuses on social justice in the study of higher education. In this program, our curriculum centers on applying and engaging with social justice theories and practices to better understand and address root causes of issues of injustice related to higher education as a social institution. It was within this context that I in 2009 offered an intensive summer course on arts-based inquiry. Although I had regularly included arts-based assignments in my courses, I wanted to introduce students, in greater depth, to the possibilities of arts-based inquiry in social justice work.

Leavy's (2009) *Method Meets Art* had just been published, and I found it very useful as a course text, supplemented by other readings, multimedia materials, and presentations by invited speakers. The format for the course was based on a three-pronged approach. First, I aimed to familiarize students with the epistemological underpinnings of a range of arts-based research methods; second, I sought to expose them to existing arts-based work; and third, I wanted students to begin to apply arts-based methods to inquiry. Rather than striving for students to achieve mastery (which would have been impossible in one course), my intention was to create an opportunity for them to take seriously the idea of different ways of knowing and to actively practice diverse ways of producing knowledge. During the class, we focused primarily on collage, photovoice, poetry, and ethnodrama. Other topics included ethical considerations in arts-based work, bridging the art-science divide, issues of funding, and finally we also discussed the politics, challenges, and possibilities of using arts-based approaches to complete theses and dissertation work. In addition to meeting face-to-face daily for 5 hours over a 2-week time period, the class engaged in rich online discussions. While this first class was small in numbers, it was made up of a diverse interdisciplinary group of students. Collectively, they represented the study of higher education, sustainable agriculture, integrated studio arts, English, applied linguistics, sociology, public administration, and women's studies.

Taking the Leap

Meeting for the first time as a class, students were both excited and hesitant. Before class, they read an introductory chapter on arts-based research methods, as well as an article that exemplified the use of collage in research. Outside this, however, the content of the course was new and largely foreign to most. As an interdisciplinary group, our initial conversations revolved around students identifying dominant methods of inquiry in their areas of study. Comparing these accepted approaches and considering them in relation to arts-based methods, students began to see the

methodological supremacy in their fields and disciplines. Writing about sociology on the class blog, one student commented, "sociology as I have been exposed to it . . . is quite obsessed with proving that it is on par with the 'hard' sciences. . . . I am sometimes amused (sometimes scared) by the desire for sociologists to legitimize themselves in the eyes of 'science.'" Another student described applied linguistics research as relying primarily on quantifying survey and interview data, expressing frustration that "everyone plays the game of attempting to be objective while simultaneously accepting the impossibility of having consistent results." The comparative and self-reflexive approach that these quotes exemplify was made possible by the composition of the class and a shared objective of learning about something that was new to all. Even though graduate school traditionally is about a deepening of knowledge, it is also about a narrowing of the parameters of that knowledge as a prerequisite for being identified as an expert in a particular area. Hence, the silos that often characterize graduate education rarely provide opportunities for truly open interdisciplinary dialogue like the one that transpired in class.

There are those who believe that arts-based inquiry, rather than being positioned as oppositional to traditional approaches to research, should be viewed as supplemental (e.g., Cahnmann-Taylor & Siegesmund, 2008). My belief is that the use of arts-based approaches for social justice aims, by definition, must reject traditional approaches that "are implicated in colonialist traditions of objectivity and that treat production of knowledge as a function of social privilege" (Finley, 2008, p. 74). Without examining how power functions in the production of knowledge, we risk participating in a continued practice of creating knowledge that produces and reproduces oppressive conditions (Leavy, 2009). Hence, the conversation that students had about dominant approaches in their varied fields/disciplines was of great import to sensitizing them to thinking critically about research for social justice.

To set the stage for our time together as a class, I wanted to begin by engaging students in exercises that would unsettle the dominant mind-set of scholarship as merely a cerebral activity, while also stimulating their creativity. Using an activity developed by a former student, we began with a visual free-association activity. Each holding a set of cards with diverse images, going around a table, students were asked one by one to place cards on the table and connect them with any card already on the table, based on a relationship they saw. This exercise was a way to symbolize and begin to discuss the ways in which our research is never removed from our own frames of reference. By using association rather than a linear process of organization, this exercise also sought to make salient the possibility of different forms of discovery, knowing, and interpretation (Walsh, 2006). As a closing activity for our first class meeting, I covered our meeting table with butcher paper, provided students with finger paints, and asked them to use these in any way they wanted, to describe their feelings and expectations for the class. Many started cautiously, commenting that they had not used finger paints since they were children. Nonetheless, gradually this uncertainty turned to intentionality. When finished,

students discussed what they had created and what it represented for them. Some commented that through the process they had identified feelings about the course that they had not consciously been aware of previously. Others shared gaining new insights about their own process and reasons for taking the class. Close to the end of the course, an integrated studio art student shared that following our finger painting session, she had met with her advisor and was almost unable to contain her excitement about being in a class where she was allowed to get her hands dirty. Even though she was working on a degree in art, much of her coursework to that point had been cerebral in nature, and through finger painting, she recognized how much she had missed the tactual elements of art creation.

From Theory to Practice

The first arts-based approach we explored was photovoice. Photovoice is a community-based methodology that is founded on the assumption that community members have the greatest knowledge of their own lives. Prevalent in community health research, photovoice uses documentary photography by study participants to engage, address, and improve social conditions. Through images, photovoice can be a powerful tool to call attention to the everyday, to communicate complex ideas, to represent multiple viewpoints, and to evoke embodied responses as well as multiple interpretations of social conditions. Given the visual nature of contemporary culture and the popularity of documenting life through photography, I imagined that most, if not all, students in the class had some previous exposure to photography. Given this familiarity, I felt photovoice was a suitable beginning point to introduce arts-based inquiry. To embark on this journey, the class read three articles (Hergenrather, Rhodes, & Clark, 2006; Ornelas et al., 2009; Wang, 1999) that exemplified the use of photovoice in social justice work. Focusing on health disparities, gender inequity, and racism, these readings functioned as an illustration of the main goals of photovoice: "To enable people (1) to record and reflect their community's strengths and concerns, (2) to promote critical dialogue and knowledge about personal and community issues through large and small group discussion of their photographs, and (3) to reach policymakers" (Wang, 1999, p. 185). Using these materials as a foundation, I introduced students to the SHOWeD method for documentary photography analysis used in photovoice (What do you *See* here? What is really *Happening* here? How does this relate to *Our* lives? *Why* does this situation, concern, or strength exist? What can we *Do* to improve the situation or to enhance these strengths?) (Wang, 1999). As the questions posed using the SHOWeD method demonstrate, photovoice, which has its roots in feminist inquiry, is particularly appropriate for social justice work as it recognizes and values the subjective experiences of those involved; gives members of the community control over how their lives are represented, often challenging dominant assumptions; and is an approach that explicitly seeks to achieve progressive social change (Wang, 1999).

Because the course was being offered as a summer intensive, there was insufficient time for students to develop a complete photovoice project working within a community and taking seriously the ethical considerations that are a must. Instead, I asked students to identify and investigate a need within a community of which they viewed themselves as being a part. This way, students served as both facilitators and participants, responding to issues they identified through their own documentary photography, for the purpose of beginning to become familiar with the possibilities of photovoice.

As an example of one of these projects, one student's work focused on the disposal of household items on the roadsides of rural Iowa. Discussing her inquiry and photographic work, which included images of big clunky computers dumped in open fields, the conversation centered on different relationships and consequences of community economic conditions, state disposal fee policies, access to appliance recycling facilities, and environmental issues. While the student did not use the language of environmental classism, the concerns she captured through her photography and the conversation that ensued lifted forth the complexity of disproportionate impacts of environmental policies on low-income communities, groups, and individuals. Through her work, she highlighted a social justice issue that is often hidden in plain sight, and the visual aspect of her work made it difficult to ignore.

Out of all the work in which we engaged in the class, students found their efforts to write poetry and ethnodramas the most challenging. In exploring poetry, the students read about multiple forms of poetry. We discussed the differences between poetry based on interviews that seeks to tell a story and poetry where the expression of emotion is primary. We also looked at poetry that seeks to bring together the voices of researchers and study participants, as well as poetry that draws on literature in order to synthesize scholarship in relation to inquiry. For their poetry assignment, students could choose to write either what is known as a literature-voiced poem, synthesizing scholarship, or an autoethnographic poem, exploring some aspect of their lived experience. In this verse from a poem capturing her graduate school experience, a student articulates her frustration with gaining access to a research site.

> Smoke in mirrors.
> We had the approvals, then they said no, what's going on?
> Raised a red flag—like a fire through the place!
> Who is she? Is she legit?
> So yeah, it's been quite a process—an education in itself.
> But my thesis will be done early fall.

When we covered ethnodrama, that is to say, the dramatization of research data through script writing, members of a local reader's theater group visited class. The group, which came together as part of an English class in 2007, shared their

process of collaboratively creating a reader's theater script based on interviews with a wide range of community members, concerning the changing landscape of rural Iowa. Bringing together the voices of local Iowans, from small-farm owners to meatpacking plant workers to representatives of large agribusiness, the group's performance put a human face on changing conditions in rural communities. In so doing, the play explored tensions between the well-being of the members of these communities and the profit motives of large agribusiness taking over. In addition to performing parts of their reader's theater and assigning parts to students in the class, the members of the group also discussed the ways in which different audiences responded to their work. Depending on the composition of the audience and which of the characterized individuals with whom they identified the most, lively conversations would ensue. College students concerned with sustainable agriculture focused on the importance of environmental stewardship, while local community members identified with losing their family farms, while yet others, such as local business owners, placed emphasis on the attainment of a balance between preserving the community and the need for economic growth. Together with the theater group members, students in the class engaged in a lively discussion about the purpose of performing research and the role of audiences. This conversation highlighted the ability of ethnodrama to present multiple experiences in ways that are accessible to a wide range of audiences and to stimulate critical conversations in an effort to understand and engage with community concerns holistically. Despite feeling hesitant about their own abilities as performers due to a lack of experience, many students shared seeing the potential for performance approaches to research in their own areas of scholarship. Commenting on the class blog, one student wrote the following:

> I think that readers' theatre is the most accessible of all of the methods . . . thus far. It's accessible to participants (limited staging, no memorization) and accessible to the audience. It can involve laypersons and professionals. Most importantly, it gives *voice* and opens up new narratives. It provides a human face to policy issues and "numbers." It sufficiently complicates the world, and allows for multiple viewpoints.

From discovery to consciousness raising to exploration, collectively the class felt strongly about the possibilities of performance as an art form in the service of social justice work. Using existing data, students experimented with writing their own short scripts on issues as diverse as the continued plight of Black farmers in America to wrongful incarceration and the work of the Innocence Project to bullying in the workplace.

The reasons I believe students found these two assignments challenging brings two critical matters in arts-based inquiry to the fore. The first concerns embodied experiences. On the one hand, embodied experiences are critical to arts-based inquiry for the purpose of social justice. On the other hand, to consciously bring

our bodies to the learning experience is both uncommon and even discouraged in academia. To consciously bring our bodies to our work, to engage the body as a site of knowing, is to challenge the erasure of the body in traditional scholarly practices (Ellingson, 2006). Therefore, despite students' initial discomfort, it was important to me that I found ways for students to participate in embodied experiences. Discussions of vulnerability and self-reflexivity featured prominently in our engagement with embodied knowledge. In one of these discussions, commenting on the impact of arts-based inquiry on her as a researcher, one student said:

> I think that an arts-based approach forces me to involve my emotions, and implicate myself in my research. I can't hide behind the "objectivist" framework, and I can't pretend that it's "just research." I think that involving the arts is a way to consciously bring humanity into my work—it holds me accountable to my research participants and my own ideals.

As the outlook of this student reveals, self-reflexivity "is both an epistemological statement about the connected nature of knowledge and a political statement about the noninnocence of research" (de Freitas, 2008, p. 470). It is an acknowledgement that our own world views and life experiences impact our work, while also recognizing that the process by which we engage with our work and what we learn from it also transforms us.

The other issue students' initial feelings about poetry and ethnodrama made salient is the ongoing conversation within arts-based inquiry about who can engage in arts-based practices and what artistic and scholarly standards should be used to answer this question. While there was a general comfort level among students with engaging in work that involved photography as an art form, to pursue poetry and drama brought up concerns about not being formally trained or sufficiently skilled poets and scriptwriters. In response to this issue, there are a number of perspectives in the literature. There are those that seek to find legitimacy and belonging by using the language of science to call for the development of standards that resonate with more traditional approaches to research. For example, Cahnmann-Taylor and Siegesmund (2008) suggest that "art . . . [is] part of rationality. . . . [therefore having] a place in structured inquiry" (p. 242). Others place strong emphasis on the adoption of aesthetic artistic standards. Piirto (2002), for instance, advocates for strict aesthetic standards, expressing outrage over the use of art by scholars without formal training. Her argument is based on the idea that to use art forms without being trained in traditional conventions is an offense to the form and to those who have achieved mastery through formal schooling. Some see science and art-based methods as complementary (e.g., Mc-Niff, 2008). Yet others suggest that arts-based inquiry is located outside of existing frameworks for traditional research, and art and must therefore be understood as an approach in its own right (e.g., Finley, 2003; Springgay, Irwin, & Kind, 2005). From the standpoint of seeing arts-based inquiry as "one among many systemic

studies of phenomena undertaken to advance human understanding, not exactly art and not exactly science" (Finley, 2003), efforts have been made to develop ways of assessing arts-based inquiry that focus on process as the core assessment of work rather than the final product. Along these lines, the suggestion is made that standardization and rule making are the building blocks of elitism and exclusivity and thus stand in opposition to arts-based inquiry as an effort to engage in living inquiry "that breathes, that listens," (Springgay, Irwin, & Kind, 2005, p. 899), that is forward looking, that seeks to address social and economic injustice, and that is grounded in community.

Doing work for social justice, the *process* in arts-based inquiry is central to my practice. A couple of years ago, I conducted a collage workshop in relation to organic coffee growing and sustainability in Boquete, Panama. The purpose of the workshop was to introduce participants to the use of collage as an approach to inquiry, conceptualization, and reflection. The participants included local community members fighting to preserve small locally owned organic coffee farms and a local way of life. Their fight was in response to an influx of European and American expatriates with financial resources and ideas of "growth" that threatened the local community's existence. Students from the United States who had spent time in Boquete studying this issue were also a part of the group. After introducing the group to collage work, students and community members worked collaboratively to create collages that captured the current issues at stake in Boquete through their eyes, as well as depicting future visions for the community. Through the process of collage making and the discussion that took place both during and after the art-making activity, viewpoints of group members were crystallized, language barriers were curtailed, and new understandings of the situation lifted forth. Because participants were engaged with something that was new to all of them, hierarchies based on social status were also significantly diminished. Those who had not previously spoken up in meetings were able to visually capture their sentiments, making others aware of them and also providing an avenue for further discussion. While the students would eventually return to the United States, community members asked to keep the collages to share with others who had not been present, as a way to continue the conversation about the issues with which they were struggling. Through this process, the practice of collage became a dynamic tool for engaging with social justice concerns in Boquete.

I share this experience because it represents a process as well as an outcome that is specific to the use of arts-based inquiry. It is not something I think I could have been achieved through traditional methods. I believe, as Finley (2008) argues and my experience exemplifies, that "arts-based methodologies bring both the arts and social inquiry out of the elitist institution of academe and art museums, and relocate inquiry within the realm of local, personal, everyday places and events" (p. 72). If the purpose of our work is social change through understanding, consciousness, and action, then our primary modes of evaluation must be in relation to the communities with which we work. Concomitantly, as a photographer and a

former dancer, I recognize that there are elements of my training in these areas that give me access to modes of expression that may not be available in the same way to someone without this training. Having said that, dominant understandings of what is beautiful or powerful artistically are laced with histories of racism, sexism, colonialism, homophobia, xenophobia, and classism. Hence, in our work, we must reevaluate not only how we understand truth and knowledge, but also how we understand beauty (Leavy, 2009). To my senses, to my body, to my mind, I repeatedly experience powerful ideas articulated through art by people without any formal training in their chosen art forms. There are multiple ways in which art forms are expressed grounded in culture, history, identity, and context, and there must be a place for these forms of expression if arts-based inquiry is to address social inequities through participatory community-based approaches. To my thinking, this in no way takes away from what formal training in art can/may add to the work. Instead, it is about a broad and inclusive, fluid conception of art. It is for these reasons that I believe we must be willing to experiment in arts-based inquiry. According to Saldaña (2008), "Most of us have been indoctrinated through the culture of university coursework and scholarly publishing to … think in certain standardized ways" (p. 203). Therefore, if we don't experiment with how we practice as well as how we represent our work, we limit what is possible by having access only to that which is deemed hegemonic in research as well as art (Finley, 2003).

Making Meaning of the Experience

The content and intensity of the class, and the small number of students with a variety of areas of expertise, collectively exploring something new, created a situation where a sense of community formed quickly. It was not unusual for conversations to begin before our set start time and to end well after class was officially over. At the end of the course, several students commented that as a result of the intensity of the class, there was no time to think about whether or not this was something they were good at, if they were doing the "right" thing, or if their work was of high enough quality to share with others. In an unexpected way, the intensity of the class coupled with its size created somewhat of a reprieve from doubt and self-consciousness, while making room for engaged and embodied practice.

For their final projects, students created triptych collages to capture their experiences at the beginning, middle, and end of the course. I encouraged them to work on this project throughout the course to capture their feelings and experiences at these different time markers. Using this approach, their art functioned as a self-reflexive tool during the class and also provided me with assessment data on their course experience. I was struck by the variety in the work students produced. No longer were projects similar to one another as is often the case in graduate classrooms, where playing it safe holds greater value than experimenting with something new. Instead, defining triptych broadly, projects ranged from photography to multimedia, collage, and painting.

In one piece, a student used a garden to symbolize her work in sustainable agriculture, and growth as metaphor, to capture her experience. In the first piece of her triptych, she used a lawn to represent the control of nature and hegemonic aesthetics, a safe to represent locked up creativity, and the cow and moon as a reminder of childhood and greater access to our intuition. Building on this, she illustrated the midpoint of the class using a lawn once again, but this time it was wild and uncontrolled with an image of hands on it. Writing about this time period, the student said, "At this time, I felt especially vulnerable, but the hands express the way that the class took care of me, and the safety I felt expressing my story." In her final piece, representing the end of class, she played with the idea of fruit. In her statement about this piece, she says,

> Here the garden is upside down, the grass is now sky, the fruit provides the trunk for thought. There is also a living part to this garden—the plant is a cutting from my grandmother's houseplant. So, while we are bearing fruit, we are also building the roots, and carrying our experiences forward into new environs.

Her approach is self-reflexive, embodied, informed by a vision and commitment to social justice, while at the same time it gives me important information about her experience with the class.

Conclusion

Being involved with art and social justice work, I see arts-based inquiry as providing creative, imaginative, participatory, and action-oriented approaches to examining a range of issues related to social and economic justice—from questions of how knowledge is defined, to relations of power, social inequities, modes of resistance to oppression, and possibilities for radical praxis. As we develop new and promising forms of engagement that are based on social justice aims, arts-based approaches to research create new possibilities for coming to know, for discovery of self and others, for creativity and embodiment of our work, for consciousness raising, for questioning, for community engagement, for action, and ultimately, for social change.

References

Cahnmann-Taylor, M., & Siegesmund, R. (Eds.). (2008). *Arts-based research in education: Foundations for practice.* New York: Routledge.

Cole, A., & Knowles, G. (2008). Arts-informed research. In G. Knowles (Ed.), *Handbook of the arts in qualitative research* (pp. 55–70). Thousand Oaks, CA: Sage.

de Frietas, E. (2008). Interrogating reflexivity: Art, research and the desire for presence. In G. Knowles (Ed.), *Handbook of the arts in qualitative research* (pp. 469–467). Thousand Oaks, CA: Sage.

Ellingson, L. L. (2006). Embodied knowledge: Writing researchers' bodies into qualitative health research. *Qualitative Health Research, 16*(2), 298–310.

Finley, S. (2003). Arts-based inquiry in QI: Seven years from crisis to guerilla warfare. *Qualitative Inquiry, 9*(2), 281–296.

Finley, S. (2008). Arts-based research. In G. Knowles (Ed.), *Handbook of the arts in qualitative research* (pp. 71–81). Thousand Oaks, CA: Sage.

Hergenrather, K. C., Rhodes, S. D., & Clark, G. (2006). Windows to work: Exploring employment-seeking behaviors of persons with HIV/AIDS through photovoice. *AIDS Education and Prevention, 18*(3), 243–258.

Leavy, P. (2009). *Method meets art: Arts-based research practice.* New York: Guildford Press.

McNiff, S. (2008). Arts-based research. In G. Knowles (Ed.), *Handbook of the arts in qualitative research* (pp. 29–40). Thousand Oaks, CA: Sage.

Ornelas, I. J., Amell, J., Tran, A. N., Royster, M., Armstrong-Brown, J., & Eng, E. (2009). Understanding African American men's perceptions of racism, male gender socialization, and social capital through photovoice. *Qualitative Health Research, 19*(4), 552–565.

Piirto, J. (2002). The question of quality and qualifications: Writing inferior poems as qualitative research. *Qualitative Studies in Education, 15*(4), 431–445.

Saldaña, J. (2008). Ethnodrama and ethnotheatre. In G. Knowles (Ed.), *Handbook of the arts in qualitative research* (pp. 195–207). Thousand Oaks, CA: Sage.

Springgay, S., Irwin, R. L., & Kind, S. W. (2005). A/r/tography as living inquiry through art and text. *Qualitative Inquiry, 11*(6), 897–912.

Walsh, S. (2006). An Irigarayan framework and resymbolization in an arts-informed research process. *Qualitative Inquiry, 12*(5), 976–993.

Wang, C. C. (1999). Photovoice: A participatory action research strategy applied to women's health. *Journal of Women's Health, 8*(2), 185–192.

SECTION II

Theorizing and Reflections

Introduction

Tom Barone

John Dewey, in his book *Experience and Education*, suggested that within a truly educational experience facilitated by a teacher there could be identified two significant, if overlapping, dimensions. The first of these is the arrangement of the learning environment in a manner that induces students into seeing and understanding facets of the world in a surprising new way. In the second phase, the student is given an opportunity to reflect on the meaning of that experience. The two sections of this book are designed to approximate an analogy of a text that exhibits those two dimensions—with the author of each chapter playing the role of pedagogue, and each reader that of student.

As you have read, the first section offered a number of chapters designed to pull readers into an array of strange new worlds. Each is intended to acquaint us with innovative artistic projects from a variety of locations, but all sitting at the intersection of the arts, education, and social justice. Each enables us to vicariously experience the manner in which art can be a tool for enabling children and adults to gain greater mastery over their worlds and their futures.

The second section is meant to complement the first, insofar as it allows for critical reflection on and theorizing about important issues, if also within the contexts of specific examples from the same sort of intersections. For inclusion within it, as with the first section, we have selected, from numerous submissions, a powerful set of chapters that collectively reflect diversity in several dimensions.

One dimension involves the existential positioning and cultural backgrounds of the authors, whether in terms of gender, race, or ethnicity. But some chapters are also more intimately autobiographical than others, with authors more likely to declare themselves as members of social categories, while, of course, avoiding any pretense of acting as a singular, privileged spokesperson for any social group.

Another dimension of diversity concerns the art forms on which the authors focus. For Heather Homonoff Woodley, the medium is dance. Christine Morano Magee and Carol A. Kochhar-Bryant suggest the power of learning the arts in a studio environment where "students are empowered to take charge of their learning . . . by selecting the tools and modality that best fit their cognitive style."

Yet another source of diversity involves the expressive approaches and compositional styles that each author employs. Many chapters are in the form of literary essays. Some, such as the chapter by Ayoka Chenzira, highlight the power of narrative storytelling. And Mary E. Weems and R. A. Washington actually move beyond the composition of a typical literary essay into a kind of qualitative case study that consists of a collage of poetic imagery. Some chapters seem broadly and deeply philosophical. Marit Dewhurst maps the theories and practices of the arts as social justice. I would cite here Justin Laing's remarkable contribution to our thinking concerning African-centered arts education in American schools. Laing argues cogently for enabling African American students to realize their conception of "the good" through a form of arts instruction that stresses the importance of the imagination in creating counternarratives to the debilitating regime of truth about who they are and who they can become. Gilda L. Sheppard and bell hooks imagine teaching and learning as artistic forms through a set of dialogues that claim the margin as a position of possibility, critique, and action.

Still other chapters in this section are remarkable in their capacity to surprise us with their portraits of unexpected educational venues where art and emancipatory struggles might comingle. There are Heather Homonoff Woodley's belly dancing classes, which—much like the storytelling in Chenzira's beauty parlors—serve, perhaps unexpectedly to some readers, as a route to understanding female community and "ourselves." And, again, Weems and Washington's powerful cri de coeur expresses the exquisite pain of those whose homes were stolen from them in the American home foreclosure crisis.

In these and other ways, the chapters in Section II offer diversity; each is, in fact, unique. But while exhibiting these variegations and others, the chapters also have one very important thing in common, which they share with the chapters in Section I. Each in its own way offers itself up as a starting point for exploring the possibilities of culturally relevant arts education.

12

NARROWING IN ON THE ANSWERS

Dissecting Social Justice Art Education

Marit Dewhurst

1. How do we best articulate the practice of social justice art education? Who are the "players"? Where is the "action"? How do we know it when we see it?
2. In preparing young people to create works of social justice artwork, how do we teach them about the context of their work and how to evaluate their success?

Like many educators interested in creative ways to engage young people in reimagining the world to be a more just and equal place, I was immediately drawn to the innovative ideas that seemed to coalesce around emerging theories of social justice art education. The more I participated in this field, the more I became fascinated with the various ways that the intersection of art and social justice is labeled, researched, and practiced. Perhaps more importantly, I began to take note of the subtle differences of interpretation and generative questions that have surfaced in recent scholarship on social justice art education. From questions about the potential for "real" change outcomes and how to measure those outcomes, to discussions about the very identity of the artist in social justice education, there is much to learn from a dissection of the ways in which social justice art education is written about and debated.

Drawing on literature from across multiple disciplines, this chapter offers a brief overview of the field of social justice art education. In identifying the key characteristics of the artist, the artwork, and the audience within social justice art making, I offer tools to help educators and researchers better understand the nature of this work. Finally, I draw attention to some of the pressing questions that regularly arise in discussions of social justice art education—questions that can shed light on how we analyze and support contemporary practices of social justice art education.

Terms and Foundations

Before proceeding, I offer a brief note about the theoretical foundations and terminology on which this chapter rests. Artwork that addresses or attempts to directly impact social inequality and injustice has been called by many names, among them activist art (Felshin, 1995), community-based arts (deNobriga & Schwarzman, 1999), public art (Lacy, 1995), art for social change (O'Brien & Little, 1990), Theater of the Oppressed (Boal, 1979), art for democracy (Blandy & Congdon, 1987), and community cultural development (Adams & Goldbard, 2001). What this work shares is a commitment to creating art that draws attention to, mobilizes action toward, or attempts to intervene in systems of inequality or injustice. In the context of this chapter, it is the artwork I refer to synonymously as *social justice art* or *activist art*. While there is a history of art historical scholarship about this work (Felshin, 1995; Lacy, 1995), rarely has it been viewed through the lens of education. Sharing the same intentions as activist art—to impact systems of inequality and injustice—critical pedagogy provides the ideal framework to situate social justice art education.

As an important subfield of education, critical pedagogy has, for decades, challenged educators to reframe knowledge as emancipatory and to strive for a critical awareness of the world that can be used to dismantle oppressive social structures (hooks, 1994). Brazilian educator Paulo Freire (1970) described critical pedagogy in opposition to the concept of "banking education," writing that "authentic liberation—the process of humanization—is not another deposit to be made in men" (p. 60). Subsequent scholars called for altering the ways in which learners and teachers value and pursue knowledge: Through a coconstructed critical inquiry into understanding the world, critical pedagogy would transform how people made sense of the world (Darder, 2002; McLaren, 1989/2003). This transformation, or development of critical consciousness, would occur through "praxis: the action and reflection of men and women upon their world in order to transform it" (Freire, 1970, p. 60). These two key activities contained within the concept of praxis—critical reflection and action—are at the core of social justice education practices increasingly gaining popularity in progressive education circles (Giroux, 2001; Horton & Freire, 1990; Shor, 1992).

Mapping the Field: Converging Disciplinary Strands

Long before there were scholars and critics seeking to name the kind of social justice–infused art practices currently gaining popularity in art education, people were creating art as a way of narrating, shaping, and making meaning of their experiences in the world (Eisner, 2002; McFee, 1998). As Chalmers (1996) writes, "all groups need and use art for purposes of identity, continuity, and change and to enhance their cultural values" (p. 28). Without dwelling on the many ways in which art has been employed in cultures across time and place to document, convey, and communicate cultural norms and expectations, it is important to recognize that

the roots of social justice art education can, in fact, be traced to these early social artistic practices (Chalmers, 1996; Muri, 1999). Throughout human history, the unique capacity of socially engaged artistic practices to impact political and cultural understandings, attitudes, and behaviors has been a powerful tool for social critique and action, be it as a way to motivate people to attend religious services or as a tool for informing people about social atrocities or inequalities (Felshin, 1995; Hirschman, 2002; Lippard, 1984; Reed, 2005). In contemporary history, art created with social justice aims in mind includes the freedom songs of the civil rights movement, the Chicano mural movement, the performance pieces of the AIDS awareness campaigns, and the rise of Hip Hop (Baca, 2005; Felshin, 1995; Lippard, 1984; Reed, 2005; Rose, 1994).

To provide a map of the field is a complex endeavor, largely due to the multiple disciplinary lenses applied to this work. At first glance, it appears that there are two major strands of writing about the juncture of art and social change. The first stems from the world of art history and art criticism and focuses largely on the distinction between art made with social justice aims and art made for other purposes. In this strand, art is often discussed with an awareness of the economics of art and the historical traditions of fine art (Allen, 2011; Lippard, 1984). Emphasis is placed on the final product as the site for critiquing, challenging, documenting, and at times posing an intervention against inequality and injustice. Artwork often discussed through the lens of this strand includes works that are occasionally purchased by large collectors and are a part of the art market. Key examples are likely to have clear, timely, and overtly political aims that guide the art making, such as the work of Group Material, Alfredo Jaar, Emily Jacir, Judi Werthein, Peggy Diggs, or the Guerilla Girls, among many others.

The second strand grows out of community organizing and focuses more on the relationship between art and the people who choose to engage in its creation (Goldbard, 2006). Here, the discussion of art emphasizes the psychology and sociology of creation and its ability to communicate with, inspire, and motivate people (Blandy & Congdon, 1987; Cleveland, 2002; Korza & Bacon, 2005). In this strand, art is often viewed as a tool for exploration, advocacy, expression, and at times direct action against inequality and injustice. Though disparate in their approaches to the subject of activist art, these domains offer important contributions to understanding how and why people use various artistic practices to actively engage audiences in changing conditions of inequality and injustice (Dewhurst, 2010; Knight, Schwarzman & Forney, 2006; Quinn, Ploof, & Hochtritt, 2012). Artwork analyzed through the lens of this strand often operates outside the art market and is rooted in the local experiences of the artists. Key examples are likely to be driven by inductive organizing efforts that aim to impact unjust attitudes, beliefs, and relationships, such as the work of El Teatro Campesino, Alternate ROOTS, and Liz Lerman's Dance Exchange.

These two strands mark decidedly different disciplinary lenses through which to view social justice art education. The first strand, which is more art historical, brings a keen awareness of the aesthetic quality, historical and cultural context, and

analysis of the art-making process to the understanding of social justice art education. Meanwhile, the second strand offers a nuanced assessment of the community significance, psychosocial outcomes, and possibilities for individual and social transformation. While these disciplinary approaches can make for complicated conversations about field-wide definitions and practices, they also meet, overlap, and move away from each other in ways that may reveal the important and binding commonalities of this field. Drawing on literature from across these strands, a picture of the key features of social justice art making emerges as a helpful tool to understand the nature of our work.

Key Features of Social Justice Art Making

In an effort to articulate the inherent qualities of social justice art, it is useful to artificially isolate the three main "players" of this practice: the artist, the artwork itself, and the audience. These three components offer entry points into the cross-disciplinary analysis of the key characteristics of this unique social phenomenon, while simultaneously drawing attention to the important connections between these three pieces of the puzzle.

Defining Social Justice Art: The Artist

A closer look at how the artist has been discussed in anthropological, sociological, and art historical literature sheds additional light on this art form. From the tradition of the *griot* to modern muralists, artists have played a pivotal role in memorializing, critiquing, and shaping society (Felshin, 1995; Ianni, 1968; Reed, 2005). As a social figure, the artist is often seen as a moral or cultural visionary offering affirming or critical commentary on societal values and actions. In this position, the artist has been framed as a cultural agent capable of powerful social and political influence (Becker, 1994; Boal, 1979; Marcuse, 1978; Reed, 2005). In looking across literature that describes the artist as an agent for social change, several recurring traits or abilities are described as guiding the artist's actions in making and sharing activist art. These traits consist of the following: a dedication to critical inquiry and reflection, an ability to imagine possibilities, a commitment to collaboration across socially constructed barriers, and a sense of agency or empowerment resulting from their work in the arts.

Core to art making is the process of inquiry—a cycle of asking questions, pursuing answers, and making connections (Albers, 1999; Perkins, 1989). This inquiry can be seen in how an artist might continually explore the way lines and colors can convey sunlight on a body of water. Artist Yong Soon Min (cited in Cahan & Kocur, 1996) describes this process in her artwork:

> Art making for me is a process of discovery and learning about myself and my relationship to the world. This art making also involves my desire to

communicate and to share this exploration and understanding with others and thereby complete the dynamic. (p. 141)

In investigating such essential issues of identity and purpose, the social justice artist combines critical self-reflection with "a high degree of preliminary research, organizational activity, and orientation of participants" in order to come to a greater awareness of one's artistic work in relation to the community in which it takes place (Felshin, 1995, p. 11). This dual act of reflection engages the activist artist in a layered act of inquiry into her own role in society and the purpose of her artistic practice within the community in which it is situated, often paralleling the reflective inquiry espoused by critical pedagogues (Darder, 2001; Freire, 1970).

This inquiry is extended beyond a critique of one's own identities when it interacts with the creative imagination required of art making. In writing about his work as an activist artist, Guillermo Gomez-Peña (1994) claims that "the job of the artist is to force open the matrix of reality to admit unsuspected possibilities" (p. 212). The capacity to imagine is a recurring theme among activist artists, for it is this ability that permits the exploration of alternative possibilities to the status quo. Maxine Greene (1995) poetically defines imagination as the practice of "looking beyond the boundary where the backyard ends or the road narrows, diminishing out of sight" (p. 26). Imagining new ways of being in the world and dreaming of alternative ways of interacting with society is a practice that is a recurring theme for the activist art where the artist strives to show her audience that another way of being or understanding is possible.

Paired with the parallel reflective inquiry required of creative production, activist artists can thereby offer a visceral or physical alternate vision of reality, what Dimitriadis and McCarthy (2001) name "utopian visions," that may serve as an act of resistance, critique, or affirmation of the social status quo (O'Brien & Little, 1990). The ability to imagine possibilities beyond the scope of the status quo has a profound impact on one's understanding of one's capacities and the potential for change in society (Dimitriadis & McCarthy, 2001; Greene, 1995). It can be a way of redefining one's self image, moving beyond socially imposed identities, and asserting one's active role in society. Given the accessibility and visceral nature of art as a form of communication, social justice artists provide important counternarratives to dominant discourse, exposing the experiences of ignored communities of people and offering alternative ways of being in the world. Such characteristics bear a remarkable similarity to social justice education's call for counterhegemonic action and the inherent move to work toward a world devoid of oppression (McLaren, 1989/2003).

Defining Social Justice Art: The Artwork

In addition to an understanding of the common characteristics and historical significance of the activist artist, it is useful to look at the ways in which the artwork itself has been described in the literature. Across multiple purposes and genres, one

of the most important characteristics of all art is its ability to communicate ideas, emotions, or experiences through imagery, audio, movement, metaphor, or other forms of expression (Chalmers, 1996; Davis, 2005; Dewey, 1934/1980). When paired with the intention of social change, the ability to communicate ideas where words alone might not adequately suffice opens up an additional way to interact with ideas. Social justice art may provide an indirect avenue by which one may reflect on and confront complex or contentious ideas that are difficult to discuss in conventional modes of direct verbal communication (e.g., death, racism, and love). As Becker (1994) explains, "What is almost unspeakable, what cannot be contained is allowed to live through the form of art" (p. 118). When defined as the critical expression of an idea, activist art offers a unique space to engage with concepts that may be otherwise challenging concepts to explain, such as issues of identity, oppression, or freedom.

As the product of a social artistic practice explicitly intended to change social attitudes, behaviors, or policies, activist art is often used to awaken awareness, mobilize people to action, or inform people of specific social conditions. As discussed in the role of the social justice artist, this is often referred to as "giving voice to" or "making visible" a specific issue, community, or action. The artwork then becomes the voice or symbolic stand-in for the people or issue that has been "invisible" or "silent" in society. Chalmers (1987) describes this marriage of "voice" and social justice in art, pointing again to the communicative role of works of art:

> As used by dissident groups, art may create awareness of social issues. In this context it provides a rallying cry for action and social change. To be sure, art can be used for decoration and enhancement; but to fulfill its total function, art has to achieve communication with its audience. If art has no communicative role, then it cannot maintain or change cultures. (p. 4)

Here we see how the artwork itself, existing beyond the artist, can "speak for" or otherwise represent an idea that can be communicated to a wider audience.

Finally, drawing on its capacity to give voice or visibility to issues or communities, as we discussed previously, social justice art often provides a new way of seeing the world (Greene, 1995; Baca, 2005). Bailey and Desai (2005) describe activist art as a "vehicle for examining the world in which we live through multiple and critical lenses and for imagining our responsibilities and actions within that world" (p. 39). Many arts educators speak of the ability of works of art in general to "invite comment and reflection, arouse memories, and encourage sharing of personal stories," thus expanding the public "vision of the world" (Piscitelli & Weier, 2002, pp. 128–129). When combined with an explicit drive for social change around a specific issue or community, artworks have the capacity to enlarge an audience's understanding of a focused issue or community, drawing them into a more critical understanding of themselves and the world around them (Quinn, et. al., 2012; Korza & Bacon 2007).

Defining Social Justice Art: Audience

As highlighted earlier, a defining factor of social justice art is its relationship to the public domain (Dewey, 1934/1980; Felshin, 1995; Lippard, 1984). According to scholarship on activist art, the artistic process of this art form serves "to engage at least a portion of its audience at the core of its own experience, and at the same time to extend that experience" (Lippard, 1984, p. 38). In describing her own work in theater, Cohen-Cruz (1995) writes, "Rather than a formal conception of art in a static relationship to a community [the work] embodies art functioning dynamically in the ongoing contexts of people's lives, thus engaging them actively as subjects/doers" and setting up "an active host-guest dialogue rather than a passive spectator role" (p. 124). This redefining of the term *audience* is a critical piece of the conversation surrounding activist art whereby the conventional vision of a passive audience viewing or consuming the final artistic product is contested. No longer is the audience simply an absent or abstract presence; rather, the audience becomes a critical component of the creation of the artwork as the recipient of the intended social justice impact.

So strong is this vision of the active presence of an imagined audience that much of the literature describes the process of creating and sharing a work of art for an audience as a form of dialogue (Burnham & Durland, 1998; Korza & Bacon, 2007; Quinn et al., 2012). In participating in what Adams and Goldbard (2001) describe as "reciprocal communication through arts media," the audience becomes an actor in the move for social change as they shift into the role of participant in the imagined "dialogue" occurring between the artist and the audience *via* the artwork (p. 64). In this dialogic role, the activist artwork may serve as a space for sensory communication where ideas about complex or contentious issues may be explored—providing an intermediate space for such dialogue. In a sense, the artwork may be seen as drawing the audience into a conversation with the artist—a conversation framed by the artist's interests or intentions. From the perspective of the artist, the audience is expected to react to, engage with, or otherwise be impacted by their experience with the work of art—therefore becoming an agent in dialogue, not merely a passive viewer.

Generative Questions: Navigating Difference

While the defining features of the components of social justice art may appear tidy, there are still several critical questions about the nature of this work that we must navigate to reveal a richer analysis of social justice art education. The ways in which artists, educators, and researchers respond to the following questions impact where they locate their work and how they understand its role in society—thus, it has large repercussions for a field still in the process of finding its footing. While these questions are actually deeply intertwined, I have artificially separated them to highlight how they contribute to a more nuanced understanding of the

foundations, practices, and tensions in this field. Furthermore, in an effort to simplify the debates, I present several of these questions as bifurcated tensions where, in reality, they are often sliding spectrums based on context.

How Can Art Impact Inequality or Injustice?

For some, the move to affect systems of inequality or injustice in society, in other words, to affect social change, must require explicit changes in local or global policies (i.e., the amendment of a law, the creation of a local resource, etc.). For others, social justice work might also include shifts in social attitudes or behaviors. How might the role of art shift when viewed on a microlevel (individual change) versus a macrolevel (systemic change)? Can the act of critical learning and teaching be considered an act of social justice that can result in real change? How might the experience of simply viewing art impact social justice?

Where/When Is the Art? Is It Found in the Process or the Product?

When Nelson Goodman (1968) asked, "When is art?" he highlighted the influence of context on defining art. Here, the question refers to whether or not the act of making art is considered art, or if the artwork lies only in the final product. In the sphere of art education, this debate is often characterized as the product versus process dilemma. For those who fall on the product side, the artwork itself represents the work that led to its creation and can stand alone. For those on the process side, the art begins with the very first acts of creation—identifying ideas, imagining possibilities, critiquing, and revising. Does the artwork begin with an investigation of the artist's life experiences to identify the inequality or injustice in her daily experiences? Or, as often happens when topics are predetermined by a teacher or assignment, does it begin with a previously defined issue of inequality or injustice? How does our vision of when the art is impact how we teach and analyze art for social justice?

How Is Social Justice Evaluated?

This question is closely related to the questions about what constitutes social justice and is predicated on how people define social change: Is it about systemic shifts or attitudinal changes? Perhaps evaluation might best be viewed on a spectrum where social impact may fall anywhere from basic community building to codified policy change. If so, shall we base our evaluative methods on the intentions of the artists? Or on the stand-alone outcome of the work itself? Who determines when social justice has been achieved—the artists? Audience members? Policy analysts or social workers?

Narrowing In on the Answer(s)

These questions highlight the complex nature of the juncture of art and social justice. Depending on how one answers these questions, the field can, at times, feel stretched from product-focused, explicitly policy-directed political artwork to artwork that is generated through an inductive, collaborative process of artists working to deconstruct attitudes and beliefs about injustice and inequality. That's a pretty far-reaching landscape. It is no wonder that confusion over terminology, methods, and philosophy have clouded the conversation about the intersection of art and social change. Despite these differences, there are key similarities that reveal the important and binding commonalities of this field. If we intend to move the field forward, we will have to continue to build on those binding features—the views of the empowered artist, the artwork of possibility, and the participatory audience—to forge more nuanced definitions of our work.

At a time when many schools' curricula have become increasingly focused on high-stakes test preparation, potentially limiting students' freedom to critically analyze and creatively contribute to their own communities and lives, the need for social justice art education is ever more important. For those of us who have experienced social justice art education, it is tempting to answer questions about its definition with emotive descriptions of the "power of the arts to change the world." However, this does not begin to capture the rigorous learning and teaching that occurs when young people create works of social justice art, nor can it guide beginning educators in their quest to teach social justice art education. In exploring the defining characteristics and generative questions of this field, we gain additional tools to articulate our work. Yet this is only a starting point. As educators, researchers, and artists interested in understanding and supporting social justice art education, we must continue to push toward an articulation of what it is we do, even if our answers are not quite complete. (And even if they only beget more questions.)

References

Adams, D., & Goldbard, A. (2001). *Creative community: The art of cultural development.* New York: Rockefeller Foundation Creativity & Culture Division.

Albers, P. M. (1999). Art education and the possibility of social change. *Art Education, 52*(4), 6–11.

Allen, F. (2011). *Education* (Whitechapel: Documents of Contemporary Art). Cambridge, MA: MIT Press.

Baca, J. (2005). The human story at the intersection of ethics, aesthetics and social justice. *Journal of Moral Education, 34*(2), 153–169.

Bailey, C., & Desai, D. (2005). Visual art and education: Engaged visions of history and community. *Multicultural Perspectives, 7*(1), 39–43.

Becker, C. (Ed.) (1994). *The subversive imagination: Artists, society, and social responsibility.* New York: Routledge.

Blandy, D.E., & Congdon, K.G. (Eds.). (1987). *Art in a democracy.* New York: Teachers College Press.

Boal, A. (1979). *Theater of the oppressed*. New York: Urizen Books.

Burnham, L., & Durland, S. (1998). *The citizen artist: 20 years of art in the public arena*. Gardiner, NY: Critical Press.

Cahan, S., & Kocur, Z. (Eds.). (1996). *Contemporary art and multicultural education*. New York: New Museum of Contemporary Art and Routledge.

Chalmers, G. (1996). *Celebrating pluralism: Art, education, and cultural diversity*. Santa Monica, CA: Getty Center for Education in the Arts.

Chalmers, G. (1987). Culturally based versus universally based understanding of art. In Blandy, D. & Congdon, K. (eds). *Art in a Democracy* (pp. 4–12). New York: Teachers College Press.

Cleveland, W. (2002). Mapping the field: Arts-based community development. *Community Arts Network*. Retrieved from http://wayback.archive-it.org/2077/20100906194747/http://www.communityarts.net/

Cohen-Cruz, J. (1995). The American Festival Project: Performing difference, discovering common ground. In N. Felshin (Ed.), *But is it art? The spirit of art as activism* (pp. 117–140). Seattle, WA: Bay Press.

Darder, A. (2002). *Reinventing Paulo Freire: A pedagogy of love*. Boulder, CO: Westview Press.

Davis, J.H. (2005). *Framing education as art: The octopus has a good day*. New York: Teachers College Press.

deNobriga, K., & Schwarzman, M. (1999, October). Community-based art for social change. *Community Arts Network/Art in the Public Interest*. Retrieved from http://www.communityarts.net/readingroom/archivefiles/1999/10/communitybased.php

Dewey, J. (1934/1980). *Art as experience*. New York: Perigee Books.

Dewhurst, M. (2010). An inevitable question: Exploring the defining features of social justice art education. *Art Education, 63*(5), 6–14.

Dimitriadis, G., & McCarthy, C. (2001). *Reading and teaching the postcolonial: From Baldwin to Basquiat and beyond*. New York: Teachers College Press.

Eisner, E. W. (2002). *The arts and the creation of mind*. New Haven: Yale University Press.

Felshin, N. (Ed.). (1995). *But is it art? The spirit of art as activism*. Seattle: Bay Press.

Freire, P. (1970). *Pedagogy of the oppressed*. New York: Herder and Herder.

Ginwright, S.A., Noguera, P., & Cammarota, J. (Eds.). (2006). *Beyond resistance! Youth activism and community change: New democratic possibilities for practice and policy for America's youth*. New York: Routledge.

Giroux, H. (2001). *Theory and resistance in education: Towards a pedagogy for the opposition* (Rev. and Expanded ed.). Westport, CT: Bergin & Garvey.

Goldbard, A. (2006). *New creative community: The art of cultural development*. Oakland, CA: New Village Press.

Gomez-Peña, G. (1994). The Free Art Agreement/El Tratado de Libre Cultura. In Becker, C. (Ed.), *The subversive imagination: Artists, society, and social responsibility* (pp. 208–222). New York: Routledge.

Goodman, N. (1968). *Languages of art: An approach to a theory of symbols*. Indianapolis, IN: Hackett.

Greene, M. (1995). *Releasing the imagination: Essays on education, the arts, and social change* (1st ed.). San Francisco, CA: Jossey-Bass.

Hirschman, J. (2002). *Art on the line: Essays by artists about the point where their art and activism intersect* (1st U.S. ed.). Willimantic, CT: Curbstone Press.

hooks, b. (1994). *Teaching to transgress: Education as the practice of freedom*. New York: Routledge.

Horton, M., & Freire, P. (edited by Bell, B., Gaventa, J., & Peters, J.M.). (1990). *We make the road by walking: Conversations on education and social change.* Philadelphia, PA: Temple University Press.

Ianni, F. A. J. (1968). The arts as agents for social change: An anthropologist's view. *Art Education, 21*(7), 15–20.

Knight, K., Schwarzman, M. & Forney, E. (2006). *Beginner's guide to community-based arts: Ten graphic stories about artists, educators, and activists across the U.S.* Oakland, CA: New Village Press.

Korza, P., & Bacon, B.S. (2005). *Dialogue in artistic practice: Case studies from Animating Democracy.* Washington, DC: Americans for the Arts.

Korza, P., & Bacon, B. S. (eds.) (2007). *Art, dialogue, action, activism: Case studies from Animating Democracy* (1st ed.). Washington, DC: Americans for the Arts.

Lacy, S. (1995). *Mapping the terrain: New genre public art.* Seattle, WA: Bay Press.

Lippard, L.R. (1984). *Get the message? A decade of art for social change* (1st ed.). New York: E. P. Dutton.

Marcuse, H. (1978). *The aesthetic dimension: Toward a critique of Marxist aesthetics.* Boston: Beacon Press.

McFee, J. K. (1998). *Cultural diversity and the structure and practice of art education.* Reston, VA: National Art Education Association.

McLaren, P. (2003). Critical pedagogy: A look at the major concepts. Darder, A., Baltodano, M., & Torres, R. D. (Eds.). *The critical pedagogy reader* (pp. 69–96). New York: RoutledgeFalmer.

Muri, S. (1999). Folk art and outsider art: Acknowledging social justice issues in art education. *Art Education, 52*(4), 36–41.

O'Brien, M., & Little, C. (1990). *Reimaging America: The arts of social change.* Philadelphia, PA: New Society Publishers.

Perkins, D. (1989). Art as understanding. In H. Gardner & D. Perkins (Eds.), *Art, mind, and education: Research from Project Zero* (pp. 111–131). Urbana: University of Illinois Press.

Piscitelli, B., & Weier, K. (2002). Learning with, through, and about art: The role of social interactions. In Paris, S. (Ed.) *Perspectives on object-centered learning in museums* (pp. 121–151). Mahwah, NJ: Lawrence Erlbaum.

Quinn, T., Ploof, J., & Hochtritt, L. (2012). *Art and social justice education: Culture as commons.* New York: Routledge.

Reed, T.V. (2005). *The art of protest: Culture and activism from the civil rights movement to the streets of Seattle.* Minneapolis: University of Minnesota Press.

Rose, T. (1994). *Black noise: Rap music and Black culture in contemporary America.* Wesleyan, MA: Wesleyan.

Shor, I. (1992). *Empowering education: Critical teaching for social change.* Chicago: University of Chicago Press.

13

FROM THE PLANTATION TO THE MARGIN

Artful Teaching and the Sociological Imagination

Gilda L. Sheppard and bell hooks

1. As educators, how can we develop pedagogy using artistic expression to inspire students to choose their marginality as a "site of radical possibility" instead of a site of deprivation?
2. How can imagination, teaching as an aesthetic act, and critical literacy move learners from being "resisting spectators" to creators of new knowledge for social justice?

This chapter begins with a dialogue between the author Gilda L. Sheppard and cultural critic bell hooks on how the 2009 film *Precious* represents "plantation culture" in its uncovering of social ills among the Black urban poor while re-inscribing stereotypes cloaked in sentimentality for the subject. Plantation culture negates the importance and possibilities of resistance from border positions. Drawing on critical analysis, social theory, and biography, the chapter moves from this dialogue to the development of critical literacy and teaching as an aesthetic act to inspire learners on the margins of schools and society—in the case of this chapter, adult learners and incarcerated men and women—to shift from being "resisting spectators" to choosing the margin (hooks, 1990) as a place of radical possibilities. Pedagogical examples using sociological imagination (Mills, 1959) and oppositional gaze (hooks, 1996) in a liberal arts college and designing such space in a prison setting reveal a scaffold and method to create new knowledge for the practice of social justice.

> *The function of art is to do more than tell it like it is—it's to imagine what is possible.*
> —bell hooks

Dialogic Setting: Sometime in 2010 Talking about the Film *Precious*

bell hooks

As a cultural critic, it is really difficult to write about this stuff when the truth is this is just so bad—what you want to write about is not the film itself—you really want to write about the emotional need people in our culture have that they take this kind of slap and act like it is some kind of nourishing—almost like documentary investigative journalism.

When I raised critical questions about *Precious*, I was actually bombarded by Black people saying the film is "real and raw."

When actually it is not real—the narrative in this film is itself a fantasy—it is an interpretation of a fantasy projected on Black people. The author of the novel *Push* said she constructed the character from a composite of Black students she met while substitute teaching in New York. But we have this magnified image of Precious as every Black child—well, that is crazy and false.

I am in agreement with any critique that says—to some extent—this film is about the worship of whiteness—not about dislodging whiteness or interrogating its symbols and practices of privilege and disparities. The irony is that the symbol of whiteness in Western civilization is—"literacy"—supposedly, but it is never literacy—we do not have Precious dreaming of herself being a teacher. What is fantasized is celebrity, money, and being worshipped by the crowd, so the fact is—literacy is not there, just like incest is on display, but only as a backdrop—both are ridiculed and mocked by this film.

In fact, our culture has emerged in what I call plantation culture. Plantation culture is what happens in colonization when one colonizing force takes over, then tries to find aspects of the culture that they actively seek to destroy—and bring it back to sell it to the people it has stolen it from—selling it back to them in a cruel, bastardized, and even rotten form. The movie *Precious* is a perfect example of plantation culture.

Gilda L. Sheppard

A plantation culture where the neighbors, mothers, and children show no compassion or resistance, only perpetuation of and compliance with a culture of violence—as if there is no social change and resilience in poor neighborhoods.

These conditions become tropes that validate the practice of punishment as justice, perpetuate an adherence to zero tolerance for our youth in public schools, and give a nod and a blind eye to a pipeline from school to prison. The film *Precious* presents intergenerational poor Black families as dysfunctional and criminal, left with market-driven fantasies of neoliberal yearnings of celebrity that reinforce internalized oppression. This internalized oppression is particularly evident when

Precious gazes in the mirror and the image of herself as a large Black woman is ambushed by the image of herself as a skinny White woman with long blond hair.

These fantasies punctuate the abuse that Precious endures from her father, mother, neighborhood boys, and so forth, while leaving capitalist cravings and internalized oppression as the only solution for poor people. However, through another lens, perhaps the character Precious understands neoliberalism better than the public intellectuals who use this system to describe how corporate-driven pedagogy uses media and other agents of socialization to promote individualism, internalized oppression, the persistence of poverty, and the growing inequities between rich and poor while individuals are blamed for their living conditions rather than seen as entitled to social support (Giroux, 2012). Precious is making us look at our own imaginings. Is Precious the trickster here? Is she signifying? As an educator, sociologist, and filmmaker who uses film as a pedagogical tool, in the classroom, these scenes serve as an opportunity for critical literacy. Hence, a film can be read as text to uncover its multiple standpoints yielding a space and even a structure for critical intervention. In this context, critical literacy is also media literacy where students and teachers dialogue about the persuasive strategies that films deploy and how these strategies are present and reflect our imaginings of self and society (hooks, 1996). This is teaching as an artistic activity where interactions create meaning while pushing boundaries.

These multiple standpoints do not mask the point that the film *Precious* is packed with social problems with little to no sense of agency among its characters. To paraphrase W.E.B. DuBois (1898)—poor people become problem people instead of people who face problems. The film's primary trope is a slow fade into gore, reinforcing the notion that poor people have no imagination, albeit economic cravings; no critical consciousness; and at best, an unwavering adjustment to their conditions of deprivation. We leave Precious at the end of the film with an eighth-grade education, temporary housing, children with learning and physical disabilities, and her diagnosis with HIV/AIDS—in the context of the 1980s, this is a death sentence, especially if you were poor. Does this filmic representation of the urban poor represent art as social justice?

bell hooks

Precious is asking us to become voyeur—come into the apartment of this poor underclass Black family that is scamming, violent, lying, and cursing—come on in and take a look. Anyone who reads my work knows I have no trouble critiquing that which is dehumanizing in Black culture.

I try to say in my work that confession in itself, or exhibition, or even telling your story doesn't give us deeper meaning; it is what you make of that story—and what Precious makes of her story is very little. It is all fantasy, and the real object of fantasy in *Precious* is not the character Precious, but the character of her mother.

Any film made by anybody displaying violent male sexuality to women and children in this decade that does not address issues of patriarchy and feminism is already letting us know that it stands on the side of the very violence that it purports to be critiquing—violence is glamorized in our culture. I can tell you this—if we took all the violence out of *Precious*, most people would not have even looked at the film.

If we took out the mother's violence, the overall sexualized violence, you know not even the worship of whiteness would have been enough to carry people to see this film. So this is the danger of any of our artists who try to make such entertainment—because let's face it, this kind of film is about entertainment—violence as entertainment.

Gilda L. Sheppard

Yes, and in fact this breathes life into the 1960s report by "liberal" senator Daniel Moynihan on his thesis that the structure of family life in the Black community constituted at "angle of pathology." This particular notion of Black familial life has become a widespread, if not dominant, paradigm for comprehending the social and economic disintegration of late twentieth-century Black urban life. It assures a "blaming the victim" thesis of "culture of poverty"—reducing poor peoples' behavior as the cultural reason for poverty—leaving little to no analysis of structural or systemic forces. Social justice is criminal justice.

If this film is about literacy as liberation, justice, and redemption as the book *Push* tried to emphasize, why weren't the classroom scenes or scenes of Precious with her peers in the classroom not presented as pivotal points in the film? These scenes were hardly mentioned in review of the film.

Yet it was these scenes in the classroom at the "alternative school" *Each One Teach One* where we are forced to look at Precious when she feels safe and takes risks. Here is where we can possibly confront our view of a very dark, overweight, "angry," illiterate Black woman—away from the Hollywood stereotype and rather within the politics of our looking relations. Looking relations go beyond "identity politics" and even body images. How society "sees" or "looks" at or renders Black women invisible is reflected in disparities in health care, income, incarceration rates, and other societal contexts. As a sociologist, looking relations decode and uncover social forces that inform biography.

The introduction to the young women in this classroom was interesting and displayed an imagination defined not by commodity accoutrements of Hollywood and capitalist culture. These diverse women introduced themselves as you say, bell, "resisting spectators of their life"—answering the questions, What is your name? What is your favorite color, and tell something that you do well? Speaking their names and where they are from in New York created a learning community where they all, in spite of and because of their difference, found a sense of agency, hope, and the imagination of possibility. These scenes are not talked about as

much when the film is critiqued and praised. Sisterhood becomes for a while an activity within the urban ghetto. Imagine that!

Yes, introductions could have been a scaffold for deeper sociological questions about the lives of young women who enter the classroom—yet the audience never hears them explore posttraumatic stress disorder, patriarchy, incest, young single motherhood, poverty, love, fear, and immigration. And when Precious attempts to make an analysis of political economy when she surveys her options of workforce/ welfare and school, she sees the inequity, yet we never hear her act on it. The film moves to a narrative jump cut, leaving this opportunity to display consciousness a mere thought without action.

bell hooks

But Precious' mom does have a voice—she articulates her rage, loneliness, and sadness—how can it be that she has a voice and her daughter has nothing. This is the negation of the idea of any kind of functional parenting. I grew up in a dysfunctional household as did you, Gilda, but that does not mean that there was no caring; there were good things happening in that household as well. If anything, we need to talk about how people have come to read dysfunction within blackness—especially when it is among the underclass—and how it gets equated with horror and obesity and dysfunction. Can it coexist when other meaningful things are taking place? So what is the justice we are talking about?

> *The opposite of poverty is not wealth. . . . In too many places, the opposite of poverty is justice.*
>
> —Bryan Stevenson (2012)

> *I am located in the margin. I make a definite distinction between marginality which is imposed by oppressive structures and that marginality one chooses as site of re-sistance—as location of radical openness and possibility . . . We come to this space through suffering, pain, through struggle. We know struggle to be that which pleasures, delights, and fulfills desire. We are transformed, individually, collectively as we make radical creative space which affirms and sustains our subjectivity, which gives us a new location from which to articulate our sense of the world.*
>
> —bell hooks (1990, p. 155)

Dialogic Setting: Sometime in 2011 at the Evergreen State College in Tacoma, Washington—Teaching as an Art Form

The Evergreen State College in Tacoma (TESC-T), Washington, is an upper-division interdisciplinary liberal arts college located in the urban working-class community known as Hilltop. Hilltop is rich in cultural diversity and is often maligned by its media characterization as gang and drug infested. The "Hill" has been the entry

point for immigrant populations. It has a strong history of activism, and TESC-T has been a hub for this activism. TESC-T's 220-adult student body has a significant number of first-generation college students whose average age is between the ages of 35 and 40. Seventy seven (77%) of the student body is below the federal poverty level. According to The Evergreen State College website (2013) the student population ranges from 35% to 40% African American; 31% to 40% White; approximately 8% Native American; between 8% and 9% Asian and Asian American; 4% to 5% Pacific Islander; and between 5% and 8% Latina/o, with a growing population of recent immigrants from East and West African countries, as well as countries in Asia, the Caribbean, Latin America, and Eastern Europe. The college's retention rate is 90%, with several of its graduates enrolling in and completing graduate school in such areas as public health, social work, law, education, environmental studies, fine arts, and public administration. Courses are thematically driven and team taught by faculty who reflect the diversity of the student body: African American, Pacific Islander, Chinese, and European American. The program was founded in 1972 by an African American woman, Dr. Maxine Mimms, and leadership in the program has consistently been African American. The college's motto is "Enter to Learn, Depart to Serve," and the institution is guided by values of reciprocity, inclusivity, civility, and hospitality.

> *This school reflects social justice by offering a curriculum that is community-based, promotes access, equity and excellence and seeks to serve populations not historically included in higher education.*
> —Tyrus Smith, PhD, Director, TESC-T Program

Gilda L. Sheppard

Practices of plantation culture are too often found in educational settings where the population reflects TESC-T's learning community. However, when faculty and students choose the margin as the site of resistance, a counterhegemonic narrative and practice of revision (hooks, 1990) can emerge that challenges the conventional structures of domination that uphold and maintain White supremacist capitalist patriarchy (hooks, 1990). This is not an essentialist argument, but rather a claim that beckons educators to intentionally develop a critical pedagogy that ruptures and extends the notion of social justice from merely being an awareness of social conditions that people on the margin need to rise above. When faculty actively engage students to develop an "oppositional gaze" (hooks, 1996) of teaching and learning as an art form (Eisner, 2002) where power relations are not only documented but also interrogated, then the pathways for resistance can be imagined and created.

As a member of the faculty at TESC-T, I believe our success is due, in part, to our view of teaching and learning as an artistic activity that, as bell hooks (1994) says, transgresses the usual rote and assembly-line approach to teaching and learning. In her book *Teaching to Transgress*, hooks (1994) writes about an engaged pedagogy: "To educate as the practice of freedom is a way of teaching that anyone can

learn . . . that there is an aspect of our vocation that is sacred . . . our work is not merely to share information but to share in the intellectual and spiritual growth of our students . . . To teach in a manner that respects and cares for the souls of our students is essential if we are to provide the necessary conditions where learning can most deeply and intimately begin" (p. 13). Elliot Eisner (2002), in *The Educational Imagination*, situates teaching as an art in four senses:

- First, teaching can be performed with such skill and grace that, for the student as or the teacher, the experience can be justifiably characterized as aesthetic. . . .
- Second, teachers, like painters, composers, actresses, and dancers, make judgments based on qualities that unfold during the course of action. . . .
- Third, the teacher's activity is not dominated by prescriptions or routines but is influenced by qualities and contingencies that are unpredicted. . . .
- Fourth, the ends it achieves are often created in process. (pp. 154–155)

It is in these four senses—teaching as a source of aesthetic experience, as dependent on the perception and control of qualities, as heuristic, and an act of seeking emergent ends—that teaching can be regarded as an art (pp. 155–156). This framing of teaching as an art is social justice.

How does this translate in the context of TESC-T's development of our interdisciplinary curriculum, for example, the integration of mathematics and photography?

Paul McCreary

As a mathematics faculty member at TESC-T, I developed the course *Mathematics and the Considered Snapshot* with Arlen Speights (MFA) whose areas are integrated electronic arts and Native American studies. Our course integrated algebra, precalculus, and calculus with digital photography and design. It was important for us to include algebra for our students at TESC-T because of its opportunity for social justice. Robert Moses (2002), the 1960s civil rights activist and founder of the Algebra Project, explains that the connection between civil rights and the right to math literacy is logical. The civil rights movement ensured that poor people and people of color had a voice; now they need economic access—and that starts with education—math and science skills are essential to succeeding in a tech-dependent society, and algebra provides an entry to all of this. He goes on to write that math literacy is "an issue as urgent as the lack of registered Black voters in Mississippi was in 1961 . . . solving the problem requires exactly the kind of community organizing that changed the South in the 1960s" (p. 5).

Economic access or redistribution and the point about community organizing particularly speak to teaching as an art for social justice. Students and faculty have in our hands an opportunity to examine fear, dismantle its entrails, and see its angles. As faculty, we have an added opportunity to challenge our own assumptions and worldviews about students' abilities and interrogate the narrow framework when educators merely attempt and often fail to equip students to compete.

At the beginning of the course, Speights and I instructed students to write a memoir of their experience with math. This memoir writing allowed the students to enter into the course as subjects, not as objects of fear and failure. They gave the faculty pathways for interactivity based on students' skills in language, storytelling, symbols; an understanding of their authentic self, reflexivity, and their critical consciousness of context and conditions that constructed barriers and or bridges to their learning. The pedagogy of discomfort (Boler, 1999) was engaged; it became like jazz with opportunities for solos and improvisation. Students worked in groups and read their memoirs to each other. As faculty, we positioned ourselves as facilitators not as lecturers.

I design the class to make it convenient for students to work in groups, and I position myself behind students. This kind of stage design and choreography actually breaks down power relations. Hence, when students have a question, they must look at their peers to look at me. These looking relations move the students; I am standing behind, to speak, find voice, and feel a sense of responsibility to the learning community. Also connected to this class is a service component where students tutor students in a local alternative public school. Oftentimes, their memoirs help them to feel confident and ready for the task because the context of many of the memoirs was middle and high school. Compassion became a driving force for these tutors. As a result, five students from this class have become tutors for other interdisciplinary math courses at TESC-T and are preparing to get their endorsements in math as they enter the TESC-T Masters in Teaching program. One of the students, an African American man who is wheelchair bound, is developing visual aids to encourage his peers in school and community to pursue math.

Arlen Speights

Photography became more than a tool for math literacy. The snapshots that students planned set the stage for a conversation between math and photography. The photographs represented aspects of their life and a discovery of math principles in the documentation and interrogation of their life. They became conscious of composition, choice, and freedom to frame aspects of their life. Discussions of their snapshots became sociological as well as covered the ratio of length to width of the photographs, which led to a quadratic equation that yielded the so-called golden ratio—a classic idea important in mathematics and aesthetics. The ratio of camera aperture and shutter speed (reciprocity) provided a context for gaining deeper understandings of essential mathematical ideas.

Many of the snapshots were amazing. One student, whose memoir talked about fear and domestic violence, photographed her new partner with her son watching television by a window where light hit them bouncing gently across their bodies. She discussed the light as a vector entering into the photo that revealed an angle of possibilities likened to a mathematical equation. She is not developing a career in math; however, she explored her biography and constructed an aesthetic that brought her a sense of healing. This is art as justice.

When we come together for our own liberation we are unstoppable.
—Michelle Alexander (2010)

Dialogic Setting: 2010–2012, Washington State Reformatory for Men and Washington Correctional Center for Women, Sociology Class—Aesthetics on Choosing the Margin for Social Justice

Teaching as an aesthetic form is the perspective I also bring to my work in sociology classes for the past 3 years in a women's and a men's prison. Many of the men and women in my classes were incarcerated between the ages of 18 and 25. One student has been "down" since he was 13. Arthur Longworth, recipient of the PEN memoir 2010 Prison Writing Contest and incarcerated since he was 18, explains it this way: "So many young people who came here—their perspectives were so narrow and their problems were so big." His analysis and succinct yet packed explanation is sociological imagination (Mills, 1959); the relationship between "private troubles" and "public issues," or to give this approach to analysis a broader meaning, "is a quality of mind that seems most dramatically to promise an understanding of the intimate realities of ourselves in connection with larger social realities" (p. 15).

Michelle Alexander (2010) writes that H. R. Halderman, one of President Nixon's key advisers is quoted as saying, "He [President Nixon] emphasized that you have to face the fact that the whole problem is really the blacks. The key is to devise a system that recognizes this while not appearing to do so" (p. 44). The prison population rose in the 1970s from 300,000 to more than 2 million today (p. 6). With this in mind, I also needed to look at how I saw this population that I would be working with in prison. What did choosing the margin for my students while in prison mean for me as their teacher? Was I their savior? I was not! Sociological imagination had been alive in the Black Prisoner's Caucus (BPC) for more than 40 years and in the even older Concerned Lifer's Organization (CLO) that the men founded and sustain to this day. The Women's Village, a newly formed organization at the women's prison, had been developing for a long time, and like the BPC and CLO, it was initiated and formed from the inside. This women's prison had the reputation of the most violent prison in Washington State, however since the village's formation the violence has been reduced by 50%. The backdrop of disparities, which at times cages this activism, uncovers the complex work that these organic intellectuals (Gramsci, 1973) have to deal with internally and externally. In 2005 in Washington, Blacks were incarcerated at 6.4 times, and Latinos at 1.3 times, the rate of Whites. Nationally, women are the fastest growing population of people incarcerated. The majority of people who fill our prisons have dropped out of high school and had minimum to no college; hence, they are among the rural and urban poor.

Avoiding the narrative of the "plantation culture," I turned to one of my students who has been a great teacher to me, Kimonti Carter, of the BPC, who explained,

"It is one thing studying the subject and another thing being the subject." Taking this as my cue, I used the idea of sociological imagination as a starting point for discussions, papers, and assessments in our class. The following are examples of how the class went from biographical discussions to sociological theory and practices.

Emilio Maturin

The disparities that we see in prison start in our neighborhoods. I always wonder why my friends' school had computers and my school did not. I wondered why we lived in this poor neighborhood. I thought that there was an innate force that predetermined a person's life. I have a responsibility, but an analysis helps.

When I was in the third grade, my father got deported back to Mexico, so my mother, who is White, moved my brother and me from Southern California to Ellensburg, Washington, to live with her family. Ellensburg is a mostly White college town. I was called "spic," and I was not use to that. In Southern California, there were Mexicans and Blacks. One day, I got in a fight with my cousin on the school grounds, and the school officials said I was gang related. I was never in a gang. I was 8. My mom wanted to sue them. I had always been in the Talented and Gifted program, but that never stopped them. This put me on the defensive, but I never joined a gang.

To carry Maturin's narrative from private troubles to public issues, students engaged in research on immigration, construction of race and White supremacy, public housing, and zero tolerance in school; diverse sociological perspectives were applied to issues embedded in the narrative to create debate teams. Sociologist Katrina Hoop (2009) emphasizes the importance of using a students' lived experience as text in the teaching of sociological imagination. Mills (1959) emphasizes this approach: "to be aware of the idea of social structure and to use it with sensibility . . . to be capable of tracing such linkages among a great variety of milieu" (p. 10).

The following statements take these linkages to its practical dimensions.

Kimonti Carter

The BPC was the reason I started to make the necessary changes in my life. This pushed me to want to be educated. Education gave us in BPC the ability to translate our suffering into academic and sociological terms helping many of the members of the BPC make the connection between education and social justice.

Sociology helped me understand the connection between people, different classes, cultures, genders, and how they all are influenced positively or negatively by institutions. That helped me look at the world not only with a set of new eyes but with a new heart. Education has helped me evolve from a hungry, confused, and misled youngster into a driven community organizer, determined to make a difference in the lives of poor young people. Young people have to be challenged by people who love them despite their mistakes and shortcomings. That is important for them to realize that rebelling against a broken and unfair system only

reinforces its position in their lives. However, standing up and speaking truth to its power strengthens the community and weakens its hold over them, and I know this from experience because that's what education has done for me.

Felicia Dixon

I see myself as a teacher. Now that is art as magic. But really I do. I was 18 when I came to prison, and now I am 26. I see a mother, grandmother, and daughter here. This is terrible. I can change this. I have been down, and there is nowhere else to go but up. I mentor my sister now. Taking sociology helped me to see my place in the world, and I was ashamed. Now I think about things that go on in the world and see not only connections but also where I can make a difference. Social justice is the art of compassion.

Tonya Wilson

Studying social forces that inform my biography gave me strength to develop the Women's Village and see possibilities for my life and the lives of women in prison. My classes and my work in the Women's Village are like a work of art. Through the Village, we hold up a mirror for people to see. I say take a look—see yourself—you are beautiful. My words are my art, and maybe my art will only be hung on the walls of this prison [metaphorically], but just like seeing a moonscape for the first time, you will never forget it, and that is how the painting we hang on these prison walls will be. We do not have to conform to mediocrity or a label. This idea threatens people who conceived prison. They just see us as ugly; we saw ourselves as broken. If I can use my mirror, my words to change a little hood girl's mind, I can change the culture in here and ultimately the world. Everyone will want to choose the margin.

Conclusion

Teaching and learning may be a subversive act that has the ability to transform, disrupt, uncover, and displace an unhealthy life and living while imagining and creating a new life. When teaching and learning become an artistic and aesthetic activity and critical literacy finds intimacy within a person's life—this new learning has a chance to pollinate and disrupt places where depravation and nihilism are thought to reside. It has the ability to uncover places and spaces where critical thinking and engagement with community is thought to be lost in rusty old pipelines from broken schools to the foreboding sound of the lock of a prison door and to transform the feeling of ambush and despair to hope. This is the magic that people create when they interrogate social forces that inform their biography, examine their choices and consequences, and dare to gaze intently at images of internalized oppression in order to understand its political economy on our lives. Choosing the margin provides an opportunity to examine decisions and pathways and beckons us to make another way. Choosing the margin, we notice and recall

the proverbial empty chairs at the table of equal rights and social justice. When we get an opportunity to reflect, we understand the tensions and the need for more chairs, and guided by our vulnerability and compassion, we can organize and speak truth to power. Choosing the margin, we celebrate rhythms and melodies that sustain our belief in community and ourselves.

References

Alexander, M. (2010). *The new Jim Crow: Mass incarceration in the age of color blindness*. New York: New Press.

Alexander, M. (2010, August 8). Speech recorded by Chicago Access Network Television. Retrieved from http://www.youtube.com/watch?v=UZaQFYQsphQ

Boler, M. (1999). *Feeling power: Emotions and education*. New York: Routledge.

DuBois, W. E. B. (1898). The study of the Negro problems. *The Annals of the American Academy of Political and Social Science, 11,* 1–23.

Eisner, E.W. (2002). *The educational imagination* (3rd ed.) Upper Saddle River, New Jersey: Prentice Hall.

The Evergreen State College. (2013). Retrieved from http://www.evergreen.edu/tacoma

Giroux, H. (2012). *Disposable youth: Racialized memories and the culture of cruelty*. New York: Routledge.

Gramsci, A. (1973). *Letters from prison*. New York: Harper and Row.

hooks, b. (1990). *Yearning: Race, gender and cultural politics*. Boston: South End Press.

hooks, b. (1994). *Teaching to transgress*. New York: Routledge.

hooks, b. (1996). *Reel to real*. New York: Routledge.

Hoop, K. (2009). Students' lived experiences as text in teaching the sociological imagination. *Teaching Sociology, 37*(1), 47–60.

Mills, C.W. (1959). *Sociological imagination*. Oxford: Oxford University Press.

Moses, R. (2002). *Radical equations*. Boston: Beacon Hill Press.

Stevenson, B. (2012, March). We need to talk about justice. *TED Talks*. Retrieved from http://www.ted.com/talks/lang/en/bryan_stevenson_we_need_to_talk_about_an_i justice.html

14

FILMMAKING

Expressing the Beauty Parlor Lessons within Me

Ayoka Chenzira

1. How do we honor our own informed voices of authority?
2. Isn't filmmaking just about entertainment?

Coming of age in the late 1960s, when consciousness raising around identity was valued as a political act, has informed my sense of social justice, my art, and my teaching practices. I was shaped in part by the rallying cry heard by many women during the 1970s, *the personal is political*. The term foregrounded women's narratives of personal experience, which consistently revealed gender inequities and made connections between those experiences and the social and political frameworks that impacted our lives. Propelling women's stories into public arenas was one strategy used to alert people to the richness and inequities of women's lives and to encourage women to pay attention to and value their own lived experiences. The overall objective of the use of the phrase *the personal is political* was to move women to be more politically involved in creating an equitable, socially just society. This was inspiring, however, as I began to explore what type of artwork I might produce. I found as a source of direction the words of Toni Cade Bambara (1970:30) who penned, *"revolution begins in the self and with the self."*

My art practices and teaching considers a consciousness-raising approach to social justice focus through centralizing the lives of African American women, placing them as protagonists in their own stories (unusual in American cinema), and highlighting the idea of self-actualization in a way that breaks us free of stereotypes. Another dynamic particular to African American women and their stories is that in this area of dynamic social change, the 1960s, their stories were among the least told. They were women, and they were women of color. This made them doubly dismissible. I believe that this granular focus is as critical to social justice as is working on the macrolevel of marching and lobbying. Artists/educators

who work in this way are focused on transformational experiences for individuals (whether a character or a subject in a film story, or students in a class). This focus is not a disconnect from a larger collective struggle but a critical ingredient in that struggle for women's emerging equitable status in society. It is a way of working that addresses the culture of silence, a position frequently taken when Black women (meaning women of African descent) internalize the negative images of ourselves that are often put forth in various forms of discourse. If one believes that her rights are not worth fighting for, the chance that she will acknowledge and fight for inequities is miniscule. This is a central focus of my life's work: amplifying and laying bare African American women's stories in their intricacies, pain, and glory. From this validation and authentication through film, steps toward redress and growth can emerge.

The Parlor Stories

Over the years, I have studied at a variety of educational institutions where I earned degrees. The degree I value most was obtained in my mother's beauty parlor. I grew up in Philadelphia in the 1950s listening to stories told primarily by Negro women and a few Irish and Jewish women who were clients of my mother. I say "Negro women" as we were just beyond Colored and not yet Black, Afro American, or African American. My mother was a divorced woman, a shameful status back then, but one that she initiated and was proud to have done so. She owned a beauty parlor located in the first building designed for interracial housing. She was not a hairdresser, she was quick to say, but a cosmetologist concerned with the entire body and mind, which gave her the community-awarded license of psychologist and marriage (and nonmarriage) counselor.

The parlor was a special world where women conversed, publicly dreamed, complained about injustices, admonished, whispered, guffawed, cried, and consoled each other amid the comfort-inspiring mahogany furniture that held tools of the beauty parlor trade. It would be years later before I learned that beauty parlors like this were among the few places where women like these felt safe and free to be open with the joys and sadness in their lives. Although I was nowhere near being a woman myself, and did not fully understand all that was being said, it was here that I first heard oral narratives of personal experiences by African American women and learned through firsthand observation the healing power of giving women and their stories an opportunity and a place to be heard. In my mother's parlor, their stories could be shared . . . and heard . . . and valued. The customers' oral narratives informed me about what it was to be a grown-up woman in the world.

It was in this informal educational environment, amid the daily verbalization of working-class women's triumphs and tribulations, that I became interested in and aware of the importance African American women's stories as a counternarrative to the commercially marketed image of women's lives in the 1960s. Through

these parlor stories, I learned about inequality primarily through the lens of sexism, although no one ever used this word. For them, sexism was tied to feminism, feminism was tied to White women (and to man hating), and White women were just as culpable as White men when it came to injustices. No, the narrative for these women was only about *racism*.

You've Never Heard a Parlor Story?!

In the 1970s, I attended New York University (NYU) as a film major. I became well versed in the major film genres; could critique French, German, Italian, Czechoslovakian, Hungarian, Brazilian, and Japanese cinemas; and could analyze the canon of film literature that one was expected to know. I concluded that the parlor stories from my youth were a rich resource from which to draw stories for film. These stories were every bit as compelling as what I was seeing in world cinema. Ironically, it is my fly-on-the-wall experience of listening to women's stories in my mother's parlor that gave me a deep appreciation for non-American films, particularly post–World War II Italian neorealism. These films focused on the working poor, used nonprofessional actors, and highlighted stories about people living under the fist of poverty where morality was frequently challenged.

As one of four Black students in the NYU film program, and one of two African American women, I assumed correctly that I had allies with whom I could speak openly. We realized that our lives were totally foreign to our classmates and apparently too foreign to even register as a foreign film. Our White classmates were more familiar with African American characters in films dominated by what seemed to be an endless parade of Black male superhero films of the day, such as *Superfly* (Parks, 1972) and its female counterpart *Cleopatra Jones* (Starrett, 1973). This proliferating African American film genre of the 1970s focused largely on urban criminal plotlines and featured poorly developed characters and sophomoric story arcs. They did not reflect the truths and beauty of the African American experience with which I grew up.

I was slow to awaken to the fact that I knew more about the world of my classmates than they did about mine and that Black women's stories were not a part of everyone's experience. The rich stories that I had come to know and value were too often relegated to the confidential therapeutic exchanges in parlors. They were the fabric of the oral tradition, the way that marginalized communities pass knowledge, news, and history forward. The academic work, I learned, had not yet come to recognize and value this way of being and communicating in the world. With few exceptions, my White teachers and classmates were accustomed to a world where they were the only ones at the table discussing, constructing, portraying, and giving voice to what it meant to *be* in the world: largely White, middle-class, young, Christian or Jewish, and heterosexual. I wish that I had been armed with Christine Obbo's analysis of class, gender, privilege, and exclusion (1997).

Male models of storytelling serve as templates for what it means to be human ... Women's voices have been devalued by male chroniclers of cultural history even when the men acknowledge female informants; they are overshadowed by the voice of male authority and ascendance in society. Most often, women's views are dismissed with smirks or disparaged as nonsensical in the apparent belief that men talk and have discussion on serious matters but women gossip. This attitude is not limited only to the men in societies we study; until recently, professional academics, too, had problems taking women's utterances seriously. (p. 43)

Obbo is writing about her research in Uganda, but the analysis is palpably transferable to the United States and continues to be a global problem. Despite the privileging of text as the primary form of literacy in Western culture, oral narratives of personal experience can and do reflect the complexity of our thinking. They represent another way of theorizing and knowing. When expressed by women, these narratives are often marginalized—seen as gossip, old wives' tales, and nonintellectual thoughts. However, women's oral narratives of personal experience are equally valuable testimony, although seldom authenticated in text, in film, and on television.

Many women artists have mined oral narratives, recontextualizing them for use in different ways: Anna Deavere Smith, in *Fires in the Mirror* (1992) and *Twilight: Los Angeles 1992* (1994), collects interviews and compiles and replicates them for what she calls her documentary theater; Eve Ensler (1996), in *The Vagina Monologues*, begins with interviews and then shapes them for her stage performances; and Lynn Nottage constructed her play *Ruined* (2009) after interviewing refugee women in Uganda. In my multimedia stage play *Flying Over Purgatory* (Chenzira, 2002), I constructed the production in part by recontextualizing testimonies given by South Africans who appeared before that country's Truth and Reconciliation Commission. All of these works uniquely address issues of social justice by delving into the personal that highlights women's voices and perspectives.

Swallowing Stones and Telling Stories

While collecting oral narratives for my art practice, I discovered that women have too often learned to swallow stones. So, for me, the priority is how do we honor our own informed voices of authority? This untying of the tongue is at the root of my interest in issues of social justice. In the 1980s, I read the book *All the Women Are White, All the Blacks Are Men, but Some of Us Are Brave: Black Women's Studies* (Hull, Bell-Scott, & Smith, 1982). This groundbreaking book presented a type of new world order constructed in part by the works of authors such as Alice, Maya, Toni, and Toni—yes, even without meeting them, I was on first name basis with these women who inspired me and illuminated the path to which I would devote a career. Their understanding of the experiences of women of color was further

articulated by Black feminist scholars Beverly Guy-Sheftall, Patricia Hill Collins, Barbara Smith, Johnnella Butler, Jackie Royster Jones, and bell hooks, to name just a few. Their words got down into the marrow of who I knew I was—how I was constructed—and elevated the lives of the women I had listened to in my mother's parlor (and by extension, elevated me as well). Their interpretations and articulations of being a Colored/Negro/Black girl/woman historically and contemporarily were the bedrock to stand on and an accessible validation for which I would carry a torch forward. If you have never read Alice Walker's (1970) *The Third Life of Grange Copeland*, Maya Angelou's (1970) I *Know Why the Caged Bird Sings*, Toni Morrison's (1972) *The Bluest Eye*, or the essays and short stories of Toni Cade Bambara (1970), you may not understand what all the brouhaha is about, why folks get so upset and at times overly protective of the images of African American women as presented in commercial films. Understand this: Industrialized images of Black (as in the diaspora) women protagonists often lack a context that makes them feel authentic when compared to the works of the above-mentioned writers. When the authentic context is present, as it is in Kasi Lemon's *Eve's Bayou* (1997) and Dee Rees's *Pariah* (2011), you recognize it instantly.

One could not be misled if one had read the flurry of anthologies that were produced by African Americana feminist writers during the 1980s. Roseann Bell, Bettye Parker, and Beverly Guy-Sheftall edited the anthology of Black women writers in *Sturdy Black Bridges* (1979), our first opportunity to read a breathtaking range of work. Then, bell hooks got a hold of us in 1981 with *Ain't I a Woman: Black Women and Feminism* to deftly explain to those who did not get it (which was most of us)—"it" being the confluence of race, class, and gender—and further helped us understand (and get over) why we were feeling so ambivalent about the term *feminist*, given the history of leaving out poor women and women of color (and thereby reinforcing what it claimed to be addressing). Then, just as Black women were feeling more empowered than we had ever felt, Barbara Smith's anthology *Home Girls: A Black Feminist Anthology* (1983) armed us with a new canon of knowledge. This work notified everyone that if feminism wasn't just White, it wasn't just heterosexual. Cherríe Moraga and Gloria Anzaldúa (1981), editors of *This Bridge Called My Back: Writings by Radical Women of Color*, further informed us that we didn't know everything yet if we hadn't figured out that there was deep connective tissue between Black, Latina, Native American, and Asian American experiences, and here, the notion of "universal" looks a whole lot different. Just when we were on the rim of connecting all of these ideas to our lives, understanding how oppression works locally and globally, hooks (1984) served us notice that men were an important part of ending sexism with *Feminist Theory: From Margin to Center*. This work articulated that an antimale stance just would not move anyone forward in the long term.

These and other groundbreaking feminist scholars were performing psychic surgery as they shifted thought around what it meant to be a Black woman. Their work brought about a consciousness where we Black women began to value ourselves

and understand how systems of oppression worked. Best of all, they forced the is-sues in academic arenas, duking it out with their White feminist colleagues who had never thought about feminism and Black women being connected. These Black women intellectuals carved out that direction within the feminist agenda and created spaces to educate a new generation of male and female students. Lin-ing up behind role models like Harriet Tubman, the above-mentioned pioneering thought leaders (and others) stood up to ridicule, apathy, the law, and prevailing thought to formally establish that women of color had something valuable to add in academic discourse. They etched out their positions like a tattoo onto the aca-demic skin of an unwelcoming academia. Their efforts were eventually accepted, and over time, they permeated every discipline within the arts, humanities, and social sciences. So, in the 1980s, when friend, filmmaker, and educator Kathleen Conwell Collins Prettyman encouraged me to teach filmmaking while still pro-ducing films, I knew why it was important to do so. I accepted a faculty position at the historic City College of New York. While there, I cocreated the MFA in Media Art Production, which continues today. I also accepted invitations to develop the talents of emerging filmmakers in several African countries.

Early Work

My early work as a filmmaker was centered in thinking about identity, African American culture, and history. *Syvilla: They Dance to Her Drum* (Chenzira, 1979) documented the life of the unsung first-generation concert dancer Syvilla Fort, who was also the ballet mistress for the famed Katherine Dunham Dance Com-pany; *Hair Piece: A Film for Nappyheaded People* (Chenzira, 1982) is an animated satire that looks at the question of self-image for Black women living in a society where beautiful hair is viewed as hair that blows in the wind and lets you be free; *Zajota and the Boogie Spirit* (Chenzira, 1989) is an animated film that traces the history of the African slave trade through dance; *Pull Your Head to the Moon: Stories of Creole Women* (Chenzira, 1992, written by David Rousseve) told the story of a family of women who organized to retaliate when learning that a cousin had been raped; *Al-ma's Rainbow* (Chenzira, 1994) is the story of a teenage girl's struggle to find her sense of self within the repressive household of her single mother who eventually learns that she is the one that must come of age; *Snowfire* (Chenzira, 1994) is a meditation by parents coming to terms with the death of their gay son from AIDS; *My Own TV* (Chenzira, 1993, written by Thomas Osha Pinnock) portrays a woman struggling with the memory of her husband, an immigrant enamored by the American dream, murdered shortly after winning the Lotto, which he played religiously; and *In the Rivers of Mercy Angst* (Chenzira, 1997) uses as its protagonist a homeless women stuck between history and dreaming. What these works have in common is giving voice to the lived experience of African American women protagonists.

Since 2000, my work continues to be centered in the lived experiences of women of African descent and involves film and digital media installations. *Flying*

Over Purgatory (Chenzira, 2002), which was originally a screenplay, was reworked for the stage as a multimedia stage play featuring actor/activist Ruby Dee and the late South African actor Mabel Mafuyo. In 2003, I designed and implemented a video booth for the HIV/AIDS conference at Spelman College, which allowed participants to privately record and then share, if they chose to, their stories with a larger audience. *Survival Mode* (Chenzira, Bayless, & Buck, 2008), an interactive installation about Hurricane Katrina and the broken levees, merged art and current events into a multiscreen interactive installation that recreated stories from survivors. *Making Beauty* (Chenzira, 2010) is an interactive installation that uses video and sensing technologies that allow objects that belonged to my mother to tell their memories of her. A more recent project, *HERadventure* (Chenzira, 2013; Chenzira and HaJ, 2013) is a science fiction film with built in games that highlights issues of social justice and activism.

The Digital Moving Image Salon

Many things have changed since I was student at NYU in the 1970s. There are more African American women enrolled in film programs and employed in the film and television industries. However, some things have not changed. There are many more ways in which the public can receive stories (movie theaters, television, the Internet, mobile phone), and yet there continues to be a narrow range of stories about the lives of African American women. Many academic film programs do not include African American cinema as part of their course offerings or on syllabi. African American women studying film at the graduate level continue to experience a knee-jerk resistance when bringing their interests and knowledge to the development process of filmmaking. Feminist theorist Chandra Talpade Mohanty provides useful insight to help us through this continuing dilemma: "A just and inclusive feminist politics for the present needs to also have a vision for transformation and strategies for realizing this vision" (2003, p. 3).

In 2001, I was invited to Spelman College in Atlanta, Georgia, a historically Black college and one of two for African Americans. I was honored to serve as the first William Camille Olivia Hanks Cosby Endowed Professor in the Arts. Later, I was approached to join the faculty, and today Spelman remains my institutional home. I often think of my friend Toni Cade Bambara, who also taught at Spelman (1978–1979). She believed that we could rise above our training, think better than we'd been taught, and as a result we could transform a society.

When asked by the college president, Beverly Daniel Tatum, what I would like to do at Spelman, I asked for two things: the opportunity to help students deconstruct the popular mythology that was being created about them in the media and the opportunity to create a year-long production course that would link filmmaking practices to real-world issues that impacted women's lives as articulated through their oral narratives. The result is the Digital Moving Image Salon (DMIS), which is located in the Women's Research and Resource Center

(WRRC) at Spelman College. The center was founded in 1981 by Black feminist scholar Beverly Guy-Sheftall. WRRC is the only women's studies program in the country to incorporate history and theory, activism, digital media production, and women's health within the overall discipline. The value of this to an artist interested in centralizing the lives of Black women as protagonists is that it keeps the focus on *the personal as political* as an underpinning in which to develop visual stories.

Film as Storytelling and Social Justice

At the heart of DMIS is storytelling. The history of art is the history of creative practices that consider the world and what it means to "be" in the world—how we represent human subjectivity. Storytelling as an art form serves to build bridges across similar and disparate ways of being in the world. It is a tool that we use to help us make sense of others and ourselves and to critique the world(s) that we inhabit. DMIS is situated within the concept of hybrid experimentation and is open to all majors. The year-long production course is called Documenting Women: Oral Narratives and Digital Media. It is structured as an a interdisciplinary approach to pedagogy using digital technologies to explore humanistic questions, particularly those that relate to gender, race, class, and sexuality, with an emphasis on the lived experiences of women of color. The DMIS program empowers students, most of whom have no prior filmmaking experience, to research burning issues related to their lives, build consensus, form filmmaking teams, go out into communities, talk to women about their lives, and ultimately construct a documentary or docudrama. Final works are presented each spring to a general audience where students also engage in a question-and-answer session. Many powerful works have emerged from the DMIS laboratory. An example of student work that exemplifies a model of direct action includes *Sisters on the Sojourn* (2005), produced by Moya Bailey, Takkara Brunson, and Pier Smith, which chronicles contemporary student activism at Spelman College, including the highly publicized confrontations with rapper Nelly. Bailey comments in the documentary film *Inside the Digital Moving Image Salon* (HaJ, 2009):

> One of the things that we focused on in our documentary was the student actions at Spelman around Nelly coming to campus. He was supposed to come to campus to do a bone marrow registration drive, but some students had some questions about, you want us to help you save your sister's life but you promote all of these other problematic representations of Black women.

The students who invited Nelly wanted to talk with him about his music video *Tip Drill* (an expression used by some men for having anal sex with a woman because they think she is unattractive and do not want to look her in the face). His then popular music video featured the rapper swiping a credit card down the buttocks of a featured dancer. Nelly issued a public statement saying that he had been disinvited by Spelman students. This was not true. The students were thrust

into a national spotlight and ignited a national dialogue that included appearing on *Oprah* to discuss the images of African American women in popular culture.

Another student work was *No Hetero!* (2007), a documentary produced by Leana Cabral, Taryn Crenshaw, and Diana Houghton. The video highlights the experiences of gay and lesbian students at Morehouse and Spelman Colleges. This production examined the broader issue of sexual orientation and discrimination in African American communities. The production occurred at a time when there were a number of gay and lesbian students who were being verbally and physically attacked on and off campus by fellow students. It featured rarely seen imagery of Coretta Scott King supporting gay rights and a compelling and thought-provoking interview with a transgendered activist.

In 2012, *Unsung Heroes: African American Women in the Military*, produced by Carina-Michelle Francis and Jamiere Smith, highlighted the fastest growing population in the military and secured an interview with the first African American prisoner of war, Shoshana Johnson, whose story never made the press.

My experiences have taught me that cross-cultural exchanges are critical to one's global view. The natural complexities, disparities, and similarities one observes provide a special lens that informs the observer forever thereafter. I create opportunities for my students to travel with me and assist in developing productions. One research assistant, Juliana Montgomery, joined me in South Africa to serve as an associate producer and videographer. Later she was awarded an Emmy for her own work. In 2009, two students, Cydnee Bayless and Jennifer Buck, accepted invitations to join me in traveling to Bahçeşehir University in Istanbul to dialogue with students and faculty about their work as DMIS student researchers. DMIS students continue the tradition of activism with twenty-first-century technologies to propel women's stories into the forefront of what it means to be in the world.

I see DMIS as my contribution to the generative fabric started by the Black feminist writers and scholars who broke new ground in the 1970s, and those that preceded them. Their work, combined with the oral narratives first heard in my mother's beauty parlor, helps me to understand and value the need to be heard and the importance of my voice. I continue to believe that *revolution begins in and with the self*. The projects that I have created over the years continue to be used extensively in film communities, in educational institutions, by activists, and in corporations. This interconnection between the work created by an artist and its use by institutions and grassroots community organizers is an important strategy for social change.

References

Angelou, M. (1970). *I know why the caged bird sings*. New York: Random House.

Bailey, M., Brunson, T., & Smith, P. (Producers). (2005) *Sisters on the Sojourn*. [DVD]. United States: Digital Moving Image Salon-Spelman College.

Bambara, T.C. (1970). *The Black woman: An anthology*. New York: New American Library.

Bell, R.P., Parker, B.J., & Guy-Sheftall, B. (1979). *Sturdy black bridges: Visions of Black women in literature*. Garden City, NY: Anchor Press/Doubleday.

Cabral, L., Crenshaw, T., & Houghton, D. (Directors). (2007). *No hetero!* [DVD]. United States: Digital Moving Image Salon-Spelman College.

Chenzira, A. (Director). (1979). *Syvilla: They dance to her drum* [Motion picture on DVD]. United States: Filmmaker.

Chenzira, A. (Director). (1982). *Hair piece: A film for nappyheaded people* [Motion picture on DVD]. United States: Filmmaker.

Chenzira, A. (Director). (1989). *Zajota and the boogie spirit* [Motion picture on DVD]. United States: Filmmaker.

Chenzira, A. (Director). (1992). *Pull your head to the moon: Stories of Creole women* [Motion picture on DVD]. United States: Filmmaker.

Chenzira, A. (Director). (1993). *My own TV* [Motion picture on DVD]. United States: Filmmaker.

Chenzira, A. (Director). (1994). *Alma's rainbow* [Motion picture on DVD]. United States: Filmmaker.

Chenzira, A. (Director). (1994). *Snowfire* [Motion picture on DVD]. United States: Filmmaker.

Chenzira, A. (Director). (1997). *In the rivers of Mercy Angst* [Motion picture on DVD]. United States: Filmmaker.

Chenzira, A. (Director). (2002). *Flying over purgatory*. Live performance in William Burrows Theatre/Spelman College, Atlanta.

Chenzira, A. (2011). "Haptic Cinema: An Art Practice on the Interactive Digital Media Tabletop." *Dissertation Literature, Communication, and Culture*. Atlanta: Georgia Institute of Technology.

Chenzira, A. (2013). *HERadventure*. In *The Digital Moving Image Salon: A Cutting-Edge Program*. Retrieved from http://www.spelman.edu/academics/majors-and-programs/comparative-womens-studies/womens-research-resource-center/digital-moving-image-salon/heradventure.

Chenzira, A. (Director/Producer). HaJ (Producer) (2013). *HERadventure* [Motion Picture and Web]. http://www.heradventure.com United States: Her Short Film.

Chenzira, A., Bayless, C., & Buck, J. (Producers). (2008). *Survival mode* [Motion picture installation]. United States: Digital Moving Image Salon-Spelman College.

Ensler, E. (1996). *The vagina monologues*. New York: Dramatists Play Service.

Haj (producer and director) (2009). *Inside the Digital Moving Image Salon*. [DVD]. Atlanta: Spelman College Women's Research and Resource Center.

hooks, b. (1981). *Ain't I a woman: Black women and feminism*. London: Pluto Press.

hooks, b. (1984). *Feminist theory: From margin to center*. Boston: South End Press.

Hull, G.T., Bell-Scott, P., & Smith, B. (1982). *All the women are White, all the Blacks are men, but some of us are brave: Black women's studies*. Old Westbury, NY: Feminist Press.

Lemmons, K. (Director). (1997). *Eve's Bayou* [Motion picture]. United States: Trimark Pictures.

Mohanty, C.T. (2003). *Feminism without borders: Decolonizing theory, practicing solidarity*. Durham, NC: Duke University Press.

Moraga, C., & Anzaldúa, G. (1981). *This bridge called my back: Writings by radical women of color*. Watertown, MA: Persephone Press.

Morrison, T. (1972). *The bluest eye*. New York: Washington Square Press, Pocket Books.

Obbo, J. (1997). What do women know? ... as I was saying! In K. M. Vaz (Ed.), *Oral narrative research with black women* (pp. 41–63). Thousand Oaks, CA: Sage.

Parks, G., Jr. (Director). (1972). *Superfly* [Motion picture]. United States: Warner Brothers.

Rees, D. (Writer, Director). (2011). *Pariah* [Motion picture]. United States: Focus Features.

Smith, A. D. (Writer). (1992). *Fires in the mirror*. Live performance in New York.

Smith, A. D. (1993). *Fires in the mirror: Crown Heights, Brooklyn and other identities*. New York: Anchor Books.

Smith, A. D. (1994). *Twilight Los Angeles*. Live performance in New York, N.Y.

Smith, B. (1983). *Home girls: A Black feminist anthology*. New York: Kitchen Table—Women of Color Press.

Starrett, J. (Director). (1973). *Cleopatra Jones* [Motion picture]. United States: Warner Brothers.

Walker, A. (1970). *The third life of Grange Copeland*. New York: Harcourt, Brace, Jovanovich.

15

FREE YOUR MIND: AFROCENTRIC ARTS EDUCATION AND THE COUNTER NARRATIVE SCHOOL

Justin Laing

1. What kinds of roles are the arts playing today in assisting and/or retarding Black children's capacity to imagine a bright future for themselves and the world?
2. Can we talk about Black children having specific needs and still be having a "twenty-first-century conversation"?

The point may have been made most clearly in the title of Woodson's (1993) *Mis-Education of the Negro*: American schooling regularly supports the metanarrative of White supremacy and African American intellectual inferiority. This was not merely the claim of a lone scholar or just an issue of the early twentieth century. The negative impact of our education process on the psyche of African American children has been the subject of a century of consistent resistance and legal action (Asante, 1989; DuBois, 1935; King, 1992; Kozol, 1992; Sizemore, 2007). In supporting this metanarrative, American school systems withhold from African American children a capacity to imagine a bright future for themselves and their community. This ability to imagine a future that could reasonably be said to be in one's best interest has been termed a *capacity for the conception of the good* (Rawls, 1996), and it is a right violated in much of current standard educational processes. However, despite the effort to withhold this right from African American children, the Black community has a long history in employing strategies that support Black children in developing a motivation to learn and envision a future not only for themselves but also for the larger Black community (Perry, Steele, & Hilliard, 2003). Perry (2003) has synthesized these strategies into a unified framework. This chapter will seek to show the relationship between this theory, the right to freedom of thought, and the arts of Africa and the diaspora in promoting a narrative that helps Black children realize their conception of the good.

As a program officer of a regional foundation, a good portion of my work has been focused on an initiative titled culturally responsive arts education (CRAE), and key ideas of this chapter are rooted in my experience in working with this initiative. However, before I worked as a program officer, I was a teaching artist. The ideas that led to the funding of CRAE were shaped by my work for Nego Gato Inc., an African Brazilian arts organization inside Miller Afrocentric Academy, a public school in Pittsburgh's Hill District. Thus, I have a particular interest in a specific branch of the CRAE tree: African-centered arts education (AAE) (C. Sykes, personal communication, May 20, 2010). So as to avoid the theoretical, practical, and political complexities of teaching issues of Black and White identity in mixed-race settings, the particular AAE arts education model discussed in this chapter is designed to be implemented in those schools with a largely African American population. I saw stellar results for children at Miller African Centered Academy, and it was due to the combination of the principal, children, teaching artists, parents, and my teacher, Mestre Nego Gato. The strategies in this chapter imagine a similar kind of relationship between a teaching artist and the school community but also include ideas that we may not have considered as closely, such as the benefits of helping children build knowledge of how to connect to White culture in addition to understanding their own heritage and background. In this paper, these two forms of cultural knowledge will be referred to as bridging and bonding cultural capital.

The Conception of the Good

The capacity to conceive *or imagine* the good is the chief element of freedom of thought, the underpinning of the fundamental human right to freedom of expression as seen in our national matrix of rights such as *freedom of association* and *freedom of speech* (Rawls, 1996). Thus, in discussing the education of Black children, strengthening their capacity to envision a *good*, not only for themselves but also for the larger Black community should be key in any discussion of arts education and social justice. However, in my experience working with children, they will not be interested in simply dreaming up the future. Ironically, although their future as adults lies ahead of them, they share with Martin Luther King Jr. a sense of the *urgency of now*. Thus, helping children to create artistic work of a quality that demonstrates an alternative present is central to their capacity to imagine an alternative future. Simultaneously, the African-centered artist must mine his or her particular art form for the skills and strategies that will allow children to both challenge and circumvent the White supremacy with which they are *currently* confronted. These are tall orders, and the artist cannot accomplish this goal alone. Rather, the work is best done in the context of a larger educational agenda that has the express purpose of challenging the current racial hierarchy. In this case, the arts of Africa and the diaspora can play a unique role in supporting the Black child's capacity to conceive the *good*.

In order for such rights as freedom of speech and association to be more than a mere formality, society must act to ensure that citizens receive "fair value" for these rights (Rawls, 1996). It is not enough that the rights to free speech and association exist in the constitution and legal structure of a country. Rather, there must be equal opportunity within the citizenry to take full advantage of these rights. So, to the extent that American schooling inhibits the capacity of Black children to conceive the *good*, it prevents them from extracting fair value for the formal rights they are ostensibly to receive as adult American citizens.

The African-centered, multicultural, and culturally responsive education models pose curricular solutions to the challenges noted previously, but these solutions rarely have a comprehensive view of how the arts might embolden and facilitate their aims. These strategies that acknowledge the role of culture in supporting the learning of Black children would have much greater impact were they to involve strategies to effectively employ the arts of Africa and the diaspora. Likewise, arts education strategies that speak of the benefits of developing the imagination of African American and Latino children (often these populations are brought to mind through references to "urban" and "at-risk") would benefit from greater attention to discussions focused on the benefits of arts education rooted in a child's cultural experience.

The Conception of the Good as Counternarrative

Perry (2003) poses the challenge of high academic achievement as one of motivation. They pose the following dilemmas as the crux of the matter:

> *How do I commit myself to achieve, to work hard over time in school, if I cannot predict (in school or out of school) when or under what circumstances this hard work will be acknowledged and recognized?*
>
> *How do I commit myself to do work that is predicated on a belief in the power of the mind, when African-American intellectual inferiority is so much a part of the taken-for-granted notions of the larger society, even good and well-intentioned people, individuals who purport to be acting on my behalf, routinely register doubts about my intellectual competence?* (pp. 4–5)

Perry et al. (2003) pose the source of the dilemma as the following: "The issues involved with African Americans being able to commit themselves over time to do intellectual work at a high level are also fundamentally informed by the larger society's ideology of African American intellectual inferiority. For no American group has there been such a persistent, well-articulated and unabated ideology regarding their mental incompetence" (p. 105). It is because of this ideology that African American students face a unique social, psychological, and political challenge to achieve academically as African Americans. In response, Perry poses a theory of African American achievement with the central strategy being to assist

African American children in developing a "counternarrative" (i.e., an internal narrative that provides a set of answers to the dilemmas noted previously and facilitates the development of the kind of identity that succeeding as an African American student requires).

Implicit in Perry's model is a need for imagination in order to resolve those dilemmas. This includes a process of quality arts instruction that would not only build African American children's capacity to conceive a quality life for themselves and their community, but also build the necessary discipline to bring such a conception to fruition. There are essentially five strategies that Perry (2003) suggest in order to successfully construct a counternarrative with Black children. Embedded within each of these strategies is the potential for the theory to become even more powerful through a link to the arts of Africa and the diaspora. Thoughtfully implemented, the arts could play a critical role in supporting Black children's capacity to conceive a *good* both for themselves and the larger Black population. As stated previously, this conception is tantamount to freedom of thought and will be required if African American children are to later receive fair value for the rights to freedom of expression. In the next section, I describe five strategies that I see in the work of Perry et al. that are linked with African diasporic arts education and a school that helps children build a counternarrative.

Arts of Africa and the Diaspora, and the Five Strategies of a Counternarrative School

Strategy 1: Explicitly communicating stories of African American intelligence, achievement, and commitment to the African American community as a fundamental component of what it is to be African American. In order for Black students to not associate academic achievement with "acting white" (Ogbu, 2004), there must be a concerted effort to help African American students to see intellectual achievement as part and parcel of what it means to be Black. This strategy would be augmented through teaching focused on placing the arts of Africa and the diaspora in historical and cultural context, one of the four areas of focus for most state arts standards. Essential questions could regularly be posed in the examination of the works of such artists as Thelonious Monk, Alvin Ailey, Romare Bearden, Oscar Micheaux, Amiri Baraka, and August Wilson that ask children to consider the intellectual complexity and social commentary of the creations of these artists. The thoughtful consideration of the work of these artists will encourage children to make associations between the intellectual capacity of these artists and the child's larger conception of what it means to be Black. Simultaneously, it should help to create discussions within schools that challenge the dichotomy between cognition and art that has relegated the arts to secondary importance (Eisner, 2002).

Strategy 2: Assist children in developing an opposition to a "know your place identity." Here, Perry (2003) discuss an idea best captured in the traditional advice given to Black students that they should stand and walk "like you are somebody" (p. 90).

In other words, principals and teachers promoted practices "curricular, behavioral, ritualistic, and so on—designed to counter the expectations of Black students that they were permanent members of a caste group with little or no chance for social mobility" (Perry et al., 2003, p. 89). By slightly altering Putnam's (2000) social capital concept and by using Perry's discussion of "cultural capital," it could be said that in counternarrative schools children were given two kinds of cultural capital: *bonding cultural capital*, or value for and commitment to their referent group, and *bridging cultural capital*, or knowledge of how to connect and relate to other groups.

Bonding cultural capital is constructed in part by helping African American children to understand that racism is still a large part of American culture yet can and must be overcome. Learning designed to help children understand the history and continued existence of racism helps to ensure that African American children are prepared for times when their best efforts are neither validated nor fairly assessed, rather than internalize the experience as evidence of their own shortcomings." (Perry et al., 2003). The kind of message is typified in the Curtis Mayfield's classic song, Keep on Pushing. This type of instruction helps to build in an identity of African Americans as resisters to oppression and strengthens connections to the referent group.

Equally relevant is bridging cultural capital. This concept was constructed in part when African American children were given explicit information and training on the cultural signs of the dominating culture (i.e., how upper- and middle-class White America speaks, ties a tie, shakes a hand, etc.), so that they would be endowed not only with the best of African American cultural capital but also the cultural capital of the dominating society as well. This kind of capital transfer is evident in strategies for teaching children mainstream language by bridging to their home language (Perry et al., 2003). This kind of an effort would require some thought in order to avoid falling into the kind of assimilationist strategies that can support the metanarrative of Black inferiority (Hanley & Noblit, 2009).

From the perspective of an AAE program, the creation of *bonding cultural capital* is invigorated by immersion in arts of the African diaspora in such a way that a child has an opportunity to build skill. In this manner a child is able to experience the richness and complexity of the art form as he/she develops advanced skill. As the child sees and, more importantly, experiences the complexity in b-boying, capoeira, jazz, or mural painting, the seed is planted: "To be a part of the tradition of Black culture is to be part of something both beautiful and complex." This message does not need to be preached to children in the didactic manner that most children (and adults for that matter) resist, but rather is placed in the background, secondary to learning the art form and all of the intrinsic benefits it has to offer. In this way, Black children are able to make their own meaning and build their capacity for free thought rather than learning the "right answers" to which less creative versions of African-centered education too often default. Advocates of Paulo Freire's "pedagogy of the oppressed" will recognize the latter model as "depositing" forms of education (Freire, 1970).

The second component of "an opposition to a know your place identity," bridging cultural capital can be also be supported through a rigorous arts instruction process. Here, children are given sufficient time on task (no small accomplishment in the current urban school environment), expected to develop skill, and then encouraged and held accountable for how they present themselves and the art form. In the performing arts, particular attention must be paid to how children carry themselves onstage and present themselves to the audience such that their heads are held high, their voices are projected, and authority is felt and demonstrated in their body language. Efforts should be made to teach children to speak to audiences about the complexity of the art form using school culture language, so that Black children whose home language differs from their school's language have access to the bridging cultural capital that being able to speak both school culture and home culture English provides. Once children develop skill, the opportunity to present their work in a variety of settings is limitless. For African American children from lower income Black community settings, this will invariably mean chances to perform in higher wealth White communities both close to and far away from their homes. It is on these occasions that Black children have the opportunity to see worlds different from their own and ones they may find inspiring. These can be important moments in their developing capacity to conceive the good. In these times, they are able to observe the cultural cues that can be employed in order to assist their travel to new environments. While discussion of this particular approach is beyond the scope of this paper, efforts might also be made to engage African American children in works of the Western canon in order to build bridging cultural capital.

Strategy 3: Participation by the surrounding community in the development of the counternarrative. In the early twentieth century, the era prior to *Brown v. Board of Education*, social, economic, and religious institutions continued to have their own focused missions. However, there existed a broader consensus focused on communicating to African American children the larger idea of "freedom for literacy and literacy for freedom and racial uplift, citizenship and leadership" (Perry et al., 2003, p. 106). In these cases, churches, neighborhood stores, and so forth, communicated to children that achievement was what was expected and needed in order for the Black community to advance itself. With this explicit guideline in place, whenever children are asked to share their work in a community setting, and with a skilled troupe, they will also receive messages from the reverend, executive director, and community leader about the importance of educational attainment and its place as a part of the Black identity. This cannot be expected to occur as a matter of course, so program leaders must look for partners who can share this message naturally and as a part of their core mission. Arts education participation by the community might entail the children giving performances in community settings such as religious organizations (churches, mosques, and temples), ensuring that community members are active in supporting the student artist by attending school-based performances, providing mentoring support, and providing recognition to student artists or being involved in programming in other ways.

Strategy 4: The development of an ethic of persistence. Under this heading, children were "explicitly passed on those dispositions, behaviors and stances that were viewed as essential to academic achievement (persistence, thoroughness, a desire to do one's very best, commitment to hard work)." In the area of an African-centered educational program that is specifically about arts instruction, children are given substantive and interesting artistic challenges, learning an Afro-Brazilian rhythm of samba reggae, polyrhythmic stepping, a piece of African American choral music; and in overcoming the challenge of learning these pieces, they learn that through diligent work they can accomplish amazing results. It is through the development of an ethic of persistence that children can be said to be introduced to themselves and their own capacities. Equally important, teachers and parents can become acquainted with the child's capabilities in ways they had not previously imagined.

It might be argued that the ethic of persistence can be built through dedication to any art form, and this is correct. Still, why not an assumption of first priority for art forms from a child's general ethnic and cultural background? Yet, there is an even better rationale for a focus on arts of Africa and the diaspora: All of the strategies of a counternarrative school work together to support one another, and so while we are talking about the ethic of persistence that is built through focused attention on the art, what is also happening is that the child is learning about the complexity and value of Black culture. This message of Black cultural complexity, which is playing in the background or in the subtext of the child's learning experience, helps to inure Black children from the more toxic messages of Black incompetence and ineffectiveness that are coming from the many portals of society, including the school. The danger embedded in questions that challenge the assumption of a priority of Black art forms for Black children is they often hide an assumption of primacy and appropriateness of Western European classical music or the work of Monet, and so forth, for "at-risk," "underserved," or "children of color." There is a danger because there is seemingly no awareness or acknowledgement of how the eradication or diminishment of African or Native art forms and the elevation of European-based art forms as "high art and culture" was part and parcel of the systematic oppression of Black people and other ALANA (African, Latino/a, Asian and Native American) people (Ogbu, 2004). Arts education advocates and programs that make the assumption regarding the "high arts" actually support the metanarrative of White supremacy.

Strategy 5: The use of ritual, symbols, and protocols to create a "figured world." By *figured world*, "we mean a socially constructed realm of interpretation in which particular characters and actors are recognized, significance is assigned to certain acts, and particular outcomes are valued over others" (Perry et al., 2003, p. 93). An African-centered program with a clearly designed role for the arts would create and implement rituals, symbols, and protocols to that end. Countless African-centered schools employ such rituals as morning drum call and the singing of James Weldon Johnson's "Lift Ev'ry Voice and Sing"; and churches employ African American liturgical dance to similar ends. This is an obvious strength of many

African-centered programs where less discussion of the relationship of the arts to this strategy is necessary.

I hope that I have been successful in showing the relationship among (a) the theory of African American achievement (Perry, 2003) and its argument that America's metanarrative of White supremacy requires a counternarrative from Black children if they are to achieve an academic success that provides them with a commitment to the larger Black population and world, (b) the arts of the African diaspora, and (c) the right to freedom of thought (i.e., the capacity to conceive the good). I offer this framework not simply to support a theoretical claim for the justness of the theory of African American achievement and the arts of the African diaspora, but in hopes of offering a framework that advocates of African American culture and/or arts education could build on in the struggle to develop an educational process that lifts up and supports the lives of Black children.

Advocating for Socially Just Arts Education

Equally important as developing a mental model for how arts education might advance social justice in education is thinking about what kind of advocacy and organizing could help to bring it about, particularly in urban school settings. There are a couple of developing forces in education that might be strengthened by merging the issues of freedom of thought, Black culture, and the arts. In 2010, the National Black Education Agenda (NBEA) released a position paper criticizing the common core standards for failing to address the culture of African American and Latino students (NBEA, 2010). NBEA's critique is in the tradition of *Mis-Education of the Negro* (Woodson, 1933), and as a part of the tradition of this groundbreaking work, there is little reference to the arts as cultural production and thus the perfect candidate to promote the "cultural excellence" highlighted as a goal of education.

Simultaneously, colleagues of mine in the world of arts education are beginning to organize around the role of the arts in the developing educational policy. Much of recent policy is focused on the urban school districts that are particularly failing Black and Latino children. However, it seems that arts education advocates are missing an opportunity to discuss the arts that emerge from the culture of Black and Latino children. Since Black people's earliest moments in this land, music, visual arts, and dance have been essential to our making sense of, expressing, and altering oppressive efforts to limit our conception of the good; this is a particularly valuable issue to raise in discussing the role of arts education in urban settings. Arts education policy formulations for urban systems that do not make explicit reference to the need to support the cultural formations of African American, Latino, Asian, and Native American children, or imply the need for White Western art forms and music for poor Black and Latino children, risk supporting the metanarrative of White supremacy and its misplaced assumptions of classicality. Advocates for a pedagogy that empowers African American children might seek

to blend the arguments used by advocates of arts education with the arguments used by advocates of African-centered education. This could be accomplished by the two constituencies looking at the links between one another's arguments. From this type of interaction, additional educational models might emerge that not only involve the arts in the substantive questions facing urban education but also allow multiple subjects to rally around one focus, the achievement of African American children.

Potential Challenges

The development of an AAE model will not be without challenges. It will require the creation of a number of assessment tools, including those that measure artistic development in art forms of Africa and the diaspora, as well as those that assess the extent to which Black children's identity includes academic achievement. It will require the training of teachers and teaching artists, so that they are prepared to help Black children have deep artistic experiences as a process of developing their own counternarrative. It will also necessitate the development of community collaborations that will support the message of the program. Nevertheless, what it may most require is community demand and support. The "brand" of African-centered education has suffered greatly from the media onslaught of the early 1990s, and so its promotion brings up specious arguments for Ebonics and/or inferior educational standards for both White and Black people. Advocates for AAE will need to develop partnerships with a range of community members in order to acquire the resources to create full-fledged programs. As this model of education challenges a number of pervasive arguments regarding not only the inferiority of Black culture but also the marginal importance of the arts, clear explanations for why such a program could be successful will be necessary. My hope is that this chapter might be helpful in that regard.

Conclusion

In order for Black students to have the capacity to conceive the *good* in the face of a metanarrative of White supremacy and Black intellectual inferiority, they must develop a counternarrative that includes academic achievement as a key part of the definition of what it means to be Black (Perry et al., 2003). This capacity to conceive the good amounts to freedom of thought, the underpinning of our First Amendment rights of freedom of speech and assembly (Rawls, 1996). Theresa Perry's theory of African American achievement deserves more attention in the formulations to advance the achievement of Black students, particularly those in predominantly African American schools. Arts of the African diaspora should play a critical role in how this theory is implemented. However, the challenge lies in the development of the human and financial resources that will enable hundreds of thousands of Black children to conceive of an individual and collective *good*, a

conception that will be required if there is to be real improvement to the dangerous conditions in the minds of so many of our children.

References

Asante, M. (2009). Afrocentricity. Retrieved from http://www.asante.net/articles/1/afrocentricity/

DuBois, W. E. B. (1935). Does the negro need separate schools? *The Journal of Negro Education, 4*(3), 328–335.

Eisner, E. (2002). *The arts and the creation of the mind.* New Haven, CT: Yale University Press

Freire, P. (2007). *The pedagogy of the oppressed.* New York: Continuum.

Hanley, M.S., & Noblit, G. (2009). *Cultural responsiveness, racial identity and academic success: A review of the literature.* Pittsburgh, PA: Heinz Endowments.

King, J. (1992). Diaspora literacy and consciousness in the struggle against miseducation in the black community. *The Journal of Negro Education, 61*(3), 317–340.

Kozol, J. (1992). *Savage inequalities: Children in America's schools.* New York: HarperCollins Publishers.

National Black Education Agenda (NBEA). (2010). *For Black America—we are "still a nation at risk."* Retrieved from http://blackeducationnow.org/id17.html

Ogbu, J. (2004). Collective identity and the burden of acting white in Black history, community and education. *The Urban Review, 36*, 1, 1–35.

Perry, T., Steele, C., & Hilliard, A. (2003). *Young, gifted and black: Promoting high achievement among African-American students.* Boston: Beacon Press.

Putnam, R. (2000). *Bowling alone: The collapse and revival of American community.* New York: Simon & Schuster.

Rawls, J. (1996). *Political liberalism.* New York: Columbia University Press.

Sizemore, B. (2007). *Walking in circles: The Black struggle for school reform.* Chicago: Third World Press.

Woodson, C. G. (1933). *The mis-education of the negro.* Associated Publishers.

16

CLOSURE

A Critical Look at the Foreclosure Crisis in Words and Images

Mary E. Weems and R. A. Washington

1. How can visual art and creative writing relate a counternarrative?
2. What are the elements of a social justice narrative told through the arts?

> *This just in from CNN: New reports point out that just 4% of troubled homeowners are getting foreclosure help from either banks [they bailed out with taxpayer money] or federal programs designed to help.*
>
> December 11, 2009

This is an artistic case study, a collage of words and images. It takes a creative-critical look at the foreclosure crisis, using our hometown—the majority African American city of Cleveland, Ohio, nationally recognized as one of the hardest hit cities in the country—as a site of resistance. To echo the late Gordon Parks, it is our choice of weapons, our cry for justice.

Why use art as a political act for justice? Because historically, Black Americans have used the arts as one way of resisting race hatred, injustice, and oppression. Our ancestors made a way out of the "no way" of slavery and the subsequent institutionalizing of racism following the end of the Civil War through the drum, the oral story, the slave song and narrative, gospel music, visual art, poetry, plays, novels, and dance. Our Harlem renaissance of the 1920s and the Black arts movement of the 1960s, as well as the ongoing Hip Hop movement started in the 1980s, continue a major contribution to the arts grounded in political activism and the demand for the freedom and justice for all promised in the foundational documents of this country.

Unlike statistics and countless media reports that in effect wash the color out of the issue and make it appear to be about everything but race, the work that

R. A. Washington and I share reflects our critical interpretation of this crisis. Our goal is to articulate the foreclosure phenomenon in ways that touch the minds, spirits, and hearts of all who engage this work and to inspire outrage, questions, and critical dialogue followed by the long-term action needed to recover from an economic reversal of fortune for Black Americans and one of the worst economic periods since the Great Depression.

As a descendant of slaves, the irony of tens of thousands of my ancestors being owned as property less than 200 years ago, coupled with the fact that the overwhelming majority of Blacks in America who *still* did not own property were targeted for these loans contributes to the sadness of this historical moment.

The foreclosure crisis is an American tragedy growing in intensity each day like a single snowball rolling down a cold-blooded, snow-covered mountain. Americans from all races, ethnicities, and classes have been struck by this phenomenon, the result of unregulated long-term greed, racism, and the criminal mismanagement of the housing industry. Poor, urban areas have been particularly hard hit as house after house is emptied, boarded up, and left standing like unwelcome ghosts of what used to be.

As *Plain Dealer* reporter Mark Gillispie points out in a recent, comprehensive article: "Cleveland is regarded by many as the epicenter of the nation's foreclosure crisis, a meltdown blamed on a combination of high-risk lending, investors willing to buy billions of dollars of high-risk loans packaged as securities, rampant mortgage fraud and financially unsophisticated buyers" (Gillispie, 2009, p. A17).

Space will not permit me to adequately respond to the term "unsophisticated buyers." It reads like the money lenders, in the city-financed Afford a Home program, and their homies around the country did *not* know their duped buyers were "unsophisticated." It describes my mama, siblings, cousins, and other folks I care about who know a lot about a lot of things—but little to nothing about the complexities of owning property and *the human* vultures who prey on others for money.

Why are the objects speaking in this work? When I saw an exhibit of a short collection of black-and-white photographs of objects left behind in foreclosed houses, I immediately thought, *This looks like a funeral for a home.* Keeping in tune with a creative vibe that typically strikes like a sudden fire, I put my ear to the moment and started to recall what I'd seen in neighborhoods all over Cleveland and in local and national news reports about the foreclosure crisis. I also thought about what I'd been experiencing vicariously for months in the stories of family and friends. After I created the poems, I invited fellow poet and photographer R. A. Washington to collaborate with me. His work adds an important layer to this piece by inviting each audience member to experience this tragedy on both a visual and textually visceral level.

According to Phillip Graham in *How to Read an Unwritten Language*, objects have stories to tell—and in his novel, the ones he collected spoke to him:

> I scanned the room and silently savored my objects' stories one by one, inevitably leading to the tale of the wooden stepstool that now rested before our bookshelves. It once belonged to an elderly man who stood on it when his memories threatened to overwhelm him, who reached up and let his palms press against the ceiling as if the rigid pressure in his arms held something unspeakable in place. I could feel my own arms tremble from that imagined exertion. (1995, p. 169)

Like the elderly man in the previous excerpt, the things people collect carry their touch, memories, and moments they've shared with others. They're not just objects, any more than a person is just flesh, bone, and blood. The following objects left behind by heart-crushed owners in a hurry spoke to me, and here I share their stories along with R. A. Washington's images and word-windows describing what inspired him to create the images.

Art hurts. Art urges voyages—and it is easier to stay at home.

—Gwendolyn Brooks

"4 Closure" Image Narratives

The images for Mary E. Weems's poems attempt to create a dialogue with the poems in a way that adds a visual to the characters created or highlights a nuance within the poem that brings the viewer/reader of the project to new conclusions. The images are not just illustrations of the poems but can act as an index—extra chapters to the story created. While several of the images are staged with the use of models or self-portraiture; some have actually been composed in a documentary state—and exist in real life. (R. A. Washington)

The image for this poem comes from the idea of public loss (Figure 16.1). When a house is seized by the bank, they place a sticker on the door letting everyone know of the trouble. Weems sets up the story beautifully—the pitch from the realtor, the peephole as guardian. (R. A. Washington)

4 Closure

He cased her like a joint he was going to rob.
Walked up to me after midnight each time,
put his eye over mine, like an optometrist
checking my eyesight.

The light he saw inside came from a reading
lamp Mrs. C always kept on, my fractured

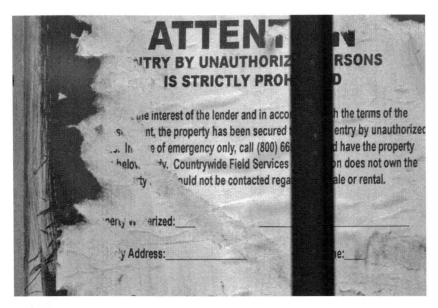

FIGURE 16.1 R. A. Washington, "4 Closure."
Used by permission.

sight trying to dim, to blur enough to send
him packing toward another target.

I kept my eye open day after day as Mrs.
C came and left, tried to get inside her head,
leave a subliminal message, a head alarm,
the sound of my love for her in a code
only she could understand.

But she couldn't see where I was coming
from, kept me clean so she could see outside
not realizing my hindsight would be 20/20
Over the years I've learned to read lips,
and can still read his mouth: "Well you see ma'am,
you couldn't have picked a better time to buy
property, why we can offer you no money down,
a variable interest rate lower than anything
this business has seen in forty years—Hell"
and so on and so on. By the time the sucka
left, Mrs. C had been so bamboozled,
I felt myself closing—the hope in her eyes
leaving me blind.

"Reversal of Fortune"

The poem begins—"See a penny, pick it up."

The sentiment behind such a whimsical statement frames the image I created (Figure 16.2): Two fingers reaching down, snatching up a penny. I wanted to capture the time right before the penny is in-hand. (R. A. Washington)

Reversal of Fortune

"See a penny, pick it up
all your days you'll have good luck"
Penny:
My back bruised and rusted, and damn if this
floor isn't where we met. He, brown-sharp-sugar
had just entered this place, an after hour joint called *Kools*.
Picked me up in front of the coatroom.

It was hot that night, and the pile of coins
I was with started sweating on my head,
the pocket we lived in—linen-white and light.
Our man's hand jingled us like keys
as he strutted inside, loud talked the brothers
draped around tables holding more money

FIGURE 16.2 R. A. Washington, "Reversal of Fortune."
Used by permission.

than we'll ever amount to. He tossed us on
a poker table with his money clip—let us get some air
while he lost everything but his shirt and me.

"Hole in the Wall"

I wanted to add the feeling of neglect, so I found a house where the yellow pages were left on the porch, hasty move out—weathered and melted by the outside, a metaphor of a house broken, a family destroyed (Figure 16.3). (R. A. Washington)

Hole in the Wall

Houses know when sky's
about to fall, moisture in air outside,
hunted faces, empty boxes,
floors undone, repairs stop, loose boards
furniture picked, delivered to homes
with room for something owners give up,
less to mourn.

Sometimes Anger appears, heads
for the crazy house, a path cut through walls
with fists, axes, chain saws attached to hands

FIGURE 16.3 R. A. Washington, "Hole in the Wall."
Used by permission.

that wave red flags in a sea of white:
4 closure papers delivered,
shredded, left on the lawn.

"Through the Wall"

This poem gave me shivers. The implied domestic violence gave me an idea of woman's downtrodden face reflected on the TV screen. I wanted the woman to be attractive even though she was obviously devastated by the constant struggle to keep her husband's massive temper down. All of this is implied by the poem. The image of a wall kicked in, the house as immovable witness (Figure 16.4). (R. A. Washington)

Through the Wall

The hole in me
the only sign
one size 12 foot
pushed into my oak
center hard as a bullet
through a body

As a bedroom door
I know intimate secrets

FIGURE 16.4 R. A. Washington, "Through the Wall."
Used by permission.

made when no one is looking
after-talk in low voices:
compliments, love-lies, troubles

My opening the loud noise
in the house morning after bank called
kicked so hard at 3 am in the middle
of a drunken rage the neighbors heard
but didn't call police.

Next day they opened me like I was whole
started breaking the house apart
cupboards, sinks, cabinets, carpet, wedding
pictures, tub.

Put it back like it was when they moved
in: Dirty, empty, hollow, and full of holes.

"Not a Home"

With this poem, I wanted to give a face to the woman Weems creates in this poem. While Weems does identify the woman as suburban, possibly even White—I find that the poem speaks to any woman (Figure 16.5). (R. A. Washington)

Not a Home

Woman bought me at the thrift store
around the corner, ran her hand across
my slightly splintered top—split from
years of hands rubbing with wet cloths
in the diner I used to live in.

Most days she pretends.
A white, wooden puppet with moveable
arms and legs, a mouth that opens
and closes so he can add words to it

a perfect house in a suburb where
if you don't have enough money
you hide it like a stain in the rug.

When spoken to on the street
she whispers her name, tucks

FIGURE 16.5 R. A. Washington, "Not a Home."
Used by permission.

 head between shoulders twitches
 with the kind of nervousness
 that's used to being knocked down

 black and blue black and blue
 she writes on me in chalk
 pushes me from corner-to-corner,
 pretends to have friends for tea,
 carves: Martha, Age: 54,
 Hair color: brown, Eyes: Blue
 in my face, so like Sybil once he makes
 her disappear, she won't be forgotten.

"No Longer Needed"

The poem tells the story of the Latchkey Kid we are all familiar with, and it led me to thinking about what the Latchkey Kid is like as a young child. What is it like to have to work, but not earn enough for day care, or babysitters? What is it like for a child to grow up without that steady hand, the presence of a parent always there? The child in the picture is playing on the porch with no shirt on—around the age of 3 (Figure 16.6). The porch railing reminds me of a crib. (R. A. Washington)

No Longer Needed

I used to live with a key on a hook in Sheila's
pink-little-girl room. A latch key kid with a hard working
mama, who went from one low wage job to the next
to keep a decent, one-day-will-own roof over our heads.

Sheila got me as a gift when she started 3rd grade last year.
Her mother unable to pick her up, or find someone else to walk
her home when the boy who used to live next door graduated.

Thanks to a mother who reminded her every day,
Sheila never forgot me. She used to run her small fingers
over my plastic bristles and recite her ABCDEFG's
out loud to the air, singing at the top of her lungs.

When she opened the door with the key and me after school,
her first move after she locked us in, was to go to her room
for her Brat doll resting on her bed like a Queen. Sheila'd
brush her long brown hair with my stiff bristles, re-sing
nursery rhymes, and raps songs, wait for her mama
who always came home with a small treat, a tired smile
and a big hug.

FIGURE 16.6 R. A. Washington, "No Longer Needed."
Used by permission.

Times got harder than usual this year, and Sheila's mama
kept going from three jobs, to two, to one, to none.
One day she came home and sat Sheila down to say
they had to pack and leave. Too sad to worry her mother,
Sheila never complained, helped as much as she could
and when they moved, she grabbed her Brat doll under her arm,
took the key off me and left me on her bedroom floor.

"If the Walls Could Talk"

The poem depicts a family in the midst of crisis from the point of view of the walls. The walls are the speaker in the poem—the narrative is almost formal, and chock full of details. I thought of what Sara was like as a small girl—the parents early in the dance of marriage—the baby girl standing at the front door, absently chewing on the lid of her "sippy cup." There is an alternate image that depicts both young children looking directly into the camera (Figure 16.7). (R. A. Washington)

If the Walls Could Talk

Over the years we've been different
hallway colors: Blue when baby John
was born, yellow-not-pink when Sara

FIGURE 16.7 R. A. Washington, "If the Walls Could Talk."
Used by permission.

joined him two years later, white for the breast
cancer year when Mr. Wilson didn't have the energy
to think about color, and the kids had been marking
us up with red crayons.

Noooooooooooooooooooooooo!
It's Thanksgiving and our family
left without leaving a note,
without running its hands
across our faces so we could share
our grief.

Through it all, we kept the heart of the house
intact, our skins pulsing with feelings shared
by a family that was so close, they ate every meal
together, talked about their deepest feelings, where John
and Sara grew to pre-teens knowing they were loved.

One night, we shuddered with the force of the front
door slamming like a repeat rifle. Breast Cancer bills
fell from wife's hands, as the husband's voice shifted
from shouts to fear.

Later, when they stood between us to hold each other,
their sighs turned us blue like the moon outside—
that's when we knew we were in trouble.

"I Can't Sing a Rainbow,
Sing a Rainbow,
I Can't Sing a Rainbow"

*The little boys caged by the fence (Figure 16.8), the poverty being so despairing that you
can almost imagine that their childhood will lead to prison. . . (R. A. Washington)*

I can't sing a rainbow, sing a rainbow,
I can't sing a rainbow
Blue—Lawd help this family, 3 children
left in the basement, no school, scraps from the table
for food, once-a-week baths.

I don't know what *foster* means out in the world
me, a brick wall they paint with their hands when
no one's looking—the leftovers, cans of skylight blue,

FIGURE 16.8 R. A. Washington, "I Can't Sing a Rainbow, Sing a Rainbow, I Can't Sing a Rainbow."
Used by permission.

sunflower yellow, and bare-wall white, the colors
of the rooms upstairs.

At night, when house is silent, Mark 7, Josie 9, and Tina 5,
strangers when they met, hold each other, make up stories
with mamas and daddies who care, share what they have,
lean against me to pray.

"Reflect"

Weems paints a picture of a man who has nearly lost everything—the job, the wife, the possibilities. I wanted to capture the aimless quality of a man like that. The image of a man absently picking paint chips of his decaying house; the point of view leads us to believe he is just looking at the street watching the cars roll by, counting the hours, the seconds of his demise (Figure 16.9). (R. A. Washington)

Reflect

I'm a window in a Black man's Wonderland.
Bathroom the space in the house he escapes
to when voices get too loud, bills too high,

FIGURE 16.9 R. A. Washington, "Reflect."
Used by permission.

when he wearies from wearing the world
on his head like a hard hat.

Today he enters sideways, tries to use
the toilet on the wall, opens me like a cabinet—
no fresh air. He wears fruit of the loom boxers,
T-shirt with a hole in it, white socks
dusky from walking across floors
that haven't been washed since his wife
left, after she found out the mortgage
she thought was fixed was broke
and the house note was more than their two
salaries and a tin cup could afford.

"Open Access"

*I could only think of rusted pipes (Figure 16.10). The economy of this poem is astounding.
(R. A. Washington)*

Open Access

In the end everything goes
House vacated

FIGURE 16.10 R. A. Washington, "Open Access."
Used by permission.

like a cemetery
after a funeral

Water pipes play Taps,
me the background music
behind the bathtub
open as a grave

My panel removed
like monetary safeguards
in the name of greed.

"The Last Drop"

The character in this image is the craftsman, after a day of work, smoking a cigarette, the night black with the thought of him not being able to keep his own family together. I wanted the image to be stark and frail—so I shot just the few fingers holding the cigarette (Figure 16.11). (R. A. Washington)

The Last Drop

This used to be a Maxwell house coffeehouse.
Everything started in the morning in the kitchen

FIGURE 16.11 R. A. Washington, "The Last Drop."
Used by permission.

sink, and when the water flowed from the toilet,
to the tub, I knew it was on its way down to me,
the spigot in the basement waiting my turn.

The craftsman who forged me out of copper
made me for the long run—no planned obsolescence,
each bend, screw, line built for water that only drips
on the occasions the mistress forgets to line my guts
with a fresh washer.

I was always the last to get the news, the bangs
in the copper pipes, cousins accustomed
to having their say, shared their gossip
in drips and drabs.

I wasn't privy to the shift that started emptying
this space out like a last minute eviction, this being
one tale my cousins kept to themselves until the water
was shut off.

Today one man turned the side door into a window
twisted dozens of my cousins into short lengths

brighter than a fluorescent light, dropped
them into big bag with a bang, left me in tact
over the tub to tell this story.

"Absence of Light"

I wanted to take the idea of the money people make on foreclosure and turn it into the
metaphor for the victimization the process really is. The image is of a house—the advertis-
ing sign haphazardly tacked to the front—"WE BUY HOUSES, WE TAKE OVER
PAYMENTS"(Figure 16.12). (R. A. Washington)

Absence of Light

Weeks before they lost
their house, I was evicted
like a roomer, window shades,
drapes, doors closed for good.

I've been waiting outside
for a crack, waving
my rays over house like arms.
Finally, one dark room gives in:

FIGURE 16.12 R. A. Washington, "Absence of Light."
Used by permission.

Nothing can stop me,
so good do I feel inside

Foreclosure fell on our neighborhoods like a bomb. It left behind many homeless children and adults, rerenters who'd lost first-owned homes, lonely houses no one's moved into, copper-stripped basements, and plywood- and sign-covered windows and doors.

What's not talked about are the people who continue to own homes in these devastated neighborhoods including me and mama who still live in our house. Like the victims of secondhand smoke, we hang on to property in the midst of broken homes, empty, trashed lots, and property values that continue to drop like deadweight at the end of a rope. But we've refused to abandon our neighborhoods. In the midst of this unjust madness, we take care of our homes, pray, reach out for each other, rebuild lives in different spaces, and reconnect with ancestors whose spirits continue to whisper, *Hope.*

References

Gillispie, M. (2009, December 13). How Cleveland aggravated its foreclosure problem and lost millions in tax dollars—all to help people purchase homes they couldn't afford. *The Plain Dealer,* p. A1, A16, A17.

Graham, P. (1995). *How to read an unwritten language.* New York: Scribner.

17

THE STUDIO

An Environment for the Development of Social Justice in Teaching and Learning

Christine Morano Magee and Carol A. Kochhar-Bryant

> All learning is social. It is with our peers that we will ultimately find our voice
> and change our world. It is in community that our lives are transformed.
>
> Peter Block

1. What are the connections between individuality and social justice?
2. What are the characteristics of a learning environment that best promotes
 social justice through the arts?

Introduction: The Studio Concept

This chapter explores teaching and learning in the art studio tradition as an exem-
plar of an environment that minimizes hierarchy and competition, leading to egali-
tarian practice. Rooted in the teaching of arts and architecture, the studio allows
students to work as individuals within a supportive communal setting. Furthermore,
project-based hands-on learning departs from traditional emphasis on uniform pro-
cesses to achieve common academic outcomes, to emphasizing accommodations
of all cognitive styles allowing individuality to be reflected in student work. The
studio model provides a platform for socially just classrooms that foster commu-
nity and respect developmental diversity (neurodiversity).

Social Justice and the Studio

The arts have historically allowed disparate voices to be heard through expres-
sive work. Each artist is free to move through the process of creating a unique
expression of the subject or content being explored—to celebrate life as well as
to protest injustices that occur in society. For example, Pablo Picasso's *Guernica*, on

one large canvas, sums up the horrors and oppression of war, providing a stunning example of how art can reflect on the human condition, personally and philosophically. Studio teaching and learning allows for free expression and open dialogue. There may be a right way to use materials, but no ultimate wrong answers in artistic expression. After reaching proficiency in the use of a material, an artist can expand the boundaries of its application through cognitive and physical processes— achieving new art forms and new ways to express concrete and abstract ideas. If a classroom environment offers this freedom of expression fusing the physical and the cognitive, allowing both collaborative interaction and individual expression of ideas, students will ultimately arrive at new levels of understanding and critical thinking about themselves and the content of a discipline. This process is transformative for the student, as an individual and as a member of the community.

Emergence of the Studio as a Teaching and Learning Philosophy

The development of the studio as a teaching and learning philosophy can be found in preschool through higher education and throughout the world, and it can be traced historically to varied disciplines including sciences, the arts, and architecture. In ancient Greece, the contemporary philosophy of humanism found artistic expression in the studio through sculpture and poetry. Scholars suggest that studio learning models are rooted in the educational philosophy advanced by Socrates and Plato in which ideas and knowledge were not explored in solitude but exchanged freely in dialogue (Chafee, 1977; Green & Bonollo, 2003).

Studio Learning and Teaching Philosophy

A formalized model of learning in the studio developed between the 1600s and early 1900s rooted in the Ecole des Beaux-Arts, founded in Paris by Cardinal Jules Mazarin. Using classical Greek and Roman art and architecture, the students studied drawing, painting, sculpting, gem cutting, modeling, and engraving (Drexler, 1983). Architectural historian Chafee (1977) describes how students worked in *ateliers*, or studios; they shared a common space under the guidance of a master architect, became proficient in their craft, worked collaboratively, and were self-governing. The more experienced members of the *atelier* assisted those who needed help. Chafee relates an account of student learning in an *atelier* of the Ecole des Beauxs-Arts that evidences a relaxed collegial atmosphere where "jokes fly back and forth, snatches of songs, excerpts of operas, at times even a mass may be sung, yet amid the confusion and the babble—strange as it may seem—work proceeds" (p. 991).

The Bauhaus movement, founded in Weimar, Germany, in 1919 under the direction of Walter Gropius, lasted only 14 years, from 1919 to 1933, but had a great impact on the development of a philosophy of the art of studio teaching and learning in the United States. It was influenced by industry and automation, moving art

further from the human idealized form and aesthetic ideals to an interest in "process" rather than "product" (Phelan, 1981, p. 7). The Bauhaus looked at the physical structure or building where one functions as the confluence of physical, natural, and man-made form. The workshop or studio is where craftsmen and artists work in collaboration to problem solve through the creative process. The Bauhaus explored the use of the scientific method as a way of bringing a new window of understanding to art. The creation of art was a process of problem solving through analysis, accomplished through hands-on experience and collaborative thinking (Phelan, 1981). Gropius noted that "all the teaching programmes should exist only to support the studio and the design problems it is working on, reflecting the reality of professional practice, which is entirely driven by the needs of the project" (1981, p. 1). Further, this concept of studio learning as reflective of interactive problem solving is also grounded in the theories of American pragmatist John Dewey (1897) and constructivist theories of Lev Vygotsky (1978) and Jerome Bruner (1997).

Dewey's philosophy included the key elements of studio learning, which are collaborative and interactive problem solving: all education proceeds by the stimulation of the child's powers by the demands of the social situations in which he finds himself; and through these demands he is stimulated to act as a member of a unity, to emerge from his original narrowness of action and feeling, and to conceive of himself from the standpoint of the welfare of the group to which he belongs (Dewey, 1897, pp. 77–80).

Dewey opened the first laboratory school for elementary school children at the University of Chicago in 1896. The environment was a studio classroom in which students learned by doing, collaborating, and observing each other and the world. The teacher acted as a facilitator or guide, providing the tools and materials necessary for learning, the students formed mini learning communities, interacting and problem solving together (Harms & DePencier, 1996). Contemporary influences on the studio are rooted in Vygotsky's constructivist learning theory of the zone of proximal development (ZPD). His seminal work, *Mind in Society: Development of Higher Psychological Processes* (1978), defines ZPD as "the distance between the actual developmental level as determined by independent problem solving and the level of potential development as determined through problem solving under adult guidance, or in collaboration with more capable peers" (Vygotsky, 1978, p. 86). Jerome Bruner expanded on this notion of learning as active engagement and participation in the community. His theory of discovery learning rejects the traditional classroom exchange of lecture and recitation, replacing rhetoric with *things* and *doing*: "Mind is an extension of the hands and tools that you use and of the jobs to which you apply them" (Bruner, 1997, p. 151).

Contemporary studio learning and teaching philosophy has also been influenced by the philosophical underpinnings of the Reggio Emilia approach to learning (Edwards, Gandini, & Forman, 1998). This renowned early childhood education program founded in post–World War II Italy has proved that studio-centric

programs offer elaborate, multimodal ways of connecting content with doing to create languages of knowing. Materials in a Reggio Emilia school branch out from the commonplace to a philosophy where anything can be a learning material. A liberating aspect of the Reggio Emilia philosophy is that the student has the freedom to decide how they will learn and what they will use to learn. The unlimited ways that children express knowing in a Reggio Emilia school is supported by the *alterista* (art teacher) who works in concert with the classroom teacher to assist students in creating their own languages of knowing (Edwards et al., 1998).

The concept of learning in an educational studio setting can be found in technical schools focused on engineering and applied science. In 1824, Stephen Van Rensselaer founded Rensselaer Polytechnic Institute, "for the purpose of instructing persons . . . in the application of science to the common purposes of life" (Rensselaer Polytechnic Institute, 2007, para. 1). In 1861, William Barton Rogers founded Massachusetts Institute of Technology (MIT) as a school for higher education that would combine the demands of knowing how to apply information in a world of rapidly changing technology with the rigors of a traditional education. Rogers looked to the French and German models of technology institutes to craft MIT, stressing a pragmatic and practical approach to education. Rogers believed that "professional competence is best fostered by coupling teaching and research and by focusing attention on real-world problems" (MIT, 2007, para. 3). Toward this end, he pioneered the development of the teaching laboratory. MIT has been dedicated to laboratory learning and problem solving that connects with the world outside of the institute. Its mission has influenced our definition of studio learning today. Problem-based, project-driven, hands-on collaboration that focuses on the process and elaboration of ideas through direct interaction with other and materials, tenets rooted in the arts, are key to studio learning and the philosophy that influenced it.

Today, the North Carolina State University Scale UP program and the Technology Enabled Active Learning (TEAL) at MIT are examples of how the studio process of hands-on problem solving is taking hold in the sciences. Research shows that Scale-UP physics improved problem-solving ability, increased conceptual understanding, reduced failure rates for minority and women students, and gave students who were considered "at risk" a foundation that increased their achievement in higher level classes (Beichner et al., 1999). Significant findings from research on the TEAL studio physics at MIT documented that failure rates decreased substantially and "learning gains as measured by standard assessment instruments have almost doubled" (Dori & Belcher, 2005, p. 274). These scientific uses of studio methods craft a broader definition of studio learning, which includes varied interactive technologies as teaching and learning materials. A twenty-first-century studio classroom then expands the possibilities for teaching all subjects through hands-on, interactive project-based inquiry and learning.

At MIT, freshmen physics is taught in the TEAL format, a studio classroom that uses embedded technology to teach students, allowing the teacher to guide

students to understanding through the use of multisensory learning. The students sit at tables in teams of nine, further divided into groups of three sharing computers. Students work collaboratively, and peer teaching is expected. The following is an example of a typical class in the MIT physics studio.

As the students file in, electric guitar music is broadcast over the sound system. A video camera is focused on a large plank of wood with guitar strings stretched across it; this scene is projected onto multiple video screens around the room. As the students settle into their seats, they prepare to view a presentation by the professor on sound waves that will be given in three modalities—through their laptops, corresponding PowerPoint slides, and in hard copy notebooks. The professor, using a wireless microphone, greets the students, announcing that today they will be learning about sound waves. There is a palpable level of excitement as students hear the music and see the electric guitar on the video screens. They are engaged as the professor calls on a volunteer to play the makeshift guitar. Everyone laughs and applauds as a student plucks the strings producing very loud sounds. The professor then moves to a whiteboard—the camera following him—and explains the mathematical formula for sound waves. He stops and asks, "Can you answer this?" in the style of a game show host. Students take out their interactive personal response systems (small wireless remote-controlled keypads) and respond to a multiple-choice question, which is flashed onto the laptop monitors and projected on screens around the room. Through this personal response system the professor receives immediate feedback, knowing how many students understand the concept thus far and is able to adjust his teaching accordingly. Questions are asked at varying times during the 2-hour class and are answered with the personal response system. As the professor continues, teaching assistants roam among the student groups answering specific questions. After the concept is demonstrated and explained, it is immediately applied collaboratively by students through (a) hands-on creation of a soundboard and sound, (b) measurement of the sound, and (c) translation of the sound into a visual and mathematical computer model (applets) (Magee, 2009).

The studio classroom atmosphere is relaxed and hands-on. Students are empowered through active engagement. Technology is seamlessly embedded into both teaching and learning. Although there are more than 100 students and four teaching assistants in the MIT-TEAL studio physics class, the collaboration and varied pacing allows for an intimate, student-centric learning experience.

Neurodiversity, Arts-Based Learning, and Social Justice

Research from the field of cognitive neuroscience is transforming our understanding of how children grow; acquire language, knowledge, and skills; and conceptualize their social worlds. Neurodiversity is a new idea that asserts that neurological (neurodivergent) development is a normal human difference that is to be recognized and respected as any other human variation (Harmon, 2004). Every child has

a unique expression of neurological development that makes him or her a unique learner with a unique temperament, talent, and responsiveness to learning, particularly in the arts (Rothbart, 2007; Rothbart & Sheese, 2007). This knowledge is advancing our understanding of how the arts change the brain (systems of connections within the brain) in a manner that promotes both cognitive development and pro-social behavior.

New research in cognitive psychology and neuroscience about variations in child development are validating the notion of the creation of art as a process of problem solving through analysis and hands-on experience. These ideas are now supported by contemporary research in neuroscience that demonstrates that creativity and art involve a "fusion" of both hemispheres of the brain (Report of the Task Force on the Arts, 2008). In the human brain, the left hemisphere controls language, the ability to classify, and routine behavior in general. The right hemisphere specializes in reacting to emergencies, organizing items spatially, recognizing faces, and processing emotions. Both are needed for highly complex problem solving (MacNeilage, Rogers, & Vallortigara, 2009). But how do the arts enhance learning?

In 2004, the Dana Arts and Cognition Consortium brought together cognitive neuroscientists from seven universities across the United States to grapple with the question of why arts training has been associated with higher academic performance (Gazzaniga, 2008). For the first time, coordinated, multiuniversity scientific research is bringing us closer to answering the question, Are smart people drawn to "do" art—to study and perform music, dance, drama—or does early arts training cause changes in the brain that enhance other important aspects of cognition? Current research on learning, arts, and the brain is advancing our understanding of the effects of music, dance, and drama education on other types of learning. Children motivated in the arts develop attention skills and strategies for memory retrieval that also apply to other subject areas (Gazzaniga, 2008; Posner & Rothbart, 2005).

Studies Connecting Arts, Place, and Cognitive Development

Neuroscience tells us that much important learning happens between birth and the sixth birthday. Early learning is experiential. It's physical, aural, visual, and tactile—quite the opposite of sitting still and being quiet (Eilber, 2007). Early environments are simulating and nurturing. When we arrive at school, we already have a highly successful system of learning that we have been perfecting all of our lives (Eilber, 2007).

Uninspiring and impoverished learning environments negatively impact learning. If children are not motivated and inspired, then they will not learn. Brain research suggests that there are "potentially lasting negative effects on the brain as a result of extremely poor environmental conditions" (Bergen & Coscia, 2001, p. 65). Therefore, stimulating learning environments are essential for young children's growth. Such an environment is one where physical space nurtures concentration, creativity, and the motivation to independently learn and explore.

Posner, Rothbart, and Sheese (2007) studied how training in the arts can influence other cognitive processes through the underlying mechanism of attention. Their research investigated a network of connections between brain areas that appear to be important for cognitive improvement that occurs during arts training. This network is related to attention, self-regulation of cognition, and emotion (Posner & Rothbart, 2007a, 2007b, 2005; Rothbart, Sheese, & Posner, (2007); Posner, Sheese, Odludas, & Tang, 2006; Rothbart & Rueda, 2005). Posner, Rothbart, Sheese, and Kieras (2008) also identified the neural network (system of connections between brain areas) from among the several involved in attention that is most likely to be influenced by arts training. Their 3-year research led to a general framework for viewing how arts training changes cognition. The theory stresses that there are individual differences in interest and motivation toward the arts. It suggests that arts training works through the training of attention to improve cognition for children with interests and abilities in the arts. These researchers hypothesized that (a) there are specific brain networks for different art forms; (b) there is a general factor of interest or openness to the arts; (c) children with high interest in the arts, and with training in those arts, develop high motivation; (d) motivation sustains attention; and (e) high sustained motivation, while engaging in conflict-related tasks, improves cognition. They hypothesized, therefore, that the brain network involved in executive attention and effortful control can be strengthened by specific learning. Moreover, they hypothesized that the enthusiasm that many young people have for music, art, and performance could provide a context for paying close attention. This motivation could, in turn, lead to improvement in the attention network, which would then generalize to a range of cognitive skills (Rothbart, Sheese, & Posner [2007]; Rueda, Rothbart, Saccomanno, & Posner [2005; 2007].

Researchers have also examined the relationship between cognitive systems that underlie music and mathematical abilities. Specifically, researchers undertook studies to determine whether, when children or adolescents produce music—comparing and operating on melodies, harmonies, and rhythms—they activate brain systems that also enable them to compare and operate on representations of number and geometry (Spelke, 2008). Their experiments supported the association between music training and mathematical ability.

Wandell, Dougherty, Ben-Shachar, Deutsch, and Tsang (2008) undertook a series of studies investigating how aesthetic ability and arts education correlate with improvements in children's reading abilities. Their longitudinal study of the development of reading skills and the brain structures indicated that the amount of musical training measured in year 1 was significantly correlated with the amount of improvement in reading fluency demonstrated in children over the 3-year period of our study.

The following summarizes the research findings from the studies introduced previously:

1. An interest in a performing art leads to a high state of motivation that produces the sustained attention necessary to improve performance and the training of attention that leads to improvement in other domains of cognition.

2. Specific links exist between high levels of music training and the ability to manipulate information in both working and long-term memory; these links extend beyond the domain of music training.
3. In children, there appear to be specific links between the practice of music and skills in geometrical representation.
4. Correlations exist between music training and both reading acquisition and sequence learning. One of the central predictors of early literacy, phonological awareness, is correlated with both music training and the development of a specific brain pathway.

Neuroscientist Michael Gazzaniga claims that specific pathways in the brain can be identified and potentially changed during training, that sometimes it is not structural brain changes but rather changes in cognitive strategy that help solve a problem. Early targeted music training may lead to better cognition through an as yet unknown neural mechanism (Gazzaniga, 2008).

The Studio Model as Socially Just Instructional Innovation

Policy and the Studio

The Individuals with Disabilities Education Act emerged from the civil rights movement for justice on behalf of children with disabilities (IDEA, 2004). The law requires a free and appropriate public education for students with disabilities. The studio model promotes the aims of Congress and the Department of Education to break down barriers between general education and special education, offering classroom practice that includes all learners. There is not a strict traditional classroom blueprint in the studio learning environment, students are expected to collaborate rather than work independently; therefore, best practices in inclusive learning and instruction can be realized. The use of multimodalities or differentiated instruction in both how students are taught and how they express knowing in the studio contributes to an egalitarian learning environment that reaches a full complement of learners.

Assessment in the studio classroom is ongoing, holistic, and reflective, resulting in a portfolio of work. This portfolio includes both formative and summative assessments collected through documentation, observation, and self-reflection. The studio's flexible physical setting and pacing removes physical and learning barriers by offering accommodations for a neurodiverse student population.

The Studio as a Socially Just Setting

Building on historical models of social justice, the twenty-first-century notion emphasizes dialogue and remaining attentive to each student's social environment. The studio is an egalitarian setting where pro-social skills and student-teacher interaction is fostered. Because the teacher introduces the information to be learned

through demonstration and then has the students immediately apply the concepts to be learned, the power structure of the teacher lecturing at the front of the class is removed. The teacher in the studio becomes a trusted guide, observing, reflecting, and encouraging the learner to understand the process of how they learn. Students have the freedom to interact with each other and the materials. The atmosphere is informal—allowing student and teacher to sit together on an equal level and discuss the process of learning. In a studio classroom, there is an emphasis on ensuring that students have a full understanding of the tools they are using to learn, removing inequities that may arise from varying foundational knowledge. Like a painting teacher demonstrating the difference between acrylic and oil paints, emphasizing what is common and disparate about these media and demonstrating the proper types of brushes and thinner for each, all students are given the opportunity to understand the media. This provides a platform for socially just education, allowing the teacher to develop foundational preteaching strategies so that all students will be taught how to use materials such as textbooks, computer programs, the library, and the Internet before content is introduced. Assessment of each student's expanding proficiency in the use of tools for learning in the studio classroom should be ongoing, observed, and documented so that pacing is adjusted to accommodate the learning needs of each student.

Another socially just hallmark of studio learning is equal and open access to tools and materials for learning. Students are empowered to take charge of their learning in a unique way by selecting the tools and modality that best fit their cognitive style. Hetland, Winner, Veenema, and Sheridan (2007) studied the process of thinking revealed in the studio by students documenting eight "habits of mind": "develop craft, engage and persist, envision, express, observe, reflect, stretch and explore, understand the art world" (p. 6). The studio learning environment allows transparency of process, connecting the mind and body. The student and teacher have a complete picture of learning, mapping out through the process what the student knows, what they need to know, and how they would like to learn and show knowledge. The learning process in the studio allows students to connect new knowledge to their existing knowledge base and to the world.

Summary: Implications of the Studio Model

The studio creates an environment that fosters student resilience, holistic assessment, development of pro-social behavior, self-determination, and self-directed learning. It holds promise as a socially just model where teaching and learning are creative and student centered, actively involving students in their own learning, resulting in increased engagement, which fosters high school retention.

With research from the field of cognitive neuroscience transforming our understanding of how children grow; acquire language, knowledge, and skills; and conceptualize their social, emotional, and moral worlds, the studio model provides

a platform for a socially just classroom that supports community and respects neurodiversity. It emphasizes creative practice and varied outcomes, removing the competition of getting "correct" answers.

The multimodalities of teaching and learning in the studio serve all learners by identifying their individual talents, resilience, and persistence. It provides equal and open access to tools and materials for learning, which are visible and readily available to the student. Students are empowered to take charge of their learning in a unique way by selecting the tools and modality that best fit their cognitive style.

The challenge of every teacher is to create a learning environment that promotes student engagement in the learning process and addresses the unique learning style of each individual student in an effort to encourage both engagement and learning. The studio model presents a means to successfully meet this challenge.

References

Beichner, R., Bernold, L., Burniston, E., Dail, P., Felder, R., Gastineau, J., . . . Risley, J. (1999). Case study of the physics component of an integrated curriculum. *Physics Education Research, American Journal of Physics Supplement, 67*(7), 16–25.

Bergen, D., & Coscia, J. (2001). *Brain research and childhood education: Implications for teaching.* Olney, MD: Association for Childhood Education International.

Bruner, J. (1997). *Culture of education.* Cambridge, MA: Harvard University Press.

Chafee, R. (1977). The teaching of architecture at the ecole des beaux-arts. In A. Drexler (Ed.), *The architecture of the ecole des beaux-arts* (pp. 61–110). Cambridge, MA: MIT Press.

Dewey, J. (1897). My pedagogic creed. *The School Journal, 54*(3), 77–80.

Dori, Y.J., & Belcher, J. (2005). How does technology-enabled active learning affect undergraduate students' understanding of electromagnetism concepts? *The Journal of the Learning Sciences, 14*(2), 243–279.

Drexler, A. (Ed.). (1983). *The architecture of the Ecole des Beaux-arts.* Cambridge, MA: MIT Press.

Edwards, C., Gandini, L., & Forman, G. (Eds.). (1998). *The hundred languages of children: The Reggio Emilia approach to early childhood education.* Greenwich, CT: Ablex.

Eilber, J. (2007). *A child's first method of learning is still the best.* Washington, DC: Dana Foundation.

Gazzaniga, M. S. (2008). Arts and cognition: Findings hint at relationships. In C. Asbury & B. Rich (Eds.), *Learning, arts, and the brain* (The Dana Consortium Report on Arts and Cognition). Washington, DC: Dana Foundation.

Green, L.N., & Bonollo, E. (2003). Studio-based teaching: History and advantages in the teaching of design. *World Transactions on Engineering and Technology Education, 2,* 269–272.

Greenblat, et al. (2008). *Report of the task force on the arts.* Cambridge, MA: Harvard University.

Harmon, A. (2004, May 9). Neurodiversity forever: The disability movement turns to brains. *The New York Times.*

Harms, W., & DePencier, I. (1996). *Experiencing education: 100 years of learning at the University of Chicago Laboratory Schools.* Chicago: University of Chicago Laboratory Schools.

Hetland, L., Winner, E., Veenema, S., & Sheridan, K. (2007). *Studio thinking: The real benefits of visual arts education.* New York: Teacher's College Press.

Individuals with Disabilities Education Improvement Act of 2004, Pub. L. No. 108-446. (2004). Retrieved from http://idea.ed.gov/explore/view/p/%2Croot%2Cstatute%2C

MacNeilage, P. F., Rogers, L. J., &Vallortigara, G. (2009, July). Evolutionary origins of your right and left brain. *Scientific American Magazine*, 60–67.

Magee, C.M. (2009). *A phenomenological, hermeneutic case study of two studio learning environments: Reggio Emilia Pre-school Atelier and MIT TEAL Freshmen Studio Physics* (Dissertation). George Washington University, Washington, DC.

Phelan, A. (1981). The Bauhaus and studio art education. *Art Education, 34*(5), 6–13.

Posner, M., Rothbart, M. K., Sheese, B. E., & Kieras, J. (2008). How arts training influences cognition. In C. Asbury & B. Rich (Eds.), *Learning, arts, and the brain* (The Dana Consortium Report on Arts and Cognition). Washington, DC: Dana Foundation.

Posner, M. I., & Rothbart, M. K. (2005). Influencing brain networks: Implications for education. *Trends in Cognitive Science, 9,* 99–103.

Posner, M. I., & Rothbart, M. K. (2007a). *Educating the human brain.* Washington, DC: APA Books.

Posner, M. I., & Rothbart, M. K. (2007b). Research on attentional networks as a model for the integration of psychological science. *Annual Review of Psychology, 58,* 1–23.

Posner, M. I., Rothbart, M. K., & Sheese, B. (2007). Attention genes. *Developmental Science, 10,* 24–29.

Posner, M. I., Sheese, B. E., Odludas, Y., & Tang, Y. (2006). Analyzing and shaping neural networks. *Neural Networks, 19,* 1422–1429.

Rensselaer Polytechnic Institute. (2007). *Rensselaer's history* (para. 1). Retrieved from http://www.rpi.edu/about/history.html

Rothbart, M. K. (2007). Temperament, development, and personality. *Current Directions in Psychological Science, 16,* 207–212.

Rothbart, M. K., & Rueda, M. R. (2005). The development of effortful control. In U. Mayr, E. Awh, & S.W. Keele (Eds.), *Developing individuality in the human brain: A tribute to Michael I. Posner* (167–188). Washington, DC: American Psychological Association.

Rothbart, M. K., & Sheese, B. E. (2007). Temperament and emotion regulation. In J. J. Gross (Ed.), *Handbook of emotion regulation* (pp. 331–350). New York: Guilford.

Rothbart, M. K., Sheese, B. E., & Posner, M. I. (2007). Executive attention and effortful control: Linking temperament, brain networks and genes. *Perspectives in Development, 1,* 2–7.

Rueda, M. R., Rothbart, M. K., Saccomanno, L., & Posner, M. I. (2005). Training, maturation and genetic influences on the development of executive attention. *National Academy of Sciences, 102,* 14931–14936.

Rueda, M. R., Rothbart, M. K., Saccomanno, L., & Posner, M.I. (2007). Modifying brain networks underlying self-regulation. In D. Romer & E. F. Walker (Eds.), *Adolescent psychopathology and the developing brain* (pp. 401–419). New York: Oxford.

Spelke, E. (2008). Effects of music instruction on developing cognitive systems at the foundations of mathematics and science. In C. Asbury & B. Rich (Eds.), *Learning, arts, and the brain* (The Dana Consortium Report on Arts and Cognition). Washington, DC: Dana Foundation.

Vygotsky, L. S. (1978). *Mind and society: The development of higher psychological processes.* Cambridge, MA: Harvard University Press.

Wandell, B., Dougherty, R. F., Ben-Shachar, M., Deutsch, G. K., & Tsang, J. (2008). Training in the arts, reading, and brain imaging. In C. Asbury & B. Rich (Eds.), *Learning, arts, and the brain* (The Dana Consortium Report on Arts and Cognition). Washington, DC: Dana Foundation.

18

EMBODY THE DANCE, EMBRACE THE BODY

Heather Homonoff Woodley

1. How can working with students to unpack misconceptions of others impact or shape the unpacking of students' own oppression?
2. What may be the various pedagogical implications for creating gendered spaces for learning?

What do you think of when you picture a Muslim woman?

> "Princess Jasmine."
> "Women who gotta wear those things in Afghanistan."
> "They can't drive, right?"

What would an average person say if asked to paint a verbal picture of the teen-age girl from DC?

> "Loud-mouth."
> "Pregnant."
> "Fighter. The bad kind, not the good."

This was the conversation in room 402 of our small, alternative high school in Washington, DC. This was the conversation that started it all, that brought *raqs sharqi* (or belly dance) into our learning space, creating a new context to deepen our understanding of ourselves and others, to build a community among women within our own building and connect with women halfway across the world. Finding belly dance and experiencing what it embodied not only allowed me to empower myself, but also to share the knowledge and experience with my students as they found themselves and a community within the dance.

I have been caught at many a red light by eyes in the next lane while I lost myself in a driver's seat dance, moving everything from the waist up. As I talk, my hands join in the conversation, each finger elongating, wrists twirling, moving directions, for emphasis or emotion. It is all part of the everyday action that is dance, part of what I knew was in me, and knew I could use as a positive teaching tool but searched and struggled to identify.

I grew up dancing in tap and jazz classes, in basement studios and second-floor schools above restaurants; joined the dance team; and headed up the choreography in school musicals. I loved dance, really down-to-your-gut loved it—loved learning, practicing, creating, watching, and performing. I had never felt more free, more beautiful, or more good at something. It made me feel good, plain and simple. Dancing made me feel like the best version of myself, but no matter how much I practiced in the mirror, or how many school talent shows or slumber-party dance contests I won, something was missing. As I grew up and grew more curves, that something grew with me.

Thick. Curvaceous. The adolescent mental camera does add 10 pounds, but I had developed the contours contrary to the dominant standards of beauty and appeal. I was not fat by conventional standards, but I was no longer an average little kid, and certainly not the ideal body type for the dance classes to which I was accustomed. I had inherited the body of my grandmothers—the wide hips and voluptuous behind of Eastern Europe and Semitic lands. As a girl growing up in America, struggling with body image was almost a rite of passage, something that we all seemed to go through at one time or another, and mine sprang up as early as third grade. No one seemed to ever talk about how you felt, just how they felt about you.

It stings the most and stays the longest the first time you get slapped in the face with a question. Huddled in a circle, we chatted about what we liked to do outside of school, harmless hobby conversation. I said something about dance class. Then her face twisted up, she looked me up and down, and drenched in sarcasm, she asked, "*You're* a dancer?" I mumbled something along the lines of, "Well, I guess, I mean, I do dance," but fumbled in asserting myself as a dancer. Her disbelief hit me hard, so unexpectedly, that I didn't know how to respond. In the movie of my life, this is where I break out in an elaborate dance number exclaiming with pride, "Yes, I *am* a dancer. . . . a one-two-three-four!" and cue music. But in this time and place, I just couldn't say it and looked up and down at myself knowing exactly what she meant. Dancers don't look like you.

I would look in the mirror, and all I could see were hips and thighs quite contrary to my teachers, classmates, and images of dancers I saw all around me. I thought to myself, how can I be a dancer if I don't look like one? Why did I care so much about being able to identify as a dancer? This struggle caused me to pull back from opening up about what I loved, not advertise it from fear of others' doubt. It caused me to question my skill and ability, my own goals in dance. The need to identify with being a dancer was tugging at me, pulling me in the opposite

directions of motivation and confidence. How could I bounce back? How could I reconcile who I, and those around me, perceived as a dancer and who I knew I was?

Raqs Sharqi

I had dabbled in belly dance as a kid from travel, family, and friends and caught on quickly but never gave it much thought as a something to delve into deeper. From a Jewish family with roots in the Middle East, the movements and music felt familiar and natural, like the same Israeli and Hebrew music and dance I was accustomed to. However, there was no place to continue what I had started, and I knew of no community of belly dancers.

Fast-forward to young adulthood; I found myself in new communities. Upon moving to Morocco, I was able to experience *raqs sharqi* as an entry point for both community and identity. As I was embraced in a community of women, I also began to embrace my own identity as a dancer. *Raqs sharqi* brought women together, creating intergenerational celebrations of women, their bodies, histories, and abilities. Through this, I explored my own understanding of what it meant to be a woman, have a womanly body, and be a woman dancer.

I was there to study as a young adult and found myself at Al Akhawayn University with a thousand Moroccan classmates and 20 or so international students. At henna parties, celebrations of impending birth or marriage, or an afternoon at home or in the dorms, *raqs sharqi* became my own integration in to the female community, a chance for women to celebrate selves, each other, and a shared experience. The sound of the *zaghareet* (high-pitched la-la-la's of encouragement or approval), clapping in time, and gestures of love, blessings, and good health were intertwined with laughter, conversation, lessons, and celebration. On the living-room floor, women circled around in an art form passed down through generations of women, from grandmothers in *hijab* to granddaughters in the tightest of jeans.

I had attempted to immerse myself in learning and openness about culture, ranging from observable practices to the implicit meaning making of individuals and communities. From my own worldview, and corroborated by classmates, teachers, cultural communities, and educational materials, there was an oppression of women in Morocco. I would come to realize later that oppression is in the eye of the beholder. While we sat around seminar tables in college, waxing philosophically about those poor Muslim women in that part of the world, we never stopped to ask how they felt or to look at the diversity of experience. This was an oppression based on our American standards of what it meant to be liberated. To support this image of the female victim throughout the Arab world, individuals and media would point to a visible separation of women in public and private spaces. "They hide their women away," was a popular cry of how "they," the Muslim, the Arab, the "other," was not like "us," the perpetually co-ed, and thus allegedly equal, America. Women in these communities took two basic forms that I

could find on television and in education: the exotic or the victim. While separated from the man's world of business, government, and adventure, Arab and Muslim women were either draped in transparent harem pants and glittering bras or stifling burqas. Regardless of her getup, she was never really smiling, never satisfied, and never treated right.

I often thought about this throughout my time in Morocco as I got to know more women personally (never meeting one in a burqa, nor glittering bra). I began to realize the thick filter of an American perspective and how oppression by our standards was not everyone else's standard. As I took part in these separate spaces for women, the concept of oppression was never linked to this separation. There was certainly plenty of speech and action in the fight for equality and more opportunities, but getting rid of women-only gatherings was never connected to this fight. Here were women, only women, celebrating their separateness, their uniqueness, and their time with each other. Young girls who were shy in public opened themselves here with their dancing bodies, hearty laughs, and vibrant conversations over food and tea. Aunts, mothers, and grandmothers shared stories, health tips, dance moves, and songs with neighbors, friends, and family. The dance provided the space for "woman" to be the defining characteristic—age, body type, ethnicity, and religion were all superseded by a commonality of female identification and community. As soon as I walked into the living room, I was kissed, given food, and questioned:

"Anti muslima?" (Are you Muslim?)

"La, ana yehudia." (No, I'm Jewish)

"Ah, we cousins!" and from there I was dragged out onto the carpeted dance floor while a few of the bride-to-be's aunts, cousins, and neighbors engaged me in a lead-and-follow session of Belly Dance 101. No words, just movement, pointing, and grabbing my hips to move them in the right direction. After our first round of dancing, she turned to me with a smile and wide eyes, "I didn't know you were such a dancer." Surprised by this statement, I stumbled over my words, sounding again like my 9-year-old self, "Well, I guess, I mean, I do dance." She shook her head, stretched her smile, "You *are* a dancer," gave me a you-silly-little-girl laugh and moved on to a new topic of conversation. Her words and her look brought me back to reflect on my younger self who disconnected with something I had loved so much because of a struggle to identify as what others thought a dancer must look like.

With each gathering like this in Morocco, each formal and dorm-room lesson in *raqs sharqi*, I found myself dancing with women who looked like, and unlike, me, women of all ages and thicknesses who embodied the movements and techniques within their various shapes and style of dancing as one community, yet each shining individually. Learning face-to-face, or in a circle, catching on and creating full songs of choreography through lead and follow, physically moving hips with hands, my teachers were dancing with me side by side as much as they were leading me. As my own skill and technique grew, so did my confidence in

the dance and my own body, and I began to feel more like a dancer and part of a female community, not just a female who danced.

Conversations at these gatherings shed light onto various experiences of different women, from their joy and problems at home, to their lives at work, school, and daily adventures. Would this level of openness have been present in a co-ed setting? Were my family gatherings any different while women chatted in the kitchen and men played cards or dominos in another room? How had my education, media influences, and environment painted such a picture of female oppression? I began to rethink my understanding of the female experience in light of various cultural practices and societal structures. The strong diversity of female experiences in the room, let alone in the country and the region, was not a blanket of victimization, and the existence of a female space was not always synonymous with repression. Many women did speak of male dominance, the struggle for equality, and wanting more, but never was there talk of giving up this sacred space for female celebration, dance, and community.

Upon returning to the United States, I was wary of entering a belly dance class. Would this just be another adult dance class, full of once-overs, up-and-down looks, no sense of safety to ask questions, and an unsettling aura of competition? Fortunately, I found a community of dancers within a class, women of various dance and personal backgrounds. The studio itself was a safe space—safe to take risks, look as one looked, ask for help, and express personal style. There was no sign proclaiming this, or rules posted, but these characteristics of the space and interactions were embodied within the pedagogy of the teachers and structure of both the class and the dance itself. In one class, various participants and women led movement on and across the floor. Once a teacher felt you were ready, or even once a dancer felt that she was ready, a participant became leader for a section of a song or trip across the floor. Classmates physically approached each other for guidance and encouragement. If we noticed another classmate struggling, we would approach her, putting hands on hips to direct her body, or putting her hands on our hips to feel the movement. *Zaghareet* filled the room during solo and group improvisation as dancers waved their hands to "cool down" a "hot" moment, patted the floor, or threw blessings from the head and heart in signs of respect and admiration as the *zaghareets* grew louder and smiles grew wider. Throughout the class, the concept of personal style was encouraged even as steps were carefully broken down into technical terms in the lead-and-follow format of the class. While a movement was taught and there was a "correct" way to do it, teachers and participants peppered the movements with their own style whether it be a unique flip of the wrist or smiling with the eyes. In this environment, to learn a movement was not necessarily to mimic, but to embody what a fellow dancer was doing within one's own personal style and dance.

Leading the class were women who themselves embodied this acceptance and community through their own teaching and dancing. Several women rotated in leading the class, women of various sizes and curvature, and all with incredible

skill and technique. The diversity among these teachers portrayed a message that the dance could come through any body. What mattered was not how a body was shaped, but how it moved. The language itself spoke the feeling of the class and the sense of community within the space. After each session, we were reminded to "thank your sisters for dancing with you" and passed our gratitude to one another. Class participants were referred to as "dancers," we were greeted with "hello beautifuls" and given directions to shake out the stress, "show some love" to each other, and learn from one another.

Now it wasn't all peaches and cream the whole time. There was a teeth sucking here, perhaps a cutting in line there, but nothing big was ever made of these moments. They never escalated or became anything more than something to shake off, as if negativity could not stick around for too long in this environment. Growing familiar with each other, our space, and the dance, participants began to take on various roles in performing and teaching, as well as continuous learning. This communal feel within the studio was embodied in the dance itself through this shared knowledge and encouragement through sound and physical movements.

Teaching with *Raqs Sharqi*

So here I was, a dancer. I had found a community of women with whom to practice, perform, create, laugh, and grow, and I was confident to call myself a dancer. So now what? While I was a student in the studio, I was simultaneously a teacher in the high-school classroom. In the Shaw neighborhood of Washington, DC, our school provided an alternative setting for students in the juvenile justice system or those who had not succeeded in traditional public schools. My students were from all corners of the city, from Anacostia to around the block, and came to our small townhouse high school with its foundations in social justice education and a strong feeling of family and community within the school. The student population was racially homogenous, 100% African American, but diverse in their stories and experiences. Social justice was pervasive throughout the school, apparent in curriculum challenging dominant assumptions, pushing students to be critical and conscious of the world around them, and fostering a sense of social action and agency within the student body.

Every day working with teenage girls, I saw and heard in them many of the same struggles and issues I went through, and continued to go through to some extent, in my own life. The girls in my classes were constantly commenting negatively about their bodies with an "I'm so fat" to a "I can't dance lookin' like this." Conflict within the female community at school seemed to stem out of interactions with, and competition over, male students, and the girls consistently noticed how female classmates would "be all different acting" in front of boys. I began to share with them my own experiences in belly dance and in a female-only space. At first, I was met with puzzled looks, smiles, and lots of questions: "So you have

to wear a veil with that?" "Like the Shakira video?" "Can I try?" "Is it like strip-
ping?" No, but you could dance with one. Sort of, which video? Yes, you can. And
no, not in purpose, but you do move your hips a lot. And so we began.

What do you think of when you picture Arab or Muslim women?

"Princess Jasmine."

"Women who gotta wear those things in Afghanistan."

"They can't drive, right?"

What would an average person say if asked to paint a verbal picture of the teen-
age girl from DC?

"Loud-mouth."

"Pregnant."

"Fighter. The bad kind, not the good."

And so we began to deconstruct both stereotypes—those of Arab and Muslim
women, and those of the youth themselves. Coming from a common ground of
being misperceived and generalized, we worked out from there into exploring
more similarities and differences. Is being a girl any different than being a boy? A
unified "Yes!" rang throughout the classroom laden with years of frustration. How?

"You always gotta look good."

"Girls are two-faced to each other."

"You can't do as much. . . . and it's bad if you do."

We were getting somewhere. I pointed out, however, that no one had listed
anything positive in the list of how being a girl is different. Is being a girl always
bad? They thought about it and quickly interjected, citing fashion, not having to
pay on dates, and childbirth (although some protested that the pain factor kept it
in the "bad" column). The girls were identifying their own struggles with male
dominance, with themselves, and with each other. So how do we challenge this?

"Kick ass in sports."

"Get our nails done and bitch about it."

"Actually get along."

The idea of a space for women was emerging in their own experiences and
linked to the concept of belly dance as a route to understanding female community
and themselves. We went back to our understandings of Arab and Muslim women
and discussed the use of a female space for dance, celebration, learning, and com-
munity. We set ground rules to maintain our safe space and began to move.

As the girls learned the movements and the style of lead and follow, they ver-
balized new understandings of themselves and others. Connections were made to
reggae, African dance, go-go, and Hip Hop, while some took it upon themselves
to introduce their own music to the sessions for dance learning and improvisation.
Consistent comments were made about hips, curves, and a sense of rhythm finally
being put to good use, how this dance was made for these bodies, all these bodies.
As the sessions continued, some girls progressed faster than others and took on roles
of teacher and choreographer, while others took on roles of conversation starters.
They decided that since we were all here, us girls all together, that we might as well
talk about girl things. The embodied pedagogy of belly dance had come through to

the girls as they began to use the space for more than just physical movement. Topics ranged from self-esteem to sexually transmitted diseases to backstabbing. There was full-bodied laughter and silent tears, plenty of questions and sharing of multiple perspectives. As the girls came to learn about themselves and each other, they gained understanding about women with whom they had believed they had very little in common. A few girls noted the effect of the space—how they couldn't talk about "these kind of things" with guys around, and how "girls were just different" in the presence of males. The girls' own diverse experiences sparked explorations of diversity within Arab and Muslim communities of women.

Would I have been able to teach dance, facilitate classes, and provide young women with such an experience had I not identified as a dancer? Possibly, but not likely. It gave me an understanding and confidence in myself within the embodied pedagogy of belly dance and community of a class. It allowed me to take my identity as a dancer and combine it with my identity as a teacher, bridging two of my worlds and living out this connection in the class itself. Conceptions of women and life in the Arab world, as well as reflections and perspectives of self and peers, were explored and deconstructed within the teaching of a hip bump or a song of improvisation. Experiencing the movement provided a natural entry point for the students to explore further issues, including health ("What are fibroids anyway?"), body image ("Ha, not too big to dance"), and critical pedagogy ("It's like that master narrative thing").

As in the lead-and-follow learning style of belly dance, and within the conversations, I continuously engaged in the learning process through my own teaching. Other dancers constantly open my eyes to something I had not even thought about before, from a unique way to combine movements to a different perspective of an individual's identification within a gendered group. While I work on myself with my students and fellow dancers, we celebrate our separateness as women in our space of *raqs sharqi*. Here we are able to join together, bond in our celebrations, seek action for our struggles, and continuously explore more about ourselves and others. As embodied in the dance itself, my journey is that of lead and follow, teacher and student, and through it all, yes, I *am* a dancer.

CLOSING

Gilda L. Sheppard

> *Art is not a mirror to hold up to reality, but a hammer with which to shape it.*
> Bertolt Brecht

Some time ago, while I was attending an antiapartheid rally, Tyree Scott, an African American construction worker, activist, and scholar who was part of an organizing effort against discrimination in the building trades, asked the speaker, a South African journalist, an interesting question. Tyree explained that his social justice work in the United States included solidarity in dismantling South Africa's apartheid regime, but also that the work had a "self-interest." His solidarity work gave him an opportunity to share theories and tactics for grassroots organizing and education. Tyree asked the journalist to share models and ideas that he and his colleagues could use and adapt to their situation. Tyree wanted to know how the journalist gets the word out from and to the masses within and outside South Africa, especially since apartheid was such a brutal, all-encompassing system. After a few beats, the South African journalist responded, "If it happens in the morning, it is a song in the afternoon, a dance at dusk, and a public performance that evening." I will never forget the melody of this journalist's assured tone, his smile revealing an intimate understanding of the strength of this way to educate, imagine, resist, and organize for social justice. The journalist gave Tyree an example of art as social justice, not just a tool, but a pathway, an aesthetic that provides "a way out of no way" in their practice for social justice.

This is indeed social justice for the purpose of an "equitable redistribution of resources" (Barry, 2005; Bell, 2007) and as recognition of culture and identity for those who are marginalized and subjugated in society (Fraser, 1997). The arts, for us, include symbolic representations of meaning through the many

forms of dance, music, creative writing, visual arts, film, technology, and education—it is ubiquitous in these spaces where people create.

The chapters in this volume describe powerful demonstrations, theories, and models of how culturally embedded arts are social justice education across multiple contexts and how art forms not only present tangible opportunities for transformations in diverse contexts, but also throw light on and at times rupture the subsoil that cradles the interior life of theories. This access to theory invites the artists, participants, spectators, and audience to "wrestle with angles" (Hall, 1992) and reflect on and develop new knowledge of self, community, society, and the world. Hall writes: "The only theory worth having is that which you have to fight off, not that which you speak with profound fluency" (p. 278). Imagination fired in the kiln of artistic production releases the ability to "wrestle with angles," to open and explore shared experiences between people and within groups and societies. Such collaboration summons creative processes through which, as the singer Ani Di Franco (1994) says, we can "find strength in the differences between us. And comfort where we overlap."

These chapters breathe life into culturally relevant arts education as an opportunity for transformation, imagination, creativity, agency, freedom, and self-determination. Of all our cognitive capacities, imagination is the one that permits us to give credence to alternative realities (Greene, 1995). These models present the resistance and healing power of story conjured up in visionary voices located in the neighborhood beauty shops and made generative and expansive through digital arts; public pedagogy, sustained and transformed through Augusto Boal's (2008) democratized theater; photography; dance; and film. Museums become dream catchers, and peace becomes the mediator in the transformation of decades of conquest, colonialism, and neo-colonialism. A women's cultural dance and movement shift the physical sway of the hips from exoticism to a place where sisterhood, identity, and counternarratives are choreographed and cultural imperialism and patriarchy are exposed. "Organic intellectuals" (Gramsci, 1973) such as these take stage not at the center, but at the margin as a place of radical possibilities (hooks, 1990), breathing life into a quote from Rollo May (1981): "There is no authentic inner freedom that does not, sooner or later, affect and change human history" (p. 57).

Toni Cade Bambara (cited in Lewis, 2012) writes that the purpose of an artist is to make the revolution irresistible. Allow poetry to meet photography and film to frame empathy, and Hip Hop to break these frames for new melodies of consciousness, self-determination, and empowerment, then suddenly the mantra in our head, heart, and soul is filled with the old song "We who believe in freedom can not rest until it's done." This is not a mechanical process; it has no assurances, just discoveries—the stuff of possibilities. Morrison reminds us:

> From my point of view, your life is already a miracle of chance waiting for you to shape its destiny. From my point of view, your life is already artful—waiting, just waiting, for you to make it art. (2011)

These artist-activist teachers, students, and members of our local, national, and global communities present what Chomsky (1992) refers to as the "threat of an example" (n.p.). This threat is not to be discovered as examples of *best practices*, frozen in a paradigm of copy and paste. To the contrary, these are examples that have the possibility to transform our very lives and human history. We see this in youth who experience the art of dialogue as a safe place to interrogate homophobia, locate resources of power, and confront the oppressive conditions of poverty, White supremacy, and racism using film. And they dare to do this in a context of schooling that too often yields a perspective of the arts in schools as frills rather than a key vehicle to reform our educational systems (Noblit, Corbett, Wilson, & McKinney, 2009). Indeed, the nations that are thriving in the international economy now see creativity and the arts as central to preparing students for the millennial international economy (Darling-Hammond, 2010).

Implications

If you want to build a ship, don't herd people together to collect wood and don't assign them tasks and work, but rather teach them to long for the endless immensity of the sea.

Antoine de Saint-Exupéry (1948)

Social justice is not an end; it is a quest (Greene, 1995). From the models and theories presented here, we get an indication of what is being done and what is possible through the creativity and imagination of culturally relevant arts education that produces social justice. Across multiple contexts, art forms, and social justice efforts, powerful demonstrations paint a picture of a quest for the possible against the prevailing idea that marginalized groups have deficits of knowledge, skills, or worse deficits of culture. Smile, and feel joy, as art replaces this deficit view with demonstrations of agency, creativity, talent, and insight. Sometimes art as social justice in education is hidden from us, but when we find it, power, freedom, and responsibility come alive.

References

Barry, B. (2005). *Why social justice matters*. Cambridge, UK: Polity Press.

Bell, L.A. (2007). Theoretical foundations for social justice education. In M. Adams, L. A. Bell, & P. Griffin (Eds.), *Teaching for diversity and social justice* (pp. 3–15). New York: Routledge.

Boal, A. (2001). *Theater of the oppressed*. New York: Theater Communications Group Inc.

Chomsky, N. (1992). *What Uncle Sam really wants*. Tucson, AZ: Odonian.

Darling-Hammond, L. (2010). *The flat land and education*. New York: Teachers College Press.

Di Franco, A. (1994). Overlap. On *Out of range* [CD]. New York: Righteous Babe Productions.

Fraser, N. (1997). *Justice interruptus: Critical reflections on the "postsocialist" condition*. New York: Routledge.

Gramsci, A. (1973). *Selections from a prison notebook.* New York: Harper and Row.

Greene, M. (1995). *Releasing the imagination: Essays on education, art and social change.* San Francisco, CA: John Wiley & Sons.

Hall, S. (1992). Cultural studies and its theoretical legacies. In L. Grossberg, C. Nelsom, & P. Treichler (Eds.), *Cultural studies.* New York: Routledge.

hooks, b. (1990). *Yearning race, gender and cultural politics.* Boston: South End Press.

Lewis, T. (2010). *Conversations with Toni Cade Bambara.* Mississippi: University Press of Mississippi.

May, R. (1981). *Freedom and destiny.* New York: W.W. Norton and Company.

Morrison, T. (2011, May 15). Commencement speech at Rutgers University. Retrieved from http://commencement.rutgers.edu/commencement-and-convocations/2011-university-commencement-videos

Noblit, G. W., Corbett, H. D., Wilson, B. L., & McKinney, M. B. (2009). *Creating and sustaining arts-based school reform: The A+ Schools Program.* New York: Routledge.

Saint-Exupéry, A., de. (1948). *Citadelle.* Moscow, Russia: Ast Publishing.

ABOUT THE AUTHORS

Stephanie M. Anderson: PhD Candidate in Social Personality Psychology at the Graduate Center of the City University of New York. Her research centers on constructions of gender and sexuality. Anderson incorporates documentary film throughout the research process, particularly as an analytical approach and means to engage with public discourse.

Hector Aristizábal: Born in Colombia, where he had a distinguished career as director, actor, playwright, and psychologist. He has lived in exile in the United States since 1989. Aristizábal serves on the board of the Program for Torture Victims and brings theater skills to his psychotherapeutic work with those who, like himself, are survivors of torture. As the creative director of ImaginAction, he trains others in Theater of the Oppressed techniques and other methodologies aimed at community healing, community building, and reconciliation.

Tom Barone: EdD from Stanford University in 1978. He has explored various narrative and arts-based approaches to contextualizing and theorizing about significant educational issues. Barone's latest book is *Arts-Based Research*, coauthored with Elliot Eisner (2012). Barone received the American Educational Research Association Division B Lifetime Achievement Award (2010) and the Tom Barone Award for Distinguished Contributions to Arts-Based Research from the AERA Arts-Based Special Interest Group (2012).

Athene Bell: District literacy specialist in Manassas City Public Schools; PhD in literacy education from George Mason University. Bell taught English to middle school students for 19 years. Her areas of interest include the study of visual and multimodal literacy among adolescents, teacher education, and formative design methodology and how high school English-language learners learn to read in English.

Lee Anne Bell: Barbara Silver Horowitz Director of Education at Barnard College. Bell completed the documentary *Forty Years Later: Now Can We Talk?* about black and white alumni from the first integrated high school class in the Mississippi Delta to discuss their experiences then and now. She is coeditor of *Teaching for Diversity and Social Justice, A Sourcebook* (Routledge, 2007) and author of *Storytelling for Social Justice: Connecting Narrative and the Arts in Antiracist Teaching* (Routledge, 2010).

Marta Benavides: Salvadorian; human rights and peace advocate; head of the Ecumenical Committee for Humanitarian Aid, sponsored by Archbishop Oscar Romero. She founded the International Institute for Cooperation Amongst Peoples and the Movimiento Siglo XXIII. Benavides conducts training on sustainable agriculture, human rights, the arts, health, and the prevention of violence. She is one of 1,000 women nominated for the Nobel Peace Prize in 2005 and was awarded the Woman Peacemaker by the Joan B. Kroc Institute for Peace and Justice in 2009.

Patty Bode: Visiting Associate Professor, the Ohio State University Department of Arts Administration, Education and Policy. Bode specializes in the sociopolitical context of critical multicultural education, urban arts education, dismantling the school-to-prison pipeline, decolonizing global art education, and digital visual culture.

Ayoka Chenzira: Pioneering filmmaker; helped usher in a new wave of African American independent cinema. She produced and directed 25 films and is a digital media artist and interactive designer. Chenzira is a professor of film and women's studies and is the founding director of the Digital Moving Image Salon at Spelman College.

Kawachi A. Clemons: Assistant Professor of Music and Director of the Institute for Research in Music and Entertainment Industry Studies at Florida A&M University. Clemons's focus is pedagogy on the interrelationship of artistic agency (problem posing and problem solving in the arts) and culturally responsive teaching.

Kristal Moore Clemons: PhD in education from the University of North Carolina at Chapel Hill; graduate certificate in women's studies from Duke University. Clemons is a feminist historian whose teaching and research seeks to understand the narrative of gender, race, and class throughout U.S. history.

Dipti Desai: Associate Professor at New York University; Director of the Graduate Program in Art Education.

Cheryl T. Desmond: Professor of educational foundations, Millersville University of Pennsylvania. Desmond teaches at the undergraduate and graduate levels

and researches educational reform and policy, community engagement, social justice and global sustainability, and the arts as a means of human transformation.

Marit Dewhurst: Director of Art Education; Assistant Professor of Art and Museum Education at the City College of New York. Dewhurst's research and teaching interests include social justice education, community-based art, youth empowerment, and the role of the arts in community development.

Basil El Halwagy: MAT, Tufts University with School of Museum of Fine Arts, Boston; Visual Arts Teacher, K–12, Ambrose Elementary School in Winchester, Massachusetts. El Halwagy has taught art at all grade levels in urban and suburban districts. His art teaching focuses on social justice and critical multicultural education. His studio art practice explores connections between sciences and spirituality.

Marriam Ewaida: Middle school literacy coach and former secondary English/ESOL teacher; PhD student in Literacy and Educational Leadership at George Mason University. Ewaida studies at-risk immigrant youth and their literacy experiences in America, with a focus on social justice and equity.

Derek Fenner: In EdD program at Mills College, focusing on the arts as a mechanism of social justice in school and community settings. Fenner is an artist, a writer, a publisher, and an educator with 10 years of experience in the juvenile justice settings as a teaching artist, a mentor, and an administrator.

Mary Stone Hanley: PhD in Curriculum, and Instruction from University of Washington, playwright, poet, educator, scholar, and researcher; BA in Children's Theater. Hanley has spent a lifetime as an artist and 40 years as an educator and arts activist. She has taught arts education and critical multicultural education courses in higher education since 1996 and has researched drama for K–12 students, Hip Hop culture, and the arts for adult learners. She is founder and president of Hanley Arts & Education Associates, a professional development and curriculum development consultancy in arts and equity education (http://marystonehanley.com).

Yael Harlap: Associate Professor in Education at the University of Bergen, Norway. She researches social justice in teaching and learning in higher education. Yael also works with Theater of the Oppressed, primarily with Teaterkollektivet (the Theater Collective) in Bergen.

James Harmon: English teacher in the Euclid City School District outside Cleveland, Ohio; codirector and cofounder of Through Students' Eyes (http://www.throughstudentseyes.org). Harmon has been recognized as an Apple Distinguished Educator in 2007 and became a Google Certified Teacher in 2008. He is Editor of the NAPDS journal *School-University Partnerships* (jharmon@euclid.k12.oh.us).

bell hooks: Feminist, scholar, and activist; Distinguished Professor in Residence, Appalachian Studies at Berea College. Her writing focuses on the interconnectivity of race, capitalism, and gender and their ability to produce and perpetuate systems of oppression and class domination. She has published more than 30 books and numerous scholarly and mainstream articles, appeared in several documentary films, and participated in various public lectures.

Kayhan Irani: Emmy Award–winning writer, performer, and Theater of the Oppressed trainer. Irani directs participatory arts projects with government agencies, community-based organizations, international NGOs, and the general public. For the past 2 years, she has led theater-for-change projects in Afghanistan.

Carol A. Kochhar-Bryant: Senior Associate Dean of the Graduate School of Education and Human Development; former Chair of Department of Special Education and Disability Studies. Kochhar-Bryant has been widely published in disability policy and practice; interagency service coordination for individuals with disabilities, leadership development, and transition to postsecondary and employment for special learners.

Justin Laing: Program Officer in the Arts and Culture Program of the Heinz Endowments. Laing has managed, performed, and taught as Assistant Director of Nego Gato Inc. (NGI), an African Brazilian arts organization. He received a BA in Black Studies & Political Science from the University of Pittsburgh and a master's in Public Management from Carnegie Mellon University.

Stacey S. Levin: Filmmaker and PhD student in Curriculum Studies at Arizona State University. Levin received a Bachelor of Fine Arts in Film & Television from New York University's School of the Arts and has worked in the film/television/radio industry. She served as a public high school film teacher in New York as well as an art education instructor at Hofstra University.

Ann Rowson Love: Director of Museum Studies Graduate Program at Western Illinois University–Quad Cities in collaboration with the Figge Art Museum in Davenport, Iowa. Formerly, she was curator of education at the Ogden Museum of Southern Art–University of New Orleans. Love has 20 years of experience as an art museum educator.

Christine Morano Magee: Assistant Professor in Educational Leadership, Montclair State University; doctorate in Special Education at the George Washington University. Magee is Lead Faculty for Bilingual Special Education at George Washington University and was formerly the Director of Educational Services for VSA arts, the Kennedy Center. She is Founder and President of Studio Learning Associates, an arts-based educational consulting firm.

Leyla Modirzadeh: Ping Chong and Company; writer, performer, and educator. She received a BA (Humanities) from University of California Berkeley, an MFA (Acting) from the University of Washington, and an MFA (Fine Arts) from Pratt Institute.

George W. Noblit: Joseph R. Neikirk Distinguished Professor of Sociology of Education at the University of North Carolina at Chapel Hill. His work has focused on issues of race, school reform, and, more recently, the arts. He is coauthor of *Creating and Sustaining Arts-Based School Reform*, published by Routledge. Noblit is currently working on an edited book of oral histories of school desegregation. As well as being an academic, he is also a musician and farmer.

Nana Osei-Kofi: Associate Professor and Coordinator of Social Justice Studies in the Department of Educational Leadership and Policy Studies at Iowa State University. Osei-Kofi's scholarship focuses on cultural studies in education, critical and feminist theories of education, the politics of higher education, and arts-based inquiry. She also serves on the editorial board of *Feminist Formations*.

Deborah Randolph: Curator of Education at the Southeastern Center for Contemporary Art in Winston-Salem, North Carolina. Randolph is in the PhD program at the University of North Carolina at Chapel Hill, School of Education. She is the former Associate Curator of Education at the Ogden Museum of Southern Art in New Orleans.

Gilda L. Sheppard: Faculty in Sociology, Cultural and Media Studies at the Evergreen State College, Washington State. She has taught internationally in colleges and universities in Ghana, West Africa, and is an award-winning filmmaker who has screened documentaries in the United States, Cannes Film Festivals, and the International Festival in Berlin. Sheppard is currently producing a documentary, *Swinging with no Hands*, on education and activism in prison.

R. A. Washington: Multimedia artist and writer based in Cleveland, Ohio.

Mary E. Weems: Assistant Professor in Education and Allied Studies, John Carroll University. Weems is a poet, playwright, and scholar in interpretive methods. She is also author and coeditor of several books, including *Public Education and the Imagination-Intellect: I Speak from the Wound* and *Writings of Healing and Resistance: Empathy and the Imagination-Intellect*, in press.

Heather Homonoff Woodley: PhD candidate in Urban Education at CUNY Graduate Center. Woodley taught in Washington, DC, and New York City public schools. She attended Al Akhawayn University in Morocco and then joined the

Belly Dancers of Color Association dancing with Dr. Sunyatta Amen in Washington, DC. She continues to teach *raqs sharqi* to young women in New York.

Kristien Zenkov: Associate Professor of Literacy Education at George Mason University. Author and editor of more than 70 articles, chapters, and books about teacher education, literacy and language arts pedagogy, and professional development schools. Codirector of Through Students' Eyes, a project based in Cleveland, northern Virginia, Haiti, and Sierra Leone wherein youth document with photographs and writing what they believe are the purposes of school.

INDEX

Made in the USA
Lexington, KY
19 October 2018